DIGITAL PHOTOGRAPHY
STEP BY STEP

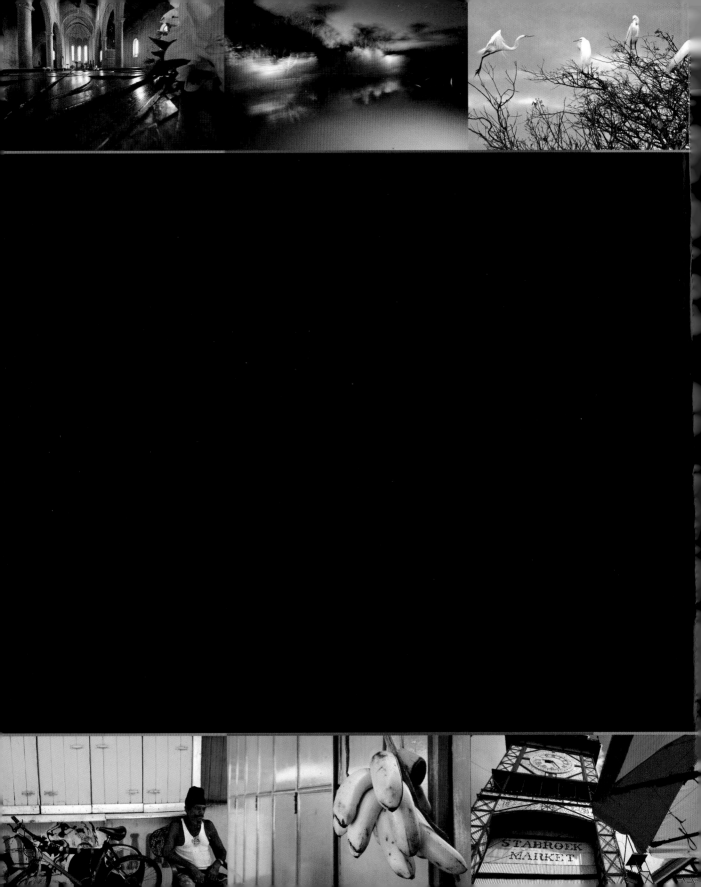

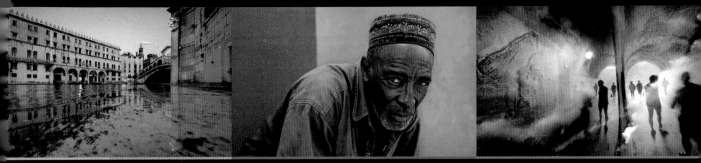

TOMANG

DIGITAL PHOTOGRAPHY
STEP BY STEP

DK LONDON, NEW YORK,
MUNICH, MELBOURNE, DELHI

For Nicky (the Faithful Retainer)

Senior Project Editor Nicky Munro
Project Art Editor Sarah-Anne Arnold
Project Editor Hannah Bowen
Editor Hugo Wilkinson
Designer Joanne Clark
Jacket Design Silke Spinges
Production Editor Joanna Byrne
Production Controller Danielle Smith

Managing Editor Stephanie Farrow
Managing Art Editor Lee Griffiths
Publisher Jonathan Metcalf
Art Director Phil Ormerod

First published in Great Britain in 2011
by Dorling Kindersley Limited
80 Strand, London WC2R 0RL
Penguin Group (UK)

10 9 8 7 6 5 4 3 2 1
001–TD443–May/2011

This edition produced for The Book People Ltd,
Hall Wood Avenue, Haydock, St Helens, WA11 9UL

Copyright © 2011 Dorling Kindersley Limited
Text copyright © 2011 Tom Ang, except chapters
7 and 8, copyright © 2011 Dorling Kindersley Limited

The software used to enhance or manipulate the images
in this book include Apple Aperture and Adobe Photoshop,
plus various plug-ins, but the techniques described are
generic. If you have one of the widely available image
manipulation applications, you should be able to carry out
the majority, and probably all, of the operations described.

A CIP catalogue record for this book is available
from the British Library.

ISBN 978-1-4053-9103-0

Printed and bound in Singapore by Star Standard

Discover more at
www.dk.com

CONTENTS

MASTERING
PHOTO-**SUBJECTS**

Introduction

Photography is the most popular and influential visual medium the world has ever known. The sheer scale of digital photography, in particular, is overwhelming: each year, more than a billion digital cameras are sold worldwide. This figure includes more than 200 million sales of cameras such as dSLRs and point-and-shoot models, with the rest consisting of sales of mobile phones with cameras whose image-capture capabilities far surpass those of early digital cameras.

Visit the top three photo-sharing websites and you'll have access to a staggering 40 billion images. That figure is worth repeating: 40 billion images. Indeed, digital images are being added so rapidly and continuously from every corner of the world that website administrators are only able to host a tiny percentage of the images available to them. In short, we routinely capture more images in a single year than were captured in the entire history of pre-digital photography.

The ubiquity of digital photography has helped fuel its popularity: today there are more photography enthusiasts than ever before. Digital technologies also enable photographers to achieve professional results with relatively little expense. The result is radically demotic: more people in more countries than ever before – across more cultures, classes, religions, and races – are able to enjoy the rewards and challenges of photography.

My first book on digital photography was published in 1999. At that time, film was the professional's medium of choice, and there were many noisy debates espousing the merits of film – often at the expense of the digital form. Back then, the burden of sorting through thousands of images was one faced only by the large picture agencies. Four editions of the book later, digital capture has all but replaced film-based photography – even at professional level. Amateurs use cameras whose power far exceeds earlier professional models which often cost as much as a car. We also have mature solutions for handling the thousands of images routinely produced on each assignment or overseas holiday. In addition, video capture has entered the scene as a thrilling and rapidly maturing function of all types of digital camera.

What remains unchanged throughout, however, are the core photographic skills: mastery of composition and camera controls, artistic drive and ethical integrity, plus a thirst for creative solutions – all wrapped up in a passion for visual perfection.

Digital Photography Step by Step celebrates and elaborates on these core qualities. Presenting a comprehensive round-up of photo-techniques, this book is ideal for those with some camera experience who wish to deepen their understanding of the subject and broaden their technical and artistic skills.

The opening chapters guide you through the key picture-making skills, while the middle section of the book examines digital workflow – from image capture and enhancement to manipulation and picture-sharing. Then, we explore the exciting realm of dSLR filmmaking. Finally, the book takes you through the equipment and software options that make modern photography so engaging. *Digital Photography Step by Step* describes every major topic, from learning how to use your camera's controls, to post-processing and picture-sharing.

In this book, I have drawn on 30 years' experience of working at top levels in photography and the photographic industry, and on my experiences of writing, photographing, and picture-directing more than 20 books on photography – including one on video. Equally, the book's publishing team is highly experienced, extremely skilled, and passionate about photography. Together, we have given it our all. We hope that our book gives you the confidence to explore the world with joy, inspired by awe and respect for its generous gifts.

QUICK-START IN PHOTOGRAPHY

Your first photos

The temptation to power up your camera and snap a few pictures – without reading the manual or fiddling around with settings – is utterly irresistible. Fortunately, modern cameras are set up to work as soon as you take them out of the box, so go ahead and have some fun with your new toy.

However experienced you might be, handling a new camera is like driving a new car: even if you know where to find all the basic controls, it still won't behave in exactly the same way that you're used to. And if you're new to handling cameras, it's especially rewarding to get to know *your* camera well. Accustom yourself to the feel of the buttons, dials, and switches, and become familiar with how long it takes to respond to instructions. Note the location of the controls, so that you'll be able to find them confidently whenever you need them.

The more sophisticated controls are located deep in the menu options: don't try to master these at the very beginning. If some of the terms in the menu are unfamiliar to you, don't worry: you don't need to understand them all to use the camera. Take advantage of the fact that it's set up to capture images straight away.

> **JACQUES-HENRI LARTIGUE**
>
> It's marvellous, marvellous! Nothing will ever be as much fun. I'm going to photograph everything, everything!

One of the first things you need to understand is that you and your camera see things differently. Elements in a scene will be more sharply defined when viewed with the naked eye, colours won't be the same, and, of course, the camera will only be able to capture a small part of the view.

To learn how the camera sees, take lots of photographs and look at them carefully and dispassionately. Don't look at images on the screen on the back of your camera; go through them only on a computer screen. Checking the review images while you photograph seriously interferes with the concentration that should be reserved for your subject. It breaks the flow and takes you out of the moment. It's also a tricky habit to shake off once you've

A different view
There's always more than one angle from which to take a picture (see pp.36–37). Pick a subject and look at it from the top, from the side, from nearby, from further away, and even from below.

Enjoy the way your camera can open your eyes to the world around you – anything and everything can become extraordinary when you capture it through your lens. Whether bringing everyday objects to life in fine detail, or recording day-to-day moments as they unfold in front of you, your camera can distil your life, and the things around you, into innumerable images.

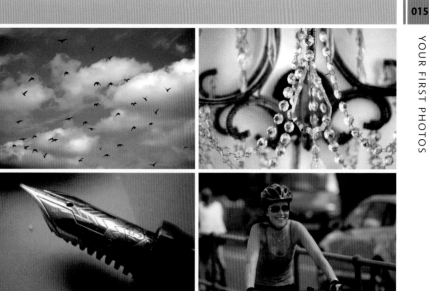

acquired it. As you gain experience, try to anticipate or visualize the image before you view it through the camera. To develop your skill in this area, try learning to shoot without even looking through the lens.

Start where you are

If you've bought a camera especially for a trip, it's essential to become familiar with it before you go – but don't feel that you need to travel to exotic overseas locations to find worthwhile shots. There are plenty of photo opportunities all around you, right now. You don't need to leave home, or even the chair you're sitting in: items on your desk, the family cat, houseplants, the view from your window – all make perfectly good subjects for your first photos. Look for unusual angles to lend your shots added interest.

Alternatively, visit a nearby park or public space and snap away: don't be self-conscious about your shots. You're not being graded, and no-one expects prize-winning images. The more pictures you make with your camera, trying different settings at random, the better you'll get to know it – and the more fun you'll have.

Surprise yourself

The more shots you take, the greater your chances are of creating something unexpectedly sophisticated from simple subject matter, such as sunlight shining through trees.

Ten pillars of photography

More people all over the world have access to photography than ever before. Among them, thousands of keen photographers aspire to ever-higher levels of skill, and some to make a career out of it. Of course, you don't have to be highly skilled to enjoy photography and find it rewarding. But the more you understand, the greater the returns will be – whether you pursue photography as a pastime or a profession.

Whether you're new to photography, or are more experienced, it's worth keeping these "pillars" in mind as you develop – they could help guide your skills to higher levels. And as your knowledge grows, you'll doubtless be able to add your own golden rules to this list.

Write with light

If there is a single element that links all the great photographers of the past and present, it's that they work hand-in-hand with light; for them, light is a partner, not an enemy. They create their images by exploiting its properties; they don't merely expose with its assistance. You'll enjoy photography more when you welcome all kinds of light and adapt your photography to the prevailing light

ERNST HAAS

> The limitations of photography are in yourself; for what we see is only what we are.

conditions. You don't need to fret if there is too much or too little light: with today's powerful sensors, it's more true than ever that if you can see it, you can photograph it.

Capture sets the standard

The fate of an image is set and sealed the moment you capture it. Processing may make it look better, but it's not possible to replace what's not there. If the camera moves during exposure, or if focus, framing, or exposure time are not spot-on, there may be several adjustments to make before it is presentable. This means that errors at capture store up work; and the more serious the mistakes, the greater the struggle to make the image look as if it had been captured perfectly. Taking as much care as possible when

The right equipment
Whatever situation you're in – whether you're on holiday, trying to get a shot of a specific location or subject, or just out and about – it's always a good idea to plan ahead and try to work out what equipment you'll need. Some situations may call for a dSLR, multiple lenses, a tripod, and flash accessories; at other times, you may be better served by a compact camera that you can carry in your pocket.

Finding a worthwhile subject is only the beginning of your task as a photographer. For every subject there are innumerable viewpoints and angles to explore, and all of them will give different results. Be patient, experiment, and don't rule out any type of shot – only then will you really start to build your skills, and find out what kind of pictures come naturally to you.

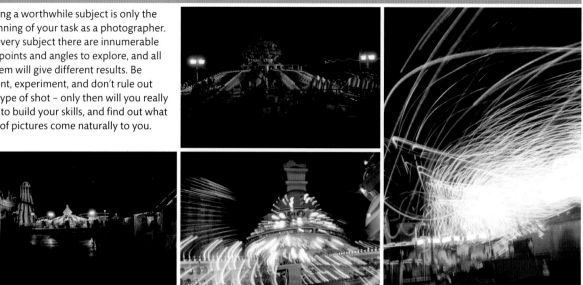

you make your images will save you hours of work at the computer. Get it right from the start, then you can enjoy your images, rather than having to apologize for them or spend valuable time making corrections.

Maintaining the rhythm

The term "chimping" means "checking image preview", and is inspired by hearing photographers exclaim "Oo! Oo! Aah! Aah!" when they check their previews. Image preview has been welcomed as one of the main advantages of the digital revolution, and many photographers say they benefit from checking their previews and making adjustments. However, they may spend as much time reviewing their images as they do looking through the viewfinder. The result is that they miss many shots, break the rhythm of their shooting, and interrupt the concentration they could be applying to the subject.

Try to reserve your reviewing to rest-breaks and moments when you're sure there's nothing going on. You don't have to go as far as some photographers, who tape up their screens, but turn off the preview and you'll find you do more photography, and get more involved in your subject.

Once deleted, always gone

Many photographers delete their unwanted photos with relish, pleased to remove all traces of their embarrassing errors and what they consider bad photographs. Others may delete such images in order to make room on the memory card. This is always a danger: it guarantees the loss of shots that might be unconventional and quirky.

Fragile: handle with care

Images are at their best at the time of capture, containing the highest-quality data they'll ever have. After each and every step of processing, the quality drops: the image may look better, but the data is degraded. This is not a fault of

DID YOU KNOW?

Big is not always beautiful. There was a time when many problems could be avoided by working with the largest possible files – the ambition was to surpass the resolution of film. From this the myth grew that large files – those with the most pixels – are the best quality. With improved understanding and more sophisticated image processing, images from modern cameras are of far higher quality than those from earlier cameras with twice the resolution (see pp.106–07). Taking care to capture the best possible quality images using the equipment you have will give better results than working with a higher-resolution camera. Avoid big files if you don't need them, because they slow you down and fill up your memory cards quickly, but don't give you a visible benefit.

EVERYDAY SUBJECTS

You needn't feel that you should save your photography for special occasions or traditional subject matter. Look for beauty in the everyday and you'll find a whole new world of photographic opportunity.

Breaking rules

There are many rules concerning how you should and shouldn't compose a shot – and there are many more reasons you should break them, if it means capturing an engaging, character-filled image.

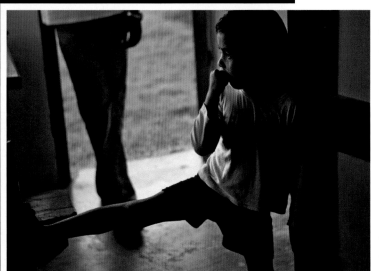

processing, software, or of your technique, but the result of the laws of nature. So, you should do everything you can to preserve the original image.

Always work on a duplicate or copy of the original, or with a proxy created by management software such as Adobe Lightroom or Apple Aperture. Then save the new version under a new name, so that you can always return to the image just the way it was the moment it was captured.

The weakest link

In the imaging chain, which extends from capture through to output, every stage has an impact on the quality of the image – its resolution of detail, the accuracy of its colour and exposure, and its level of distortion. The weakest link at time of capture is usually the operator, because that's how errors in exposure or focus enter the equation. But even if the photographer performs perfectly, the quality of the lens can be the main limiting factor.

However, all of this may be beside the point, depending on the final use of the image – which may be no larger than the largest size permitted by a photo-sharing site, or that needed to make small prints. Both these outputs greatly reduce the need for very high resolution files. Adjust your photography to your required output. Compact cameras give truly excellent results for images intended for websites; dSLRs are greatly over-specified for internet-based images. So, there's no need to hold back if you don't have the latest camera: remember that almost all the great photographs of the past were taken on cameras technically inferior to today's equipment.

Monitor your colours

The computer's monitor is the centre of the digital photography universe: everyone reviews, organizes, and processes their images using one. The key to consistent and reliable review and processing of images is in the quality and set-up of the monitor; too many photographers spend a lot of money on their cameras, only to work with their images on monitors that are of inferior quality, and not colour-managed.

For the best results when assessing and processing your images, calibrate and profile your monitor (see p.334). That's the only way to be sure that the colours you see on-screen are truly the colours captured by your

Mobile photography

Now that cameras are a standard feature on most mobile phones – some even with built-in options for effects – you needn't ever miss a photographic opportunity.

camera. And, instead of spending money on a new camera, consider investing in a higher-quality computer screen. Good monitors make a huge improvement to your photography by showing your adjustments accurately.

Photography for life

Unlike many other hobbies, photography can be undertaken anywhere, at any time, by anyone of any age. You can photograph your daily activity, from your breakfast to your bedtime, at your workplace, in your garden, or on a mountain top. It's exhilarating to discover that there are no limits to photography, either in terms of subject matter or treatment. Everything depends on how much you're willing to express yourself through the medium, and share the results with others.

Respect your subjects

Above all, look after the things that you most love to photograph. Treat your subjects with respect – in the case of plants and wildlife, do what you can to help their survival or conservation. And try to express your fondness for your subjects in your photography, for in that comes the greatest of all a photographer's rewards.

In areas such as travel and wildlife photography, remember that the photographers who came before you have left the people, animals, and location in a state that allows you to enjoy your photography. So do the same: ensure that everything you do enhances the reputation of photographers, and that others after you can also enjoy the same places, views, and subjects.

In-depth exercises

While you can photograph anything and everything, you may find you have a tendency to make images at certain times, featuring certain subjects. Follow this lead: the deeper you take a certain approach, the more rewarding your photography will become. Working to produce sets of images is good practice, and strengthens your skills.

▼ THE BRIEF

▷ Ask a friend or family member to name something at random – the first thing that they think of. Make a set of pictures based around this subject, and apply the approach that comes most naturally to you.

▼ POINTS TO REMEMBER

▷ **Allow yourself the freedom** to shoot or treat the subject in any way you feel is appropriate, or in a way that you know you'll enjoy.

▷ **Aim to create a certain number** of pictures as your target, and try to revise and improve the images in the set once you reach the target amount (say, five or ten images) – rather than simply taking more pictures.

▷ **Have fun with the idea** of being obliged to shoot something you may not have thought of as worthy of photographing, or that might not have occurred to you as a subject.

▷ **Experiment with the relationships** between the images within the set – they could relate to each other in a way that's narrative, or abstract, or that comments on the subject itself.

GO GOOGLE

☐ **Daguerreotype**	☐ **Bill Owens**
☐ **Street photography**	☐ **Martin Parr**
☐ **Wet plate collodion**	☐ **Man Ray**
☐ **Robert Capa**	☐ **Garry Winogrand**
☐ **Bruce Gilden**	☐ **Magnum Photos**

Preparing your camera

The more carefully you set up your camera before you begin shooting, the more time and effort you'll save when you start using your images – and this time can add up to dozens of hours over the course of a year. The key camera settings include the image size, the colour qualities, and the custom control settings for a variety of different conditions.

With the right collection of settings and proper photo-technique, you may not need to process your images at all before putting them to use – at least, that's the ideal we're aiming for. Furthermore, the better you know your way around your camera, the more you'll enjoy using it. And never again will you endure the frustration of trying to work out what to do when you're in a hurry to capture a once-in-

DATE AND TIME

1 Set the date and time for your location, particularly when travelling abroad. Synchronize the time with your partner's camera so that pictures will be listed in the correct order when you download them.

IMAGE QUALITY

2 It is neither necessary nor advisable always to record images at the highest quality and resolution. Set a small image size and high compression (lower quality) when making informal snaps – pictures of friends intended for social networking sites, for example. Set high quality and resolution when travelling, or when engaged in serious photography. With today's high-resolution cameras, a setting equivalent to around six megapixels is likely to be suitable for a wide range of uses, while also making economical use of memory cards and hard-disk drive space.

IMAGE SHAPE

3 Some cameras offer a choice of format proportions: from 4:3 (which fits old-style monitors and many print formats) to 16:9 (which fits HD screens but not some print sizes); 3:2 (widely used by dSLRs) lies in-between.

AUTO-FOCUS MODE

7 You can set your camera to focus on static subjects: often called "single shot", this mode allows exposure only when sharp focus is achieved. For moving subjects, set Follow-focus or Servo mode, which continually tracks changes in the scene and allows exposure to be made at any time. All cameras offer single-shot mode, most offer both modes, and some models switch between modes automatically, depending on the behaviour of the subject.

SERIES OR SINGLE SHOT

8 All cameras take one shot when you press the shutter button: this is a practical mode for the majority of situations. For fast-changing situations, it's useful to set the camera so that it makes a series of exposures for as long as you hold the shutter button down. High-grade cameras can make five exposures per second or faster. The total number of possible exposures varies: simpler cameras can make only two or three exposures, then must stop to load the pictures.

FLASH MODE

9 "Auto" mode flashes when the light is so low that the long exposures needed may blur images. Set to "Off" to avoid disturbing others, or for distant evening views – for which you'll need a tripod and a long exposure.

a-lifetime moment. Practice is the key: you can't damage your camera by trying out all the options, variations, and settings, so this is a good place to start. Push each button to see what it does, and get accustomed not only with what happens, but with the feel and location of the button. Play with the controls or dials: feel how loose or firm they are, and practise setting them precisely. Follow the flow chart below to get your camera up and running: set one option and take a shot from where you're sitting. Review the results. Go to the next one, shoot and review; repeat until you understand what the option does. This is the only time when reviewing images after each shot is good practice, to help you familiarize yourself with how your camera works and what all the terms and icons mean.

WHITE BALANCE

4 Cameras are set to compensate for variations in the colour of illuminating light (auto-white balance). Improve results by setting white balance for conditions: Tungsten for domestic lights, or Cloudy on overcast days.

COLOUR QUALITY

5 Your camera may offer a choice of colour qualities, from black and white through soft pastels to bright colours. Use softer colours for portraits or weddings, and strong colours for graphics or landscapes on dull days.

AUTO-EXPOSURE MODE

6 For the majority of circumstances a camera's fully automatic (or Programme) mode, which chooses both exposure time and aperture, delivers good results. Some cameras offer an "Auto ISO" or "Intelligent Auto" mode which also sets the sensitivity (see pp.102–03). When you want to freeze fast action, Shutter Priority gives more reliable results. And when you want specific apertures – full aperture for portraits, or small apertures for still life or landscapes, for example – Aperture Priority is the preferred setting. For experimenting with exposure, set Manual mode.

SCENE MODE

10 The range and multiplicity of different settings is usually very confusing. Scene mode (see pp.24–25) reduces the need to scroll through menus by collecting together all the settings appropriate for different circumstances. For example, a Portrait mode will set a large aperture, soft colours, and no flash, while a Night Portrait mode turns on the flash but also sets a relatively long exposure time in order to capture ambient light.

CONNECTING

11 If your camera can communicate with Bluetooth devices, 3G, PictBridge printers, or other mobile phone or internet services, you will need to activate the service and identify your camera to your existing devices. Follow the on-screen instructions: if you need to enter a code number into the target device, ensure the code is within easy reach.

SPECIAL SETTINGS

12 If your camera offers special features, set these up and take advantage of them. For example, if it's enabled for GPS (Global Positioning System) you need to enter the starting coordinates at the outset. Once the camera knows where it is, it can tag your photos with their exact location. If you want to send images to a favourite social networking site, you will need to give the camera your account details, including your password.

Camera basics

Today, even the most sophisticated, professional cameras can be treated as point-and-shoot – out of the box they work fully automatically. You can obtain huge enjoyment from digital photography without having the slightest idea what the camera is doing, or how to control its myriad functions. Here we show the key features you'll find on compact and dSLR cameras.

DID YOU KNOW?

Pixel is short for "picture element". It's the smallest unit of a digital picture, and is usually square in shape. In theory, the amount of detail you can see in an image depends on the number of pixels it has – the more pixels, the more potential to show detail (see pp.106–07).

COMPACT CAMERA

Although there's a vast range of compact digital cameras available, these are the most basic components present in the majority of makes and models.

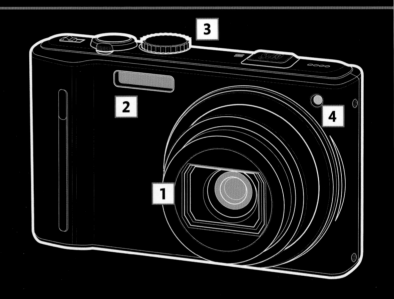

1 Zoom lens
This type of lens can vary its magnification and change the field of view captured in a shot.

2 Electronic flash
This may flash automatically or pop up on demand in low light. It provides a brief burst of light for exposing the image.

3 Mode dial
Cameras use either a dial or buttons to select different modes; for example, the auto-exposure mode.

4 Self-timer lamp
When using the self-timer mode, this light flashes to indicate when the shutter is about to open.

5 LCD screen
This is used both to frame a picture when you're about to shoot, and to select and set menu options.

6 Capture/Review mode button
This switches the camera between being set up for taking photos and set up for reviewing, printing, or slide shows.

7 Navigation buttons
These buttons enable you to navigate through images and menus.

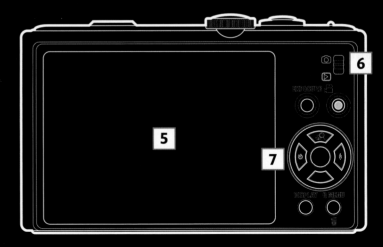

dSLR CAMERA

Here are the most basic components present in all entry-level dSLRs. More advanced dSLRs may have additional dials and control buttons (see pp.324–25).

1 Interchangeable lens
Zoom or fixed focal-length lenses can be swapped, giving high versatility.

2 Aperture
The aperture is the opening in the lens – controlled by an iris diaphram – through which light passes.

3 Mode dial
This dial enables you to switch between shooting modes, such as aperture priority and shutter priority.

4 Pop-up flash
Many models feature a small flash that pops up on demand, but all feature a hot shoe to take an accessory flash unit.

5 Shutter button
This button triggers the shutter, and also initiates focus when the lens has been set to auto-focus mode.

6 Sensor
Located inside the camera, behind the shutter, the sensor is exposed when the shutter is triggered.

7 Shutter
A shutter is a mechanical blind that opens to expose the sensor, then closes after the set exposure time.

8 Viewfinder
In most dSLRs you'll need to use the viewfinder to frame your shots. You use it to see the view through the lens.

9 LCD screen
The display is used for reviewing images and video, setting menu options, and, in some cameras, composing shots.

10 Navigation buttons
This set of buttons enables you to navigate through images and menus, or adjust feature settings.

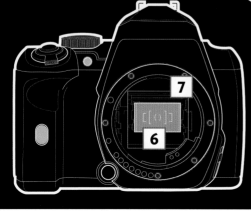
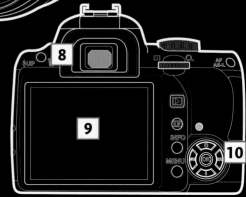

Scene modes

If you find yourself bewildered by your camera's selection of settings and their possible combinations, don't worry – you're not alone. However, it needn't be difficult. Early on in digital camera design, it was realised that certain settings are used repeatedly for different situations. For example, in low light, you'd set high ISO and use large apertures, and perhaps turn on

the flash. In contrast, when on sunny beaches or ski slopes, you'd need to over-expose to ensure brightness, using low ISO because of the high light levels. So, manufacturers created scene modes – automated settings for commonly-occurring situations. Use them as a handy shortcut, but also to learn which of the camera's settings are suitable for different conditions.

PORTRAIT

Warm tones and increased saturation make skin tones appear healthy. The lens may be zoomed out to at least 75mm and aperture set to maximum, with the flash turned off and the shutter set to a short exposure time.

LANDSCAPE

In this mode, saturation is greater than normal, and sharpness may also be increased. Wide-angle may be set, along with low ISO, maximum resolution, and small apertures. Any available image processing, such as extending the dynamic range, will be applied.

BEACH OR SNOW

Generous exposure combined with low ISO captures bright beach or snow, while allowing for high brightness; a small aperture extends the depth of field. Contrast may be reduced to compensate for hard light.

SUNSET

The primary aim of this mode is to capture the deep hues of the sun and sky. The saturation is raised, the exposure may be reduced, the ISO is set to a medium speed, and resolution is set at maximum.

PARTY

One of the most useful of all the scene modes, this sets the camera to balance flash with low ambient light. It allows relatively long exposures, helped by high ISO. Large aperture settings avoid black backgrounds.

FIREWORKS

Setting medium-to-high ISO with a fixed camera exposure combination – typically 1/4sec at f/4 – and with focus set at infinity, helps capture the majority of fireworks displays (see pp.72–73).

Scene modes are different from other exposure modes in that they set a combination of parameters according to the scene, and to the level of sophistication allowed by the camera's programmers. These parameters include ISO, shutter, and aperture, any over- or under-exposure required, colour saturation, sharpness, file size, compression, and drive speed. Point-and-shoot and superzoom cameras may also set the zoom, but scene modes in dSLR cameras with interchangeable lenses modify only the camera settings.

When getting to know a camera, work your way through each of the modes, and take a few shots to see what each one does. If you're still confused, refer to the explanations of the most popular scene modes here, and note how each is set.

DOCUMENTS

When photographing documents or artwork you'll want crisp, sharp images: this mode will sharpen the picture strongly, raise contrast, and record at the highest possible resolution, with neutral colours.

CANDLELIGHT

Here the camera sets maximum ISO and turns the flash off. Aperture is also set to maximum and white balance is allowed to be warm rather than fully neutral. Close-up focusing range may be set to maximize focusing speed.

CLOSE-UPS

For shots of flowers and other small objects, the lens will be set to its Macro mode, with a small aperture for maximum depth of field. The flash may be activated to ensure sharp results, colours may be boosted, and sharpening applied.

SPORTS

Here exposure times are minimized by increasing ISO to high levels and setting large apertures, together with the longest focal length (on point-and-shoot cameras) and rapid firing rate. This setting is also good for photographing children and pets.

NIGHT SCENERY

This setting turns off the flash, as it has no effect on exposure of distant scenery. High ISO, wide aperture, and maximum resolution will be set, and perhaps noise reduction for long exposures. When taking shots at night, support the camera on a wall or a tripod.

FOLIAGE

Foliage mode boosts a scene's colour saturation, and aims to achieve a warm white balance that in turn produces rich, autumnal colours using medium ISO, high resolution, and small apertures.

Viewing and sharing

Once you've taken lots of photos, you have plenty of options when it comes to viewing and sharing them – from displaying them in a frame and showing them on your smartphone, to disseminating them electronically by email, photo-sharing websites, and personal websites or blogs. Before doing any of these things, however, you may wish to enhance the images to show them to their best advantage (see Chapter 5), and experiment with image manipulation software to strengthen their visual impact (see Chapter 6).

Photos have become essential tokens of social exchange in the 21st century. Sharing pictures helps facilitate global connectedness: you can now share precious moments with

PRINT OUT

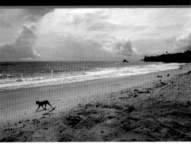

Print your pictures out (see Chapter 7). Even inexpensive ink-jet printers can give superb results. Practise with ordinary paper first, and, when you're confident, use good-quality papers for the best results. If colours are poor, experiment with the colour settings.

ORDER ONLINE

Purchase prints from online services (see pp.294–95). Order extra-large prints to give as gifts, or sell your images as prints. Prepare your images carefully before uploading them; order a small batch first to assess quality. This is an economical option if you don't own your own printer.

FRAME

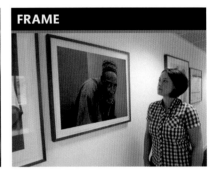

Display your prints in a picture frame (see pp.290–91). A good frame will show your picture to its best effect: take into account the colour, material, and size of the frame, where the frame will be positioned (such as on a table, or a wall), and how it may complement its surroundings.

PHOTOBOOK

Create your own photobook (see pp.292–93). Research a few different services and download their free book design software to see which you prefer in terms of design and ease of use. Order a modest print run to test the service.

SMARTPHONE ALBUM

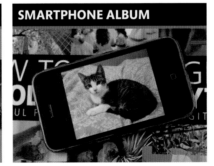

Use your smartphone as a mobile photo album – it can hold hundreds of pictures ready for instant display, and is ideal as a portfolio for your best pictures. Keep images of the same orientation together to avoid having to repeatedly turn the display around.

EMAIL

Email your photos to family and friends. Social pictures are ample at 480 pixels in length, and scenic shots work well at 720 pixels in length. Compress the images first to keep internet service provider (ISP) costs low, speed up transmission, and avoid overloading other peoples' inboxes.

friends and family from wherever you are in the world. Millions of users share billions of images every year, and this abundance of images is a thrilling prospect. Bear in mind, however, that you are responsible for the size of the files you transmit or upload. Image files today usually carry far more data than is needed, so compress your images first – in this matter, small is definitely beautiful.

DID YOU KNOW?

All photo-sharing and social networking sites require you to accept their terms of use/service as a condition of using the site. It is vital that you read these legal provisions first to understand the implications for your privacy and copyright (see pp.286–87).

DIGITAL PHOTO FRAME

Use a digital photo frame to show multiple pictures. These download images directly from your camera or memory card. Think about the sequence, as chronological order may not be the most effective. You may have to rename the files so they appear in your chosen order.

DESKTOP

Display images on your computer as desktop wallpaper or as a screensaver. For wallpaper, landscape-format shots with no sharp details work best. To set up a screensaver, go to Display in the Control Panel (Windows), or Screen Saver in System Preferences (Mac OS).

SLIDESHOW

Make a slideshow. For informal pictures, use lively transitions; use fade or dissolve if you want to minimize distractions. Slideshows take on an extra dimension when put to music: it may simply run alongside, or a careful choice can make the show highly evocative.

SOCIAL NETWORKING SITE

Post pictures on your favourite social networking sites; use apps to upload images directly from your phone. Set your albums to "private" if you wish to control who can view your images. Seek permission before posting photos of people in potentially compromising situations.

PHOTO-SHARING SITE

Share your pictures on photo-sharing sites; join groups with similar interests to get new ideas and compare results. Many sites are free; some charge for additional features. Check the terms of use/service to ensure you retain the rights to your images once you've uploaded them.

PERSONAL WEBSITE

Register a web address and use it to exhibit your images (see pp.282–85). Surf the web to find a design you like – there are many easy-to-use templates available. Some software can automatically create a website from your collection of images. Start small, and show only your best work.

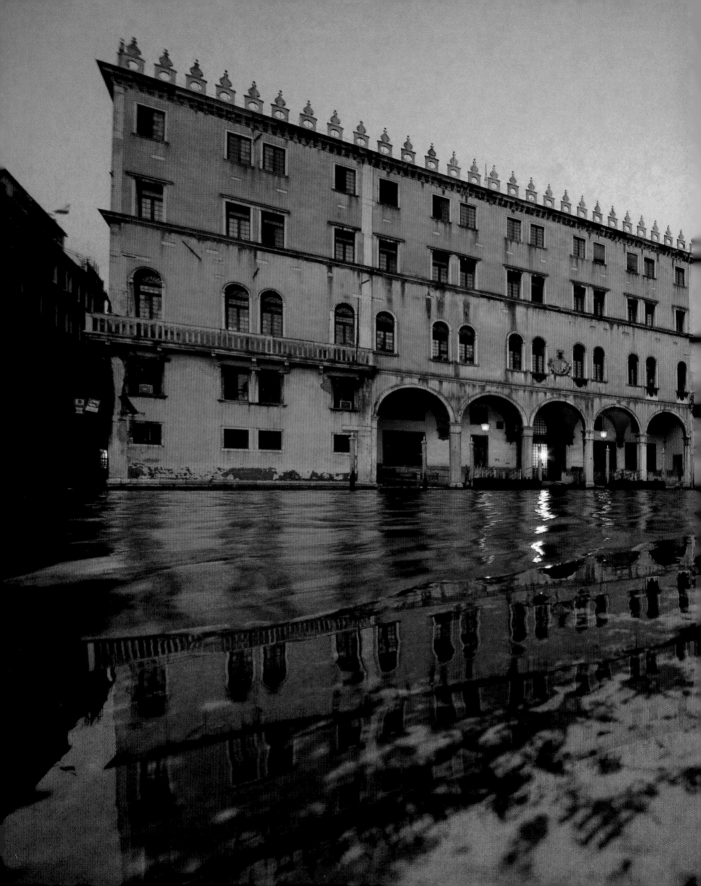

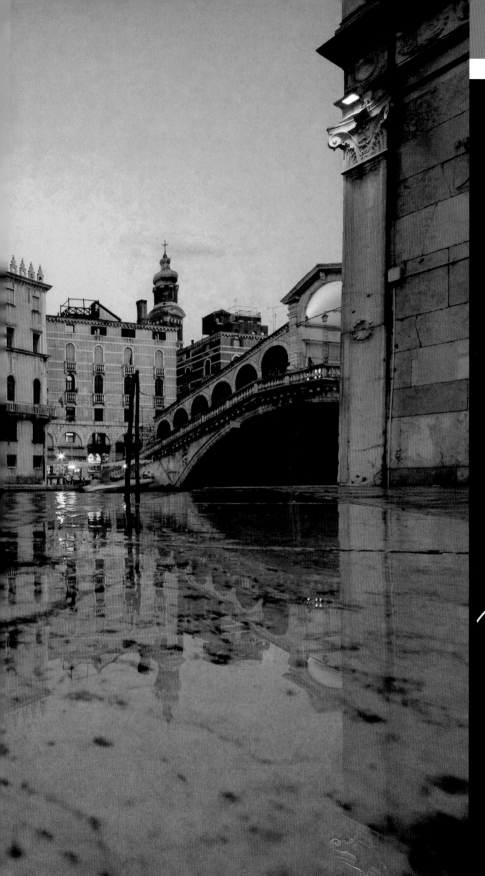

COMMANDING PHOTO-TECHNIQUE

Elements of composition

Theories of composition work well when we're free to place elements of the scene exactly where we want them. However, apart from sets constructed in a studio, photographers cannot truly compose images; we must do what we can with what we find. Indeed, photographic composition should perhaps more correctly be termed "photographic disposition", because we work with the way in which elements are disposed or located.

Often the elements of a scene are in fixed relationships to each other. If we wish to make it appear as if these elements are in different positions relative to one another, we have three key tools under our control: viewpoint, aim, and use of framing (also known as field of view).

Golden composition

In Ancient Egypt and Greece, it was known that when an object is proportioned in such a way that the length of the smaller part compared to the larger part is the same as the larger part compared to the whole, the result appears perfectly balanced. The smaller part is approximately 61.8 per cent of the larger part; or another way of putting it is that the larger part is 1.618 times longer than the shorter.

ERIC DE MARÉ

Composition is an essential part of a good photograph; photography as an art has no meaning without it.

This ratio can be detected throughout nature in the proportion of forms as diverse as snail shells, butterfly wings, flower petals, and the spirals of pinecones. It is also discernible in musical harmony. This ratio is called phi, the Golden Ratio, or the Golden Mean. Not surprisingly, it's also the foundation for our perception of human beauty. If you analyse the proportions of classically beautiful faces or bodies, you will find that they are proportioned according to the Golden Ratio.

A feeling for harmony

The popular Rule of Thirds – an imaginary grid dividing an image into nine equal squares – is an approximation of the Golden Ratio. In fact, the Golden Ratio goes much further

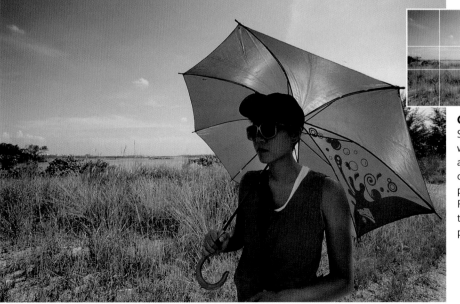

Golden Ratio
Snapshots are often surprisingly well-composed because they are directed by instinct. This casual shot turns out to be perfectly formed in Golden Ratios, as shown by the way the elements line up with a phi grid (inset).

This bright café furniture creates a visually irresistible scene. However, street-level shots taken from a short distance away (top right and top far right), fail, as distractions intrude upon the purity of the abstract shapes. The arrangement was improved by moving closer and raising the viewpoint (below and bottom right), while a shot from above emerges as the winner (bottom far right).

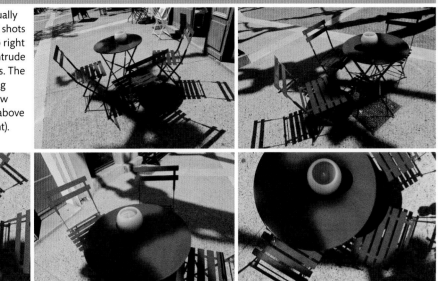

than the Rule of Thirds: when distances between elements within smaller portions of the image are at phi ratio, the composition is even more satisfying.

Everyone has an innate feel for a pleasing composition, because phi is, to use an analogy from computing, hard-wired into our brains. When we frame up a shot, we position the key elements of the scene that have meaning for us so that they relate to the rest of the scene in ways that cause a heightened response – the "phi response" – in our mind. Finding a pleasing composition is similar to hearing a catchy song – our response is instinctive.

Contrarily, by placing images very close to the edge of the frame or at the exact centre of the image – indeed, by working *against* the Golden Ratio – you can inject greater dynamism or introduce a sense of repose to your images.

Involving space

There is something decidedly theatrical about photography, the way it can conjure an image that, for a moment, may trick us into accepting it as a three-dimensional reality. In the same way as a stage designer constructs a theatre set,

Magic chaos

The elements of this composition may appear randomly arranged, but major components (such as the poppies and the leaf across the centre) all lie on, or close to, Golden Ratio lines.

TUTORIAL

COMMANDING PHOTO-TECHNIQUE

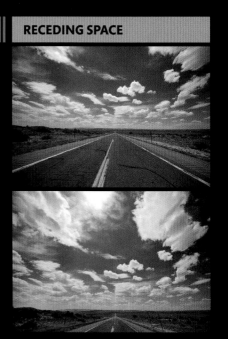

Converging lines rely on the viewer's experience to be read as receding into the distance. Nevertheless, their shape alone is visually compelling; even when reduced to a small portion at the bottom of the frame, they lead the eye into the image.

Framing the hero
The multiple frames provided by the door, the columns, and the bent pipe all work together to ensure that the worker (although relatively small) is the real centre of our attention.

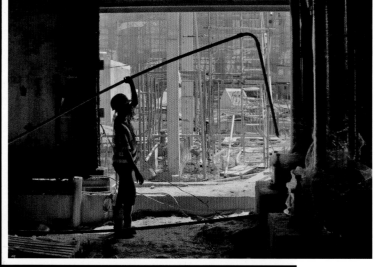

we use converging lines to suggest distance; we overlap objects to show which are nearer and which further away; we use variations in scale to imply perspective. Above all, we entice the viewer into our space, inviting them to roam around the image by offering plenty to look at while at the same time gently guiding them towards a goal: the focal point of the image. A road winding into the distance offers a visual narrative, as does a meandering river. Like all forms of narrative, you need a clear beginning to attract the viewer's attention, a sense of progression to encourage an exploration of the picture, and a satisfying conclusion. This process may take only a fraction of a second to complete, or be more leisurely, depending on the size and sophistication of the image and the amount of attention given to it by the viewer.

Shaping space
Another way to structure an image is to depict a large shape that is of a higher order than the smaller shapes from which it is composed: I like to think of this as "hyper-shaping". Spiral staircases are a good example, as the separate wedge-shaped steps make up the larger spiral shape. Flocks of birds wheeling in the sky can make hyper-shapes comprised of the individual birds. The most common examples of hyper-shaping come from the plant world, where small elements repeat to create whorls, radiating lines, and rosettes. Interestingly, many of these forms are expressions of the Golden Ratio.

The simplest form of hyper-shaping comes from symmetry, particularly where one half of an image reflects the other. Together, the two halves create a new shape – one that is internally coherent and almost always visually striking, because it suggests an inherently stable structure.

Framing devices
A favoured photographic technique for shaping space is framing, in which a framing device within the composition refers to the rectangular border of the image itself. Such a device focuses attention on the subject, while also helping define the third dimension of depth in the image as a whole. It is acceptable for the framing elements to be out of focus or under-exposed; indeed, they may not work as an effective frame if they are too sharp, or mid-toned or lighter.

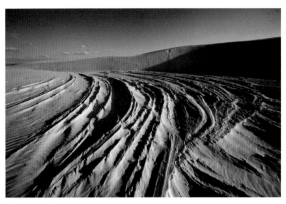

Suggesting space
Contrasting elements shape this space: the tracks in the White Sands of New Mexico draw the eye into the distance, where softly gradated tones in the sky hint at vast open spaces.

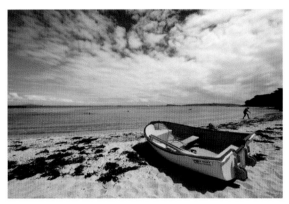

Significant detail
A tiny figure animates an otherwise static beach scene. His size gives a measure of distance, and, once you spot him, his position near the edge lures the eye further into the scene.

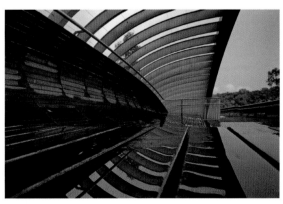

Hyper-shaping
Repetition always evokes a strong visual response. The effect is even more dramatic when the resulting shape recedes into the distance. The impact is here augmented by mirror symmetry.

Open your eyes

Photographic opportunities abound in everyday life. A rusty door ignored by commuters can be turned into an art poster, or a crumbling building might have beautiful architectural features that result in a prize-winning shot. All you need to do is take the time to see what is around you, and approach it with an eye for composition.

▼ THE BRIEF

▷ Take your camera with you along one of your usual routes, such as to the shops or on the way to work. Aim to take the best, most interesting shots that you can, focusing on the method and complexity of your compositions.

▼ POINTS TO REMEMBER

▷ **Make minuscule changes,** and feel for the moment when the image "clicks" into place: small adjustments in position and elevation, framing, field of view, and timing can make a powerful difference. It helps if you view continually through the viewfinder.

▷ **Avoid searching** for preconceived compositions; observe with an open mind.

▷ **Use your zoom** to make tight compositions. Shoot in both portrait and landscape formats, framing so you don't need to crop.

▷ **Look for details close to you** – even at ground level – and further away. Cast your eyes upwards; you'll be surprised at how many new things you notice.

▷ **Allow time for moving elements,** such as cars and people, to move in and out of frame.

GO GOOGLE

☐ **Jacopo Tintoretto**	☐ **Wassily Kandinsky**
☐ **Paul Cézanne**	☐ **Iwao Yamawaki**
☐ **Modernism**	☐ **Joel Sternfeld**
☐ **Cubism**	☐ **Luca Campigotto**
☐ **Henri Cartier-Bresson**	☐ **Ryan Schude**

Working with lines

The container port in Singapore – the busiest in the world – brims with photographic opportunities. With its mammoth ships, colourful containers, and giant cranes, richly detailed compositions presented themselves at every turn. Yet the subject was almost too easy to photograph, and I risked obtaining only abstract patterns. My aim was not only to capture the size and colour of the location, but also to convey the sense that, behind all the gigantic machinery, were men who operated and controlled it.

▷ Sony A900, 70–200mm *f*/2.8 : 70mm *f*/5.6 ISO 200 -0.7EV 1/800sec

FROM THE SAME SERIES

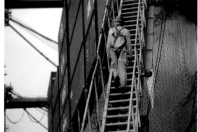

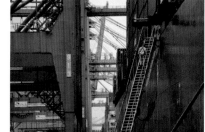

1 General view
With an ultra-wide-angle zoom set to 12mm, I used the reflections in the water to create a symmetrical, mirrored image that captures the relative positions of the containers, cranes, and ships. While it offers an unusual view, it lacks human interest and an accurate sense of scale.

2 Environmental portrait
The approach of a crane operator gave me the chance to contrast the human and industrial scales. This image positions the subject between converging lines, while a shallow depth of field brings him out of the background. But it doesn't show enough of the port, and we lose the generality.

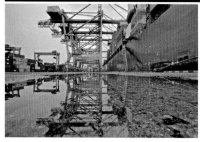

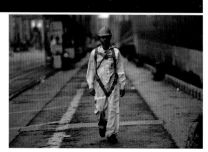

3 Shapes and colours
The contrast between the setting and the operator's high-visibility work clothes promised an interesting shot. A long focal length of 140mm compressed the separation between objects, giving the surface a flat, graphic feel – but perhaps we are still not seeing enough of the port.

4 Scale and timing
By zooming out I revealed more of the machinery, while the gangway acts as a leader line, guiding the viewer's eye to the human figure. The scale is now right, but the question of timing remains. In this image he has gone a little too far, so the best shot is the one captured a few seconds earlier.

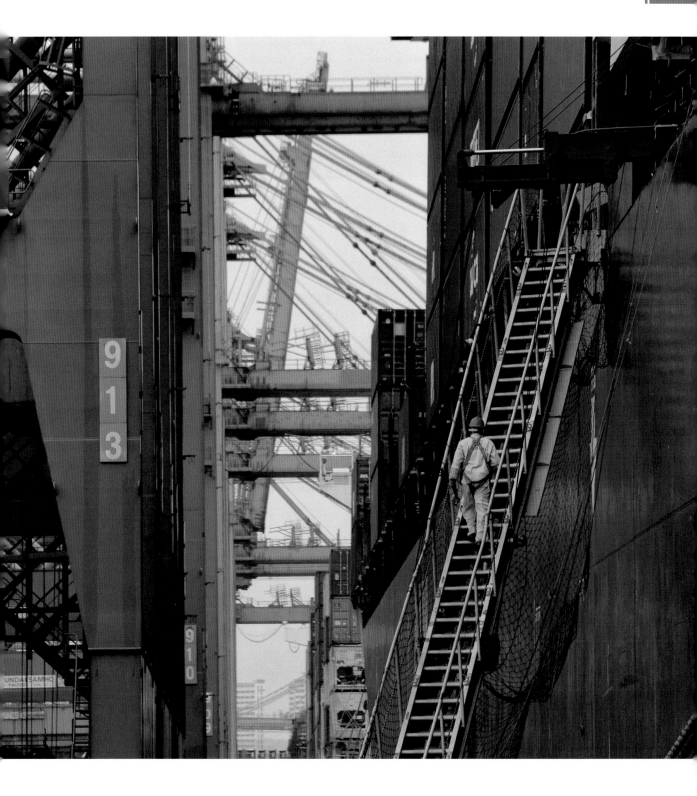

Perspective and viewpoints

It seems rather miraculous that a little lens can squeeze vast mountain landscapes or views across a city neatly onto a flat screen, in perfect form and scintillating detail. The magic that makes this happen is perspective – the process of representing three-dimensional objects so that they appear on a two-dimensional surface.

The rules of photographic perspective are simple: the lens projects its field of view onto the camera's sensor. This follows quite strict optical principles, so that an object is kept more or less in proportion to its size as seen by the lens. It creates the perception of depth: distant objects are rendered smaller than those nearby, and parallel lines appear to converge on the horizon. Because the field of view is larger than that of the sensor (except at extreme close-up ranges) the image must be reduced to fit the area of the sensor.

It follows that the perspective of any image depends entirely on where the photographer holds the camera. Perspective is not altered by changes in focal length, nor by shifting the lens. You control perspective by determining your shooting position.

Photographers may refer to a long focal-length perspective. This is the technique of viewing the subject from a distance using a long focal-length lens to make objects appear similar in size, and to appear near to each other. A wide-angle perspective of the same scene means shooting it from nearby, but capturing everything in view: this exaggerates differences in size and relative distances of objects.

Emotional values

Virtuosity in the control of perspective is the easiest photographic skill to master, and it costs nothing: simply walk around your subject, exploring the effect of changing your viewpoint. If you deviate from the "normal" position – typically at the same level as the subject, and at a moderate distance – you can suggest meaning. For example:

- close viewpoints suggest intimacy, emotional involvement, daring, or intrusiveness.
- distant viewpoints suggest cool detachment, lack of emotion, or safety in distance.
- overhead viewpoints suggest separation, lack of involvement, or aloofness from a position of power.
- views from below suggest participation in the action, subservience, or a position of powerlessness.

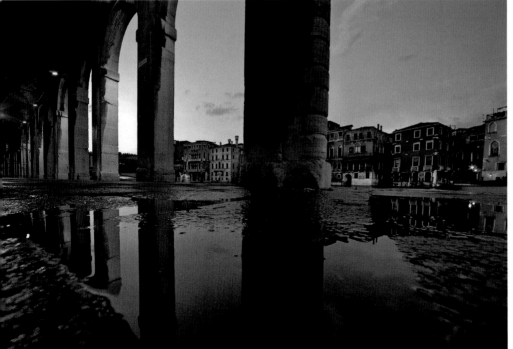

Grand puddle
Venice is extravagantly photogenic, with lovely scenes demanding to be photographed wherever you turn. Unusual views need imaginative effort: a normal level view of the Grand Canal would undoubtedly be pretty, but this view – as low as I could get without lying on the ground – reveals reflections in a puddle that are barely visible from normal viewpoints.

VIEWPOINT VARIETY

Try out lots of different viewpoints and perspectives – think of it as shopping around. Look for high or low viewpoints. Distant views don't have to be wide-angle, and close views don't have to show the whole scene. If you normally shoot from eye level, try framing views looking upwards, or at an angle, and so on. Experimenting with new perspectives and viewpoints is a quick and simple method to improve your technique.

Points of view

Choose a scene and explore it in full. Build an understanding and appreciation of how variations in perspective alter the emotional impact of your images. Experiment at first, then, as you progress, begin to make your decisions based on the specific feeling you wish to convey.

▼ THE BRIEF

▷ Select a static subject with enough space around it so that you can explore: it could be a building, a tree, a sculpture in a park, or something smaller, such as a plant at home, or even a dozing pet. With each significant change of position, record the view.

▼ POINTS TO REMEMBER

▷ **Walk around your subject** and note how its relationship with its surroundings changes. From one angle it may merge with the background; at another it may stand out.

▷ **Move close to your subject,** then further away: note how the space between the subject and objects around it changes.

▷ **At each position,** try shots holding the camera high above your head, at waist-height, and at ground level.

▷ **As you move around,** take shots with your zoom set to its shortest and longest possible focal lengths.

GO GOOGLE

☐ **Bill Brandt**	☐ **Alexander Rodchenko**
☐ **Alin Ciortea**	☐ **Alfred Stieglitz**
☐ **Georg Gerster**	☐ **Paul Strand**
☐ **André Kertesz**	☐ **Perspective distortion**
☐ **Alvin Langdon Coburn**	☐ **Perspective in art**

Framing issues

POOR PROPORTIONS

PROBLEM

The subject's proportions are all wrong – the face is large with a small nose, or the nose is too large for the face. Moving away from the subject doesn't help.

ANALYSIS

Faces appear distorted when they fill the image frame, and parts of the subject near the camera look disproportionately large. You're using a focal length shorter than 50mm, which gives a wide-angle field of view and causes you to stand too close to your subject.

SOLUTION

▷ Set a focal length longer than 70mm (35mm equivalent), but no longer than around 135mm. Bear in mind that with longer focal lengths you may have to stand far away from your subject, so you risk losing a sense of intimacy with them.

▷ If you wish to use a wide-angle lens, stand at least 1m (3ft) away from your subject and crop the image later.

▷ Place your subject in the centre of the frame to minimize distortion.

SLOPING HORIZON

PROBLEM

Your pictures are not perfectly level and they seem to slope to one side, but the effect is not strong enough to look deliberate. This is unsettling, especially when buildings appear to be falling over.

ANALYSIS

You may feel that you are holding the camera level, but, because it's heavier on one side (this is often the case with dSLR cameras), it's actually on an angle. You may not be viewing the whole image properly through the viewfinder.

SOLUTION

▷ You may be able to set your viewfinder to display a grid to help line up the horizon and verticals.

▷ If your camera offers an electronic level meter, use it.

▷ When composing a landscape or taking a shot of some other static subject, point the camera down until the horizon nearly touches the edge of the image frame in the viewfinder, then reframe the shot.

INADVERTENT CLIPPING

PROBLEM

You want to frame your subject tightly, but although you try to keep it within the image frame, parts of the subject get cut off.

ANALYSIS

Your subject may be moving erratically, making it hard to follow and frame accurately. If you are very close to your subject, its movements will be exaggerated. You may be using a long focal length setting, which magnifies all your movements.

SOLUTION

▷ Allow more space around the subject, and observe whether the subject has a tendency to move in a certain direction – anticipate its actions.

▷ If you're using a dSLR, ensure your eye is correctly positioned so that you can see the viewfinder area fully without moving your head.

▷ Use high-quality or high resolution settings to allow you to crop the image later.

INSUFFICIENT FIELD OF VIEW

PROBLEM
You want to get a whole view into shot, but your lens is not sufficiently wide-angle and you are not able to step back for a wider field of view.

ANALYSIS
Stepping back from the scene changes your perspective, so you can lose the necessary relationships between elements in the scene. You may not be using a sufficiently wide-angle lens.

SOLUTION

▷ Tilt the camera to take advantage of the wider field of view across the diagonal of the image sensor.

▷ If the subject is fairly static, take two shots – one slightly to the left of the scene, and one to the right, both overlapping in the middle. Use panorama or image stitching software to blend the images together (see pp.110–11).

LOSS OF CONTEXT

PROBLEM
You have zoomed in for a dramatic close-up, but the resulting image lacks impact and is not as interesting as you had hoped.

ANALYSIS
The context of the scene is unclear, and information that could provide a scale against which to measure the subject has been cut out. You may be using a long focal length, which tends to crop out the wider surroundings.

SOLUTION

▷ Zoom out to show more of the environment, making a composition that blends all the elements. Remember, an image that informs will be more meaningful than one that merely impresses.

▷ Keep the same focal length setting and change your viewpoint in order to take in more background or show objects in the foreground.

OVER-TIGHT FRAMING

PROBLEM
You want to introduce some dynamism into a scene, so you place key elements close to the edge of the frame. However, the result just looks unbalanced.

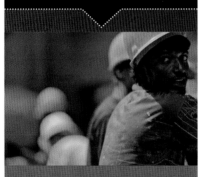

ANALYSIS
Strong elements such as vivid colours, gestures, or eyes carry more emotional weight in an image, so they appear to occupy more space than quieter areas.

SOLUTION

▷ Key figures placed near the edge of the frame may work if their body language, line of sight, or flow of movement refers back to the centre of the image.

▷ The use of extreme framing may seem more natural if elements within the image point towards an object of interest at the edge of the frame.

▷ A plain, dark, or brightly coloured background often works well with a vibrant colour close to the edge.

Composing with colour

For the non-photographer, colour is simply a physical property of a scene, but colour is profoundly integral to the photographer's experience: we use it to express feelings. As you work more consciously with colour, you will enjoy a greater sensitivity to the palette at your disposal, and your visual life will be enriched.

When it comes to photography, it's not immediately obvious that colour should be your central concern. To turn from a happy snapper into a true photographer, you have to learn to see colours in and of themselves, so that the subject that carries the colour becomes an incidental feature. You can enjoy a grand vista, but at a higher level you'll also evaluate the sky – are the colours as intense as you'd like? Is there too much haze for clean colours? Are the shadows rather blue under the trees? In short, you pick the scene apart with questions about colour.

Primary colours
One way in which we define colours is the analytic or component method, which is most familiar to us as the RGB (red, green, and blue) channels of digital photography (see pp.178–79). In this system, a colour is described in terms of its component primary colours. It objectively assigns a number to each colour, but it's hardly intuitive: for example, it's not immediately obvious that "R71:G26:B238" refers to a deep purple.

Hue, saturation, and brightness
The more intuitive model describes colours in terms of three properties: hue (the colour name we give it), saturation (its intensity), and brightness (or value). For instance, we can describe a purple as being rich and dark, or pale and bright. Within these three categories you have further levels of variation, each one an abundant source of ways to express yourself in photographic terms, with widely varied implications for the way you compose an image.

For example, working with different combinations of hue gives rise to images with different levels of "liveliness", from the gaiety of contrasting colours (think of tiers of fruit in a market stall), to the tranquillity of those that are similar (think of a misty morning). In the dimension of colour saturation, vivid saturation delivers strident colours that demand attention (think of a funfair), whereas the paler, pastel shades of an overcast day are more diffident. The third dimension of colour, brightness, is closely related to

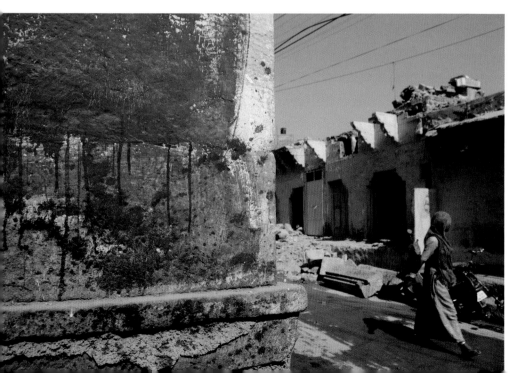

Adjacency effects
Images consisting of closely adjacent colours, such as blues and aquamarines, often possess visual coherence, as they provide a background against which our attention can be led towards textures and the overall structure of the image. A tiny splash of contrasting colour helps enliven the composition, as it introduces a sense of movement into an otherwise static picture.

A good test of the importance of colour in your image is whether the picture would survive being turned into black and white. In each of these examples, a tiny area of colour stands out because of a contrast in hue or saturation. Like waving a banner, they serve to catch the viewer's attention; if we lose their colour, we lose the visual heart of the image.

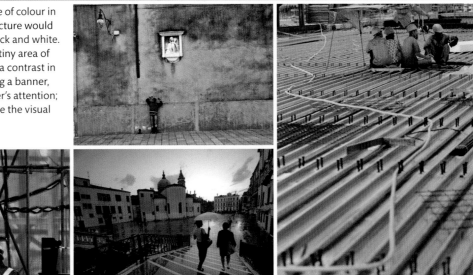

saturation, with similar, intuitively obvious meanings. Dark shades, for example, are associated with sinister shadows and night time, while lighter shades evoke comforting daylight and all the emotions this arouses.

Variations in perception

Furthermore, a patch of colour offers a different visual impact according to the context in which you see it. A splash of dark red will seem stronger when surrounded by pinks, but will appear less saturated when next to brilliant crimsons. In contrast, neutral tones take on some of the colours they are surrounded by, bringing harmony to a composition. This is why images with patches of colour surrounded by neutral or low-saturation tones are so often striking.

There is also another variable to consider: colours look different under different lighting conditions, and may even change their hue entirely. For instance, under certain street lights that offer almost no blue light at all, blues disappear into near black, while reds become yellow.

The eye versus the camera

Another phenomenon highlights an important difference between visual perception and the camera's recording of colour. Human eyes adapt to low light by increasing their sensitivity to light by reducing colour perception; the result being that colours appear less rich in dark conditions. But

the camera makes no such adaptation, even when you increase its level of sensitivity: to the camera, colours appear as rich as in daylight, even in the lowest of lights. This has the effect of gloriously transforming our view of the night: we had hints of it with colour film, but with high-sensitivity digital capture we find a whole new world

DID YOU KNOW?

The colour wheel (also called a "colour circle") is a circular arrangement of all the hues visible to the human eye. It is normally regarded as starting with red and then progressing through magenta, blue, green, and yellow back to red. First proposed by Isaac Newton, the colour wheel is the basis for the Lab colour space, the system which underlies digital colour. The arrangement is useful because it reveals that the relationship of colours corresponds to their relative positions on the circle.

COLOUR WHEEL

For example, colours opposite each other on the wheel (180 degrees apart), such as blue and yellow or green and bluish-red, are perceived as being opposites. And when two colours are additively mixed (that is, as a mixture of light), the new colour lies between the two being mixed.

of fabulous light and colour that was once invisible to us. There is, however, one proviso: the colours available will depend on the quality of the illumination: if it's, say, the last glow of the day (commonly rich in all colours, but particularly reds and yellows), the quality of the colours will be extremely warm and vibrant. But if the light comes from sodium-discharge lamps in urban centres, the light may be concentrated into just yellow and green wavelengths, leaving all other colours struggling to make themselves seen.

Culture and psychology

In an era when any image can obtain worldwide exposure overnight due to the ease of digital dissemination, it is well to be aware of cultural differences in the meanings and emotions associated with certain colours. For example, red means good fortune in some countries, such as China, but signals danger in the West; green is venerated as the colour of paradise in the Middle East, but is the colour of death and decay in parts of south-east Asia.

Psychologically, however, some responses to colour seem to be universal: red is quickly noticed in any scene, whatever the culture, whereas blues appear dark and recede into the background. One consequence is that certain colour contrasts work much more strongly than others: a red umbrella stands out brilliantly on a rainy day, whereas a yellow or even an orange one will not be so obvious. Another consequence is that a small patch of strong colour can balance out a large area of weaker colour. This means that when composing with colour, you don't need equal areas of colour. Typically, a tiny spot of red can hold acres of green at bay, and small areas of blue can enliven an image dominated by browns and yellows.

In living colour

When you have the opportunity, take a look at photography books published in the 1980s and 1990s. At this time, colour reproduction gave excellent matches to colour images, all captured on film. Compared to today, the colours are softer and less saturated, and sit comfortably with each other; the shadows are deeper and more mysterious. Now, with changes to saturation and contrast levels a mouse-click away, colours are easily excited to hyperactive intrusiveness, violently assailing the eyes. If you wish to make a mark in colour photography, aim for images with subtlety and finesse.

ERNST HAAS

Colour is joy. One does not think joy. One is carried by it.

Storm colours
Virtually all the colours are washed-out in this shot at an airstrip on a stormy day (inset). The temptation is to boost the overall saturation, but another option is to suppress some of the colours: an orange tint laid over the whole image weakens and darkens the bluish tones but boosts the warmer ones, adding depth and giving more definition to the reflections.

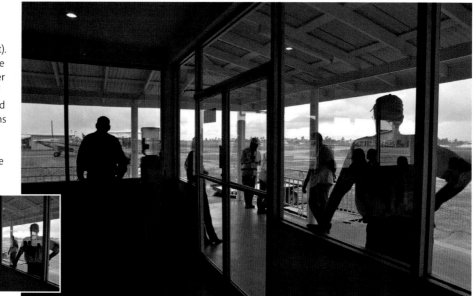

STRIKING A BALANCE

You don't always need to be conscious of your colour choices, as your instincts will do a good job of guiding you. The secret is to keep colours in balance. If you have a variety of colours to contend with (top), give them equal weighting in the scene. Relieve large areas of colour with a sliver of something different to catch the viewer's eye (middle), or keep the number of colours to a minimum to allow a full appreciation of contrast (bottom).

Spinning the colour wheel

Familiarize yourself with the colour wheel to become more confident working with colours. Investigate different combinations: experiment with adjacent (or analogous) colours, which are next to each other on the wheel. Then look at complementary colours, which are directly opposite each other. Next, explore triads – balanced sets of three colours, equally spaced around the wheel.

▼ THE BRIEF

▷ Choose a colour (preferably one that's easy to find in your environment); for this brief we'll use yellow as our example. For adjacent colours, photograph anything that is yellow, or close to yellow, such as oranges, browns, and reds. Allow only shades of these colours within each picture. For complementary colours, add violet to the yellow (other examples are red and green, or orange and blue). For triads, add cyan (bluish-green) and magenta (reddish-blue) to your yellow.

▼ POINTS TO REMEMBER

▷ **Be strict** about which colours you allow to appear in each image.

▷ **Experiment with triads** made up of less saturated colours.

▷ **Examine the results** to see which colour combinations work best for you.

▷ **Use the zoom freely** to crop out colours that don't belong to your colour scheme.

▷ **Take photographs at different angles,** not just square-on.

GO GOOGLE

☐ **Colour theory**	☐ **JMW Turner**
☐ **Colour perception**	☐ **Vincent van Gogh**
☐ **Lab colour space**	☐ **Johannes Itten**
☐ **Goethe's colour theory**	☐ **Ernst Haas**
☐ **Titian**	☐ **William Eggleston**

Order from chaos

Durbar Square in Kathmandu, Nepal, is a miraculously rich mix of sublime architecture and vibrant street life. Yet it's a hard place to photograph – so much is happening, it's almost impossible to pay attention to any one thing long enough to work up a shot. This image brings together a glimpse of ancient buildings, bustling activity, and a sky about to explode into light; and it's a success because it's all tied together by the spots of brilliant colour.

▷ Canon 1Ds MkII, 24–70mm *f*/2.8 : 24mm *f*/7.1 ISO 100 0EV 1/200sec

1 Colour axis

Much of the active colour lies on an axis from the fringes on the bell tower to the echo of red in the girl's chemise. The backlit parasol, reminiscent of a colour wheel, complements other elements in the scene: the green sari, the dun-coloured paving, the boy's red t-shirt, the blue and mauve sky.

2 Sunburst

The sun being partially obscured, there is still a range of good colour in the sky. The bright white flare of the sun – on the verge of breaking out from behind the cloud – is a key focus in the composition. A few seconds later and the scene was completely transformed by brilliant light.

3 Light and shadow

The glazed tiles reflect the sunlight which, together with their radiating form, help tie the lower half of the image to the upper half. At the same time, these tiles provide a good contrast with the shadows, and bring light into the dark foreground. The bottles in the stall also catch the light.

4 Vantage point

The man watching the world go by provides a counterpoint to the activity around him, particularly the dog wandering about and the girl walking out of frame. His silhouette provides a link with the many dark geometric shapes across the bottom two-thirds of the image.

IN DETAIL

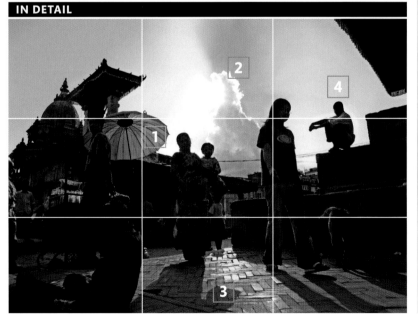

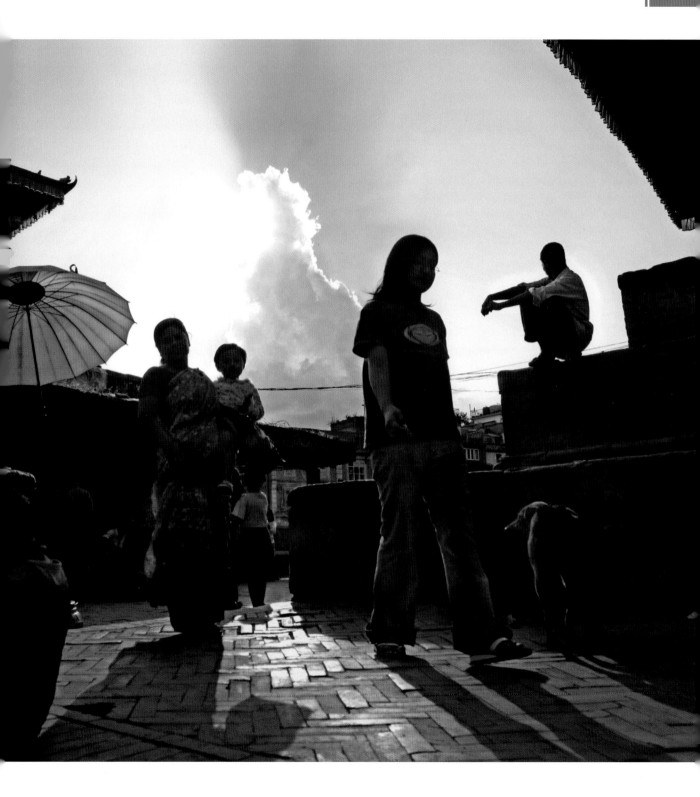

Composition solutions

There are as many ways of finding the perfect composition for an image as there are photographers. Nonetheless, a number of approaches are regularly employed by all. It's your use of these methods, your preference for one approach over another, and the impact of these choices on your photography that helps develop your own personal style.

Begin by exploring the five distinct approaches set out in this toolkit – framing, proportion, shape, perspective, and contrast – in a conscious manner. In time these strategies will be absorbed into the way you see and think and become part of your repertoire of applied technique, turning abstract knowledge into practical visualization.

The compositional approaches shown here are by no means the only ones at your disposal. Other ideas include using your camera at a tilt, or focusing on flat surfaces in search of abstract graphics.

▼ TRICKS OF THE TRADE

▷ **Start a project,** and devote some time to mastering a particular technique. Take framing, for example: think about shapes and spaces created by elements in a scene, and focus on finding anything that could work as a frame. Don't just look for obvious examples, like windows and doors, but also more subtle ones, such as the way in which the gesture of a figure in the foreground frames the people in the scene beyond.

▷ **Work in black and white** to help focus your attention on the abstract shapes in a composition, instead of the colour.

▷ **Turn images upside down** (rotate them by 180 degrees) to make an assessment: imperfections in composition and balance often become surprisingly obvious.

FRAMING ▷
A frame within a frame is an obvious device, so avoid cliché by breaking into the frame; use the shapes created by the transient position of people or objects, for instance. Use the depth of field to vary the blur of framing elements from hard to soft outlines.

DOUBLE FRAME

PROPORTION ▷
If your position is fixed, use the full extent of the zoom lens' power to vary the scale of the subject. With each change in scale, you'll have new choices about how the main subject divides up the proportions of the image. Try vertical and horizontal shots.

DISTANT SUBJECT

SHAPE ▷
Strong shapes not only organize your material but also offer a contrast to the frame, creating another level of dynamic. When the features of the subject are repetitive, they present a visual rhythmic pulse for the viewer to scan from one side to the other.

SWEEPING DIAGONAL

PERSPECTIVE ▷
In situations where you can move freely around a subject, walk about and look carefully before taking any photos. Start from a distance away and notice how the scene changes with each step you take. Record the changes and evaluate the results later.

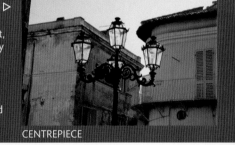

CENTREPIECE

CONTRAST ▷
Strong colours tend to "push out" from a picture, and so introduce energy to an image. Strong contrasts allow some leeway in the placement of the main subject; the composition doesn't have to be precise if the resulting image has sufficient impact.

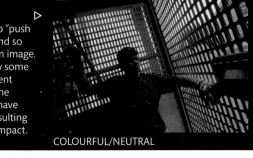

COLOURFUL/NEUTRAL

ENCLOSING LINES

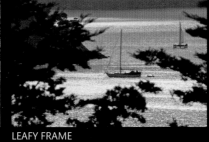

LEAFY FRAME

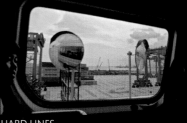

HARD LINES

LAND DOMINANT

EQUAL WEIGHTING

SKY DOMINANT

SQUARE-ON

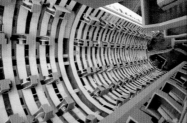

CONCENTRIC ARCS

SYMMETRICAL

FROM BELOW

ABSTRACT BACKGROUND

IN CONTEXT

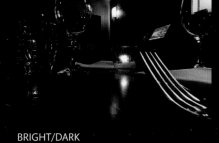

BRIGHT/DARK

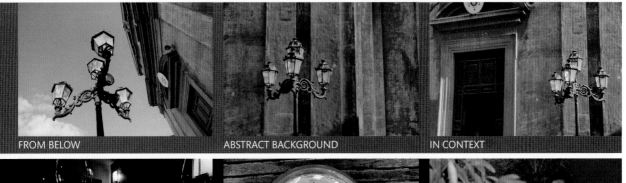

SOFT/HARD

NEAR/FAR

Zoom lenses

Photographers configure the world through a lens. To see photographically, you must learn to view the world the way the camera does. While it could be said that a camera lens shares superficial similarities with the human eye, the typical lens is radically different, thanks to its ability to zoom and to focus selectively.

> **ERNST HAAS**
>
> Best wide-angle lens? Two steps backward. Look for the "ah-ha!"

The majority of lenses are zoom lenses, so the first decision you need to make regards the zoom setting. To take in a wide field of view, you choose a wide setting or short focal length. The natural consequence of squeezing more of the scene into the picture is that everything looks smaller. The opposite approach is to magnify objects in your scene, such as part of a building or a face: to do this, you set a long focal length. You will see a narrower portion of the scene, but the objects in view will appear larger than in a wide view. As you get more familiar with your zoom, predicting the best zoom setting will become second nature.

Zoom first and ask later

There are two basic ways to adjust your zoom setting. The most common method is to do it while looking through the lens. This slows you down: you may have to wait for the lens to respond to your commands. Worse still, each small change in zoom setting may call for a slight adjustment in your aim and composition. The reason for this is that the zoom functions around the optical centre of the lens, but the visual centre of your picture is usually off to one side. The result is that each zoom action shifts the visual centre of your composition – which can turn out to be quite a nuisance.

The other method is to have your zoom lens set to a preferred focal length most of the time. Some professionals have the widest setting as their default, while others use their zooms as if they offered just two focal lengths and only employ the extremes of the range. If you adopt this approach, your camera is always ready to shoot and, if you need to and have the time, you can make small adjustments to the zoom for a tighter or looser framing.

FIXED VIEWPOINT

Zoom lenses come into their own when your freedom of movement is limited – during events or special ceremonies, such as weddings, for example. Make use of the full zoom range on your camera to pull back or move into the scene, alternating as required. Use nearby people or features to help frame the scene, give variety of scale, and draw the viewer into the action.

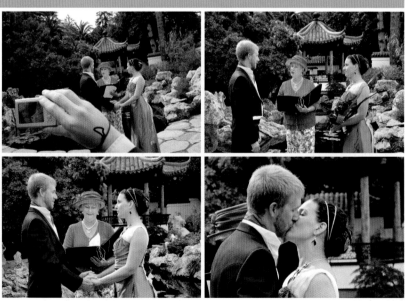
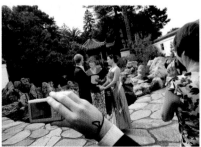

Zoom types and uses

In the early days of photography, zoom lenses that offered a 3x zoom ratio (the longest focal length divided by the shortest) were considered perfectly adequate. Lenses offering greater ratios were seen as outlandish, sure to be optically inferior, too bulky, or both. Today, a combination of in-lens, camera, and software technology enables zooms with ratios of 18x or greater, and these lenses are compact, inexpensive, and produce acceptable images. Broadly speaking, what you gain in zoom ratio is paid for by slower maximum aperture and lesser image quality: if you want the best image quality, choose zooms with modest zoom ratios. This applies whether the lens is fixed to the camera or interchangeable.

NORMAL ZOOMS

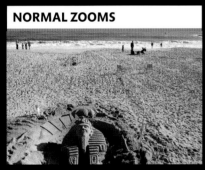

36MM

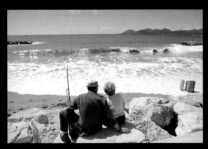

70MM

Zooms covering the range of about 24–80mm are excellent as "walk-about" lenses. Those with a modest maximum aperture can be light, compact, quick to focus, and easy to use, making them ideal for use when travelling.

The best image quality and fastest lenses can be found in this range. These lenses also offer good handling of veiling flare and the lowest levels of distortion overall. You can use screw-in wide-angle or tele-converter lenses to increase zoom range, but these can be cumbersome

WIDE-ANGLE ZOOMS

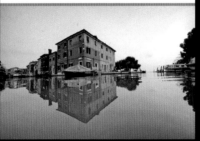

12MM

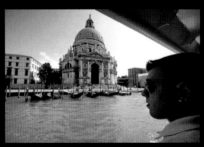

16MM

True wide-angle zooms are found on dSLR and other cameras with interchangeable lenses: they cover the equivalent of 12–35mm. The widest lenses are large, and the fast models are costly, but they are superb for landscape and travel photography.

Image quality varies widely between designs, but all suffer from light fall-off (which darkens image corners), and distortion may be visible. At the widest settings these lenses are also prone to internal reflections. Nevertheless, their versatility outweighs these shortcomings

TELEPHOTO & SUPERZOOMS

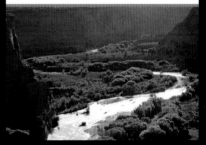

100MM

400MM

The very best quality lenses are found in the telephoto category, which ranges from 70–210mm. Superzooms, from 28mm wide-angle to 350mm or greater, are useful for scenery, travel, and wildlife photography in good light.

To make the best use of very long focal lengths, image stabilization or camera support is essential. Avoid architectural subjects, and don't place the horizon close to the frame edge, as distortion may be obvious. Vignetting is often a problem. Use a lens hood to avoid flare.

Optimizing image quality

Good photographers aim to capture the best possible image they can at the moment of exposure. From this point onwards, degradation in image quality can occur. To minimize this, it's important to understand the strengths and weaknesses of the equipment you use, and to be aware of common flaws caused by the mechanics of camera lenses.

Zoom lenses suffer from two technical problems to a greater extent than single focal-length lenses: distortion, and vignetting. Zooms distort the image, but not badly enough to cause trouble in general photography. Barrel distortion usually occurs at the short focal length end of the zoom range, in which the magnification decreases with distance from the axis – making the image appear as if it's bulging in the middle. Pincushion distortion occurs at the long end of the zoom range, when magnification increases with distance from the axis – so the image appears "pinched" in the middle. On some zooms, the type of distortion varies across the image, and is difficult to correct in post-processing.

Vignetting, a darkening in the corners of the image, is caused by a narrow lens barrel obstructing the light bundle. This is particularly common with compact long zooms, and

HENRI CARTIER-BRESSON

> The picture is good or not from the moment it was caught in the camera.

is seen most often at the longest focal length end. Using apertures smaller than maximum, where possible, will help reduce vignetting. DSLRs using APS-sized chips (see p.325), but mounted with lenses designed for full-frame sensors – which crop into the centre of the image – will escape the worst vignetting.

Getting the best out of your lens

A common error many people make is to buy the most expensive camera they can afford, and then equip it with an inexpensive lens. In fact, the best way to upgrade a camera is to attach a superior lens: this is because you easily waste a camera's imaging quality with an inferior lens, and, once you have a beautiful lens, you can keep it when you upgrade your camera. Whatever lens you have, there are many well-tried ways to get the best performance out of it:

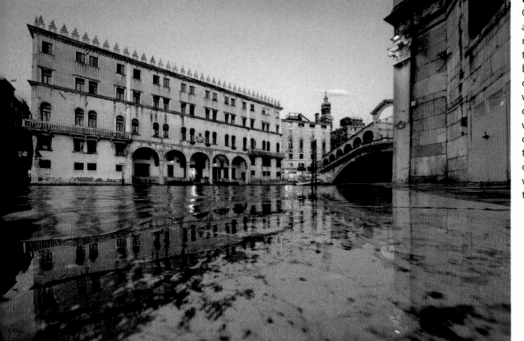

Economic stability
Given a wonderful location, an expensive lens and a high-resolution camera, it's a shame to waste it on a shaky image because of low light. Here's one solution if you're caught without a tripod: put the camera on the ground. You will naturally capture a great deal of foreground, but in this case I made a virtue of necessity by working with the reflections on the rain-wetted stone.

- Use your lens at its optimum aperture: this varies with each lens model, but is usually two or more stops less than full aperture. For instance, if full aperture on your lens is $f/2.8$, the optimum aperture is usually around $f/5.6$.
- Avoid using the maximum aperture unless you have a top-quality lens.
- Refrain from using the minimum aperture (such as $f/16$ or smaller), as image quality will drop, irrespective of lens quality.
- For the lowest levels of distortion, set the zoom to the middle of the zoom range.
- Always use a lens hood to prevent veiling flare.
- Avoid the closest focusing distances, unless the lens offers a close-up range or is designed for close-ups.
- Keep the lens meticulously clean (see pp.338–39).
- Focus manually if using a dSLR camera (see pp.52–53).

DID YOU KNOW?

Image quality is bound up with sensor size, which impacts on focal length and other specifications. The larger the sensor, the better the possible image quality, which is why dSLRs produce inherently better images than compact cameras with their very small sensors. But dSLRs are more expensive to make, so the need for compromise spawns a growing profusion of formats, and this has led to a confusion over focal lengths.

In order to compare focal lengths, we need to relate them to sensor size. In the diagram below, the red circle represents the image projected by a 50mm lens onto the classic 35mm film format (the red rectangle). The lens used on a smaller sensor crops or takes in a smaller view (the green circle), so it's effectively a longer focal length, say 75mm. Hence a 50mm lens designed for the smaller sensor (the green rectangle) has a narrower field

of view than the 50mm for the bigger sensor. Standard practice is to relate focal lengths for any sensor size to the equivalent for the full 35mm format: for example, a 50mm for the smaller sensor is said to be the equivalent of 75mm in focal length.

SENSOR SIZE

Taking the measure

The aim of this simple exercise is for you to get to know your camera and its lenses. By assessing your equipment objectively, you'll be able to use this technical knowledge to make the best images possible. From this foundation, the world of serious photography opens up to you.

▼ THE BRIEF

▷ Find a large advertising poster with a lot of text, or surrounded by plenty of bare brick wall. Set your camera on a tripod or a steady support, and systematically photograph the target, changing focal length and aperture.

▼ POINTS TO REMEMBER

▷ **Set up at least 10m (33ft) from the target.** Ideally, your distance from the target is around 200 times the effective 35mm focal length you set.

▷ **Aim the camera level and square** to the target.

▷ **Set Aperture Priority** and highest resolution.

▷ **For each focal length** – say 35mm, 50mm, 100mm, and 200mm – shoot at maximum aperture, and at each full aperture down: for example, $f/4$, $f/5.6$, $f/8$, and $f/11$.

▷ **Examine the images on-screen at 100 per cent,** and find the ones that are the sharpest and least distorted. Note the corresponding aperture and focal length in each case.

GO GOOGLE

☐ **Camera obscura**	☐ **Four Thirds system**
☐ **Depth of field**	☐ **Aspect ratios**
☐ **Crop factor**	☐ **Lens aberrations**
☐ **Full frame sensor**	☐ **Interchangeable lenses**
☐ **APS-C sensor**	☐ **Lens tests**

Focusing on essentials

Using focus is a vital part of your photographic expression. It's usually defined as the adjustment of the lens so that the subject appears sharp. While this is true enough in a mechanical sense, it misses out the most important point: that it's about deciding which part of the subject to focus on.

Artistically, focus is your way of saying, "Look at this!" – telling viewers which part of the scene deserves their closest attention. If you lose sight of this element – easily done in an era when most cameras focus automatically – you're throwing away a valuable tool that enables you to convey the meaning and intention of your photography.

Where to focus?

Wherever you point your camera, something will fall into focus; that is, an element of the scene will appear sharply defined. This is because the lens collects the light from all over the scene, so it's likely that something will be in the right position to be in focus. And since digital cameras use very small sensors, much of any typical scene will appear sharp. Most modern cameras will focus in on the centre of the image, but some will target the high-

DID YOU KNOW?

All lenses will lose focus with recomposing because even a small change in the aim of field causes a shift in the plane of best focus. This loss is not normally noticeable, but it becomes more so where depth of field is very shallow – for example when using lenses such as 85mm *f*/1.2 or 50mm *f*/1 at full aperture on close-up subjects, such as a face. This is precisely the kind of situation in which you focus on, say, the eye, then recompose the shot: when you do this, avoid making rotational movements to recompose, but instead make adjustments by leaning to one side or the other. Hasselblad system cameras are the only kind that sense recomposing movements and automatically shift the focus to compensate.

contrast detail nearest the camera, even if it's off-centre. However, allowing the camera to decide where to focus is rather like asking someone to tell your story for you: they may use the right words, but with the wrong emphasis. To avoid this, use the focusing point only as the aiming device for the precise part of the scene you

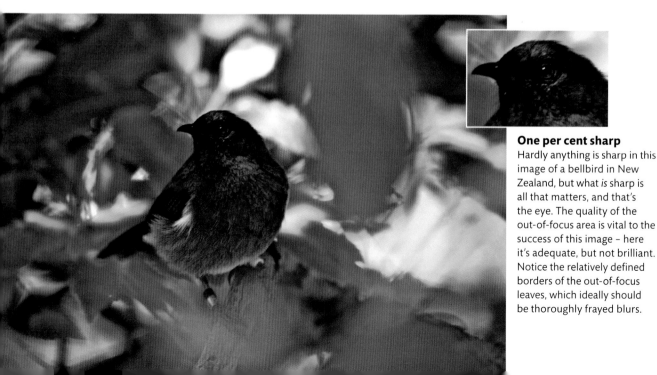

One per cent sharp
Hardly anything is sharp in this image of a bellbird in New Zealand, but what *is* sharp is all that matters, and that's the eye. The quality of the out-of-focus area is vital to the success of this image – here it's adequate, but not brilliant. Notice the relatively defined borders of the out-of-focus leaves, which ideally should be thoroughly frayed blurs.

want in focus: half-press the shutter or auto-focus (AF) start button, hold it down to maintain the focus, then carefully recompose the image.

Follow-focus

Modern auto-focus systems work by splitting the image into separate light beams. These are projected as peaks of brightness that fall across different sensors according to whether the object is in or out of focus. Using the position of the peaks and information about the lens type and settings, the camera instructs the focusing mechanism. However, when the subject is moving the camera must analyse the movements against a time base to work out the subject's speed and the trend of changes. The system can then set the focusing mechanism "ahead" of the movement so that when the exposure is made – always a fraction of a second after the shutter button is pressed – the object will be in focus. Modern systems cope easily with a person sprinting towards you, and with fast-moving activity such as motorsports, where the movement is at an angle to the photographer.

Focusing techniques

You can help increase auto-focus speeds by aiming your focusing point on subjects with sharp, well-defined edges. Avoid subjects with low contrast such as the sky, or where there is constant movement, such as the sea. Focusing on light sources can also be problematic. With top-quality zoom lenses, it's good practice to zoom in, focus, and then zoom out to the working setting. For other lenses, it's best to re-focus if you change the zoom setting after focusing the first time round. Focusing through obstacles such as branches or wire fences will be tricky, too, in which case it's best to set focus to manual.

Manual focus

Manual focusing is easiest in dSLR cameras because you can see an accurate, high-resolution image in the viewfinder as you adjust the focusing ring. It may be slower than auto-focusing, but manual focusing helps you to concentrate on the essentials of your image. And, as a bonus, manual focusing is often more accurate, delivering sharper results than auto-focus. Wherever possible you should avoid using your preview screen to check focus – the result will usually be inaccurate because of the screen's low resolution. However, you'll need to do this when using live view: for this kind of usage, it's best to zoom in for a magnified view.

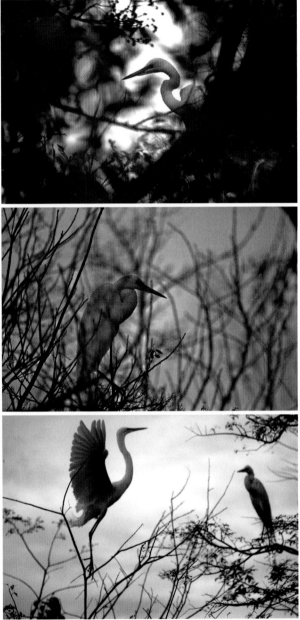

When photographing a scene through obstructions, such as these egrets partially obscured by branches, it's best to focus manually. Note the blurring effect, particularly visible in the top image: if you want to capture the image as you see it through the viewfinder (which is looking through the lens at full aperture), ensure you set full aperture by working in manual exposure or Aperture Priority mode. If the shot was taken with a smaller aperture, the branches would be too defined and dense.

Close-ups

One of the unsung revolutions in modern photography is the way in which the small sensors and short focal length lenses of compact digital cameras enable you to focus close-up very easily. In fact, the majority of cameras can focus in closer than most people's eyes can; close-up photography makes the small-scale visible.

You have two main technical points to consider when taking close-ups: working distance, and depth of field. Working distance refers to how far you are from your subject at a given magnification. The longer the focal length, the further away you can work. For instance, when copying artwork or documents, shoot with a normal focal length of around 50mm. For shots of flowers and plants, longer focal lengths – at least 100mm – give a good working distance and reduction in the depth of field. For small animals or insects that may be disturbed if you get too close, the focal length range of 150–200mm is ideal.

Depth of field

While you may have control over which focal length lens you choose, with close-up photography you have only indirect control over the loss of the depth of field. This is because the depth of field rapidly reduces the nearer you get to your subject. This means that you can't get even a small flower fully in focus from front to back.

When photographing live subjects, you may choose either to work with this reduction in the depth of field, meaning you compose the shot to incorporate the blurring in pictorially useful ways (see also pp.82–83), or you set the smallest practicable aperture on your lens for maximum depth of field. As modern cameras offer clean images even at high ISO sensitivities, set the highest ISO available so you can use the briefest possible exposure time for the sharpest images. Alternatively, light the subject with a flash unit (see pp.92–95).

Macro lenses

Manual focusing macro lenses – designed to focus to show the subject at half life-size or life-size – are some of the sharpest lenses available. They are free of distortion, and useful for a wide range of subjects. Older versions are inexpensive and perform extremely well: they offer terrific value. Lenses with a focal length of 50mm make excellent all-rounders, while 100mm versions are superb for portraiture.

THROUGH A CAMERA'S EYE

Being able to see in minute detail doesn't always come naturally – but cameras allow us to study many subjects in depth. Their lenses can not only focus in more closely than the human eye, but can reach into places we can't go (such as deep into the branches of a palm tree). Exploit the capabilities of your camera by exploring subjects to a whole new level of detail.

The cat's whiskers
Extreme close-ups may not always be flattering, but they can show more than a view from arm's length. To get the best perspective, use the longest focal length available to you.

Ambiguous familiarity
The eye of the camera can uncover the beauty in the everyday, revealing details we never noticed before. Parts of a whole can become interestingly enigmatic when viewed in isolation.

On the level
If the depth of field is limited, place important elements on or near the same plane – this way, they will appear equally sharp. Here, the eye and the strands of hair are level.

A study in detail

We seldom pay proper attention to our surroundings, but it can be very rewarding when we do so. Use close-up photography to look deeply into your subject, and open up a world that you don't normally appreciate – you never know, you might catch a glimpse of the spirit of the place.

▼ THE BRIEF

▷ Investigate a corner of your world, be it your garden, bedroom, or office: even a few minutes in a small area can yield surprisingly attractive results. Choose a place where you can work undisturbed, and minutely explore an area no greater than 1sq m (11sq ft).

▼ POINTS TO REMEMBER

▷ **Set your camera to close-up or macro** (usually indicated by a flower icon). If you have a dSLR, set the zoom lens to macro, or fit a close-up lens or extension tube. Choose a small image size and medium quality JPEG. Set high ISO and Aperture Priority mode, with an aperture of f/5.6 to f/11.

▷ **Look for abstract compositions** consisting of indistinct parts of your subject – edges of leaves, tangled wires, and so on. Be expressive with your framing and composition.

▷ **When you have made a range of images** at medium apertures, try setting maximum aperture for a sequence shot with minimum depth of field.

▷ **Train your eye** to find unusual compositions from chance juxtapositions.

GO GOOGLE

☐ **Close-up lens**	☐ **Focal plane**
☐ **Extension tube**	☐ **Wilson Bentley**
☐ **Macrophotography**	☐ **Karl Blossfeldt**
☐ **Microphotography**	☐ **Edward Weston**
☐ **Photomicrography**	☐ **Martin Schoeller**

Macro world

Head-on, bug-eyed insect shots are dramatic, but they call for skilled technique and the use of flash; yet even without special equipment, you can capture life from an insect's point of view. In this image, strong under-exposure throws the background into a sea of darkness, illuminated only by the blur of an occasional flower. The cricket, picked out by a sunbeam, is held by the blades of grass in a tracery of implied and actual lines.

▷ Canon 1Ds MkIII, 100mm *f*/4 : *f*/4 ISO 200 -2EV 1/200sec

1 Pointed reference
Fortuitously, the blade of grass points straight at the cricket. Even better, the image is in sharp focus around the insect, but falls away to a blur thanks to the very shallow depth of field – so the blade of grass points to the cricket without drawing attention to itself.

2 Dark light
Even an evaluative exposure, which analyses the image and assigns an "intelligent" exposure, would still reveal too much of the background. By dialling in a strong 2EV of under-exposure, the background became a solid black with nothing but the brightest colours visible.

3 Finely drawn
When the depth of field is extremely shallow, the question becomes where to best locate the focus. You would usually aim for the insect's nearest eye, but in this case too much of its body would be blurred. I focused behind the cricket's head and caught the bent-back antenna.

4 Burst of colour
The dab of colour emerging from the darkness is crucial to the balance of this picture. It prevents the background from being uniformly dark, and provides a counterweight to the other blur of pink at the top. The main flower, in sharp focus, acts as the visual fulcrum of the image.

IN DETAIL

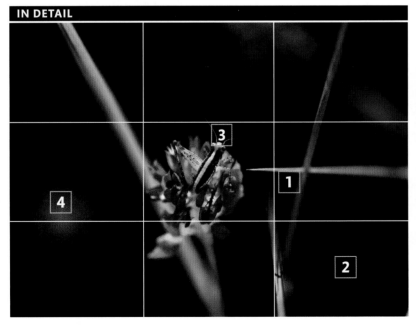

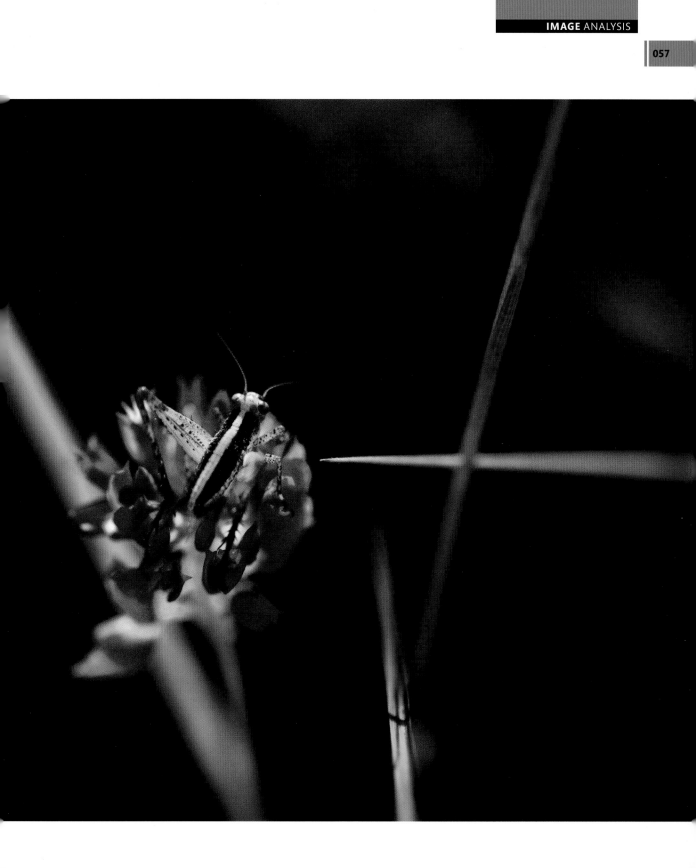

Capture problems

DAMAGED FILE

PROBLEM
The image shows unnatural coloration, or incorporates parts of another image. It can't be opened with image manipulation software (or it opens unexpectedly in a different program), or it behaves strangely in other ways.

ANALYSIS
The file was damaged while being uploaded from the memory card or when it was copied. The camera may have got wet, the problem may have been caused by a loose connection, or the memory card may have been damaged if an attempt was made to remove it during Read/Write operations.

SOLUTION
▷ Note the file name before deleting it, then upload the image again.

▷ If the image has been erased or the card reformatted, immediately use an image rescue application to retrieve the file (see pp.172-73).

▷ To avoid this problem in the future, keep your camera dry; don't open the memory card slot straight after shooting; use a high-quality memory card and card reader; place the card carefully into the reader and don't disturb it during uploading; or connect the camera directly into your computer with a cable.

POOR WHITE BALANCE

PROBLEM
The image appears too blue, too warm (yellow–red), a little green, or reddish. Whites and greys are tinted, but looked neutral to your eye.

ANALYSIS
An error in the white balance or image processing has disturbed the calibration, upsetting colour accuracy. You may have chosen the wrong setting (if the image is too blue, for instance, "Tungsten" could have been used in daylight). The exposure metering may have been locked while lighting conditions changed.

SOLUTION
▷ Set the camera to AWB (auto-white balance).

▷ For highest accuracy, use a grey card to calibrate the camera's white balance setting (see pp.104–05).

▷ Record in RAW format to allow flexibility and maintain quality in post-processing.

STRAY LIGHT

PROBLEM
Spots of coloured light, unrelated to the subject, obscure parts of the image. The image appears masked by light.

ANALYSIS
A strong light source was shining directly into the lens. Either the light reflected off the surfaces inside the lens, or off the lens hood, causing lens flare. Reflections off the lens elements show as a row of light spots, while other reflections result in flare, loss of saturation, or the appearance of unintended artefacts.

SOLUTION
▷ Use a lens hood to shade the lens.

▷ Cast a shadow over the lens with your hand (without letting your hand appear in shot), or stand in the shade of a nearby object.

▷ Remove any filters fitted on the lens to reduce the number of reflective surfaces.

▷ Take lighting into account when making your exposures. Move around to avoid pointing the lens directly towards strong light.

PARTLY BLURRED IMAGES

PROBLEM

Part of the image is sharp, but other areas – which should be in focus – are blurred, pale, and low in contrast. The image may have appeared sharp on the LCD preview.

ANALYSIS

The camera focused on the "wrong" parts of the scene. The area in focus may have been higher in contrast than the main subject or closer to the camera, or the camera was pointed at the wrong element. You may have set the camera to Servo or Follow-focus mode, and released the shutter before the camera could focus.

SOLUTION

▷ Confirm where the camera is focused before making the exposure by observing displays of focus confirmation and auto-focus points.

▷ Set to manual focus if other elements are obscuring the main subject.

▷ If you use the preview image to assess sharpness, magnify it.

▷ Set auto-focus to "single-shot", as this blocks the shutter release until a good focus is found.

▷ Set smaller aperture and higher ISO to obtain greater depth of field.

STREAKY IMAGE

PROBLEM

Nothing in the image appears sharp. Lights appear as streaks. Objects may appear doubled, or fringed; where fringes are visible, they may look relatively sharp.

ANALYSIS

While the focus is good, you, the camera, or the subject (or all three) moved during exposure. If you deliberately moved to follow a moving object, and everything in the image is blurred, then you moved at the wrong speed.

SOLUTION

▷ Set a shorter exposure time. With a standard or wide-angle lens, use an exposure time shorter than 1/50sec, and for longer lenses, fix it for less than 1/200sec.

▷ Set high ISO to enable short exposures to be made.

▷ Use an image-stabilized lens or camera, if possible.

▷ If the subject is static, use a tripod.

WEIRD COLOURS

PROBLEM

The colours in the image are strange: some are correct, but others are wrong. Exposure may be wide of the mark.

ANALYSIS

The fact that the overall image is present suggests a fault within the sensor or the camera. It may have overheated, or an operation within its software may have been incorrectly performed. The LCD screen may be damaged.

SOLUTION

▷ Reboot the camera: remove the battery, wait ten seconds, then power up again.

▷ If you have been taking many shots or are working in very hot conditions, turn the camera off and allow it to cool down.

▷ Review the image on another camera or on a computer: if it's fine, the camera's screen is faulty and needs to be repaired.

▷ If the problem persists, take the camera to a service centre. Keep the faulty image to show the staff.

Exposure metering

As the camera's evaluation of light levels, exposure metering is a tool for creative expression, setting mood and style rather like painters who use darker shades such as Rembrandt or El Greco, or brighter ones, such as Tiepolo and Monet.

At one level, you don't need to know anything about exposure metering; after all, billions of images are taken each year without a thought for exposure settings, and they turn out fine. They also all look alike, because modern camera systems analyse the distribution of brightness in a scene, and match it to a statistical average drawn from thousands of images.

Balancing act

In photography, the process of matching image capture to light levels has two stages. First, exposure metering looks at the scene using various sensitivity patterns; depending on what kind of image you want to make, you can select whether you measure the entire scene evenly, or a tiny area, or various parts of it. Whichever of these options you choose, the net result is a single datum – the light level. Then, together with the ISO and exposure mode settings,

this calibrates the exposure stage and produces an image in which the average brightness is mid-tone, or halfway between white and black.

The basic strategy for exposing an image is to use a combination of aperture and shutter settings that has the best chance of recording details across the shadows, the mid-tones and the highlights. This will work in the vast majority of situations. However, modern digital photography allows variations in exposure for artistic effect, both in terms of data capture and aesthetic attitudes. When you start purposefully doing this, you begin to put your personal stamp on the image. Remember that the "correct" exposure is the one that best conveys your intentions, and how you wish your viewers to respond to the image.

If you choose to lighten the mid-tone through over-exposure, you can soften colours and lift shadows, giving the image an airy, light-filled feel with lowered levels of contrast. Under-exposure moves the mid-tone down towards the shadows, which tends to deepen colours, strengthen blacks, and increase levels of contrast. To do this, use the exposure override, which offsets the automatic exposure with as much or as little over- or under-exposure as you dial in: it's far faster to do this than to use the manual exposure control.

On the spot

The best way to meter this scene in Agra, India was to set exposure based on the small area in the doorway when someone was standing at the threshold – when shooting, all that matters is that the exposure is correct at the right moment. A scene with more evenly distributed brightness (inset) can be measured with any sensitivity pattern.

Luminance range and exposure latitude

Exposure latitude determines how much room for manoeuvre you have when exposing your images - that is, how far you can stray from the mid-tone-averaged exposure while still retaining pictorial integrity. Conventional wisdom says that high-contrast scenes - those with a wide range of luminance, or brightness - are tricky to expose. In fact, in these situations variations in exposure can deliver a range of usable images. When the difference between the lightest and darkest areas is narrow (low contrast), you need to expose carefully in order to record an image that balances tone, detail and colour in a convincing way. Exposure correction in post-processing is easier to do in low-contrast images.

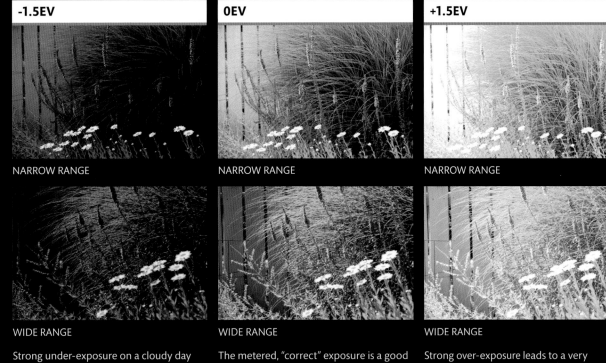

-1.5EV

NARROW RANGE

WIDE RANGE

0EV

NARROW RANGE

WIDE RANGE

+1.5EV

NARROW RANGE

WIDE RANGE

Strong under-exposure on a cloudy day (top) intensifies colours in an attractive way, with a good level of detail emerging from the white flowers. But this loses too much detail in the shadows, which results in murkiness.

Where the luminance range is wide, typically in a scene lit by full sunlight (bottom), strong under-exposure delivers very pleasing results, with saturated colours and details in the white flowers. Mid-tones - for example, in the grass - bring layers of texture to the heavy shadows

The metered, "correct" exposure is a good compromise for capturing shadow and highlight detail. Green details are excellent, but the purple flowers are rendered pallid because they require a little less exposure, and the white flowers are too bright (top).

The metered exposure works very well in wide-range lighting (bottom) because bright areas tend to drive down exposure, leading to firm mid-tones and good colours all round. However, the white flowers illuminated by the sunlight appear over-exposed

Strong over-exposure leads to a very watery look, which can produce a light and airy atmosphere suited to subjects such as gardens, nature and fashion. In narrow-luminance situations (top), over-exposure can easily lighten shadows.

Over-exposure in full sunlight (bottom) is always fun because the results are hard to predict. Here, the best parts of the image are the crisp details in shadows, which still retain density. Compositions with backlit objects against darker areas often work well, too.

Excessive dynamic range

"High dynamic range" has become the accepted, if inaccurate, term for excessive subject luminance range. This describes the range of brightness of a subject that greatly exceeds a sensor's capacity to capture it fully. Small sensors in compact point-and-shoot cameras may capture between three and five stops of brightness range compared to the nine or more stops of larger sensors.

In fact, any photographic situation in which the sun or its reflection is visible will be "high dynamic range", because the sun creates far too much brightness in which to record details. In practice, in such situations your concern is with the visually important areas of the image. A small area that's lacking in detail may not be important if it's tucked away in a landscape image, but it will be an issue in close-up portraiture.

Shadow precedence

The problem is not new to photography, so there are well-tried techniques for handling these situations. One solution that's always readily available is to work with the light: if there are no mid-tones, create them through exposure control (see pp.60–61). Exposing for bright areas brings them into the mid-tones and turns shadows completely black. Alternatively, you can fight the high contrast, either by turning your back to the sun, or by adding light to the shadows to reduce their density.

Turning and filling in

If you turn your back to the main light source, this minimizes the size of the shadow you see, reducing the size of dark areas on your image. At the same time, however, textures flatten out. A side-benefit of turning away from the sun is that it minimizes loss of quality caused by lens flare (see pp.66–67).

Alternatively, you can reduce shadows more directly by filling them with light, most easily applied with a flash unit. The smallest amount of fill is usually sufficient to lift shadows from pure black without looking unnaturally bright: set automatic flash to –2 stops, or set minimum manual power.

In-camera adaptation

If the problem of excessive subject luminance lies in the sensor, the solution can also be found there. Manufacturers have adopted two main approaches: the most widespread is for the camera to apply corrections as part of in-camera

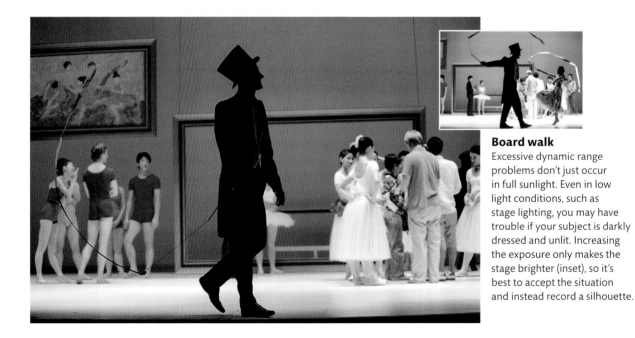

Board walk
Excessive dynamic range problems don't just occur in full sunlight. Even in low light conditions, such as stage lighting, you may have trouble if your subject is darkly dressed and unlit. Increasing the exposure only makes the stage brighter (inset), so it's best to accept the situation and instead record a silhouette.

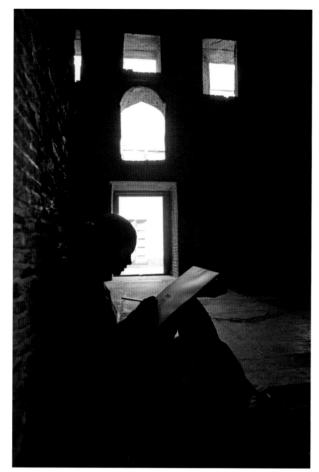

Study in black
With brilliant sunshine outside, not only is it impossible to expose to obtain shadow details, it would also spoil the atmosphere. The hints of colour in the girl's shirt, the dimly lit textures on the wall, and pale light on her drawing pad are all you need.

Excess is relative
There are no details in the brilliantly lit clouds, nor in the shadows under the apple trees, but the combination helps create the somewhat otherworldly appearance of this netting draped over an orchard.

image processing. This boosts weak signals and tones down the strongest signals. Some cameras analyse the image a few pixels at a time to apply what is essentially a filter, which brings out shadow details and reduces burn-outs from highlights. These processes usually increase image noise; you can turn them off if needed.

The other, less popular, solution is for the camera to use sensors specifically designed to cope with wide brightness ranges. One type uses different-sized photo-sites on the same sensor – small ones for bright light, larger ones for low light. If all else fails, there are image manipulation solutions, namely shadow and highlight controls, and tone-mapping (see pp.214–17).

DID YOU KNOW?

Dynamic range in photography is best considered as a system where the scene, the camera, and the output device each make a contribution to the final image. In a scene, the dynamic range is the difference between the brightest and the darkest areas – it can exceed 13 stops. In a camera, it measures the range of brightness that the sensor can record; this varies with sensor size and design. Dynamic range lessens with higher ISO settings. Finally, prints on paper may be restricted to a range as small as three stops; monitors are a little better, with eight stops, at best.

Hyper-dynamic range

Modern approaches to recording excessive dynamic range have transformed the way we photograph *contre-jour* (into the sun). Today, lenses can control veiling flare and internal reflections to an extent once thought impossible. Nevertheless, taking a shot directly into the sun is still a challenge, particularly if there's movement in key parts of the scene. In this series, the most successful image balances the hyper-dynamic range of the sun with deep shadow while still capturing the detail of the scene.

▷ Sony A900, 16mm *f*/2.8 : *f*/13 ISO 200 -0.3EV 1/2500sec

FROM THE SAME SERIES

| **1** | **Concealment** |

1 **Concealment**
One way to control the impact of intense light is to hide the sun behind nearby obstacles – in this case, vegetation. Here, the shadowing effect appears as if it was always intended to be part of the picture. Even so, the dynamic range is still larger than can be recorded easily.

2 **Veiling flare**
A fully revealed sun causes excessive veiling flare, which occludes detail and reduces contrast by bleeding light into shadow areas. While the sun appears to be low on the horizon, it is actually high in the sky behind the mountains, and the light is too brilliant to handle.

3 **Reduce the super-white**
You can try to reduce the area of an image that's brilliant white by zooming into the scene or using framing techniques. Generally, keeping the sun near the centre of an image causes less veiling flare than if it's situated near the edge of the frame. In this shot, though, the grass is too dominant.

4 **Detail in the shadows**
It always helps to ensure that there is variety and texture in the shadows, so that when you fill them with light to extract detail there is indeed something to see. The openness of this composition, nevertheless, reveals the fish-eye distortion in the sky and nearby flax plants.

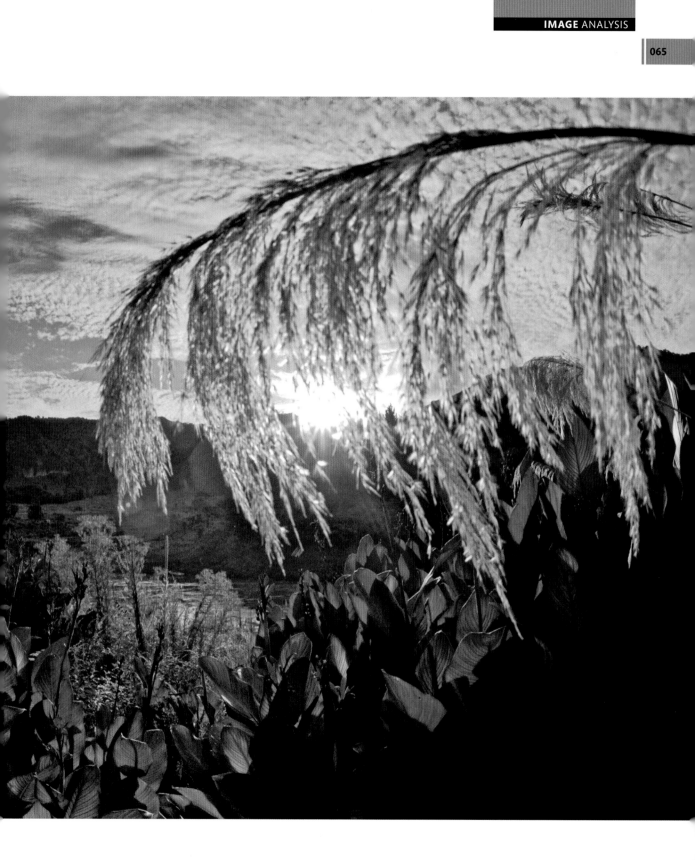

Incorrect exposure

BLACK AS GREYS

PROBLEM
Subjects with black or very dark tones (such as dark skin, hair, fur, feathers, or black objects) appear grey, with poor colours and over-bright highlights.

ANALYSIS
The camera's exposure meter reads the combination of lighting and dark subject as a lack of light, and exposes the image accordingly. This causes it to look grey.

SOLUTION
 Set your exposure to under-expose by between -0.7EV and –2EV.

▷ If the lighting is creating high contrast, err on the side of under-exposure: it's easier to recover shadows than over-bright highlights.

▷ If lighting is flat, under-expose cautiously; it may be safer to darken in post-processing.

▷ Review your test images with the histogram display switched on and adjust exposure so that the left side of the histogram just touches the left-hand edge of the frame.

BRIGHT LIGHT

PROBLEM
Shooting with a bright light source such as the sun in view makes the image too dark, with featureless shadows. Bright spots of light appear in a row in the image.

ANALYSIS
The very bright source of light causes the meter to register a high overall light level, so it sets a low camera exposure. Stray light reflects inside the lens mechanism and camera body, causing imprints of the light to appear in the image.

SOLUTION
▷ Changing the aim of the lens slightly may reduce internal reflections.

▷ Hide the sun behind any available object in view, such as a tree.

▷ Set over-exposure using the shutter control: keep the aperture small to control flare but to lengthen the exposure time.

▷ Use flash to fill-in shadows.

▷ Expose as metered but use the Shadow/Highlight controls in post-processing to extract shadow detail.

BURNT-OUT SKIN

PROBLEM
When photographing people in bright light, skin appears bleached out, with featureless expanses of white. The exposure of other parts of the image appears to be good.

ANALYSIS
Any skin, if slightly greasy, will return an almost metallic reflection in bright light. Fair skin is surprisingly reflective in direct light. We assess skin tones extremely critically, so the range of acceptable exposure is very narrow.

SOLUTION
▷ Ensure your subject's face is not in direct sunlight. Use any available shade, even your subject's own shadow, to shield it from the sun.

▷ Set the meter on the sunlit part of the face using the spot-meter mode (although this may make the rest of the image very dark).

▷ Fill shadows with light from a reflector or by using a spot of flash: this helps reduce the overall exposure without the shadow tones becoming too dark.

SUNSET SHADOWS

PROBLEM
Pictures of sunsets record the sky but the foreground looks totally dark and devoid of detail. Colours in the image lack the intensity that you can see with your eye.

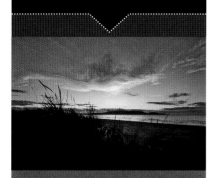

ANALYSIS
Your eyes adjust constantly to the varying brightness in a scene, enabling you to see detail in both light and dark areas. The camera exposes for the large area of brightness in the sky, but cannot hold shadow detail.

SOLUTION

▷ To intensify colours, under-expose by –0.5EV to –1EV (provided that the resulting, even deeper, shadows will not be a problem).

▷ Support the camera and make at least three bracketing exposures in preparation for exposure blending and tone-mapping (see pp.216–217).

▷ Record in RAW in preparation for using Shadow/Highlight controls to retrieve shadow details.

▷ Use flash aimed at the ground to lift foreground shadows.

ISOLATED ERRORS

PROBLEM
Your camera delivers accurately exposed images, and then suddenly a badly exposed image appears. Later exposures are accurate again. The effect is inconsistent and occurs in different circumstances.

ANALYSIS
If the camera functions correctly after an error, the mistake is almost certainly by the operator. You may have set the auto-exposure lock, or set an exposure override; you may have held the exposure reading, or set the camera to manual exposure mode in error.

SOLUTION

▷ Always make sure that the shutter and aperture settings are approximately correct for the lighting.

▷ Make sure that you have not inadvertently engaged the auto-exposure lock, which holds its reading irrespective of lighting.

▷ Ensure that the exposure override controls are at zero.

▷ Check that you have not set maximum aperture in bright light, or minimum aperture in low light.

WHITE AS GREYS

PROBLEM
Subjects that should be white or pale – with white fur, fair skin, or wearing white clothes – look grey, with colours darkened and intensified, and shadows blocked-out.

ANALYSIS
The meter reads the ample light reflected off white subjects as a relatively high ambient light level, and sets a reduced exposure accordingly, resulting in an image that is, overall, light grey.

SOLUTION

▷ When photographing fair skin, over-expose by +0.5EV.

▷ When photographing white fur, over-expose by +0.7EV to +1EV.

▷ When photographing white clothes, you may over-expose generously, depending on the effect required.

▷ Review your test images with the histogram display on: adjust exposure so that the right side of the histogram distribution just touches the right-hand edge of the frame.

TUTORIAL

High and low key

The key tone in an image is the tone that you decide is the most important. If it's a portrait, you'd usually want to ensure the skin tones are most accurate; whereas in travel photography, the vibrancy of colour may be paramount, so you might expose for strong colours. However, you can deliberately place key tones well outside normal limits to achieve a certain mood or effect – when your key tone is very bright or dark, this is known as high or low key.

You can use exposure to set the key tone so low that it's only just above shadow. This forces normal shadows into solid blacks, while formerly bright areas will be rendered as mid-tones, leaving only burnt-out highlights as white. Alternatively, you can set your key tone so high that what would be dark tones become light mid-tones or brighter. In this way deep shadows are lost and highlights are blown out (see pp.214–15).

Moving the key tones to extremes of dark or light also creates changes in colour and contrast, and is a simple way to produce powerfully expressive images. As a basic method, you can use the exposure override control to dial in strong over- or under-exposure, or use the manual exposure control to exceed the usual two- or three-stop limit of the override control. However, the most satisfying results come from partnering exposure control with the appropriate quality of lighting. For this reason, high- or low-key effects cannot be fully simulated by post-processing using Levels or Curves. As ever, it's best to capture the effect in-camera, instead of relying on image manipulation in post-processing.

Deep shadows and high values

Low key achieves a dark, mysterious feeling by assigning bright areas to mid-tones: all colours deepen considerably and contrast appears to rise. Some areas containing highlights may remain bright, while mid-tones descend into blackness. Sharply focused light on key features, such as eyes or body contours, often works well, because these areas cast deep shadows. Be prepared to lose all shadow detail in favour of concentrating attention on the key tone. Start with an under-exposure of -1.5EV or more and review the results. It is possible to create low key with image manipulation, but if you take this approach you'll need to be careful to avoid an excessive increase in colour saturation.

Tricks of the shade
Two stops of under-exposure (-2EV) turns an already moody shot into something even darker, but this was still not sufficient to tone down the bright pools of light from the street lamps. Although these have been burnt-in separately, they still leave highlights that distract attention from the face. More burning-in would look unnatural, so a better course of action might have been to frame them out altogether.

Soft tones

High key, with its soft, bright skin tones and overall lightness of feel, is particularly effective for creating baby portraits with an almost ethereal appearance. Here, over-exposure of the white background boosts the effect.

When using high key, fill the scene's shadows with light using reflectors or fill-in flash, and work in low-contrast conditions, such as overcast days. In the studio, use softboxes on the flash or a ring-flash (see pp.92–95) to eliminate deep shadows. For fashion or portraiture, if you want to ensure skin tones are accurate, make the skin the darkest element in shot, and arrange lighting so that there are no shadows. To maintain sharpness, work in Shutter Priority mode. Alternatively, if you like the flare you achieve from using large apertures (which combines well with high-key exposures) work in Aperture Priority mode. Start with an over-exposure of +1.5EV and evaluate the result.

DID YOU KNOW?

High-key photography was synonymous with fashion photography in the 1930s, made popular by photographers such as Edward Steichen and Alexey Brodovitch, the art director. The bright, airy fashion shots of the time came to epitomize the era's glamour and style, and they remain an immediately recognisable visual signature of the decade. However, the return to favour of high-key photography, ironically, may be restricted by modern technologies. In the early days of print, dark images were not welcomed by printers: the technology of the time was not easily able to differentiate dark tones, and a heavy ink load would come off on readers' hands. Not only were high-key images easy to print clearly, they worked well with the off-white papers in use at the time. On the high-white papers in use today, or when seen on a monitor screen, high-key images may look uncomfortably bright.

Exposure time and motion blur

Exposure time refers to the length of time the sensor is collecting light when you make an exposure. It's one of your principal controls over an image; along with lens aperture, it affects how much light reaches the sensor, and it determines how you capture movement.

Your choice of exposure time depends partly on prevailing light levels: when shooting well-lit scenes, you can use shorter exposure times for a given aperture and ISO setting. In dimmer light you use longer exposure times.

The amount of sharpness or blur you want will also affect your choice of exposure time: short exposures capture movement sharply, and longer ones produce blur. If your subject moves during an exposure, it creates a "streak" across the sensor. With short exposure times the streak is not visible, so the image appears sharp; if the shutter is open long enough for the streak to be visible, the subject appears as a blur.

Short exposure times

We expect most images to show cleanly visible detail, so the general practice is to set short exposure times – typically shorter than 1/125sec – that "freeze" movement. Even if the subject is static, such as an interior or a

ALFRED EISENSTAEDT

> The world we live in is a succession of fleeting moments, any one of which might say something significant.

landscape, the camera may move during exposure and blur the image. To avoid this, you can support the camera on a tripod or a surface, or use image stabilization (see pp.76–77). Or you can ensure your exposure time is brief enough to capture a sharp image: to do this, set 1/125sec or shorter for wide to normal focal lengths; for focal lengths longer than 200mm, set 1/250sec or shorter.

Long exposure times

The use of long exposures can be practical or creative. It's necessary, for example, in low light, or with small lens apertures or low ISO. You might also set long exposures when using accessories that reduce the amount of light reaching the lens – filters, teleconverters, or extension rings.

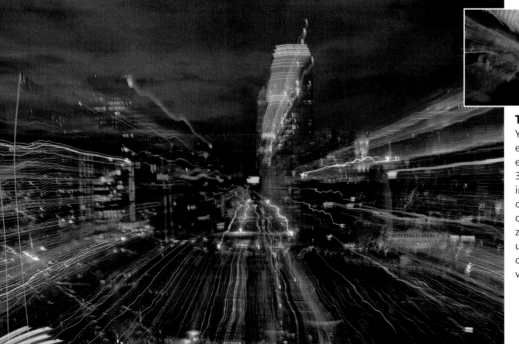

Trailing lights
You can create dazzling effects by setting a long exposure – in this case, 3sec – and then zooming in or out while the shutter is open. Here hand-held shots create wavy lines; for straight zoom lines, you'll need to use a tripod. Experiment with different exposure times and varying rates of zooming.

The exposure time that produces the best blur effect depends on the speed of movement, your distance from the subject, the lighting, and the type of effect you intend to create. Start by setting 1/8sec and evaluate the results: here, exposures of 1/8sec and 1/4sec catch different degrees of blur with different speeds of movement.

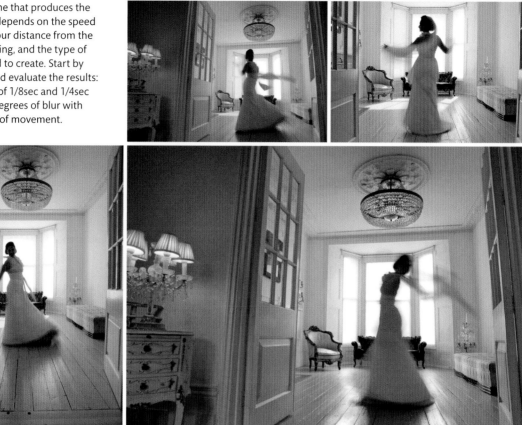

Alternatively, you can use long exposures creatively as a tool for recording motion blur. Hold your camera steady, preferably using a tripod, and open the shutter while your subject is in motion. Experiment with different exposure times and lighting to vary the amount and quality of blur – you can achieve particularly striking results in low light (see pp.74–75). Alternatively, you can render a moving subject sharp, but blur the background, by panning the camera to follow the subject during a long exposure.

Modes and other settings

Using Shutter Priority or Time Value Priority modes allows you to choose the exposure duration yourself, while the camera automatically varies lens aperture or ISO settings to give the correct amount of exposure. If you use shorter exposure times in low light, you run the risk of exceeding the maximum aperture of your lens. At that point, you or the camera need to set a higher sensitivity (ISO).

DID YOU KNOW?

The exposure times needed to capture motion so that the image appears acceptably sharp vary according to the angle of the movement in relation to the camera. Here is a guide to shooting some common moving subjects at a distance of about 30m (90ft). Use shorter exposure times for higher sharpness, more rapid movement, or for subjects nearer the camera.

	Toward (sec)	Right angles (sec)	Diagonally (sec)
Walker	1/30	1/125	1/60
Jogger	1/60	1/250	1/125
Cyclist	1/250	1/2000	1/1000
Galloping horse	1/500	1/4000	1/2000
Car	1/100	1/4000	1/2000

Working in low light

The technology allowing photographers to work in low light has been steadily improving, to the point where it seems the stuff of science fiction. With ISO settings of over 100,000 and large-aperture lenses, cameras are catching up with specialist night-vision equipment in terms of capability, but with the capacity to see in amazingly rich colour.

The essence of low-light photography is to capture a sense of darkness punctuated by subtle light sources. And thanks to large sensors with very high sensitivities, even moonlit nights present no problems for the modern camera. The results can be literally fantastic: the camera reveals colours and details in the dark that are all but invisible to the naked eye.

Photographing the dark

When darkness falls, far from being a sign to pack up and go home, instead a new world of photographic opportunities opens up. Prop the camera anywhere, expose, and prepare to be amazed. The main challenge is focusing, so choose some contrast or detail as a target. Auto-expose scenes with the aperture slightly open, but not at its widest, and set the override to -1.5EV or less. If pools of light in the scene are large, you can use settings as low as -3EV. Use auto-white balance or record in RAW for flexibility in post-processing; don't worry about noise (see pp.102–103) as you can deal with this in post-processing as well.

Twilight activities

In candlelit situations, set a large aperture and high ISO if you want to capture a sharp image of the flame itself. Always disable pop-up flash. Set the auto or Tungsten white balance to reduce the red tint, but not to correct fully. Use spot metering, or, if there's a person in shot, set the selective area on your subject's face.

If you want to capture spectacular images of fireworks, find out the timing and location in advance and position yourself for a good view. Set manual focus and a manual exposure, such as ISO 200, f/5.6, 1/15sec. Frame generously to increase your chances of catching unexpected bursts in-frame. If you lock off your camera on a tripod for successive shots, you can even blend the best bursts into a single image.

To photograph lightning, lock the camera on a tripod, set manual focus to infinity, set minimum aperture, and zoom out. When you set the exposure, remember that brightness varies greatly – as does the timing of the shots.

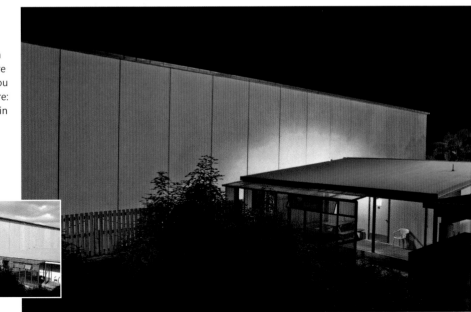

Night vision
In the dark, these expansive walls glow with geometric purity and rich colours. But in the light of day (inset), they are stripped of their finery and you can see them for what they are: dreary warehouse structures in various bleak shades of grey.

Mixed metaphors
Dusk balances light from the sky with artificial lights, providing a window for mixing different types of light with relatively long exposures, to capture both stillness and movement.

Moonshine
The moon is best shot using a zoom – here, a 200mm focal length – to show it at a good size. An exposure of 1/8sec at ISO 400 and -2EV over-exposes its detail but captures the shine.

Street furniture
A colourful post provided a place to rest the camera and became part of the picture for a 1.3sec exposure of Napier, New Zealand, famous for its Art Deco architecture.

Seeing in the dark

Take your camera out when it gets dark and discover a new way of seeing the world. Use your camera to look into the darkness for you: you'll find the night transforms the landscapes and views that you take for granted during the day. With its long, unblinking stare, a camera will reveal scenes you never imagined existed.

▼ THE BRIEF

▷ Explore the night, starting locally. The easiest time to work is just before sunset, when lights come on and the sky is still glowing. Compare night scenes with the same views in daylight.

▼ POINTS TO REMEMBER

▷ **Noise will increase with longer exposures;** you can set your camera to reduce noise but this can double the effective exposure time.

▷ **Use a tripod** for the most flexibility in positioning your camera.

▷ **Work in safe areas** and bring a companion to keep a lookout for you – and your equipment. If you're worried about drawing unwanted attention, use a clamp on railings and other objects for discreet stability.

▷ **Set your aperture** one or two stops down from its maximum to obtain a balance between good performance and short exposure.

▷ **Set ISO sensitivity** (see pp.98–99) according to the exposure time you can comfortably work with.

GO GOOGLE

☐ **Purkinje shift**	☐ **Brassaï**
☐ **Scotopic adaptation**	☐ **Rut Blees Luxemburg**
☐ **Robert Adams**	☐ **Jill Waterman**
☐ **Harry Benson**	☐ **Long exposure**
☐ **Peter Bialobrzeski**	☐ **Night photography**

The lady with the lamp

You can record spectacular effects with light painting, a technique in which you combine long exposure in conditions of low light with light applied to brighten or add colour to specific areas. All you need is a tripod, a dimly lit or dark location, a camera that can give a long (or B) exposure, and a source of light, such as a candle, torch, or flash. For this image, we transformed a hallway into a gothic tableau and set the stage for a ghost to appear, the light from her lamp tracing a mysterious arc through the air.

▷ Canon 5D MkII, 24–70mm *f*/2.8 : 24mm *f*/14 ISO 50 -2EV 30sec

FROM THE SAME SERIES

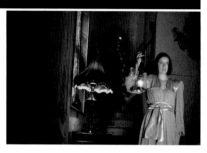

1 Doppelgänger
In an early attempt we used flash at the beginning and end of the long exposure. Our ghost and her shadow were visible at the top of the stairs, and she reappeared in the hallway – an interesting effect, but the flash exposures were clearly too much, as they destroyed any sense of darkness.

2 Darkness at noon
We set strong under-exposure to obtain a day-for-night effect. We darkened the hallway but left the lamp on the side table on. When our model reached her mark, we used the flash, but the light made her solid and sharply defined. There was also insufficient space around her.

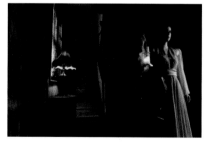

3 Trial and error
We drew back into the far corner of the hallway to improve the composition, and conducted more experiments to give us the timing for the model's walk and wait. We also practised "moulding" the light trail to form an attractive curve. But without light on the model, she became almost invisible.

4 Summoning the apparition
We solved the problem by opening a side door for a few seconds, flooding the model with light. This shot is almost perfect, but on close examination is marred by minor details: our ghost is too corporeal; her face is half in shadow; and the light trail is indistinct and follows an odd path.

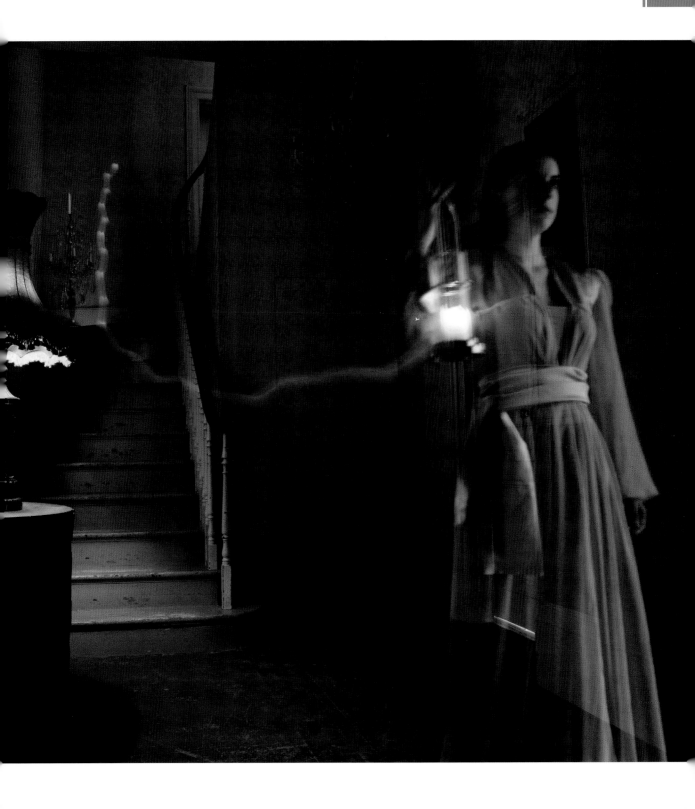

Stability during capture

Sharp, detailed images without blur are highly prized by photographers: they are easy to view, and require skill to make. In the search for sharper images, many photographers look to more expensive lenses or bigger cameras. But the least expensive, most effective upgrade to your equipment is a tripod.

Tripods were essential for high-quality photos for most of the first century of photography, and were gleefully abandoned when miniature cameras were invented. But they are making a comeback, as photographers realize that the full potential of their digital cameras cannot be obtained without a tripod to hold the camera steady during exposure.

Weight and strength

The ideal tripod is much heavier than the equipment it carries, and is rigid, with no loose joints. However, any tripod is better than none. Even very lightweight models help support the camera and take the weight off your hands – particularly useful when you want to fix the camera in one position while waiting for an animal to emerge, or for the light to change. Lightweight tripods can be made more rigid by loading them – by leaning downwards on them, or by hanging a heavy bag

LAO TZU

Be still. Just watch everything come and go. This is the way of Nature.

from the top – to tension their legs. The best modern tripods are made of carbon fibre, and combine relatively light weight with excellent rigidity; these used to be prohibitively expensive, but affordable models are now available.

In-camera

The development of image stabilization constitutes a huge leap forward in the quest for sharp images. Detectors in the camera analyse small movements and compensate for them during the exposure, to deliver sharp images. These help at all shutter settings, but particularly with longer exposure times. Generally, with wide-angle lenses, a setting of around 1/30sec is needed for sharp images, 1/60sec for normal focal lengths, and 1/200sec or shorter for long focal-length lenses. But with image stabilization, you can double these exposure times and still obtain sharp images.

A STEADY HAND

Taking the weight of the camera is the key to steady shots. Cradle the lens in your palm, keeping your elbows firm against your body. Lean on any nearby features for additional stability. Use a hand-strap for a firm grip, and a tripod whenever possible. On a slope, point your legs downhill for stability and ease of movement. Keep the tripod column vertical; extend it only when you need to.

Walking in the trees
This rope bridge was steady, provided you didn't move. Short exposures and high ISO settings helped ensure sharp results in the low light of the rainforest.

Down the path
Looking vertically down is awkward with a tripod. A heavy bag can help steady you, but image stabilization is the best solution for sharp images.

Floating world
With inherently unstable platforms such as boats, image stabilization is the best way to avoid blurry results. Here steady forward movement is usually better than trying to keep still.

Practising buttons

For photographers, learning your way around your camera – and how to hold it – is the equivalent of practising scales for a musician. Virtuoso photographers can find every setting and option with their eyes shut, identifying buttons by feel, and counting clicks to reach favourite options. A major part of the skill is also being able to release exposures without jarring the camera body, and, if you're shooting video, holding the camera steady during a take.

▼ THE BRIEF

▷ Find your way around your camera – the direction you turn each dial, and the number of clicks of a button to reach a menu item. Learn how to hold the camera and press the button so there's no camera shake for both horizontal and vertical formats, at different focal lengths, and especially with long exposure times.

▼ POINTS TO REMEMBER

▷ **Examine hand-held shots** at high magnification to check the sharpness of your long exposures, particularly those at long focal lengths.

▷ **Use custom functions** to match settings to common subjects – one for portraiture, one for landscapes, one for close-ups, and so on (see pp.24–25).

▷ **Once you're familiar** with your camera's basic workings, it's time to read the instruction manual thoroughly and learn about all the functions you haven't discovered yet.

GO GOOGLE

☐ **1/focal length rule**	☐ **Image stabilization**
☐ **Ball head**	☐ **L-bracket**
☐ **Beanbag tripod**	☐ **Monopod**
☐ **Carbon-fibre tripod**	☐ **Pan-tilt head**
☐ **Gimbal head**	☐ **VR lens**

Using aperture

Lens aperture gives you control over many aspects of photo-technique. Not only is it one of the trio of settings that affect camera exposure, it's a powerful tool for adjusting depth of field, as well as far more subtle effects such as the quality of out-of-focus blur (see pp.82–83) and image quality (see pp.50–51).

The aperture is the lens opening – technically, the entrance pupil – that controls the amount of light passing into the lens. It is measured by "f/number", which is the lens' focal length divided by the effective diameter of the opening, as seen at the sensor. The maximum aperture is where the entrance pupil is at its widest, letting in the most light: here the f/number is "high", such as f/2. The minimum aperture is the smallest hole left by the lens when fully stopped-down: the smallest amount of light is let through, and the f/number is "low", such as f/16.

Depth of feeling

Broadly, aperture is the most important setting when your goal is to control the plasticity of the image – its transition from blur to sharpness. This is achieved by choosing an aperture that gives you the required depth of field – sharp throughout, or with blur in the background or foreground – and adjusting the exposure time or sensitivity to suit. You can also set aperture to ensure the lens is working at its optimum, or, set it to exploit the lens' weakness deliberately.

DSLR advantage

Users of dSLRs have the most flexibility in controlling aperture, since these cameras have inherited full-range controls from the days of film. All dSLRs measure their aperture settings in whole stops: that is, each change doubles or halves the amount of light on the sensor. Additionally, many provide half- or even one-third-stop intervals. This is useful for finessing exposure, but it's not necessary where exposure override (see pp.60–61) is available in half- or one-third-stops.

Pointing and shooting

Many point-and-shoot cameras offer only two aperture settings – the widest and narrowest. This is not as much of a drawback as you might expect: at medium to long working distances, cameras with very small sensors such as these offer extensive depth of field, even at maximum aperture.

f/8 AND BE THERE

This photojournalist's adage brings together two essentials: the need to be in the right place, and the flexibility of the aperture setting f/8. With a 400mm lens (below), islands far apart appear equally sharp, and with a 12mm lens (right), everything is sharp from the foreground foliage to the distant peaks. In a tropical market (far right), f/8 ensures "snapshot" working speeds.

Mastering depth

Depth of field is the volume of space in which objects appear acceptably sharp: it extends in front of, and behind, the zone of best focus – the sharpest area in the image. The transitions from sharpness to blur create the image's plasticity and sense of depth. This depends on the aperture, the lens' focal length, and your position. Larger apertures such as *f*/2.8 give the most blur; smaller apertures such as *f*/11 give more sharpness. Focusing further away delivers greater depth of field, as does using shorter focal lengths. For strong effects, juxtapose blur with sharpness: use a long focal length, or frame close to the camera, and set a large aperture – handy for point-and-shoot cameras with excessive depth of field.

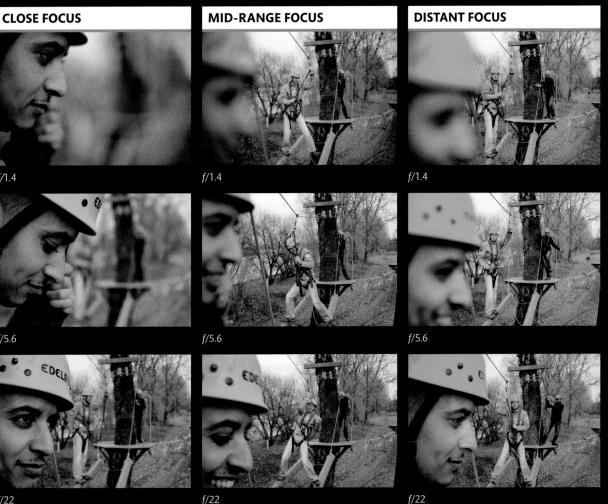

CLOSE FOCUS	MID-RANGE FOCUS	DISTANT FOCUS

f/1.4

f/1.4

f/1.4

f/5.6

f/5.6

f/5.6

f/22

f/22

f/22

The most powerful contrasts between blur and sharpness result from focusing on a nearby object. With a 50mm lens, even at *f*/5.6, the background is still very weakly defined.

With focus on the middle range, near objects are blurred, though with outlines visible, but the background is almost as sharp as the middle ground even at *f*/1.4.

With focus set to far away, all medium-to-distant objects appear sharp even at full aperture. With smaller apertures, the only easily visible change is in the closest objects.

The beauty of blur

The quality of the blur in an image – the lens' "bokeh" – is always important, but it is absolutely vital when almost nothing is in focus. The superb smoothness of the blur is the making of this shot of ballerina Madoka Toguchi as she looks in a mirror. Virtually everything is out of focus, but the catchlights in her eyes are sharp. This is thanks to a high performance at full aperture and a very brief 1/800sec exposure.

▷ Sony A900, 135mm *f*/1.8 : *f*/1.8 ISO 1600 -0.3EV 1/800sec

1 Window to the soul
Thanks to the make-up lights, the lighting on Madoka's face was perfect, and it produced catchlights in her eyes. But focus is critical, especially when working at full aperture. I used auto-focus to approximate the focus, and then adjusted it manually while looking through the viewfinder.

2 Soft differences
The red of the dancer's top and its double in the mirror could have merged into a sea of undifferentiated colour, with disastrous results. Here, the very large blur radius and soft feathering effect separates the reds close to the camera from the more defined folds in the reflection.

3 Reality is untidy
Once noticed, this amorphous dark patch is irritating as it distracts from Madoka's perfect face. This is just the kind of detail that would be avoided in a directed shoot, but its presence is the mark of an impromptu shot, grabbed in the moments between stage appearances.

4 Noisy blur
The high sensitivity of ISO 1600 is accompanied by noise, originally most evident in the shadows. As darker areas take up a significant portion of the image and worked against the smoothness of the focus blur, I reduced the level of noise in post-processing (see pp.230–31).

IN DETAIL

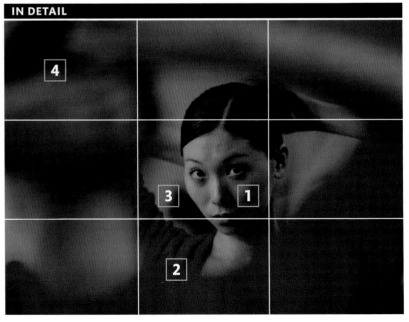

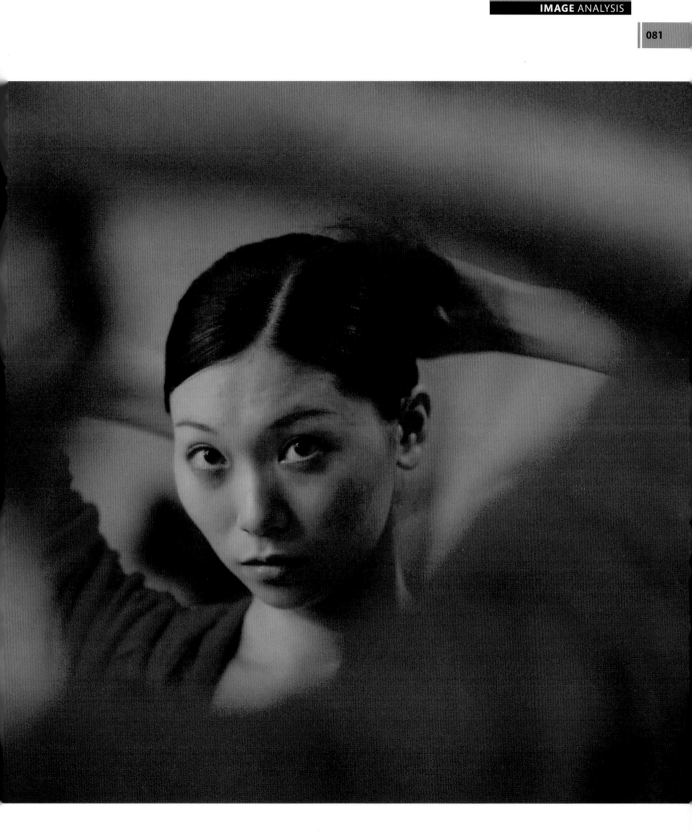

Plane of focus

The weight of an image can be said to be carried on the plane of sharpest focus. Standard photos often show the foreground rolling away towards objects in the middle and far distance: the shape of the visual field is concave, like the inside of a vast hall. The further you deviate from this norm, using focus tools to control sharpness and blur, the greater the individuality of the images you can produce.

The basic technique is to work with a depth of field that is less than the separation between key elements in the scene. One element you keep in focus, the other is thrown strongly into blur. You work, therefore, with the contrast, one effect enhancing the power of the other: if the whole image was in blur, it would be hard to make it work; and images that are perfectly sharp all over are often perfectly dull.

Blur tools and bokeh

Your best tool for creating blur is a fast, single focal-length lens used with a dSLR or Four Thirds camera, although point-and-shoot cameras with larger sensors can work well too. For a dSLR, 50mm *f*/1.4 or *f*/2 lenses are ideal (secondhand copies are often excellent value). On crop-

sensor cameras – those using a sensor smaller than 35mm – these are the equivalent of 75mm in focal length. Use the lens at full aperture: this gives the added benefit of allowing you to work with short exposure times, or in low light.

The quality of a blur image is called "bokeh" – a term formerly circulating in optical laboratories, and only Japanese ones at that: the term comes from the Japanese word "boke", meaning blur, or haze. Bokeh is considered "good" when the blur transitions smoothly from a sharp core to becoming completely indistinct. An abrupt or stepped transition will suggest detail and so is considered undesirable. Good bokeh results from highly corrected lenses using a perfectly circular aperture. Bokeh can be destroyed by over-sharpening an image in post-processing.

> **DID YOU KNOW?**
>
> **Focus shift with stopping down** occurs when the focal plane moves with changes in aperture. This used to be a serious problem for photographers, but now is not so common. If your images are a bit too fuzzy, try taking shots a little in front of, or a little behind, the auto-focus position – you should see improved results.

Gilding the lily
The standard view of a flower (inset) relies entirely on the subject to lend interest to the image: the result is, it looks like a million other pictures of a lily. A more interesting approach combines the lilies with an out-of-focus reflection of leaves from outside, using a 135mm lens set at its maximum aperture of *f*/1.8.

Eye-catching
Confound the viewer's expectations by using the plane of focus to create a hierarchy of interest. Here, the horse is the centre of attention, rather than the man riding it.

Heavenly creatures
By focusing on the distant trees instead of the dancers, I was able to render them closer to their ethereal nature than a correctly focused image would have been able to achieve.

Playing with blur

If you have been brought up on the idea that the only good image is a lovely, crisp image, then this is your chance to break free of convention: blur is now part of your repertoire. Learn how it smooths out space and simplifies subjects, transforming an objective, clinical view into one with more interest and feeling.

▼ THE BRIEF

▷ Work with your favourite subject – whether flowers, a street scene, or a friend – and make a series of images in which you focus in front of, or behind, the main subject.

▼ POINTS TO REMEMBER

▷ **Keep the composition simple** while you learn how to work with blur in ways that you're not used to.

▷ **Assess the results** on your computer later. The camera's review screen is too small to allow you to accurately evaluate the quality of the blur.

▷ **Large areas of blur** tend to make an image appear lighter than usual: emphasize this effect with extra exposure, or tone it down with under-exposure.

▷ **If the full-aperture performance** is very poor, stop down by just half a stop. This is likely to greatly improve the quality without impacting on the shallowness of the depth of field.

GO GOOGLE

☐ **Circle of confusion**	☐ **Chris Friel**
☐ **Tilt shift**	☐ **David DuChemin**
☐ **Claude Monet**	☐ **Keith Carter**
☐ **Kim Kirkpatrick**	☐ **Vincent Laforet**
☐ **Susan Burnstine**	☐ **Miklos Gaál**

Focal length

Photographers using zoom lenses enjoy an enormous versatility in image magnification and composition not available with fixed focal-length lenses. Focal length controls the field of view, level of magnification, and your spatial relationship with your environment.

To make full use of your camera lens, explore a location by moving in and out, trying different focal lengths in each position. Keep in mind that each small change in focal length opens up new options in terms of framing, positioning, and where you aim your camera.

Each lens is different, and you'll take a lot more pleasure in your photography when you know you're getting the best out of your equipment. Learn about the sweet spots and weaknesses of your lens: some are sharpest at long focal lengths, some are best at their shortest. If you're considering splashing out on a dream lens, it's worth considering that an average-performing lens, used well, produces better results than a first-rate lens used without skill.

▼ TRICKS OF THE TRADE

▷ **Use your legs:** you'll achieve a sharper result by reducing the working distance between yourself and your subject, rather than by increasing the focal length. Use the zoom if an obstacle prevents you from getting any nearer.

▷ **Know how your lens behaves.** All zoom lenses tend to produce images in which the corners are slightly darker than the centre. You can use the effect to help shape your compositions, but it should be avoided when photographing landscapes with large areas of even tone.

▷ **Aim to capture the sharpest image;** fixes in post-processing only imitate the appearance of sharpness and cannot recover lost detail.

RACKING FOCUS ▷
Limited depth of field allows you to choose the distance – be it near, middle, or far – for the plane of best focus. By racking the focus from front to back through a scene, you have a powerful and economical way to direct your viewers' attention.

INFINITY

BACKGROUND VARIATION ▷
Work with longer focal lengths and large apertures for greater background blur. When you wish to bring the background back into focus, simply use smaller apertures (such as f/11) instead of full aperture.

f/2.8

WIDE-ANGLE ▷
Very small changes in focal length at the wide-angle range make a big difference when compared. Here, just 8mm up from 12mm closes in on the scene, making a new viewpoint necessary. 130mm up on 70mm causes a much less dramatic change.

12MM

POSITIONING ▷
Your main control over the size of objects is your position, not focal length. Small objects, such as these poppies, can look small, whether shot with a long or a short focal length. But if you get closer and use a shorter focal length, objects can be made to look large.

18MM

RANGE ▷
Working with a range of focal lengths enables you to make the most of any scene, but is particularly useful in confined spaces. Try different focal lengths in each position, and use framing to vary the background to emphasize flat or receding spaces.

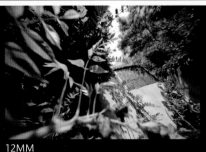

12MM

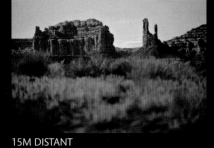

15M DISTANT

5M DISTANT

3M DISTANT

f/5.6

f/11

f/22

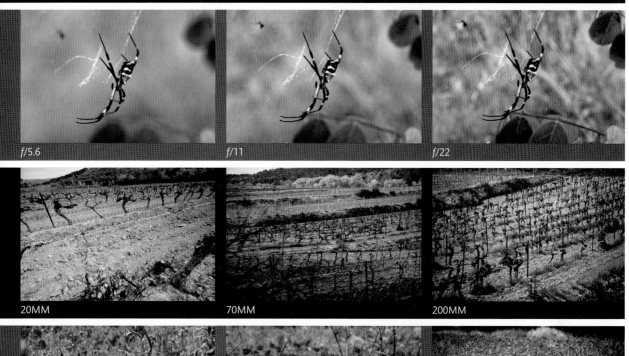

20MM

70MM

200MM

150MM

73MM

73MM

35MM

80MM

135MM

SKIN TONES

Bright sun tends to return harsh highlights and shadows which fail to flatter the subject. By contrast, diffused, soft light readily gives attractive results; indeed, the best lighting for skin tones is the soft light of a cloudy day.

Against the sun
Modern lenses work well when pointed toward bright light sources, so don't hesitate to shoot *contre-jour*. Lens flare may look worse in the viewfinder than in the final image.

Lighting fundamentals

Experienced photographers respond to light the way musicians listen to sounds, or actors listen to voices – with an attuned and informed sensitivity. This is because the images you can capture depend not only on the characteristics of the light available, but also the lighting elements you have under your control.

Where some people simply register a change in the light, keen photographers learn to note the nature of the alteration and analyse the prevailing light in terms of its principal components of level, quality, direction, and colour.

Light levels
The more light that falls on a scene, the brighter the scene appears to be. This may sound obvious, but to the human eye a scene can appear to be the same brightness despite a very wide variation in the amount of light falling on it. Our eyes and the visual part of the brain adapt precisely to a wide range of overall brightness. In the course of a normal day, brightness varies considerably, but it all looks the same to us because the eye has its own auto-exposure system that tries to keep the perceived brightness fairly constant. This is why judging exposure settings by eye is unreliable – an imperceptible change in lighting may yet require an adjustment of exposure. In addition to being more precise, camera exposure systems can adjust to a much greater brightness range than the eye by varying ISO settings, using longer or shorter exposure times, and adjusting aperture, thus ensuring images of the same overall brightness.

This leaves out a vital dimension, for the quality of high light levels tends to differ from that of low light levels. Typically we see deep shadows and bright highlights in very high brightness, and shadows are often soft in conditions of low brightness.

Light quality
Technically, the quality of light depends on the degree of the scattering of the light rays. Sunlight or light from a spotlight is not greatly

There's only one thing you need to know about lighting: all light is good light. You can create striking portraits using only available light: prevailing lighting conditions can, without further ado, be used to produce strong silhouettes (top left). A backlit scene can be compensated with fill-in light or extra exposure to brighten the subject (bottom left). An interior shot can take advantage of curtains, which act as "barn doors" restricting the fall of light and controlling the placement of shadows (right).

diffused, so objects are lit intensely: shadows are sharp and deep, textures are strongly defined, and bright areas are very bright. This "hard" light typically gives rise to high contrast in an image. This kind of light works well for travel, urban views, and landscape shots, as it accentuates textures and shapes. In a studio setting, we obtain hard light from a bare bulb or by confining the light through a snoot.

Diffused or scattered light, such as that seen on a cloudy day or within a large interior lit with many lights, creates soft highlights and casts soft shadows (or none at all). In the studio we can create soft light by diffusing light over a large area using a softbox or by reflecting light in a brolly (see pp.96–97). We favour soft light as it's kind to skin tones and textures; in the studio it's far easier to use soft lighting rather than hard.

Direction and colour temperature

The angle of light fall makes a difference, too. The more obliquely light falls onto the subject, the longer the shadows and the greater the relief. Light coming from behind the subject is more tricky to meter for than light coming from other directions, while light coming from in front of the camera can cause problems with veiling flare.

Lastly, the colour temperature of the illumination and the fullness of the colour are crucial to the quality of the image's colour reproduction. While colour temperature, measured in degrees Kelvin, defines whether the image tends towards blueness or red-yellow, the fullness of the spectrum defines how richly colours are reproduced (see pp.104–05).

Lighting the way

Gorgeous sunsets over Auckland, New Zealand, are so common they can easily be taken for granted. But you can't guarantee a good result if you just point your camera at the sky and press the shutter. A successful shot requires a strategic vantage point, calling for local knowledge along with serendipitous timing: the best moments of a spectacular sunset are short-lived. This view from a railway bridge would have been splendid as it was, but the arrival of a train with its headlights on proved the icing on the cake.

▷ Sony A900, 24-70mm *f*/2.8 : 50mm *f*/4 ISO 1600 -0.7EV 1/15sec

FROM THE SAME SERIES

1 Location and props
Both the timing and our viewpoint were perfect – we noticed the beautiful sky while travelling towards a bridge spanning a railway yard, and from here we had an uninterrupted view of the city. I was caught without a tripod, but I propped my camera on the parapet of the bridge.

2 Camera settings
I set a high ISO of 1600 and an aperture of *f*/4; the limited depth of field did not pose a problem as everything in the scene was far away. The camera I used is terrific for extracting shadow detail, so I set the exposure to -0.7EV, then zoomed in to improve the composition.

3 X-factor
With the combination of under-exposure and good shadow detail, the image enjoyed rich colours and contrasting textures. Then a third, unexpected factor arose: the lights of a shunting train appeared from under the bridge, and I adjusted the zoom to accommodate.

4 Capturing the moment
The light from the train brought out detail in the foreground, but it was "unmotivated" – that is, it was not obvious where the light came from. As the train rolled slowly along the tracks, however, it seemed to be illuminating the city. I then waited for the train to come fully into view.

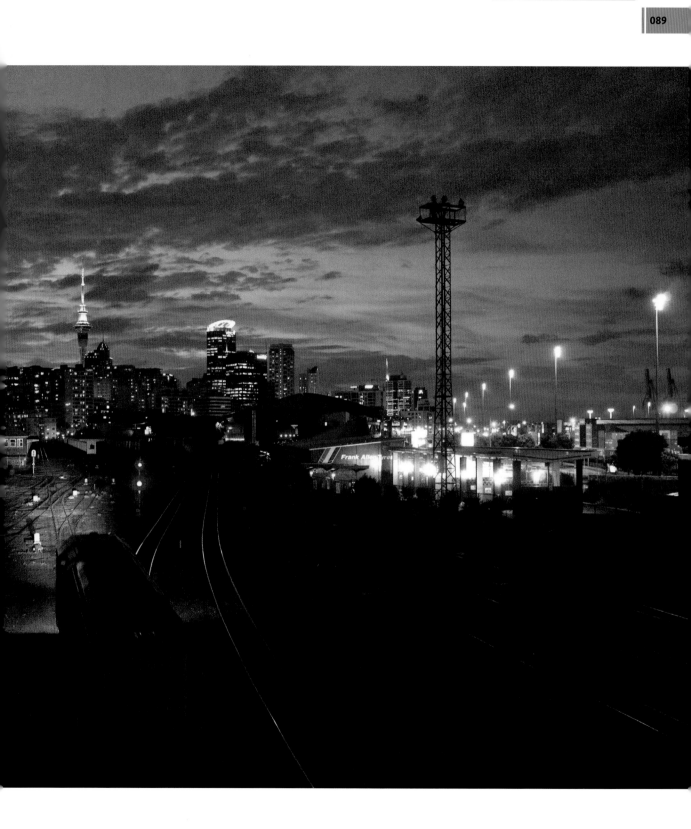

Partnership with light

If photography means "writing with light", then photo-technique means "working with light" – so don't fight with it. Let it guide and inspire you; if the light is bright, let your image be bright, and if it's dark, allow it to be dark.

Observe the light with a keen eye. Be aware of the effects of even the smallest changes: the way that a tilt of the head will alter textures and shapes on a face, or how a passing cloud may soften the light without losing the acutance of the shadow. Use the light that you have, but be prepared to wait for it to change.

Working with light means more than relying on your camera's auto-exposure function: you need to adjust the exposure constantly to suit the subject, lighting conditions, and your position relative to the light. Under-expose when contrast is high, such as when the sun comes out, and set it back to normal when conditions are overcast.

▼ TRICKS OF THE TRADE

▷ **Use automatic bracketing** – set to plus or minus 1EV – if you're unsure about the best exposure to use.

▷ **Under-expose,** if in doubt, in steps of 0.5EV.

▷ **Give yourself options** by changing exposure in steps of 1.5EV in situations of excessive dynamic range.

▷ **Reserve bracketing** for static or slow-moving subjects, or you may capture the best moment at the wrong exposure.

▷ **Employ the spot-meter mode** (if your camera has this function) to help you learn to understand metering.

BRIGHT SUNSHINE ▷
Often regarded as a challenge, bright sun is actually a delight to work in. Keep the sun behind or to one side of your subject, and work in their shadow to avoid lens flare. Over-expose to open up shadow detail, and under-expose for silhouettes.

BRIGHT SHADE

DIRECTIONAL LIGHT ▷
Bright sunlight produces strong shadows, which you can exploit by using their shapes and textures. When shooting directly into the sun, obscure it behind an object to avoid lens flare. Shoot through translucent objects to bring out their colours.

SHADOW FEATURE

DULL DAYS ▷
What overcast days lose in interesting shadows they gain in increased colour intensity. Work with shapes, patterns, and implied movement. And don't put your camera away on rainy days – water on the ground can make lovely reflections.

IMPLIED MOVEMENT

VERY LOW LIGHT ▷
The key to working in low light is to allow your images to be dark – it's not always necessary to reveal shadow detail. Use any light source available, such as candles, computer screens, or street lights. Wait for people to move into a pool of light.

STREET LIGHTS

SUNSETS ▷
As the sun goes down the sky changes, minute by minute, offering endless variation for the patient photographer. A sun high in the sky gives cooler colours than one closer to setting; clouds give texture and shape. If it's overcast, wait for a break in the cloud cover.

FIERY COLOURS

BACKGROUND OUTLINE

SHADOW SHAPING

OPEN SHADOWS

OBSCURED LIGHT

TEXTURE

TRANSLUCENCE

SPOTS OF COLOUR

PATTERNS

REFLECTIONS

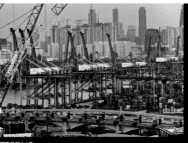

POOL OF LIGHT

CANDLELIGHT

SCREEN LIGHT

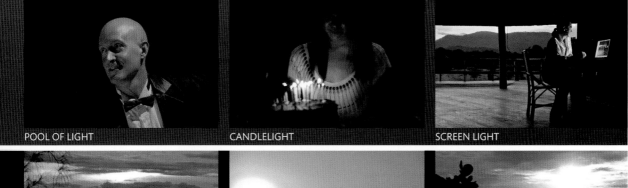

CLOUD TEXTURE

SMOOTH SKY

SUNBURST

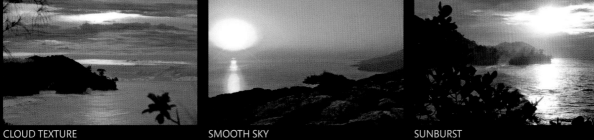

Portable flash

Flash units, whether built in to the camera or used as an accessory flash, work by pushing an extremely high voltage charge into a tube of rare gas: this causes an intense and incredibly brief (measured in millionths of a second) burst of light. Flash not only allows you to capture images in the dark, but it helps balance luminance range, and can freeze motion.

The flash built into virtually all compact cameras, many dSLRs, and even cameraphones are handily compact and always available. But they use the main camera battery and are slower at recycling (powering up ready for another flash) compared to larger units. The main disadvantage is that the flash is very close to the lens, so its light produces unflattering modelling on the subject. In addition, a flash in this position can cause red-eye (see p.246). For these reasons, on-camera flash is best used as a fill-in light that balances backlighting, lifting shadow tones when shooting into the sun.

Offhand light

For greater versatility and better results, use an accessory flash that mounts onto a socket on top of the camera – the hot shoe – which is offered by dSLR cameras and more advanced compacts (see pp.330–31). Accessory or hot-shoe mount flashes are much more powerful than built-in units and recycle more quickly, while some offer tilting heads for bounce flash, and can zoom to suit the lens in use. Ensure that the unit you purchase fits your camera: some types use proprietary hot shoes, and full automation may be available only with compatible units.

For even better results, take the flash off the camera. This gives you the freedom to direct the flash where you wish. The camera and flash still need to communicate with each other to ensure that the flash output is timed to go off when the shutter is fully open. Some systems use a cord that connects the flash unit to the camera's hot shoe or other socket. Others use a wireless system with a receiver either mounted on the camera's hot shoe or built in; this is the most convenient set-up (though if there's a crowd of photographers nearby, there's a risk of someone else setting off your flash).

Quick one-two

The key to understanding how flash works is to remember that all flash exposures consist of two independent contributions of light. One is from the flash itself, but

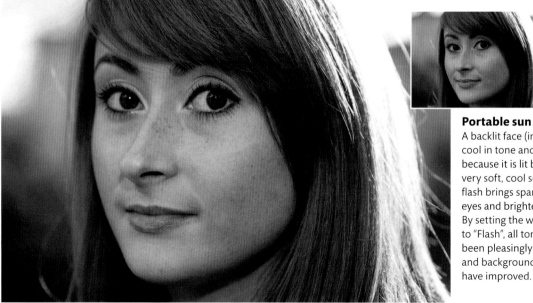

Portable sun
A backlit face (inset) appears cool in tone and dull in daylight because it is lit by the sky – a very soft, cool source. Fill-in flash brings sparkle to the eyes and brightens the hair. By setting the white balance to "Flash", all tones have been pleasingly warmed, and background tones have improved.

Off-camera flash

When you liberate the flash from its attachment to the camera, you hold the versatility of studio lighting in your hand. The sense of freedom that comes from being free to place the flash anywhere you can reach is quite exhilarating. And if you use lightweight stands to assist you, you have even greater freedom for placement. Make test exposures and use the camera's previews to help set up the position and power of the flash. As portable flash units are very small, they present a very small light source, which produces a very hard light. You may need to modify the light: the easiest method is to bounce it off a suitable surface, such as a reflector. You can also fit diffusers, which fit on the flash to soften the light.

HEIGHT

BOUNCE

ANGLE

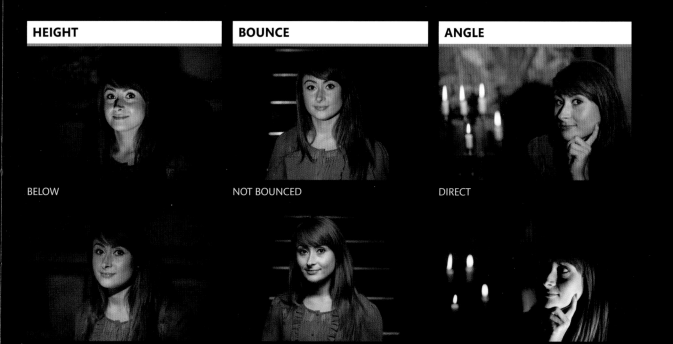

BELOW

NOT BOUNCED

DIRECT

FLASH EXPOSURE

The correct flash exposure is simply what's right for the subject: if your priority is to see the subject clearly, you need more exposure (top), but if you want more atmosphere, less exposure is best (bottom).

Freezing movement

An exposure of 1/25sec at f/4.5 and ISO 1600 records the lights, but it's the flash exposure that stops the action. The flash was synchronized with the first curtain, shown by the boy on the skateboard seeming to move backwards.

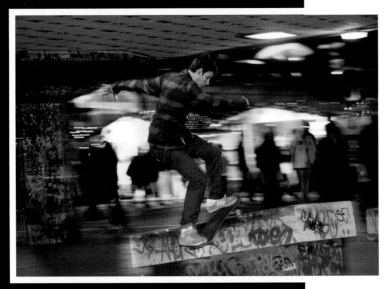

the other is from the ambient, or available, light present during the time the sensor is exposed and collecting light. When light levels are low, and exposure time brief – typically 1/60sec or shorter – the contribution of ambient light is very small. In this situation the background looks very dark while the contribution from the flash dominates. If you set greater exposure duration – longer than, say, 1/8sec – the sensor can collect more ambient light, which therefore contributes more to the exposure. This is the so-called "drag shutter": you may capture movement as blur, and objects lit mainly by the flash will appear sharp. At the same time, the ambient light will contribute more of its qualities, by softening shadows and adding its colour to the overall lighting.

First and second curtain

Balancing flash with daylight or any other continuous light source is therefore about balancing the two component exposures. If you wish to record a scene that's lit by ambient light, the camera exposure – the combination of sensitivity, shutter, and aperture setting – needs to be sufficient for a normal, or slightly under-exposed exposure without the flash. The flash then adds its contribution: it's usually best set to under-expose, as there will be a contribution from the ambient light.

Experimentation and lots of experience will help you obtain images with a natural-looking balance. Alternatively, you can use a deliberate imbalance for special effect: portraits illuminated by flash in daylight with the ambient light strongly under-exposed can be highly effective.

In low light, you may have to set a long exposure in addition to wide aperture to capture the ambient lighting. Any movement during the exposure will be blurred (or "dragged"). The flash will capture the subject sharply because it is of such short duration, that is, the exposure time is very short. If the flash occurs at the beginning of the exposure (known as the "first curtain"), the blur may appear to go backwards – from blur to sharpness – where there are clues as to the proper direction of the movement. To avoid this, more advanced flash units allow the flash to go off at the end of the exposure: this so-called "second-curtain" synchronization shows a sharp subject at the end of a blur, which looks more natural.

AMBIENT BALANCE

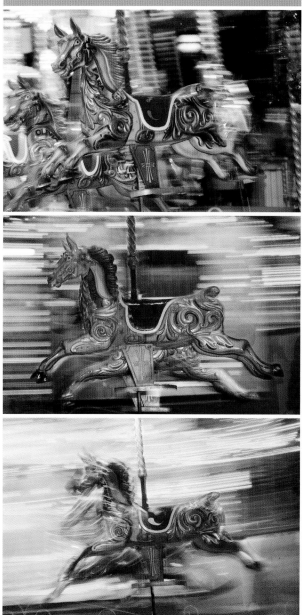

When you turn on your flash, you may think you're working with one light, but in fact you have two sources of light under your control. The ambient light can work in your favour, or you might try to work against it. Here, the fairground lights have been exposed for, with a 1/15sec exposure producing a good level of blur against which the flash-exposed horse emerges (top). Under-exposing the flash and ambient exposure but with a longer exposure (1/8sec) gives more interesting streaks of light (middle). An even longer exposure time (1sec) plus weak flash delivers a much more subjective, blur-dominated image (bottom).

Colourways

Flash units are designed to be as efficient as possible, to output the most light to cover the area seen by the lens using the least power from the battery. This seldom makes for the prettiest or most subtle lighting. However, you can make things much more interesting by placing materials in front of the flash to modify the light.

▼ THE BRIEF

▷ Experiment with different materials placed in front of the flash: anything from coloured or plain tissue paper to coloured filters, glassware, and crystals. Try lighting different subjects, from flat objects to faces, with and without the material, in order to learn how best to make use of their effects.

▼ POINTS TO REMEMBER

▷ **Make different exposures** with the material at different distances from the flash. The larger the material, the further you can hold it away from the flash.

▷ **Thick materials** will absorb more light, so you may need to adjust the exposure to compensate.

▷ **If you have an accessory flash,** try bouncing the light from your material by turning the flash away from the subject and towards the material.

▷ **Try covering the flash only partially:** this creates a graduated lighting effect on your subject.

GO GOOGLE

☐ Synchro-sun	☐ Yousuf Karsh
☐ Drag shutter	☐ Annie Leibovitz
☐ Guide Number	☐ Gjon Mili
☐ Flash coverage	☐ Gregory Crewdson
☐ Weegee	☐ Bill Henson

Studio lighting set-ups

The variety of lighting equipment available is extensive, from narrow-beam penlights to enormous flash units; from light-shapers, such as small, cone-shaped snoots to large reflectors; and from softboxes to umbrellas of every size. Add to this all the different positions in which lamps can be placed around, above, and even below the subject, the fact that you can use more than one light *and* vary the relative levels of brightness, and the range of possible lighting effects becomes almost infinite.

It's easy to get carried away and go over the top with your lighting. In fact, even a single luminaire can produce an amazingly wide range of effects – so, when setting up

FRONT AND SIDE SOFT LIGHT

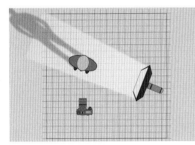

A very versatile light source is a medium-powered studio flash unit with a small softbox, around 1m (3ft) square. A softbox is like a tent that is fixed over the lamp. It has an internal diffuser and an outer diffuser layer, which combine to give soft, even light. This kind of lighting is very flattering.

- Lighting from the front and side accentuates facial features with shapely shadows.
- By lighting from an angle, the model can be positioned close to the background without casting a visible shadow.
- The diffuser colours the flashlight, and usually helps to warm the tone.

FRONT LARGE SOFT LIGHT

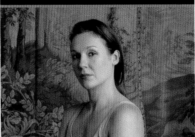

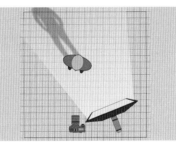

A large softbox – 1.5m (5ft) square – produces a very broad and highly diffused light, particularly when placed close to the camera and pointed directly at the model. You may have to work right next to, or even under, it. The resulting lighting is almost flat; that is, it casts very soft shadows, if it casts shadows at all. If the model is placed near the background, the background will also be illuminated. This lighting technique is excellent for making high-key images.

- If you place the softbox a little above the camera, you can shape the face with highlights and produce catchlights in the hair.
- As the background will also be lit, choose it with care, and arrange the model appropriately.

BACKLIGHT AND REFLECTOR

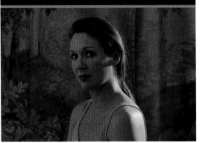

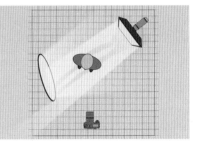

Backlighting is not a common choice as the main source of lighting in the studio, so if you want to be different, simply place the luminaire behind the subject. Here, I used a reflector to return light into the model's face, giving a beautifully soft effect, in contrast to the highlights outlining her. The warm tone results from a slightly longer exposure time, allowing room light to contribute.

- Use soft lighting whenever you can, to avoid over-exposing skin tones.
- You can use silver, gold, or white reflectors to vary the colour of the fill-in light. Gold gives a flattering, tanned look to skin, but may contrast strongly with the cool light from the flash.

studio lighting, it's a good principle to start with a single light source and then add extra lights, reflectors, or other accessories only as needed. Building up from a simple, single set-up helps avoid problems with multiple shadows – one cast by each lamp – and the need to balance their output. Each additional lamp also tends to double the time needed to set up a shot.

Take time to study the effect that different light-shapers, reflectors, and diffusers have on light fall. You'll quickly discover your favourite techniques, and with experience will gain the knowledge to plan your shots before you set up. Visualize the results you want, then think about lamp placement and which kind of reflector or diffuser to use. This will save hours of work in the studio.

SMALL REFLECTOR

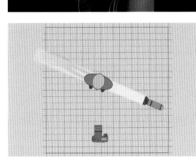

Luminaires equipped with small reflectors, placed to the front and side of the subject, will produce a tight bundle of light to deliver strong and sharp shadows. At the same time, they will search out any shiny areas in the skin – here, even with make-up and powder, the model still has highlights on her face. Not the most flattering light, this method is often reserved for dramatic or film noir portrayals.

- Work with dark backgrounds or position the model well away from pale-coloured walls for maximum effect.
- Err on the side of under-exposure in order to keep highlights under control.

SPILL LIGHTING

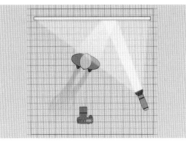

With the lamp turned away from the model, the background is lit, but a little light spills from the sides of the reflector. Here the lamp is aimed so that this light just touches the subject. This results in a visual and emotional tension between the half-lit model – whose features are not clear – and a well-lit background.

- Experiment with unconventional lighting arrangements for an unusual look: keep in mind that lamps don't always have to be pointed at the model.
- Use a diffusing reflector – that is, a reflector made of fabric or polyboard – to ensure that shadows aren't totally black.
- Position the model carefully to avoid the background becoming too prominent.

MIXED LIGHT

Using studio lighting doesn't mean you have to light solely with flash. The majority of units use a tungsten-filament modelling light for showing ("modelling") the effect of the flash. With longer exposure times, you can include the contribution from the lamp or any other light source that is on. This warms up the image and softens the result. If you under-expose the image, you can create strongly moody lighting.

- If you use exposure times longer than 1/60sec, ensure that the model stays still, or the image will be unsharp.
- You have some control over colour temperature, as the modelling light lamp will be more red when reduced in brightness than when it is fully bright.

Lighting small objects

Once a specialized practice pursued by only a few professionals for a handful of clients, the photography of small objects is now one of the fast-growing areas of photography. The reason is simple: online sales and auction sites have created, almost overnight, a huge demand for enticing images of all kinds of small object.

Although the need to produce a clear, sharp image that accurately shows the object being offered for sale doesn't sound like it is full of room for artistry, there is a subtle subtext. If the purpose is to persuade someone to buy the item, you need to make the object appear so desirable that it becomes a "must-have" as soon as it's seen.

Seductive lighting

The secret is in showing the object in the best, most alluring lighting. Naturally reflective objects will reveal the slightest concentration of light because their curved surfaces collect it into small, specular highlights. For these objects, use a light tent. These are available to buy in a range of sizes, or you can improvise with any diffusing material such as a bed sheet or bubble wrap fixed or draped over a support frame (a cardboard box with its sides cut out is ideal for this). Place

DID YOU KNOW?

Camera exposure needs to be increased with close focusing. This is because the lens is further away from the sensor to focus on close-up objects. As less light reaches the sensor, the aperture is effectively reduced. With modern cameras, this effect is automatically taken into account by metering systems that measure through the lens – an action that's related to the fact that the power and brightness of a light increases the closer it is placed to the object. This means that compact flash units can be surprisingly effective for a wide range of small object photography.

the object inside and light it simply by aiming a flash at it. The soft light will show up the details without specular highlights, but, because of the softness of the highlights and shadows, the net result may lack contrast and sparkle.

If your objects are not highly reflective, try lighting directly without using a diffuser. You can fill shadows with reflectors (see p.331), and reintroduce a little highlight to give sparkle to the final image by aiming a small torch (covered with a blue filter for neutral white balance) at the object.

SOFT KEY LIGHTING

The most versatile lighting for small objects is a large softbox. A softbox looks like a pyramid with the flash unit at the top, aimed into the centre. Light comes out of the "base" via one or more white diffusing panels. The entire base – 1m (3ft) square or larger – is the light source, giving soft shadows with good detail; ideal for anything from cupcakes to cut-glass.

Trick of the trade
Jewellers often display their products on polished surfaces. Taking just that little bit of extra care makes your item stand out and look more special.

Translucent objects
Glassware and transparent plastics are easily photographed with widely different types of lighting – the translucence works with whatever light source you aim at it.

Hot shoes
Black backgrounds made of matte, non-reflective materials give reliably elegant results with any kind of object. The black also absorbs shadows, making lighting easier.

Desktop studio

Lack of specialist equipment calls for improvisation: modern homes have so many different types of lighting, and all can be press-ganged into photographic tasks. You'll also be able to find all the reflectors and diffusers you need around the house: from papers, aluminium foil, bed sheets, netting, and plastic sheeting.

▼ THE BRIEF

▷ Turn your desk or kitchen table into a studio by using a desk lamp as the main light, and any material on hand for background diffusers and reflectors. Photograph a variety of small objects – both matte and reflective. Try different coloured backgrounds and surfaces to create a variety of effects.

▼ POINTS TO REMEMBER

▷ **Use different types of lighting** for direct, diffused, and reflected light. Try using a pocket torch to focus a small highlight on your object.

▷ **Set white balance manually** to Tungsten for accurate colours.

▷ **Use a tripod** to ensure your images are as sharp as possible.

▷ **At close focusing distances**, your lens may not be at its best. Stop down to just past the middle of the range of apertures to balance depth of field and image quality, with not too small an aperture.

GO GOOGLE

- ☐ **Inverse square law**
- ☐ **eBay photography**
- ☐ **Still life set-up**
- ☐ **Light tent**
- ☐ **Ring-flash**
- ☐ **Tilt lens**
- ☐ **Fibre-optic lighting**
- ☐ **Desktop photo studio**
- ☐ **Homemade lightbox**
- ☐ **Mini studio lights**

On location

Our task was to create an intimate portrayal of a bride on her wedding day. We hired a location house in London and chose a suitably elegant, feminine room as our romantic setting. The ornate furnishings provided a pleasing contrast with the soft folds of her wedding dress. It would have been easy to flood the scene with soft light, but everything we'd have gained in high-key clarity we would have lost in drama.

▷ Sony A900, 24–70mm f/2.8 : 28mm f/16 ISO 100 1/90sec

1 | Green background
We closed the curtains to exclude all daylight, but this left the back wall dark. We aimed a flash fitted with a green gel to light up the wall: the tint of the flash shows up in the shadows cast by the other lights. This area was masked and lightened in post-processing to improve the effect.

2 | Lighting the bride
The model was lit with a flash unit from the left, carefully aimed to exploit unevenness in light coverage: light is hotter in the middle than at the edges, so it picked up on her bodice without being too bright on her face. The light wasn't so soft that we lost the shadows framing her figure.

3 | Purple counterpoint
Our third light source was placed high and off to the right-hand side. A purple gel was chosen to complement the green light and add warmth to the scene. Hovering in the wings were the editor, make-up artist, and various assistants, all taking care to stay out of view.

4 | Perfecting the scene
We dressed the vanity table simply with a few items of make-up and some jewellery. We took a series of shots, experimenting with the model's position, posture, and expression, and adjusted the side mirror by increments until her face could be seen clearly from each angle.

IN DETAIL

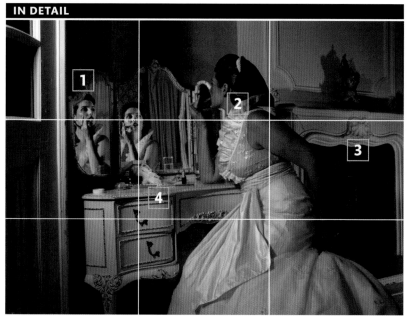

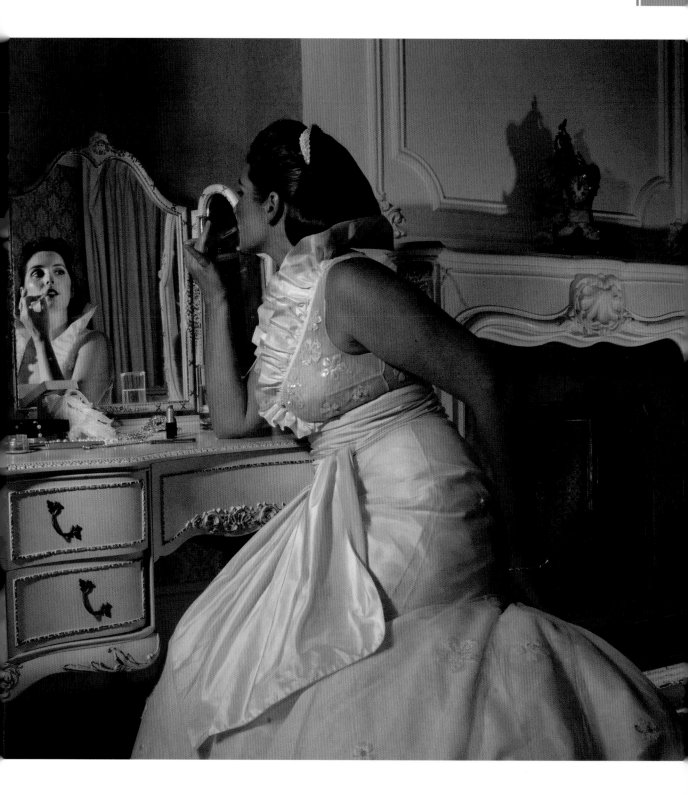

ISO and noise

A camera's ISO or sensitivity setting gives you an idea of how much light the sensor needs to register an image. On one level, you don't need to concern yourself with it, as most modern cameras can automatically set the appropriate ISO for the prevailing lighting conditions.

As your skill develops, however, the matter of ISO settings can reveal itself as a creative tool in its own right. Because it's one of the many controls inherited from photography's film-using days – ISO originally referred to a film's sensitivity to light – the same ISO setting may produce different results in different digital cameras, particularly at high settings. This is because there are various ways in which the sensitivity of sensors can be measured. Broadly, however, a doubling of ISO indicates a doubling of sensitivity.

Camera settings

In practice, low ISO settings – around ISO 100 – enable you to use large apertures (see pp.78–79) or long exposure times (see pp.70–71) in bright light. As you increase ISO settings, so you can use shorter exposure times or smaller apertures. It's often said that image quality is better at low ISO settings than at high. In practice, modern cameras – apart from the cheapest

models – provide excellent image quality from ISO 400 or faster. The main impact on quality is due to image noise, which can occur with high ISO settings (see box, opposite). This is comprised of random patterns of pixels, or groups of pixels, in which the colours are not based on light from the scene, and that tend to disrupt the definition of details.

In modern cameras, you'll find little practical difference in image quality in the range of ISO 100 to 400, or even 800; at these settings noise levels are visually acceptable. This means you can use ISO settings that were once considered high as your operating default. Another consequence is that, for the first time in photography's history, there is no premium to be paid for working in colour over black and white: within a broad range, from ISO 50 to 800, you can choose sensitivity levels for artistic reasons, not technical ones. Note, however, that some in-camera procedures, such as sharpening, or increasing the dynamic range the camera records, do cause noise levels to rise.

The size of noise

A minor consequence of the noisy images you might get from using high ISO settings is that the resulting JPEG files are larger. This is because the extra detail created by the

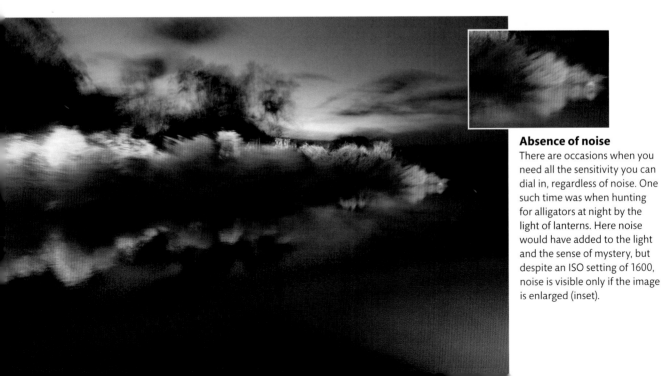

Absence of noise
There are occasions when you need all the sensitivity you can dial in, regardless of noise. One such time was when hunting for alligators at night by the light of lanterns. Here noise would have added to the light and the sense of mystery, but despite an ISO setting of 1600, noise is visible only if the image is enlarged (inset).

Black velvet
Deep in the jungle, very little light penetrates the canopy, so high ISO settings are a necessity. When shape is most important, but not texture or detail, noise is not a concern: here, much of it is absorbed into the black shadows.

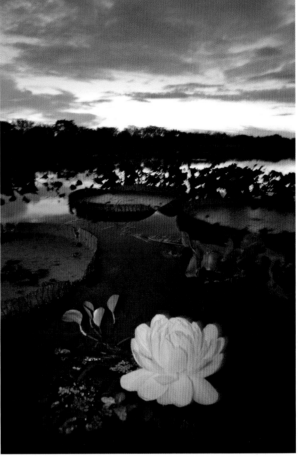

Smooth as silk
The *Victoria amazonica* opens fully in 20 minutes – but only at nightfall. Capturing the scene called for high sensitivity, to expose for the sunset, and image smoothness, to retain the delicacy of the petals. Flash supplemented a 1sec exposure at *f*/7.1, ISO 400.

noise is hard to compress. In fact, any smoothing in an image, even blur from shallow depth of field, causes file sizes to be slightly smaller, but the difference is not dramatic. Noise can be reduced, at times almost eliminated, using specialist software such as Topaz DeNoise 5 or Noise Ninja (see pp.198–99). Any noise processing software has the tricky task of separating the real details in an image from noise. Some types of noise, particularly banding – noise in regular rows – are very difficult to remove. Modern algorithms are effective at removing noise without blurring too much image detail, and Topaz DeNoise 5 can handle banding noise. De-noise processing, however, can be slow on large files, so it's not a good idea to make a habit of it.

DID YOU KNOW?

Noise arises from a combination of elements – the nature of the electrical signals that create the digital image, the effects of heat, minuscule defects in the sensor, and image processing errors – all of which are always present to some extent when you make an image. Noise increases with higher ISO settings because the camera is trying to achieve the same results with less light, which produces weaker signals: if they are sufficiently low, the signals approach the level at which noise occurs, and so become harder to separate from the noise itself.

Colour settings

There are two ways to approach colour settings. The simplest, at capture stage, is not to set colour at all: you record in RAW (see pp.184–87), and leave colour decisions until post-processing. Alternatively, you can record in JPEG, and try to set the camera to capture the light sufficiently well to minimize post-processing time.

The main colour settings are defined as colour balance, white balance, and saturation (see p.226). You can assign these settings to RAW files in post-processing; JPEG files encode colour values during image capture, but you can still adjust them later (see pp.218–19).

DID YOU KNOW?

The ability of light to reproduce colours is known as the colour rendering index (CRI). Light with a full spectrum ensures good reproduction – a high CRI. But a low-CRI spectrum with gaps can't reproduce all colours well – low reds in the light means that reds can't be captured in full brightness. The CRI of full daylight is nearly 100, but that of overcast days is much less. Trying to improve dull-day images by boosting saturation is often unsatisfactory: it exaggerates an already unbalanced capture of colours.

Colour or white balance?

Colour balance adjusts colour temperature, measured in degrees Kelvin (K), which determines how yellowish or bluish the light looks, so there's no overall colour cast. White balance adjusts both colour balance, and the colours ranging between green and pink. When you select the Tungsten setting, this affects the colour balance; if you set your camera to Fluorescent, it compensates for the green tint of fluorescent lamps, as well as their yellowness, so this determines the white balance. Using the camera's auto-white balance (AWB) when

recording in JPEG is the most convenient method. In conditions such as candlelight, however, making colours perfectly neutral spoils the atmosphere of the shot.

Colour space

Almost all digital cameras record into the sRGB colour space (see p.179) which is adequate for viewing pictures on monitors and for a wide range of printing. More advanced cameras can also record into Adobe RGB space, which encompasses a much larger range of colours than sRGB.

All tones matter
Black is often defined as the absence of colour, but it's more helpful to see it as a lot of colours mixed together. Black is the most important colour to balance accurately: once this is correct, other colours are more likely to fall into place. Here the original image (inset) had an overly cool colour balance; the corrected version brings the dark tones to life.

NEUTRAL IDYLL

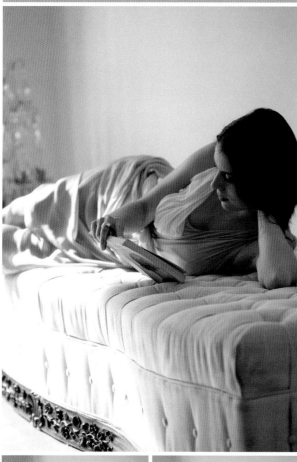

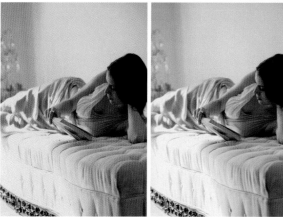

Large areas of neutral tones are easy to colour accurately, but they are also the most forgiving of "inaccurate" settings. This is because our eyes tend to adapt to large areas of any colour. A warm balance (bottom left) of 9000 K feels cosy, and a cool balance of 3500 K (bottom right) is equally acceptable, although both are inaccurate compared to the correct setting of 5000 K (top).

Unbalancing colour

White balance settings can be counterintuitive, as they compensate for the lighting conditions they describe, and so have the "opposite" effect. "Candlelight" gives a cold, bluish effect, while "Fluorescent" gives a pink balance. You can also adjust the colour temperature manually using the custom colour balance setting.

▼ THE BRIEF

▷ To help you master white balance, make a systematic range of test shots. For various subjects under different lighting conditions, make a series of images at every white balance setting offered by your camera, recording in JPEG, and compare them.

▼ POINTS TO REMEMBER

▷ **The "incorrect" setting** for the lighting condition – such as using the Daylight setting under tungsten light – may give better results than the "correct" setting.

▷ **In mixed lighting conditions** the colour balance in the shadow areas differs from the colour balance of fully lit areas.

▷ **You can try a more advanced version** of this exercise by using different colours as a "grey card" for setting colour balance. To do this, set the camera's colour balance to Custom, and take a shot of a neutral area – usually a patch of plain grey or white. The camera then uses this as a reference point for its white balance. Varying the colour of the reference area can give results with strong bias in the hues – using a pale blue "card" gives very warm tones.

GO GOOGLE

☐ **Kelvin scale**	☐ **Jean-Baptiste**
☐ **August Bradley**	**Tournassoud**
☐ **Morfi Jiménez**	☐ **Alex Webb**
Mercado	☐ **Black body**
☐ **William Thomson**	☐ **Grey card**

Image size and format

In early digital cameras, image quality was poor, so safety was sought in sheer image size – working with as many pixels as possible. But today your choice of image size is not critical. More effort has been squandered on creating the largest possible image than on any other technical issue. Yet pixel numbers offer no guarantee of image quality.

Today's image processing is vastly superior to that of the past, so images would show higher resolution – be able to reveal more fine detail – even if pixel counts had not grown.

Additionally, increases in resolution tail off as image size grows: a 12 MP (megapixel) image is visibly better than a 6 MP image, but it's very hard to see any loss of quality in an 18 MP image compared to a 24 MP one.

The cost of quality

To take full advantage of high pixel counts, you need to use the highest quality lenses and proper technique. What's more important is the image processing capability of your camera, and the quality of the lens and its mounting. And of course there's also your input – the exposure accuracy,

Detailed priorities
The twigs need many pixels to be defined, but much of the detail is lost when the image is viewed or printed at a small size. But image quality, not size, ensures that sky and water tones are smooth.

DID YOU KNOW?

If your files consistently take up a lot of memory, your images may be unnecessarily large for their intended use. Systems for uploading to photo-sharing sites or for online services all work faster if you first scale the image to the correct size; for prints, larger files than standard won't necessarily print better. Suggested approximate file sizes are shown in the table below. Remember to check the file size while it's open, because when closed, compressed JPEG or TIFF files will be read as being much smaller on your computer system.

Ink-jet print	7½ x 12½cm (3 x 5in)	**1.9 MB**
	10 x 15 cm (4 x 6in)	**2.7 MB**
	20 x 25cm (8 x 10in)	**5 MB**
	21 x 30cm (8½ x 12in)	**6.9 MB**
	30 x 42cm (12 x 16½in)	**12.6 MB**
Image for web page	480 x 320 pixels	**0.45 MB**
	600 x 400 pixels	**0.7 MB**
	768 x 512 pixels	**1.12 MB**
	960 x 640 pixels	**1.75 MB**
Book or magazine printing	21 x 30cm (8½ x 12in)	**18.6 MB**
	20 x 25cm (8 x 10in)	**13.6 MB**
	12½ x 20cm (5 x 8in)	**9.3 MB**
	12½ x 7½cm (5 x 3in)	**3.9 MB**

focusing, and steadiness. The upshot of all this is that a well-made, smaller image can be of higher quality than a larger one: your results are likely to be better if you concentrate on making the best possible image, rather than using the largest possible file size. Also, bear in mind that working with large files slows down operating time: they take longer to open, to save, to copy, and to manipulate.

File guidelines

Choosing a resolution that suits your needs will save you time and trouble. Use a smaller image size of 640 pixels wide when photographing friends for social networking sites. For prints or printed books, images 3,000 pixels wide will output at around 250mm (10in) wide. The most

space-efficient way to work is to record in JPEG (see pp.174–75) and match your image size to the intended use (see box, opposite). You can record in RAW (see pp.184–87), if your camera allows; this gives the best quality and scope for image manipulation, but means the most processing work, and uses the most memory space.

Input versus output

Once the image is put to use, much of its quality is swallowed by the output devices, unless it's going to be used at a great enlargement. Printing blurs fine detail, and monitors muddle detail deliberately – a process called "dithering" – to render smooth-looking screen images. High pixel counts are not an advantage in either case.

Aspect ratios

Throughout history, creative works have been written, painted, and captured in rectangular formats; photography in particular has dallied with rectangles of many different proportions, or aspect ratios. These format solutions have included the square – an aspect ratio of 1:1, used by old-fashioned medium-format cameras – and the long, thin 5:2 ratio of panoramic cameras.

Today, the choice has boiled down to three options. The 3:2 ratio is the classic proportion – based on 35mm film, it's perhaps the most versatile of all. The 4:3 ratio also has historical roots. Being nearly square, it's a good all-rounder on computer screens, as vertical (portrait) orientation wastes little screen area. The 16:9 ratio is becoming increasingly popular, but is best used in landscape (horizontal) orientation only.

3:2 RATIO

4:3 RATIO

16:9 RATIO

This shape makes good use of the image circle projected by the lens, being neither too square nor too narrow. Also, there is a clear difference between upright and horizontal orientations, which is important for design variation. However, it doesn't fit neatly onto monitor screens or paper sizes.

As it's based on old TV standards, this shape neatly fits many screens, including new devices such as the iPad. Being close to square, it needs to be used more carefully than other formats for effective composition, because it's trickier to create drama through separating elements – all areas bear a similar relationship to the centre of the image.

Based on HDTV (high-definition television) standards, this aspect ratio is excellent for the dramatic sweep of a landscape or cinematic compositions with the key elements widely separated. But on screen, it is really a horizontal format: turning it on its side, to portrait, greatly reduces the size of the image and wastes a lot of space.

Optical techniques

GETTING IT ALL IN

PROBLEM
You want to capture the full range of a scene, but you don't have much room to manoeuvre. You need the widest possible field of view, but you want to avoid the distortions of fish-eye contours.

ANALYSIS
Fields of view greater than around 100 degrees are extremely difficult to capture without distortion, or making straight lines appear curved. If you want to capture a 180-degree view, distortion is impossible to avoid, but it can be mitigated by using post-processing to straighten out some of the curved lines.

SOLUTION

▷ Use a full-frame fish-eye lens to make the field of view fill the frame, and to capture a 180-degree field of view diagonally across the image.

▷ Use plug-in software to straighten key lines, without losing the wide field of view.

▷ Make use of the characteristic barrel distortion as part of your visual vocabulary.

▷ Remember that lines running through the centre of the image are not distorted.

LIMITING DEPTH OF FIELD

PROBLEM
Your wide-angle lens is giving you too much depth of field, making it difficult for you to separate foreground detail from the background.

ANALYSIS
Wide-angle lenses produce an extensive depth of field, even at full aperture, when focused to medium or longer distances. The only in-camera method of reducing depth of field is to use a tilt-shift lens, and reverse-tilt or swing the lens to move the plane of best focus as required.

SOLUTION

▷ If, as is usually the case, objects nearest to you lie towards the bottom of the scene, tilt the lens upwards to reduce depth of field.

▷ If objects nearest to you are on the left-hand side of the image, swing the lens to the right (see image above), and vice versa.

▷ You can blur the background in post-processing (see p.245).

SUPER DEPTH

PROBLEM
You need to work at wide or maximum aperture, perhaps because there isn't much light, or you're using low ISO settings, but you want extensive depth of field at the same time.

ANALYSIS
The plane of best focus normally runs parallel to the plane of the sensor – if you focus on a wall directly in front of you, the plane is at the same angle as the wall. But if the plane of your subject is not parallel to the sensor plane, you need to tilt the plane of best focus with a tilt-shift lens to obtain greater depth of field.

SOLUTION

▷ If, as is usually the case, objects nearest to you lie towards the bottom of the scene, tilt the lens downwards to increase depth of field.

▷ If objects nearest to you are on the right-hand side of the image, swing the lens to the right, and vice versa.

▷ Focus accurately on the low-contrast objects in the view, since high-contrast objects – such as shiny reflections – appear sharp even if they're not precisely in focus.

SOFT FOCUS

PROBLEM
You're making a portrait, but your lens is overly sharp and is revealing too many details, bringing out wrinkles, spots, and other skin blemishes. You want to achieve a softer, more flattering rendering.

ANALYSIS
Modern lenses are highly corrected, which means that optical aberrations – in particular, spherical aberration – are reduced to help produce sharp, clear images. The dreamy, soft glow of old photographic portraiture is down to under-corrected spherical aberration.

SOLUTION

▷ For the very best results, use a specialist soft-focus lens.

▷ Use soft-focus filters on a medium telephoto lens at full aperture. Try different designs, as effects vary.

▷ It's possible to approximate the effect in post-processing: duplicate the image on a new layer, set to Lighten, then blur this new layer. Blur again, with the central area protected, to strengthen blur towards the image corners.

PINHOLE CAMERA

PROBLEM
You want to create a distinctive, old-style look in a consistent way, using your own dSLR body if possible. You'd prefer to use minimal specialist equipment, and you'd rather not do any post-processing to obtain the result.

ANALYSIS
The best way to achieve an old-style look is to use old-style techniques. It helps if you have a camera that can be set to record in black and white, or even in sepia tones, to eliminate the need for post-processing altogether.

SOLUTION

▷ Turn your dSLR into a pinhole camera: drill a small hole in a spare body cap, fix a piece of aluminium foil over the hole, and use a needle to punch a tiny hole in the foil with a diameter of about 0.3mm. Next, set capture to black and white or sepia, if available, and take some test shots (if necessary, use a new piece of foil with a new hole and try again).

SPLITTING FOCUS

PROBLEM
You'd like to be able to focus on a nearby object while sharply capturing the rest of the scene, which is relatively distant. You need to split the focus between different parts of the scene.

ANALYSIS
The depth of field required is well beyond what's possible using minimum aperture, or the tilt/swing movements of a tilt-shift lens. You need a supplementary lens that focuses on the nearby object, while your camera lens focuses on the more distant part of the scene.

SOLUTION

▷ Use a simple lens, such as a magnifying glass or strong pair of reading glasses, as an additional lens. Set a large aperture to avoid showing the edges of the glass too clearly, focus on the distant part of the scene, then hold the lens over the nearby object. Adjust the distance of the makeshift lens over the near object to obtain focus, while holding focus on the distant object with the camera lens.

Expansive panoramas

Panoramas are a popular way of capturing monumental cityscapes and sweeping landscapes; and, unlike images created with ultra-wide-angle lenses, their distortion is more acceptable. In the days of film, panoramas were made by swinging a lens round a vertical axis while projecting the image onto a curved surface – but this is almost impossible to do with sensors in digital cameras.

Instead, we can make panoramic images by taking a series of pictures and using sophisticated image manipulation software to stitch them together on a computer. Professional-quality panoramas call for specialist panorama heads set up specifically for the lens being used. Happily, modern software is smart enough to match and blend shots with poor-quality overlaps, so even an imprecisely shot sequence can produce acceptable results.

Taking the shots

Start off by setting normal or moderate focal lengths to minimize distortion. Meter the scene in manual mode, and set a specific white balance (not auto-white balance)

to ensure consistent colour and density. Level the camera on a tripod and, if you can, set the lens over the centre of the tripod column. Make a series of shots from one side of the scene to the other, overlapping adjacent images by at least a third of their width and keeping the horizon in the centre of the frame. With practice you can even shoot panoramas hand-held; just remember to turn the camera round its own vertical axis, and avoid turning your body.

Stitching together

Once you've taken your shots, load them into your computer and assemble them in a folder. Resist the temptation to make any corrections to them at this stage. Join or "stitch" the images together using software that can match like-for-like edges of contiguous images: there are several free versions available, such as Hugin, PhotoStitch, and PTStitcher. You may need to set parameters first, such as focal length used. When the software program has made the panorama (see opposite), tidy the edges, if necessary, by cropping. You are now ready to make any colour or tonal adjustments to the overall image.

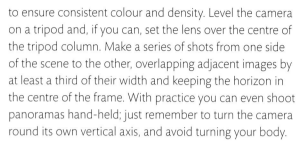

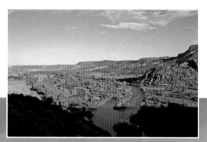

General view
Even an ultra-wide-angle, 121-degree view only partly reveals this river bend near Hernandez, New Mexico (inset). With a plain sky and much of the foreground in shadow, a stitched panorama promises the best rendition of the scene.

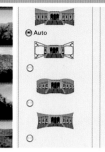

Panning series

The best view was on the edge of the cliff, with no room for a tripod. I set the zoom to 50mm, turned the camera for good vertical coverage, set exposure and white balance manually, and shot with generous overlaps.

Preparation

Panoramas can produce very large images – even if you have small files to start with – so reduce the series in size and collect them into a folder ready for the stitching software to pick up. Leave enhancements until later.

Layered assembly

Some stitching applications assemble an image in which the components are placed in separate layers with their own masks. This allows very fine adjustments to be made in both masking and alignment.

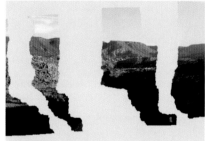
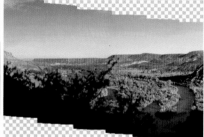
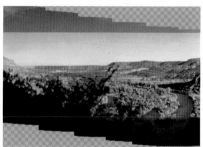

Elaborate masks

Masks are created using sophisticated image-matching algorithms, which align adjacent images to preserve details and then "mask off" unwanted areas. See the masks by turning off every other layer.

Uncropped

The composite sequence is curved, as the camera pointed slightly downwards during the exposures. A little cloning in the corners and middle of the image can fill in the gaps to produce a deeper final crop.

Cropped level

Cropping in to produce a clean rectangle across the centre of the sequence trims off a good deal of the raw, "native" data, but results in a wide, narrow, and complete strip of image – our panorama.

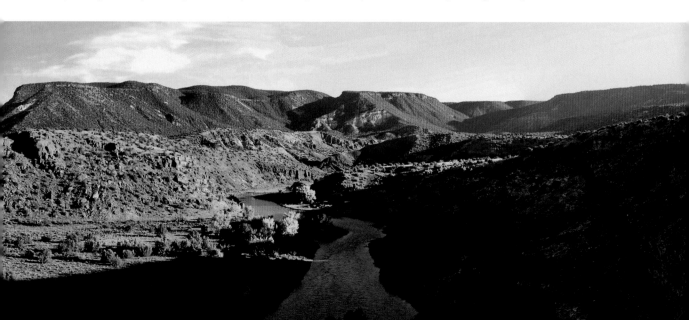

Effects filters

Before the age of digital photography, one of the few ways to manipulate colour images was to mount a filter in front of the lens. A filter changes or filters the light entering the lens, so altering the image. Their effects range from simple colour tints to distortions, blurs, and gradients. Filters were all the rage in the 1980s and 1990s, a sign that some photographers were keen to extend the boundaries of the possible; indeed, these filters were precursors for the digital filters we use in post-processing today.

There are signs that filters are making a comeback, as photographers are learning that some effects, such as focus diffusion, are actually better achieved in-camera, or others,

POLARIZING

FILTER

NO FILTER

GRADIENT

FILTER

NO FILTER

CONTRAST-ENHANCING

FILTER

NO FILTER

Polarizing filters are the most useful filters, offering an effect impossible to achieve with image manipulation. They darken blue skies, so increasing colour intensity and drama. They also minimize glare, and cut out reflections from water and glass.

- Use only circular polarizing filters with dSLR cameras. Less expensive linear polarizers can be used with some compact cameras (unless the instructions forbid doing so).
- Rotate the filter on its mount until you obtain the desired effect.
- Skies are darkened with maximum effect when the sun is behind the camera.

Gradient filters are darkest at the top and become more transparent towards the bottom; this uneven coverage compensates for varied lighting. Neutral density gradients are colourless and good for balancing bright skies with dark foregrounds, making shadow and highlight control easier. Coloured gradients can enliven dull conditions.

- Gradient effects vary strongly depending on aperture and focal length.
- Use normal to moderately long focal lengths and a wide aperture for the smoothest transitions.
- Square filters are best as they allow you to adjust the position of the gradient.

Using coloured filters for black-and-white photography can be revelatory, and will save you a lot of post-processing work. Set your camera to record in black and white, mount a filter, and enter a world of subtle contrast enhancement.

- Orange or red filters brighten warm colours and darken blues and cyans. The example above uses an orange filter, which lightens the red bricks but strongly darkens the blue sky reflected in the window.
- Yellow-green filters are excellent for landscapes, as they lighten leaf tones and moderately darken blue skies.

like polarization, can only be achieved with a physical filter. The most convenient method is to use square filters made of resin that mount onto a frame. The frame can be fitted to different-sized lenses using adaptors, enabling you to have just one example of each type of filter for all lenses. Adaptors are also available for compact cameras. If you use only one or two lenses, glass filters that screw into the lens' filter mount offer the best optical quality. A filter's effect depends on the field of view and aperture, so you need to evaluate the effect of a filter through the lens at the working aperture and focal length. Any uneven effect, such as a gradient, will make sharper transitions when the depth of field is greater (with a small aperture), or when the field of view is greater (at a short focal length).

NEUTRAL DENSITY

FILTER

NO FILTER

A filter that simply blocks out a lot of light may seem pointless – but suppose you want to use a large aperture in very bright light, or set a long exposure time to capture movement blur. You've set the lowest ISO, but the scene is still too bright for your chosen camera settings: enter the neutral density filter to make the scene darker.

- These filters are available in different densities, such as -1 stop and -2 stops. Heavier densities will be needed in extremely bright conditions.
- High-quality neutral density filters block all colours equally, thus avoiding any colour cast.

SOFTENING

FILTER

NO FILTER

One of the most popular filters was the soft-focus, as they were very flattering for portraits. The best soften what is already soft, but have a minimal effect on sharply defined detail. When used with a limited depth of field, they give faces a subtle glow that is hard to reproduce digitally.

- The strongest softening effects are achieved at full aperture.
- Softening filters are designed for portrait focal lengths, that is, about 75–105mm.
- These filters tend to lower contrast, so lighting can be a little harder than usual for portraiture.
- Try over-exposing for a stronger halo.

SPECIAL EFFECTS

FILTER

NO FILTER

Placing thickly embossed plastics or filters with cut-outs in front of the lens gives results ranging from distortions and rainbow-coloured diffraction patterns to multiple images. These filters are best used on a zoom lens spanning from moderately wide to moderate telephoto, so you can freely make adjustments. The example above shows a multi-prism filter.

- Stop down the lens to working aperture, or make trial shots to check the results, as effects can vary with aperture.
- Take a shot of the scene without the filter in place, for use as a reference and in case you need to restore detail later.

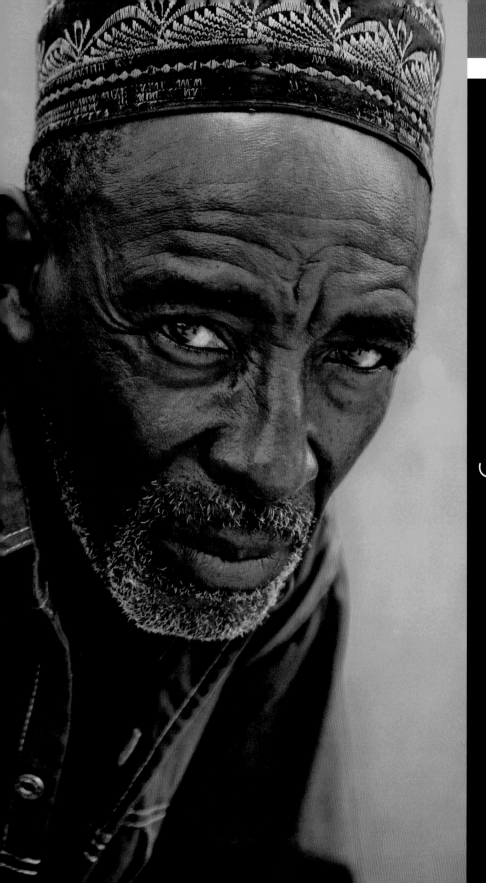

MASTERING PHOTO-SUBJECTS

Portraiture

People have been – and continue to be – by far the most popular subject for photography. But long gone are the days when having your portrait taken meant posing formally in a studio, dressed in your best clothes. Modern portraiture embraces a huge variety of styles, from casual snaps at home, to group shots of friends at social events, to the fully-lit, art-directed portrait in a studio setting.

ANNIE LIEBOVITZ

When I say I want to photograph someone, what it really means is that I'd like to know them.

The expansion of what's acceptable in portraiture means you no longer have a formula to work with – it's open season and anything goes. Faces may be clearly defined or concealed by blur and movement. Your subject may or may not make eye contact, indeed, he or she may even face away from the camera. Poses range from the regal to the ridiculous, and clothing may vary from casual, to formal, to fancy dress – or might be dispensed with altogether.

Posing questions

In terms of your interaction with your sitters, there's a correspondingly large range within which to work. You might ask them to act as if you're not there, or you might pose them with minute precision, determining how they sit or stand and directing their facial expressions. Between these extremes, you can explore an infinite variety of portrait styles, so don't be afraid to try out different approaches.

The way you pose your sitters is, in part, an expression of your relationship with them. You can't order CEOs, film stars, or children around – and in any case, whoever you're photographing, you'll get better results if you cajole them into working with you. The secret to a successful portrait session is collaboration, so share your ideas with your subjects and discuss how they wish to be portrayed. Even with paid models, you'll find that things go more smoothly once they understand what you're trying to achieve. As Alfred Eisenstaedt observed, it's no use clicking the camera if you don't click with the person.

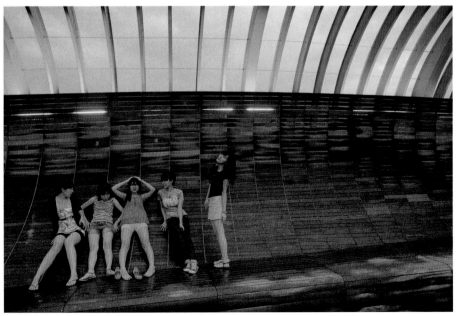

Lively groups
When you find a group of teenagers willing to have their photo taken, the chances are that they'll play up for the camera. Allow their creativity and the dynamic of the group to dictate the shot.

Busy professionals, such as this captain of a cruise ship, have little time to spare. After being introduced, locate the best positions to maximize available light, and scope out suitable backgrounds: with practice you can do this within moments of entering a room. You'll then be able to give precise instructions, which will ensure that your subject quickly gains confidence in you.

Fly on the wall

Posing a portrait also requires you to give close consideration to the environment or background of the scene. Should you choose to isolate your subject from their surroundings – for example, by placing them against a plain backcloth – you concentrate the viewer's attention on the person's character, as you've removed all other clues about who they are. All we have to go by are their expressions, gestures, and pose. Since we are highly attuned to reading body language, we can appreciate a great deal about someone by the pose they strike for the camera.

In contrast, you can include your subject's environment – their living or working space, or wider surroundings – as part of your observation. In this approach, the size of your subject in the image relative to the space around them is intuitively a measure of the importance of that space to the person's life. For example, if you show someone small amongst a large grove of trees, you are, in effect, telling the viewer that the trees are important to the person. The environment takes on meaning, and at the same time reciprocally contributes its significance to the person.

Natural charm

Our model was asked to hold her phone and pretend that she was taking a call, but it wasn't until she received a real call that she acted in a truly unselfconscious way.

BEING AT EASE

Faced with a subject who is uneasy in front of the camera, one strategy is to keep them on the move. Go from one location to another and talk all the while until they relax.

Technical considerations

Despite the liberalization of portraiture styles, there remain some technical points that are worth remembering if you want to increase your chances of producing successful portraits. Unless you want comic distortions, it's best to avoid approaching within touching distance of your subject when you're using short focal-length lenses or a zoom set to the short end of the range.

You'll seldom go wrong if you focus on the eye nearest the camera, particularly if you're using a large aperture ($f/2$ or greater). If your camera uses multiple focusing points, it's easiest if you set it to use only the central focusing point. Use this to focus on the eye, then recompose the shot while holding the focus. However, should you have the good fortune to be using a lens capable of $f/1.2$ or $f/1$ at full aperture, you'll need to use a different technique. In this case it's best to frame the image as you want and then focus manually; don't focus on the central spot and then recompose, because you'll lose the focus.

While you may often use wide-open apertures to blur the background, it always helps to ensure that there are no highlights or specular reflections. Bright, blurred spots in the image distract the viewer from the sitter's eyes. However, if your subject is facing a light source, he or she may gain alluring catchlights in their eyes.

Breaking the rules

Portraits don't always have to be a clear-cut representation of a person. This image is distorted from using a wide-angle setting up close; it's shot from below; and we can't see the subject's eyes. But the whole effect – of bright sun and palm trees reflected in the sunglasses, and a relaxed holiday mood – is a sum greater than its parts.

ANATOMY CLASS

Every part of the human body can be expressive. The hands – used to communicate, touch, eat, work, and carry out myriad everyday tasks – are particularly evocative. Try concentrating your portraiture on a specific part of the body: choose the eyes, hands, or feet, for example. This approach not only results in unusual, intimate portraits, but also frees you from the problems of identifying people in your images (although it's still best to obtain permission before you use any such images).

In character

The best portraits elicit an emotional response from the viewer, offering as they do a window into the subject's character. This exercise aims to remove you as an influence on the photograph, with the aim of ensuring that the sitter's personality shines through.

▼ THE BRIEF

▷ Create a set of portraits of a single group of people: close family, friends, or colleagues. Choose a simple background so your subject isn't competing for attention. Make a series of formal images that aim to be "objective", with minimal instructions to the sitter regarding pose and expression.

▼ POINTS TO REMEMBER

▷ **Decide how you want your subject to dress:** formally or informally, or even in costume – and whether you want to introduce props into the shot.

▷ **Encourage your subject to make conversation,** but wait for them to stop talking before making the exposure.

▷ **Keep lighting simple**, and consistent for each sitter.

▷ **Vary the proportions and framing** in each image; experiment with headshots, head-and-shoulder shots, and full-length portraits.

GO GOOGLE

☐ **August Sander** ☐ **Araki Nobuyoshi**

☐ **Peter Korniss** ☐ **Richard Avedon**

☐ **Disfarmer** ☐ **Eikoh Hosoe**

☐ **Irving Penn** ☐ **Helmut Newton**

☐ **Nicholas Nixon** ☐ **Cindy Sherman**

Informal posing

Taking pictures of friends and loved ones is the easiest photography of all, and offers a superb way to practise your technique. Testament to this are the millions of portraits that are uploaded onto social networking sites every day from all around the world.

It's such a pleasure to photograph a willing subject. If you spend a lot of time with someone, take advantage of the many opportunities you have to experiment; don't restrict your picture-taking to holidays or special occasions. You'll find that an amazing variety of poses are possible once you've the mastered basic, straight-on shots.

Enter a creative partnership with your model. Think how best to capture his or her personality: introduce in-jokes, interact with your surroundings, and let your subject take the lead. Have fun and be inventive – fresh ideas will spring up in the spirit of the moment.

▼ TRICKS OF THE TRADE

▷ **Use fill-in flash** when photographing yourselves with the sun behind you, or the shadows will be too dark.

▷ **Keep your camera in hand and switched on:** the best opportunities often arise and disappear in the space of a few seconds.

▷ **Be discreet.** If you want to take portraits in a shopping centre or any other location that may forbid photography, don't use a big dSLR camera or tripod, and do your best not to draw attention to yourselves.

▷ **Tag the people in your pictures** with image management software. Many programs now include sophisticated facial-recognition features.

INTERACTION ▷

Bring a scene to life by using street signs or tourist paraphernalia as your props. Throw off your inhibitions and turn everyday moments into mini character studies. Even the most humdrum location can sparkle when coupled with some chutzpah.

PLAYFUL

SELF-PORTRAIT ▷

Steady your camera on a small tripod for self-timed shots, or hold it at arm's length for more casual self-portraits. Some cameras detect expressions and will trip the shutter only when you smile; others have a secondary, forward-facing screen to help you frame up.

TRADITIONAL

INVENTION ▷

Look at your environment and approach it in unexpected ways: try unusual viewpoints and staged settings, and experiment with reflections in mirrors and windows. Don't be afraid to severely over- or under-expose your images: it may create a useful effect.

DRAMATIC

LOCATION ▷

So many "we were here" shots are yawningly dull because the subject has posed the same way in every picture. Coax your friend or partner into warm, rather than stiffly formal, poses, and be aware how body language influences the feel of an image.

OFF GUARD

SILHOUETTE ▷

For a change of pace in a sequence, nothing beats silhouettes for simplicity. Any bright, plain background will do the trick: just make sure that you set the exposure to guarantee maximum density in the shadows. Use any focal length you like.

INTRIGUE

HUMOROUS

COY

THEATRICAL

CASUAL

RELAXED

LOVING

SURREAL

ARTISTIC

SPIRIT

BIT PLAYER

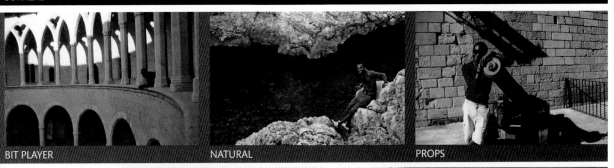
NATURAL

PROPS

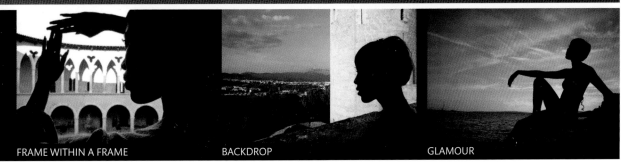
FRAME WITHIN A FRAME

BACKDROP

GLAMOUR

Child photography

There was a time when obtaining a sharp photograph of a child was nigh on impossible (unless he or she was asleep) – it involved getting an unwilling subject to hold a formal pose for a long exposure. However, now that we can capture the motion of even the fastest-moving child, there are no technical restrictions to child photography.

All parents want to "capture the memory", and those photographers who excel at making charming child portraits will always be busy. Addressing this challenge requires minimal equipment: a fast-reacting camera – a small dSLR is best – and a single lens. A 50mm f/1.4 or f/2 lens for a dSLR with an APS-C-sized sensor can meet 90 per cent of your requirements. Taking pictures of children is also a good way of practising a number of skills – framing on the move, focusing, composition, and more.

Capturing moments

The key to capturing successful shots is to allow kids to do what comes naturally to them – anything that comes into their heads at a moment's notice. For the most part, if you try to control their behaviour you'll only end up

ELIOT PORTER

Sometimes you can tell a large story with a tiny subject.

with, at best, an obstinate subject, and at worst a tantrum. Just follow and keep shooting; this way you'll also end up with more engaging photos.

Whenever you're taking portraits of other people's children, be mindful of your responsibilities as a photographer, and make sure your subjects and their guardians are happy.

Movies and moving people

A newly available strategy is to use the HD movie function that's available on many stills cameras (see Chapter 8) to keep track of fast-moving children; this works best in good, outdoor lighting. You can then extract single frames from the movie: images 1,920 pixels across have enough data for 150mm x 100mm (6 x 4in) prints, and can be emailed to relatives.

Centre of attention
Despite the clutter and conflicting colours in these shots (inset, an image from the same series), this child stands out from the distractions. Part of the reason for this is the not-so-subtle green and brown wooden beams that emphasize her place in the composition. The other part, of course, is the direct eye-contact and gorgeous smile.

On the move
A 135mm lens at full bore – *f*/1.8 – combines the virtues of good working distance to separate the subject from the background, and a short exposure time to capture movement.

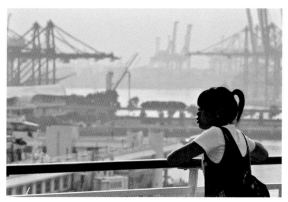

Little and large
The contrast between the little girl and the machinery of industry is supplemented by the contrast in their tone, and creates an effective juxtaposition of visual elements.

Light and expression
You don't always have to feature smiles in your pictures. Here a thoughtful expression combines with the off-centre light source to create a subtle, engaging portrait.

A world of their own

Many pictures of children show them smiling to the camera, conscious not only of the photographer but of the very act of photography – and often on their best behaviour, no doubt at the request of the photographer. But children at play inhabit another world, and the camera can be a window into that world.

▼ THE BRIEF

▷ Depict a child lost in his or her own world – playing with toys, absorbed in thought, or running around with joyous abandon. Try to capture a full range of moods.

▼ POINTS TO REMEMBER

▷ **It's easiest to start** close to home, with portraits of your own children, or those of your family or close friends.

▷ **Using a long focal length setting** – for example, of around 135mm – allows you to keep your distance, while still obtaining a good view of your subject's face.

▷ **Manual focusing** can often be more effective than using auto-focus when you're photographing toddlers and young children who find it difficult to keep still.

▷ **Flash may distract your subject,** and can take away the element of spontaneity. When shooting indoors, try turning off your flash and using a high ISO setting instead.

GO GOOGLE

- [] **Alice Auster-Rhodes**
- [] **Anne Geddes**
- [] **Diana Mara Henry**
- [] **Ed Krebs**
- [] **Sally Mann**
- [] **Roger Mayne**
- [] **Sue Packer's** *The Babies*
- [] **Annabel Williams**
- [] **V&A Museum of Childhood**

In conversation

It can be tricky to photograph young children as they often have no interest in your photography, or in cooperating. This sequence developed from a conversation about which apple would be sweeter – Gala, or Pacific Rose? As the discussion became more involved, I quietly picked up my camera, adjusted the settings, and started to shoot ... all the while exchanging views on apples. The final shot captures a moment of intense contemplation, combined with near-perfect lighting.

▷ Sony A900, 24–70mm *f*/2.8 : 50mm *f*/2.8 ISO 1600 -0.3EV 1/160sec

FROM THE SAME SERIES

1 Deliberation
A lovely backdrop of soft light spills in from the left, enveloping the child, and my elevated viewpoint helps to isolate her from the rich, warm tones of the floor. Our serious discussion was interrupted when I first introduced the camera, resulting in this slightly self-conscious shot.

2 Weighing merits
Each stage of the discussion led to a different gesture. And because we were talking about apples, I was presented with the candidates, the better to photograph them. Although these shots were obviously posed, I made the exposures anyway, as there was a chance they might work.

3 Paying attention
Being a smart young lady, it didn't take her long to begin to suspect I wasn't really all that interested in apples. She had a point: this was the 37th exposure after less than four minutes. Reading the signs, I put the camera down for a few seconds to concentrate on the conversation.

4 End of the discussion
This is the 63rd image, taken more than five minutes into our chat; you can see her thoughts are beginning to wander. It's a lovely shot, but the composition is too tight to the left. The final shot, on the other hand, not only shows beauty, poise, and grace, but is also well composed.

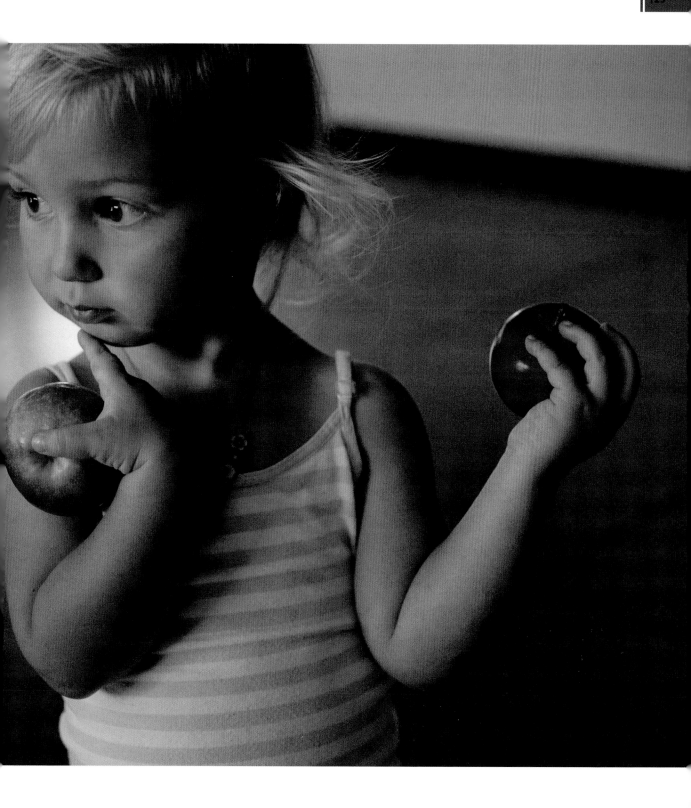

Art photography

In contrast to other photographic genres, art photography allows you to concentrate on capturing abstract concepts rather than tangible subjects. As an art photographer, you give yourself the license to explore any theme or idea that you choose – be it graceful or grotesque, beautiful or banal.

Inspiration can come from anywhere. You can take a personal approach, based on your own life and experiences, or you can tackle broad abstractions; you might reinterpret themes from other media, such as film, books, or music. You can also experiment with using photographic images as a basis for other media, such as installations using projected images, screen prints, or photo-collages. The possible approaches, and the resulting range of images, are limited only by your imagination, your own preferences, and the physical properties of the material world.

A new vision

At its best, art photography opens the eyes of viewers to a new, intriguing, vision of the world. You may not consider yourself an artist, but as soon as you alter your creative process or your subject to better represent your ideas,

ÉMILE ZOLA

A work of art is a corner of creation seen through a temperament.

you've graduated beyond the simple capture of images. As David Hockney reminds us, "The moment you cheat for the sake of beauty, you know you're an artist."

Projects and approaches

It's not uncommon to find that projects choose you, not the other way round. Ideas may come to you that lead your photography in a certain direction: if you find that you persistently try to express something in a certain way, allow yourself to develop this, and explore it from different angles. Follow your instincts – the most fruitful direction or approach is not always the most logical one, and the right one for you will become apparent in time. Make notes and rough sketches; even the simplest outline can be a handy trigger for new ideas. Above all, don't dismiss your own ideas: there are no critics looking over your shoulder.

SHADOW OF SELF

Art photography is often about challenging convention. Self-portraiture is a staple of art photography because it is practical (the subject is always willing), and it offers rich inspiration from the tradition of the painted self-portrait. Photographers often find their own shadows intruding into landscape views, so why not not turn the tables and make it the subject?

Homage to painting
You can base your art photography on art itself, making visual reference to artistic disciplines such as watercolour. Viewers often find this approach easiest to understand and enjoy.

Permanent residence
In fine art, much of an object's value is tied to its longevity. Black-and-white prints are popular as they deteriorate far less than colour prints, as well as being aesthetically pleasing.

Tackling issues

The camera provides a filter that can help us to explore subjects we might not otherwise be comfortable with – social, personal, political, and more. Whether you choose to use it therapeutically, or simply to satisfy your curiosity, art photography has the power to address issues and enrich your understanding of the world.

▼ THE BRIEF

▷ Challenge yourself: choose an emotive or "difficult" subject and produce two linked sets of images based around it. One set should show your first impressions, and initial ideas; the other set represents your view of the subject after you have explored and researched it in some depth.

▼ POINTS TO REMEMBER

▷ **You don't have to confront** your subject head-on: consider, for example, the idea of the fragility of life; you could photograph war memorials, or look at the different ways people hold memories of loved ones.

▷ **Allow yourself a period of experimentation** and exploration in which you shoot freely, without making too many demands on yourself. Your first set will come from these early images – your first impressions.

▷ **Research and read** around the subject widely through books and the internet: the more you know and understand, the more ideas you'll have for the second set of photographs – and for future projects.

GO GOOGLE

☐ **Photorealism** ☐ **Michael Kenna**

☐ **Emily Allchurch** ☐ **Loretta Lux**

☐ **Gregory Crewdson** ☐ **David LaChapelle**

☐ **Harold Edgerton** ☐ **Man Ray**

☐ **William Eggleston** ☐ **Wolfgang Tillmans**

Arts of the visual

Art photography, for all its wonderful and infinite variety, is based on a relatively small toolkit of effects, gestures, and techniques. And like other arts, it's invaluable to have a command of the basic skills – as you might for musical scales, or the brush strokes of painting.

Use these simple techniques and approaches to help you find your inspiration – or to give you a new way of working on an existing project, or of seeing a familiar subject. Remember that the difference between this and other forms of photography is the potential for significance to be found or implied in every aspect of the image. Everything matters: from the subject and your visual treatment of it, to the presentation of the image – its size, the support material, the frame and mounting if printed, or the method of projection. All of these jointly express the meaning of the work.

▼ TRICKS OF THE TRADE

▷ **You can produce direct,** easily understood images, or images in which the meaning is revealed only after a close examination, or when they are seen as part of a series.

▷ **Your choice of background** affects the meaning and readability of your work; it's not simply a case of using whatever looks best.

▷ **You don't have to step outside** your home: a major portion of Czech photographer Josef Sudek's work was created in his garden shed, over a period of nearly 50 years.

▷ **Working to a high level** of consistency over a period of time, your eventual aim should be to create a coherent set of images that are stronger as a whole than when viewed individually.

PLACE SETTING ▷

The meaning of the same arrangement of objects changes radically according to background and lighting. As you shift these elements from plain to increasingly complicated, it's important to ensure that the original objects remain clearly represented.

SIMPLE

EXPLORATIONS ▷

Many kinds of object can yield a surprisingly rich variety of results with only a few minutes' exploration. Observed from outside and inside, and in different interactions with light, the subject transcends its normal existence.

CLOSE AND BRIGHT

TONE OF VOICE ▷

The most fundamental photographic controls, such as exposure, are stepping-stones to deeper exploration. Distortion of tone forces mundane scenes into other visual dimensions, from the unnaturally bright to the intriguingly dark.

HIGH KEY

SIMPLE SHAPES ▷

The most ordinary things in life can become interesting if you give them a little attention; in series, these images gain great impact. You can take a plain and simple approach, or use post-processing to achieve greater complexity.

TWO DIMENSIONS

BREATHING SPACE ▷

Explore the subtle balance between detachment and intimacy by shooting from various different distances. Work in close-up to bring out the nuances of your subject, or take a narrative approach by showing a broader view.

INTIMATELY CLOSE

DISTINCTIVE

RICH LIGHTING

UNEXPECTED

FULL VIEW

LIGHT AND SHADOWS

DRAMATIC VIEW

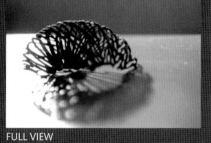

SURREAL REFLECTIONS

INTENSE LIGHTING

DARK AND DEEP

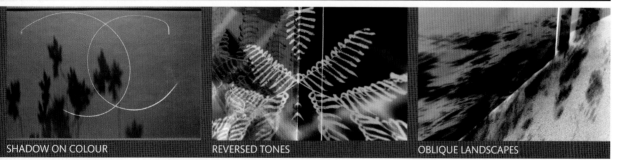

SHADOW ON COLOUR

REVERSED TONES

OBLIQUE LANDSCAPES

RESTRAINED SPACE

WIDER VIEW

NARRATIVE

Suburban moonrise

You can pass a scene a thousand times and not really see it. Perhaps because this was not my house, I didn't just see a light shining through a blind as I approached the front door: instead I saw the elements of an oriental landscape painting – a full moon, a placid lake, and the calligraphy of the bamboo leaves – composed of intriguing, incongruous elements. As always, it's not what you see that creates a photograph, but how you see it.

▷ Panasonic LX3, 24–60mm *f*/2–2.8 : 35mm *f*/7.1 ISO 400 -0.3EV 1/3sec

1 | Tranquil lake
To the naked eye the wall was a pale shade of blue, a colour that already suggested the idea of water. The camera's auto-white balance (see pp.104–05), in compensating for the very warm light, deepened and intensified the blue, reinforcing this fancy.

2 | Evening sky
The creamy white blind appears more warmly coloured because of the illumination from the lamp. Its even texture is important, as it becomes a backdrop for the complexity of the leaves, and strongly suggests the texture of silk or paper scrolls painted with classical brushwork.

3 | Phi horizon
Conceptually, the horizon separates the ethereal world from the earthly. Here, the "horizon" divides the image precisely into phi, or Golden Ratio, proportions (see pp.30–31), with the "moon" in a balancing position, which gives the image its classic proportions and poise.

4 | Full moon
Serendipity plays a part in making a photograph, too: the balance between the light outside and the lamp inside happened to be perfect the moment I arrived at the house. But the light levels were rather low, so I relied on image stabilization to capture a sharp image, at a long exposure of 1/3sec.

IN DETAIL

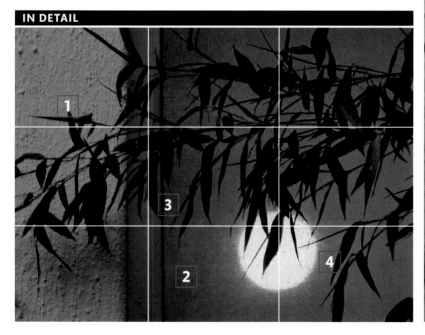

Creative block

SEEKING INSPIRATION

PROBLEM
It's a long time since you've been fired up creatively: you feel no excitement taking pictures, and can't raise any enthusiasm for your projects. You're not sure why you feel like this, and you're keen to snap out of it.

ANALYSIS
You're running low on creative juice; you need a refill. Without a regular input of fresh – even unwelcome – visual and aural stimuli, you'll deplete your working store of knowledge, images, and ideas. Perhaps it's been a while since you looked at things from a different perspective.

SOLUTION
▷ Browse the art books in a bookshop; read voraciously and indiscriminately.

▷ Search on the internet in related fields, such as art history, graphic design, typography, and fashion. Study the work of renowned photographers, and follow blogs to find out about current trends.

▷ Visit a museum and look at another medium entirely, such as engineering drawings, textile designs, or pottery.

▷ Expose yourself to different types of art – poetry, drama, movies, music – whatever you don't usually consume.

DRAWING A BLANK

PROBLEM
You have no ideas at all. You're desperate to start something new but nothing comes to you, however hard you work at it. You've already tried visiting museums, surfing the internet, and gaining inspiration from other art forms.

ANALYSIS
Photography is like any activity – the more time you spend practising it, the more creative and proficient you become. You may need to overcome an internal censor telling you that your ideas are inadequate, or that it's all been done before; interestingly, this censor is often weakest first thing in the morning.

SOLUTION
▷ Get up early, and start working while your internal censor is still dozing.

▷ Find shapes in forms such as clouds, rocks, rust patterns, or peeling paint.

▷ Brainstorm and jot down random words. Link related concepts with lines, or lasso them together.

▷ Create moodboards of images that you find attractive or intriguing.

▷ Stick with these exercises until you develop more focused thoughts. And, most importantly, stop worrying what anyone else thinks.

LACKING FOCUS

PROBLEM
Your creative energy desperately needs some direction. You have lots of ideas for projects but can't settle on any of them, being unsure whether they will work or where they will lead you.

ANALYSIS
You need to clear your mind and remove any unnecessary distractions. Perhaps you're not thinking ideas through clearly, or, conversely, you may be thinking too much. Maybe you are lacking specific goals that you can work towards.

SOLUTION
▷ Spend time thinking about what you want to achieve, and set yourself some realistic time frames.

▷ Keep a journal of all your ideas so that you don't forget them.

▷ Make prints of your work, stick them on the wall, and live with them until you know them inside out; you might come up with a fresh perspective.

▷ Enter a competition. The deadline will provide a focus for your efforts, while the guidelines will give you a ready-made framework in which to approach your project.

FEELING ISOLATED

PROBLEM
Your images are on photo-sharing sites, but you have no-one to talk to about art, photography, or how to develop your work. You need to find like-minded people to discuss ideas, perhaps even to collaborate with on projects.

ANALYSIS
Social networking sites and other contact via the internet is just not personal enough, even though it's convenient. You need to meet people in person, and make more time for face-to-face communication.

SOLUTION

▷ Join a photography club.

▷ Create or join a group that makes arrangements via the internet but meets in person. Some groups are formed around photography, others around related subjects, such as bird-watching.

▷ Attend an art class, such as still life, watercolour, or life drawing, and get to know the other people on the course.

▷ Go to talks at art exhibitions or museums.

SUFFERING FROM BOREDOM

PROBLEM
You feel as if you're producing the same old work over and over again. You worry that if you're not excited by what you produce, no-one else is likely to be.

ANALYSIS
Experience has taught you how to work effectively, efficiently, and easily. Your solutions no longer offer a challenge, even if they are admired by your friends. You need to break out of your comfort zone before you can extend yourself.

SOLUTION

▷ Photograph in unusual conditions, such as total darkness, or when it's raining. Tackle the shots in a new way.

▷ Allow yourself to make mistakes – it doesn't matter if your images are blurred, wrongly exposed, or randomly framed.

▷ Test out new subjects: if you like landscape photography, take shots of people's hands; if you like street photography, have a go at still life.

▷ Take any assignment from this book and find a different way to carry it out. Break all the rules.

STUCK IN A RUT

PROBLEM
You have been commissioned to photograph a subject, and asked to make both the subject and its treatment fresh and exciting. But you don't know how to approach the subject in an original way, nor how to do it in a stimulating manner.

ANALYSIS
You have been commissioned to do the work, so you have the photographic skills and resources for researching visual strategies. It may be that you find the subject boring, or you've photographed it too many times already.

SOLUTION

▷ Imagine that the subject is something you've never seen before, and that the commission is a dream job that will win you prizes and acclaim.

▷ Work on the problem for a short, intense period, such as 30 minutes, then stop and do something else. Return to it after a few hours.

▷ Try chance associations: open a newspaper, and think how you could link what you find with your task.

▷ Make a moodboard to collate all the elements you're working on so you can see everything at a glance.

Plantlife and gardens

The garden is a photographer's training ground. It presents a safe, tranquil environment full of shapes, colours, and attractive subjects; there you can learn, practise, and hone your skills, experimenting with exposure, composition, and focusing.

This doesn't preclude getting some serious work done, of course. Plants and gardens are popular subjects, and so your challenge is to capture them with originality, while properly representing their true nature. You could concentrate on formal or abstract patterns, explore intricate details, or take in a larger view to convey the character of the garden itself.

Lens signature

You'll be working mainly at close to medium distances. Most of the time you'd use moderate to very wide-angle lenses, or macro lenses (see pp.54–55); if there was ever a perfect partnership between subject and lens, it's the garden and the 50mm or 55mm macro lens. From undistorted general views to close-ups of a flower's stamens, these lenses are the ideal tool for shooting the widest range of garden subjects. Some modern designs offer very fast lenses – up to f/2 – and focusing capabilities all the way to life-size.

PAUL CÉZANNE

I could be busy for months without changing my place, simply leaning a little more to right or left.

Although this area of photography rarely calls for long lenses, their narrow field of view and shallow depth of field can create a visual style that will distinguish your images from the usual, run-of-the-mill plant and garden pictures.

Working with the light

Professional garden photographers love working in the soft light of cloudy, drizzly days, when colours glow and are clearly differentiated from each other. But you can obtain successful shots in any light, from bright sunshine to near darkness. If you're shooting in sunny conditions, a polarizing filter helps reduce reflections to deepen colours; at the other end of the scale, you can create wonderfully atmospheric pictures by working in low light with long exposures.

The looking glass
It's normal to avoid shooting through windows, as reflections and other effects degrade image quality. But gardens are often enjoyed through the windows of a house, so why not photograph the scene the same way you experience it? Converting the original (inset) into black and white gives it an abstract, graphic quality.

Pure and simple
Straightforward shots are not easy: your aim is to bring the subject to the fore. Focus and composition must be precise, with directionless lighting.

Shadowlands
The strong, clear shapes of a plant's shadows lend themselves to graphic manipulations, generated here by a simple reversal of both tone and colour.

The garden at dusk
Set up your camera on a tripod for long exposures at dusk: you can then light up selected features using torches to "paint" light on the plants.

Natural clarity

The joy of plants as photographic subjects is that you can shoot at any scale – from the grasses covering a prairie to individual ears of grain – and still obtain wonderful images. The challenge, however, is to capture the very essence of the plant you're photographing, revealing the core elements that make it unique.

▼ THE BRIEF

▷ Make images of plants that are as simple as possible. Strive for clarity and minimalism; your subject may be as large as a tree or as small as an individual leaf.

▼ POINTS TO REMEMBER

▷ **Try working with shapes** and outlines, particularly those of large subjects, for example the silhouette of a leafless tree.

▷ **You can eliminate textural distractions** by working with shadows. Place white card behind your plant and photograph the shadows that fall onto it.

▷ **Minimum depth of field** (see pp.78–79) is a useful tool for reducing a view to its essential elements. Set a combination of maximum aperture, long focal length, and close focusing.

▷ **You can remove the distractions** of colour by converting your image to black and white. Try distilling it further by increasing contrast to simplify textures and shapes.

GO GOOGLE

☐ **Infrared photography**	☐ **Andrea Jones**
☐ **Minimalism**	☐ **Charles Jones**
☐ **Karl Blossfedt**	☐ **Clive Nichols**
☐ **Alan Detrick**	☐ **Earl of Snowdon**
☐ **Suzie Gibbons**	☐ **Rupert Stockwin**

Animal photography

Inspired in part by the popularity of increasingly sophisticated, thrilling nature films and documentaries, there has been a huge growth in wildlife photography. And the digital era has seen a dramatic increase not only in the volume, but also in the overall standard, of animal photography.

As well as the mechanism of capture, the camera's controls also became entirely digital. This has enabled auto-focus systems to be very sensitive and responsive – able to follow subjects as dynamic as an eagle flying straight at you – while remote control and flash systems have also become more capable and sophisticated.

Into the wild

You don't have to use specialist cameras or super-telephoto lenses to obtain satisfying wildlife photographs; the secret is to make full use of the equipment you have. An auto-focus compact is all you need to take innovative portraits of pets, or to photograph animals in captivity. Even in the wild, photographers have made prize-winning shots on ordinary equipment. However, very long lenses do help reduce the time spent stalking animals, as you can shoot from far away.

FRANS LANTING

The perfection I seek ... is a means to show the strength and dignity of animals in nature.

The real keys to success for serious wildlife photography are planning, patience, and knowledge of the animal. Luck helps, too: I once found a nursing rhinoceros after two days' tracking, but before me, another photographer had tracked for two weeks without finding a trace. But you don't need to launch an expedition into the wilderness to get great animal shots: there are also many opportunities to be had photographing animals in zoos. Here you may need to check out fifty different viewpoints to find one that reveals the animal in a new light, but your reward will be capturing a picture no-one else has seen. If you're practising animal photography in zoos, it's a good idea to have a project in mind – for example, exploring the relationship between the animals and the zoo's architecture.

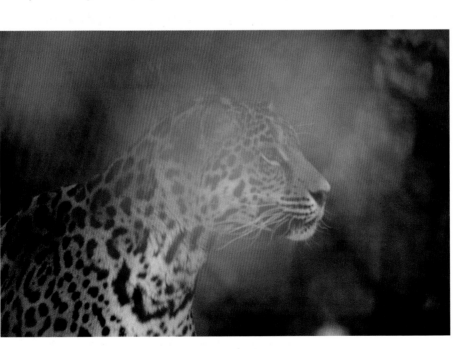

In its element
The animal is hard to see clearly, and a very out-of-focus blur dominates the whole image. But it would be a mistake to delete the image, because it gives an excellent sense of the beast as it would be seen in the wild – even though this image was taken in a zoo.

Eye-to-eye
This stern yet beautiful face belongs to a tiny owl, the size of a fist. The fierce impression is entirely the product of tight framing and a close-up view.

A dog's life
Sometimes an unusual viewpoint can bring out the character of your subject. As this dog settled down on the deck, I was able to combine beautiful open skies with a dramatic angle.

A twist in the tail
This unusual portrait of horses in the Camargue, in France, captures a quiet moment at the paddock, as they stood peacefully flicking at flies with their long tails.

Natural symmetry

Whether human or animal, faces in which the left- and right-hand sides differ widely are often found to be grotesque, whereas perfect symmetry is considered beautiful. Virtually every higher animal shows strong symmetry; however, it's often flawed, and it's in these small differences that character and individuality can be seen.

▼ THE BRIEF

▷ Make a series of portraits of the same animal taken from front-on, and close enough to see differences in detail on each side of the face. Crop tightly to the face area.

▼ POINTS TO REMEMBER

▷ **Use sufficient depth of field** to keep the whole face sharp. This is easy when you're shooting animals with mainly flat features, such as primates, but for some types of animals with snouts or long faces – horses, crocodiles, and others – you'll need to photograph from a distance.

▷ **Crop sensors** - Four Thirds format or APS-C – work well for wildlife, as the effective focal length of a mounted lens is greater in these cameras than on full-frame ones, so effective magnification is greater.

▷ **You can capture the** common characteristics of different members of the same species by shooting a number of individual animals.

GO GOOGLE

☐ **Steve Bloom**	☐ **Esa Mälkönen**
☐ **Nick Brandt**	☐ **Thomas Marent**
☐ **Tim Flach**	☐ **Paul Nicklen**
☐ **Britta Jaschinski**	☐ **Doug Perrine**
☐ **Hannes Lochner**	☐ **Stefano Unterthiner**

Cloudy waters

In wildlife photography, once you've spotted your mark the great temptation is to fill the frame with the animal. When I finally saw a black caiman – having spent ten days in Guyana looking for one, chasing glints in the dark and seeing the tip of a tail disappear into the water – I wanted to make the most of it. Tellingly, the best image from a 30-minute take is not a scary close-up; rather, it's the shot showing this impressive creature swimming peacefully in its habitat.

▷ Canon 1Ds MkIII, 100–400mm *f*/4-5.6 : 100mm *f*/6.7 ISO 400 0EV 1/1500sec

FROM THE SAME SERIES

1 **Emerging from the water**
A black caiman making a public appearance is a remarkable event, especially when, like this one, it's nearly 3m (9ft) in length. Any picture of such an animal is an achievement, but to be an outstanding wildlife image it must offer more than if it had just been taken at a zoo.

2 **Up close and personal**
Many portraits of wild animals are long focal-length views that, while magnifying the scale, lose the context entirely. Here, a 350mm zoom setting shows many of the caiman's features clearly, but the shot loses all sense of scale, giving no indication of the animal's size.

3 **Animal behaviour**
The caiman and I noticed the little egret at the same time, as the bird made its way indolently to the riverbank. I tried not to wish for a dramatic event, but the situation still added tension to the scene. However, the moment happened all in shade, so no prize-winning shot here.

4 **Into the light**
As the caiman swam out of the shade and into the light, I noticed the reflection of the sky in the water. My next shot benefited from a beautiful, almost metallic coloration, but the best image came when I zoomed out, set the lens to 100mm, and included the clouds and patches of luminous blue sky.

Live events

The joy of photographing live events is that much of the work is done for you. Rather than having to walk for miles, track down subjects, or arrange complex shoots, here all you have to do is turn up and start taking photos. Not only has it all been organized for you, there may also be special vantage points for photographers, and you'll usually be made very welcome.

The process of shooting live events – art shows, concerts, or sport – starts before you arrive. If you can, stake out the venue beforehand for vantage points and efficient routes, such as shortcuts between the holes on a golf course, or good views of a stage. If it's a well-known event, research existing images on the internet, searching for original angles and noting similar shots that appear again and again. Finally, check what restrictions there might be on photography: compact cameras may be permitted, but a dSLR with a large lens may need clearance.

From start to finish

Events share similar phases – the build up to the action, the main event, leading to a grand finale, and the clear-up afterwards. Each of these stages offers different

ELLIOTT ERWITT

Photography ... has little to do with the things you see and everything to do with the way you see them.

opportunities for photography. Behind-the-scenes coverage of the preparation is often fascinating, especially for stage-based events, and the clear-up can be a worthy subject in itself. The key point is that everything is worth photographing; you just have to look at it the right way.

On the sidelines

Remember that the main attraction, or performance, is only a part of the event: there are many other, smaller stories taking place all around you. As a photographer, you should give all of these your full attention – the sidelines often yield the most telling images. You can use any camera and any lens to record the variety of scenes: shoot within the capacity of your equipment and you'll be well rewarded.

ART IN THE DARK

For this live art event, I prepared by mounting the fastest lens I had – the 135mm *f*/1.8 – and set the camera's ISO at 640, together with an override of -2EV. This process is a kind of mental preparation for the images you'll be capturing. You never know exactly what you'll see at an event, but it helps if you know in advance what you want your images to look like.

RUNNING FREE

Any given event offers unlimited views. In large marathon runs, for example, rather than concentrating on the leaders – which is what every news cameraman will be doing – instead search for the true spirit of the race. Try to translate your feelings and thoughts into visual terms: by abstracting the event, you allow your photography to see dimensions others take for granted. It could be a ground-level shot of shoes thudding past, a member of the crowd offering support, or the blur of the runners juxtaposed with some of the stationary entertainers.

Unsung heroes

Large, high-profile events couldn't take place without the hard work of numerous support staff. They may be obviously visible, such as stewards and programme vendors, or less so, such as first-aiders and caterers. Some are paid employees, but many will be volunteers who do it for the love of the event.

▼ THE BRIEF

▷ Concentrate on a group of unsung heroes, and make them the subject of your photography. Show them at work, in order to reveal the vital role they play, treating them every bit as seriously as you would the main protagonists.

▼ POINTS TO REMEMBER

▷ **Your treatment of this subject** can range from posed portraiture through to action shots, or a mixture of styles and approaches: you don't need to be concerned by any formal considerations.

▷ **Juxtaposing your subjects** with a view of the main event is a good method of demonstrating their role in an immediate, accessible way.

▷ **Use any technique** that feels right to you: shoot with a long lens, a wide lens, in black and white, or in colour. The essential aim is to capture the spirit of your subjects' work, and to convey a sense of its importance to the event.

GO GOOGLE

☐ **Carol Friedman**	☐ **Leni Reifenstahl**
☐ **Bob Gruen**	☐ **Mick Rock**
☐ **Walter Iooss**	☐ **Christina Rodero**
☐ **Siegfried Lauterwasser**	☐ **Phil Stern**
☐ **Adam Pretty**	☐ **Rolling Stone**

Transfigured night

When photographing an event based on light shows, such as "Art in the Dark" in Auckland, New Zealand, there's no place for electronic flash. Instead, one has to make the best use of the available light, using fast (large maximum aperture) lenses and high ISO settings. This image captured the transformation of the park into a surreal landscape with pools of coloured light and people walking in and out of deep shadows.

▷ Sony A900, 135mm *f*/1.8 : *f*/1.8 ISO 640 -2EV 1/30sec

1 Clean mid-tones
The smoothness of tone in this – relatively bright – area of the image is an artefact resulting from the image processing. Compared to the rest of the image, which is very noisy, this is inconsistent and unnatural, and creates a strange boundary with the passing figure.

2 Meter for darkness
When a camera performs poorly at high ISO settings, it's best to set a relatively high setting (640, in this case), rely on fast lenses, and override the exposure to ensure suitably dark results. With a setting of -2EV, the image needed no exposure correction.

3 Framing shadow
At first I thought about removing this pole and its long shadow in post-processing. In fact, it is ideally placed to enclose the group of figures and break up a relatively even and low-energy area. Its artificially clean lines also contrast with the spindly filigree of the tree branches.

4 Crowd involvement
Several people were waving electric torches, so I waited until the light caught someone or showed up something interesting. Fortunately, the best lighting coincided with a person passing in front of me. As a top golfer once remarked, "The more I practise, the luckier I get."

IN DETAIL

Documentary photography

One of the most respected and admired of all genres, documentary photography is responsible for the heroic reportage of wars, for presenting unflinching accounts of famine and social unrest, and for holding up a mirror to the pleasures and sorrows of everyday life. It flies the standard for photography as the paramount medium for revealing humankind to itself.

In the 21st century, advances in digital technology and the widespread adoption of the internet has enabled an explosion of interest in the genre. We are enjoying a renaissance as young photographers turn over old stones to discover new, more sophisticated angles. Once upon a time, a picture story on a secluded community, for example, may have won prizes for its sympathetic voyeurism. Today, we expect genuine engagement arising from long-term involvement that leads to insight and understanding ... as well as a set of marvellous photographs.

Wearing two hats
Documentary photography is equal parts socially aware journalism and photographic skill. The journalist assumes he or she knows nothing, and asks the key questions of

> ### DOROTHEA LANGE
> The good photograph is not the object, the consequences of the photograph are the objects ...

"who, when, where, how, and why?" The photographer expresses the answers in images, and draws the viewer into the story so that they share, if only for a moment, the life of the protagonists. The best documentary photographs are made from "inside" the action: results tend to be most convincing when you're involved, yet retain some measure of dispassion to tell the story with objectivity.

The essential tool is a wide-angle lens – 35mm or shorter – with large maximum apertures of $f/2$ or better, so that you can work in low-light conditions without recourse to flash. Shoot in black and white to preserve the "film look", and process the images to incorporate film-like grain if that's the effect you'd like (see p.199). In this intimate world, large dSLRs are not the best choice. Some photojournalists favour point-

Watching from afar
Your depth of involvement is inversely proportional to your distance from the subject. Here, the military presence at a festival outside Dushanbe, the capital of Tajikistan, was because there had been a massacre in the area only weeks before. I watched with the benefit of a 300mm lens, but was not involved when a soldier paid his respects to his fellow citizens.

Travel to other countries opens up a whole new world of photographic opportunities. It can allow in-depth and extensive coverage, which is a most rewarding way to work: not only will you gain fascinating pictures, but your understanding of other cultures, their histories, and their modern-day politics will also be enriched. In fact, without this kind of understanding, documentary photography runs the risk of being mere eye candy, rather than a chronicle that, in the words of Edward Steichen, explains "man to man and each man to himself." These images were taken during my travels in Central Asia and China.

and-shoot compacts for their quiet operation and the fact that they don't advertise "Pro photographer at work". Indeed, when out taking photos, your activity exposes you to a higher risk of attracting attention, wherever you might be. No photograph is worth your life or serious injury; your personal safety must be paramount.

Building a story

The classical model for building a story employs well-known narrative techniques. Begin by establishing a feeling of place: show a general view of the location, or position your main protagonist against a relevant background. As with any story, the characters need to be introduced, so show them through posed portraits, or catch them as they go about their daily lives. Then, move onto their stories. Why should we be interested in their particular experiences? Do they offer a telling drama, or allow a fascinating insight into another culture? Whatever the motivation, how you wield your camera will be an expression of the relationships you create: the more engaged with your subject you are, the more involving your images will be.

Practice matters

Once you're on location, exploit it to the full: photograph everything – even the most commonplace item or action – as you may not learn its significance until after you have

left. You can't make it up afterwards, and you might never return. Note down the names and occupations of the people you photograph, as written records are invaluable for the corroboration and verification of your stories. Likewise, work with highest levels of integrity, and only make promises you can keep – for instance, say you'll send prints only if you truly intend to fulfill the pledge. If you disappoint someone – or worse, expose them to danger by revealing their identity – you'll make the task of the next photographer they meet very difficult, if not impossible.

Ethical considerations

Thanks to photo-sharing sites, blogging, citizen journalism, and ever-evolving news-sharing methods, stories can easily bypass traditional publishing methods and reach millions of people in less time than it takes to print a magazine. This alone makes it vital that you uphold the highest journalistic and ethical standards – an error can reverberate throughout the world, with unpredictable consequences. Keep your titles and captions concise and accurate, and be aware of the context in which your images might be viewed. Even more importantly, never manipulate your images if they're going to be presented as a work of documentary (see p.157).

With a growing sophistication in visual literacy, merely to depict is pointless: not only do we expect images to show us something new, we expect them to have consequences.

DID YOU KNOW?

Photographing people is becoming more difficult throughout the world, as awareness of the value of photographs grows and as people become more aware of their rights. The old principle that trust is the best basis for people to relate to each other applies also to photography, so be open and honest in your approach – don't photograph someone from the other side of the street, but come within conversational distance. Ask permission, if only with hand signs and gestures. It always helps if you can speak a few words in their language, such as "how are you?", "please", and "thank you". Smile and make eye contact. If you don't feel welcome, desist, say thanks, and leave. Don't pay to take someone's photograph; instead donate to local causes.

We demand advocacy from images, that they impel us to aid the hungry or support campaigns against environmental degradation. Nevertheless, the rewards are great: as viewer numbers are the oxygen of documentary, our free access to a global audience makes this the golden age of documentary. The beauty is that even if you don't have your camera with you all the time, your mobile phone can be just as useful: when it comes to documentary photography, sometimes being in the right place at the right time trumps all artistic and technical considerations.

THE RULES OF ENGAGEMENT

Your level of engagement can be measured by distance (entry into personal space proves cooperation), and eye contact (which demonstrates trust). Here, the fly-on-the-wall shots in which the protagonists seem unaware of the camera lack real interest; a big smile is engaging; and the most rewarding get close enough to enable multi-layered compositions.

TELLING TALES

It's a natural impulse to move closer to something you find interesting, and the most elemental narrative technique is to zoom into a scene. Here, each frame represents a moment in time. We begin with cashew nuts being roasted on a fire; progress to the nuts being spread around to ensure they don't get burnt, and end with our subject removing the husks: ten minutes of real-life activity, compressed into three frames.

Go on assignment

It's hard to take a series of revealing photographs if you haven't established some sort of mutual understanding with your subject: your images will be uninvolving and static unless you make a real connection first. This calls for confidence and people skills – traits essential for the successful documentary photographer.

▼ THE BRIEF

▷ Develop your ability to work with strangers by learning how to photograph people you know, but who aren't close friends or relatives. Ask a local shopkeeper or any other person you see regularly if you may photograph them at work. Produce a short sequence answering the "who, when, where, how, and why?" questions about your collaborator.

▼ POINTS TO REMEMBER

▷ **Plan what you want to shoot beforehand.** If possible, familiarize yourself with the surroundings in advance.

▷ **Shoot quickly and efficiently –** this will give your subject confidence.

▷ **Posed pictures sometimes seem contrived;** the most rewarding images are rich, complex compositions.

▷ **Cover interaction with other people,** but ask their permission before taking any shots.

▷ **Show your collaborator** the images that you're taking only at the very beginning and end of the shoot, to avoid distractions.

GO GOOGLE

☐ **Jacob Riis**	☐ **Abbas Attar**
☐ **Walker Evans**	☐ **David Goldblatt**
☐ **Mass Observation**	☐ **Sebastião Salgado**
☐ **LIFE magazine**	☐ **James Nachtwey**
☐ **Raghu Rai**	☐ **Jackie Drewe Mathews**

Café culture

If there's a central skill in documentary photography, it has nothing to do with cameras but everything to do with establishing rapport. Even the great Marc Riboud, who once told me he preferred to hide in doorways rather than speak to people, can talk his way into any situation and out of any trouble. In Kars, Turkey, these men at first looked at me with suspicion. But when I greeted them in Arabic, they invited me to join them for tea.

▷ Leica M6, 35mm *f*/2 : *f*/4 ISO 320 0EV 1/60sec

1 Initial reluctance
The man on the right was a little wary of my camera. But when my drink arrived, I raised my glass to all three, thanking them and praising the tea. He turned to acknowledge me, and I asked them in Turkish if they would all consent to having their photo taken.

2 Active space
I knew I wanted to record all three men in one shot, but the space to the right (into the café) and to the left (out onto the road) were both empty – the composition lacked a sense of life happening around us. So I waited, patiently sipping tea, until a boy arrived to chat to the shoeshine.

3 Central character
The principal figure is too much in the centre of the image for my liking. But I couldn't aim further to the right, as I was blocked by the door jamb, nor more to the left, as the road was in full sunlight. His expression shows puzzlement as to why I was taking so long to click the shutter.

4 Serendipity
It was at this point that the man on the left let his prayer beads dangle into view. When he turned round to hear the conversation within the café, I knew I had my picture: his movement revealed the activity behind him, and his gaze leads the viewer into the rest of the image.

IN DETAIL

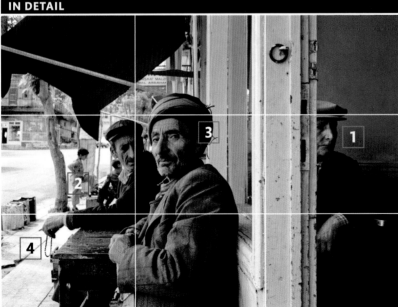

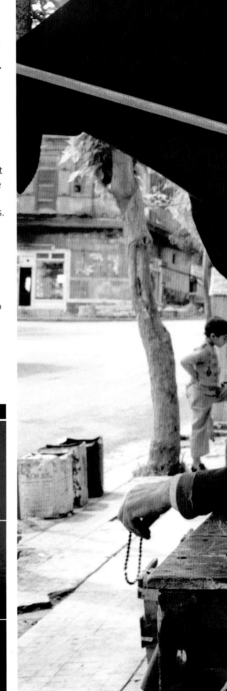

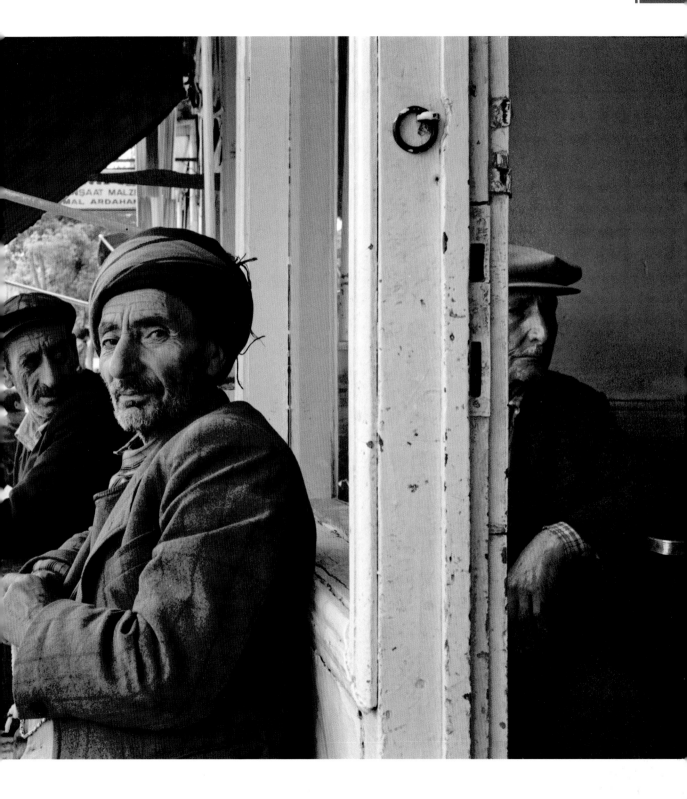

Travel photography

Photographers have always been compelled to travel. Even in the early days of photography, when the available equipment consisted of literally a ton of glass plates, gallons of chemicals, and a darkroom on wheels, photographers gamely ventured far from home. Today, no corner of the earth is un-photographed, but travel photography is still a favourite pastime for tourists – and, for many, it would be a dream job.

BILL BRANDT

It is part of the photographer's job to see more intensely than most people do.

Photographers' insatiable appetite for new subject matter drives their desire to travel: new lands mean new sights, which mean new photographic opportunities. Photography also helps you appreciate your destination, by enhancing your powers of observation. The camera has joined the passport and the toothbrush as one of the main items you wouldn't leave home without, and even recreational travellers use cameras that shoot better and faster than professional-grade equipment from ten years ago.

Looking deeply

The issue now is how to come up with new and different travel pictures: with tens of billions of images on the internet covering every spot on earth, there are few options if you

want your travel photography to stand out. One strategy is to use your insight to look more deeply – to examine each scene more closely, to uncover its many layers. This helps inform your images, so they become more than superficial records of visible elements, and instead tell viewers the story of the place. Anyone can point a camera at a lovely scene and record it successfully: all the photographic technicalities are taken care of. But it takes a smarter, more thoughtful kind of photographer to reveal the underlying layers of meaning.

Try to discard the obvious and welcome the oblique. Photograph when others put their cameras away: on dull, rainy days; after sunset; in hidden corners or places not usually considered photogenic. Attend to the minutiae of

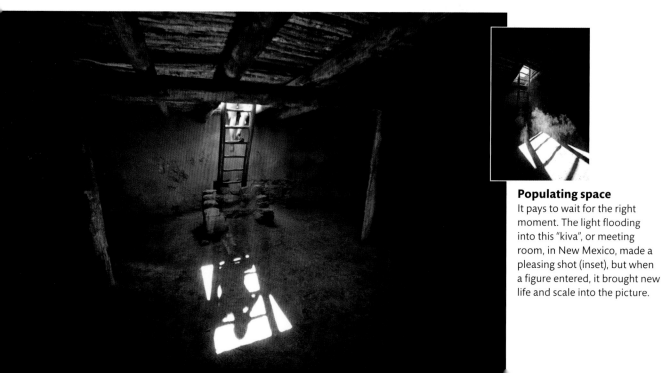

Populating space
It pays to wait for the right moment. The light flooding into this "kiva", or meeting room, in New Mexico, made a pleasing shot (inset), but when a figure entered, it brought new life and scale into the picture.

A deserted, sandy beach in Trinidad is a perfect holiday destination. The idyllic tropical scenery might seem to call for a straightforward "travel brochure" style of treatment. However, there's always more to a place than is revealed at first glance: by showing certain isolated elements you can adopt a more editorial approach, which hints at underlying stories.

life around you and the bigger picture will reveal itself. This isn't about being different for the sake of it, but rather to suggest that you dig below the surface to investigate a scene, taking nothing for granted. For example, where you would normally focus on the main person in shot, blurring the background, try focusing on the distant objects and throw the person into blur. This shifts the emphasis, perhaps suggesting that the environment is the permanent stage, while the people are merely actors who come and go.

You can try using extreme effects to make your travel images stand out, such as HDR, tone-mapping, or infra-red. However, the stronger the effect, the more it dominates, and the further it removes the image from the reality of the place it depicts.

Prepare to be different

If you have access to the internet, you probably use it to research your destination, book your flights, and check hotel reviews before making reservations. However, you can also use it to look at how other photographers have portrayed the place and its sights. Millions of community-minded photographers post their pictures on sites such as Photobucket, Panoramio, Flickr, and others. A quick search for your destination is likely to turn up many pictures – a search for even the most obscure backwaters can produce a huge selection of images. True, this may spoil the fun

of "discovering" the place for yourself, but it's the equivalent of scouting a location before a shoot, itself a thoroughly professional practice.

Take advantage of this vast library of images, and work out ways in which you might improve on existing shots, such as a slight change in position, or in the choice of lighting. This, incidentally, helps your own photography because you're actively analysing images. And if you see the same shot time and again, it's a sign of an official viewing position with limited freedom of movement – an obvious one to avoid.

DID YOU KNOW?

X-ray machines at airport security can damage film, but they don't appear to do any harm to digital cameras or memory cards. This seems to be the consensus from formal and informal testing, as well as a wide range of travellers' experience. However, the machines used to check hand luggage are less powerful than those used on checked-in items, so, to be on the safe side, it's best to keep critical items such as camera, memory cards, and hard-drives in carry-on luggage. Also, ensure that you place memory cards in your bag: if you carry them on your person, in theory the data they carry could be damaged by the magnetic fields of the metal detectors.

AERIAL OPPORTUNITY

Grab a window seat away from the wing the next time you fly, and capture highlights from the parade of wonderful sights passing under your plane.

New sunsets

You can't get away from sunsets: the fusion of light and colour is so often irresistible. But you can try to seek out unconventional viewpoints, such as this ultra-wide-angle view of Singapore from the roof terrace of a hotel.

Expeditionary forces

In contrast to creative travel photography, an expedition photographer – for example, on a trip gathering data on geology, or plant life – has the core task of documentation (though creative shots may also be needed). Should you be lucky enough to find yourself in this position, bear in mind that the expedition photographer must shoot every step of the way: preparation, transit to base camp, and all aspects of field research. Each specimen, interview subject, and location must be recorded. Thankfully, keeping accurate records is much simpler than it was in the past – with digital capture, it's easy to ensure that all images are tagged by the end of each day with date and time, location, subject, and observations.

The responsibilities of an expedition photographer cover not only recording the entirety of the expedition and research, but also the picture needs of other stakeholders, such as sponsors or grant donors. In this situation, you'd usually try to retain your copyright in the work, and give the expedition organizers a portion of any proceeds from sales of the images, which they might also use for promotional purposes.

With geotagging – embedding GPS (Global Positioning System) data in the image file – now commonplace, you can record the location of your images automatically, wherever you are in the world. Images can be tagged to a level of accuracy that enables you to zero in on the spot where the photographer stood; this resource takes travel photography into new dimensions.

Challenging conditions

Whether on an expedition or on holiday, you need to protect your camera from extreme conditions. Long-term coverage of the Iraq war has shown that digital cameras stand up well to hot, dry environments, but avoid changing lenses in the open to minimize exposure to heat and dust. In hot, damp climates, digital cameras suffer less than film ones, provided they are protected in lightweight underwater housings in heavy rain. Store in airtight cases with sachets of silica gel to absorb moisture. In extreme cold, a camera's battery life may be reduced, and LCD displays may not function; to prevent damage from condensation, place your camera in an airtight bag when bringing it in from the cold.

Atmospheric weather
Travel shots don't have to be all about sunshine and bright
skies. As happened here, the true character and atmosphere
of a place may reveal itself during a downpour.

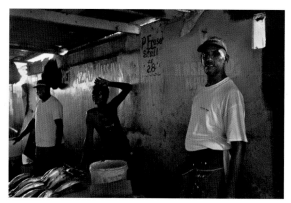

Trading conditions
Not all markets are colourful and picturesque. This one
was not at all pretty, and had an edgy atmosphere. But the
traders were won over with eye contact and a friendly smile.

Beautiful bric-a-brac
On first entering this shop, the overwhelming impression
was of an unphotogenic chaos. But with a little patience
I organized the light and reflections into a composition.

Around the edges

The popular sights at any tourist destination get all the
attention, but the most interesting subjects are often
found at the fringes of the main attraction, because that's
where the ebb and flow of life takes place. For example,
the Eiffel Tower in Paris looks much the same from one
century to the next, but around it there is constant change
in the form of the shops and street vendors, the activities
at its base, and the people who visit.

▼ THE BRIEF

▷ At your next holiday destination, make one
of your projects a subject that you'd normally
ignore. You might choose to shoot shop
fronts, street furniture, advertising posters,
bus shelters, street food, graffiti ... the list is
endless, and so are the possibilities for making
unexpected discoveries.

▼ POINTS TO REMEMBER

▷ **You can experiment with using a
consistent approach** to different subjects,
such as shooting from the same angle, or
with same focal length setting.

▷ **Night-time shooting** offers many
opportunities for capturing fringe scenes.

▷ **You don't always have to work in colour:**
black-and-white images reduce the clutter
created by different colours in busy scenes.

▷ **Images don't always have to be pin-
sharp** or precisely framed: you can
always try a more spontaneous, free-
form kind of shooting.

GO GOOGLE

☐ Ansel Adams	☐ Hiroji Kubota
☐ Edward Burtynsky	☐ Chris Steele-Perkins
☐ Andre Gunther	☐ Diane Varner
☐ Andreas Gursky	☐ Bradford Washburn
☐ Bob Krist	☐ Mike Yamashita

Crowded clichés

Venice is one of the most maddeningly photogenic places in the world. But it's almost impossible to capture an image that isn't a cliché, as it seems everyone has been there before you. The final image in this sequence, while far from perfect, is also far from the usual, run-of-the-mill shots of the Grand Canal. On one level, it's a lively shot that brings together the key elements of glorious architecture, gondolas, and tourists. But it's also a serious statement about how the city is choked with visitors, who soon move on.

▷ Sony A900, 24–70mm *f*/2.8 : 60mm *f*/14 ISO 200 -0.3EV 1/40sec

FROM THE SAME SERIES

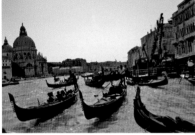

1 Rush hour
It's impossible to avoid other tourists in your shots of Venice, so accept them as part of the city's character. This image captures some of the hustle and bustle, with several gondoliers jostling for space, but it's also a rather ordinary shot, and it tells us nothing we don't already know.

2 Reflected glory
On the numerous water buses, you can spot the visitors as the people fighting for clear views. On this trip all the window seats were taken, but I still managed to find some interesting shots – images of the canal doubled up and reversed in reflections on the glass.

3 Empty waters
While the reflections in the windows were rewarding to explore, I noticed that more complicated scenes could be captured through them. Nearby and distant elements began to converge promisingly, but just when I needed a gondola in shot, there were none to be seen.

4 Chaotic outlook
By the time a gondola came into view, there was too much going on. A jumble of similarly sized objects were fighting for attention – unlike the main image, here there's no dominant shape or subject to hold the various elements of the composition together.

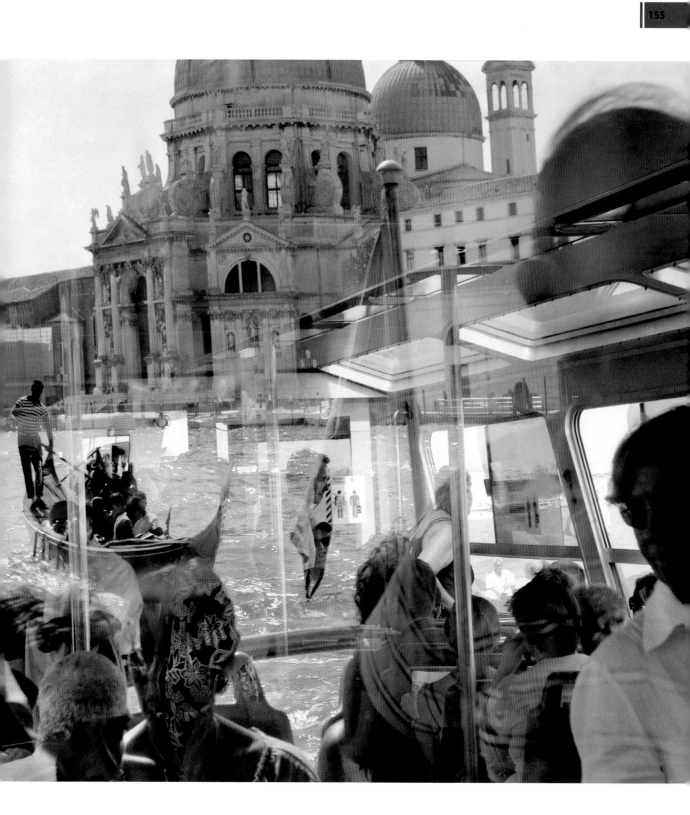

Ethical questions

COPYING FROM THE INTERNET

PROBLEM
There are many interesting images on the internet, and you want to make copies of them to help you learn more about photography. You would also like to use a copied image as part of a larger composition.

ANALYSIS
Your computer or handheld device makes a temporary copy of every image you view on the internet. But when you make a permanent copy – when you download an image or save a screenshot – you may be infringing copyright. The fact that you are highly unlikely to be found out does not annul the act of wrongdoing.

SOLUTION

▷ If an image is worth copying, it is worth something: the right thing to do is to ask the creator for permission.

▷ You shouldn't use someone else's image as the basis of a new work, as it may qualify as a derivative work and still be subject to copyright.

▷ If you use the image for study or research purposes, your copy might be exempt.

▷ There are many sources of free images available on the internet – use these for inspiration instead.

ARTWORK IN PUBLIC VIEW

PROBLEM
You'd like to publish or sell a photo of an artwork situated in a public space, such as a mural, sculpture, monument, temporary installation, piece of graffiti, or light show.

ANALYSIS
The copyright residing in an artwork will belong to the artist or the owner of the site. In theory, any photograph taken of the artwork will constitute an infringement of their rights, but in practice no-one will go after you if you don't make commercial use of the image.

SOLUTION

▷ You should not use a photograph of an artwork as a basis for deriving a new image.

▷ If you photograph a building and the artwork appears as an incidental part of the image, the artwork may not affect your use of the picture. However, you may need permission to sell pictures of the building itself.

PHOTOGRAPHING PEOPLE

PROBLEM
You want to take a photo in a public place, but it's difficult to take a shot without unintentionally getting other people in the frame. On other occasions, you'd like to take photos of people in crowd situations.

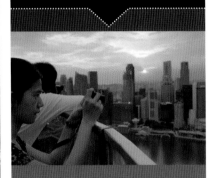

ANALYSIS
Spaces open to the public are not all public spaces as such – you may even be looking into a private space, such as a house or an office building. In some countries, the legal presumption is that people can go anywhere on their private business: their presence in a public space has no effect on their right to privacy.

SOLUTION

▷ If you're taking a picture of an individual, it's advisable to ask permission first: this will get you the best picture, and also avoid offence.

▷ Photographing people en masse, such as at a carnival or on a busy beach, is often acceptable; however, be prepared to stop if an individual within the field of view objects.

▷ Use instinct and common sense: if it doesn't feel right, it probably isn't.

INTERACTING WITH WILDLIFE

PROBLEM
As wildlife photography is now such a popular pursuit, it's tempting for tour operators to make it easy for photographers to capture amazing shots by luring animals into view using food or other means.

ANALYSIS
The welfare of the animal and the conservation of its habitat is paramount. Baiting – using food to attract animals – can make animals dependent on handouts, which is ecologically unsound. Use of live bait is completely unethical and unacceptable.

SOLUTION

▷ If you want to photograph normal animal behaviour, you may have to wait for weeks for the genuine shot.

▷ Book tours that practise sustainable tourism by limiting the use of bait, contribute to animal care and habitat conservation, and act with respect for animal welfare. Check that the tour operators are accredited by professional bodies, and do some research to find out what other people have to say regarding their experiences on these tours.

IMAGE MANIPULATION

PROBLEM
Your photo could be significantly improved with some simple image enhancement and manipulation: for example, a distracting minor figure could be entirely removed to give a composition more impact.

ANALYSIS
The level of acceptable manipulation depends on the context in which the image is used and the reasonable expectations of the viewers. Ask yourself whether, by not declaring the alteration, the integrity of the photographer and the credibility of the source where the image may appear will be damaged.

SOLUTION

▷ Corrections to exposure, tone, and white balance, and the removal of dust spots, are universally acceptable.

▷ Visual refinements, such as dodging and burning, as well as light cropping, are widely permissible.

▷ If the image is to be used for documentary purposes, such as news reporting, adding elements to, or removing elements from, an image is not acceptable.

▷ Composite images or montages are acceptable in art, games, and movies.

SELLING PHOTOS

PROBLEM
You have a photo of someone that you'd like to sell as a print or place with an agency, but you don't know whether you need a model release from the person in the picture.

ANALYSIS
A model release is a contract between you and the model, which says that he or she allows you to use the images taken at a particular session in return for a fee. The fee may be a token amount, but it must be paid for the model release to be valid.

SOLUTION

▷ If an image is used for high-revenue work, such as in advertising, a model release is obligatory.

▷ Pictures used editorially, for instance, to illustrate a magazine article, a travel book, or a personal website, generally do not require a model release.

▷ Use model releases for the avoidance of doubt, whether the person is well-known to you or not: make sure you get a signature every time.

▷ Even if you have a signed model release, the caption accompanying the image should be accurate.

Architectural photography

The traditional approach to architectural photography treats the building with reverence; we tiptoe around as if under the watchful eyes of the people who built it, and attempt to depict the edifice with fidelity to the architect's intentions. This is true whether the structure is two months or two millennia old.

An alternative approach uses the built environment as a springboard for freely creative interpretation. The two methods often result in wildly different conclusions. The middle way – of producing a creative interpretation that also respects the building's design – is the ideal.

Each man-made structure has a purpose, whether it be a place of worship, a monument, a commercial building, or someone's home. Observe how people interact within the space, and aim to capture the spirit of the building while at the same time illustrating its function. Consider the building's context: does it fit in with its environment, or does it clash?

Seeing the light
Another key consideration in architectural photography is lighting. Take advantage of shadows and bright areas that reveal textures, create shapes, and illuminate colours.

A special problem is the need to balance interior lighting with exterior conditions, which are usually much brighter. Take your shots, if you can, during the "magic hour", the times just after dawn and shortly before sunset: this reduces light-balance problems, and the quality of light is often at its most alluring.

The parallels problem
Architectural photography, however, is susceptible to one particular technical problem: the convergence of parallels. Whenever the camera does not face square-on to a rectangular surface, one or more sides will not appear parallel but will seem to converge. In particular, converging verticals, caused by pointing the camera upwards, make buildings or walls look as though they are leaning backwards.

Converging parallels can be controlled by using a shift lens: these lenses have a mechanism that lifts the lens upwards, allowing you to take in more of the upper part of a building. You can also use a wide-angle lens to capture the whole of a building. Keep the camera level, and crop out any excess foreground with image manipulation software. You can also employ distortion tools to change the shape of the image (see pp.202–03).

CLOSE AND WIDE

A close-up shot of St George's Cathedral in Georgetown, Guyana, is dramatic but uncomfortably distorted (top right). Even an ultra-wide-angle view, used at the furthest point from the cathedral with a focal length of 12–15mm, results in converging parallels, as the lens had to point upwards to catch the full height of the spire (top far right). The next shot almost does the trick, but loses the spire (bottom right). A carefully framed close-up, nevertheless, maintains the straight lines and captures the character of the building by focusing on the details (bottom far right), showing its weatherboard construction.

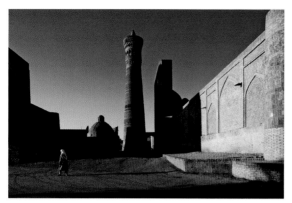

Morning glow
The beauty of the Kalyan minaret and Mir-i-Arab madrassah in Bukhara, Uzbekistan, is given depth by the extremes of light and shadow on the old, worn stone.

Know all the angles
Contextual shots – showing the building in relation to its surroundings – are your opportunity for an unusual angle exploring reflections, light, and colour.

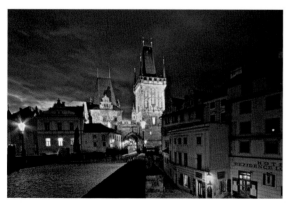

In the spotlight
Floodlights illuminate the tower on the western side of the Charles Bridge, Prague. The sky looked almost black, a sign that a foreground exposure could capture the colour of the scene.

Form follows function

There is a wealth of variety in every detail in buildings from Yemen to Japan, and from Nepal to the English countryside. Each region has its own architectural characteristics and adaptations to suit local conditions. Add to this the different architectural styles that have been developed over the centuries, and you have plenty of interesting facets to explore.

▼ THE BRIEF

▷ Turn yourself into an expert on the forms and variety of a specific aspect of architectural design. Choose arches, columns, ceilings, balconies, flying buttresses, aerial walkways, or any other element that interests you. Search for these features wherever you go and work on the project over several months: build a portfolio that will become more valuable and informative the larger it grows.

▼ POINTS TO REMEMBER

▷ **Decide whether you'll approach the subject objectively** to photograph the feature as accurately as you can, or whether you'll impose your own interpretation on it.

▷ **Think about how much of the structure you want to show.** Will your shots focus in to create small, abstract forms, or will you attempt to encompass the whole building?

▷ **Use a panoply of photographic techniques,** keeping them appropriate to the subject. For instance, zoom in to show the detail of intricate mosaics, or take black-and-white shots of a ruined castle on a stormy day.

GO GOOGLE

☐ **Islamic architecture**	☐ **Eugène Atget**
☐ **Baroque architecture**	☐ **Frank Lloyd Wright**
☐ **Christopher Wren**	☐ **Eric de Maré**
☐ **Art Deco**	☐ **Berenice Abbot**
☐ **Edwin Smith**	☐ **Jean-Claude Berens**

Interior worlds

There is a continuing demand for excellent photographs of interiors, and shooting home, office, and business interiors is one of the few areas of photography in which the professional still dominates. It demands someone trustworthy, methodical, and technically adept; and, while it's perhaps not the most glamorous subject, it also offers plenty of scope for creativity.

In terms of approach, the basic requirements are similar to architectural photography (see pp.158–59). You need to show the space at its best – there's no need to convey strong emotion, or hint at hidden meanings. Interiors are ideal subject matter for the photographer who wants a quiet life, and for whom self-effacement comes naturally.

The style of no-style

Your primary photographic controls for shooting interiors are position and aim, and both need to be judged to millimetre-accuracy. Lighting can be both technically and stylistically challenging. Light levels are often limited, and, while you need to add light to the scene, you must ensure that you maintain the character and atmosphere of the

space. Long exposure times are useful for this (see pp.60–61). For work requiring this level of precision, and the necessary exposure times for low light, a tripod is almost as important as the camera itself – a geared tripod head is best, as it makes fine-tuning quick and easy. Avoid the temptation to use an ultra-wide-angle lens to take in the whole room: it's impossible to avoid deforming object shapes at the edges of the image (this effect is not the same as lens distortion, in which straight lines are rendered as shallow curves). Lenses with little to no visible distortion – typically less than four per cent – are obligatory. A 24mm focal length offers a useful compromise, giving an 84-degree field of view.

Props and features

Don't forget that much of the character of an interior space comes from its contents, and this can be used to your advantage. You may have limited permission to move small objects around to improve the shot, and you may add discreet props, such as flowers or candles – or you can simply work with whatever furniture and features are available as you find them. Use foreground objects to frame the more distant features; spots of bright colour are effective for bringing a dull or dark corner to life.

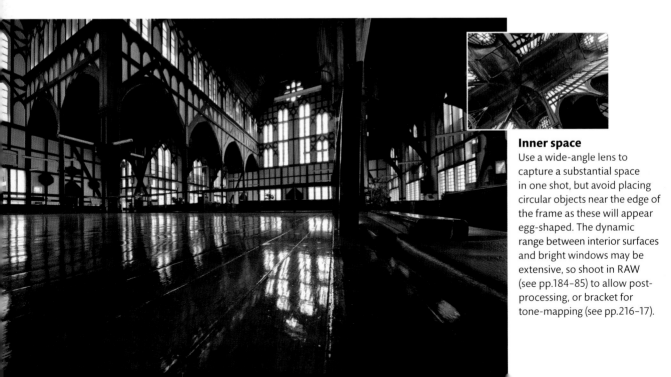

Inner space
Use a wide-angle lens to capture a substantial space in one shot, but avoid placing circular objects near the edge of the frame as these will appear egg-shaped. The dynamic range between interior surfaces and bright windows may be extensive, so shoot in RAW (see pp.184–85) to allow post-processing, or bracket for tone-mapping (see pp.216–17).

Foreground fill
One of the best ways to fill the foreground of level wide-angle views is to use reflections, as the resulting symmetry reinforces architectural lines.

Illustrating with light
You don't always need to show the full space: details of furnishings, props, or lighting may convey strongly the atmosphere and style of an interior.

Invisible lighting
This view of a hotel corridor makes use of four supplementary lights – aimed at dark corners, the painting, and the plant – that lift the image without being obvious.

Following the light

Interior spaces that receive any amount of daylight will change their character according to the hour and the season. In sunny rooms, the lighting can vary quite rapidly. In shaded rooms without direct sunlight, you may have to wait for the right time of year for the light to find its way in at all.

▼ **THE BRIEF**

▷ Create a project around the changing lighting in a room: watch and wait for light to transform the space and its contents into a small landscape of shape and shadow. Be ready to capture the scene at different times of day.

▼ **POINTS TO REMEMBER**

▷ **Select an exposure to balance** the light with the rest of the room: you may need to allow sunlit areas to burn out.

▷ **Vary your viewpoints:** the best viewpoint will change with the direction of the light.

▷ **If window light is very bright,** use tone-mapping (see pp.216–17) to control the excessive dynamic range.

▷ **To increase wide-angle coverage,** make two exposures with the camera rotated a short distance on its tripod between shots, then combine the images using stitching software (see pp.110–11).

▷ **It's not just about space:** observe how the shifting light interacts with a room's furniture and features, and compose accordingly.

GO GOOGLE

☐ Image stitching	☐ Carol M. Highsmith
☐ Lens distortion	☐ Candida Höfer
☐ Shift lens	☐ Oliver Sann
☐ Edgar de Evia	☐ Julius Shulman
☐ Beate Geissier	☐ Larry Sultan

Landscape photography

Landscape photography allows you to enjoy the widest possible scope for personal interpretation. At the same time, it's unforgiving of visual affectation: the further you stray from clear representation – showing what the landscape really looks like – the more obvious it is that you're imposing yourself on the scene.

The art of landscape photography is the search for an insightful, sensitive response to your surroundings. More than a portrait of topography, it's a record of your relationship with, and your interpretation of, the land around you. And, as with any process of discovery, it will take time for you to understand the landscape's true nature.

Taking the time
Don't expect to fall in love with a view just because it's recommended in guide books – different landscapes have different personalities. Your appreciation of scenery may also vary with the seasons, so explore different types of scenery at different times of year. The American painter Andrew Wyeth preferred winter, when he could "feel the bone structure in the landscape"; some are captivated by the sylvan colours of spring, others are inspired by the fiery,

> **MARCEL PROUST**
>
> The real voyage of discovery consists not in seeking new landscapes but in having new eyes.

saturated colours of autumn leaves. The seasons also affect your physical comfort, which in turn affects your emotional state. Your photographic eye will respond more or less favourably depending on your own preferences.

Even the most photogenic places will reveal more of themselves with repeated visits, in different weather and varying lighting – remember that all light is good, and it's useful to learn to work with, and embrace, whatever conditions you encounter.

Land in monochrome
As an occasional exercise, try setting your camera to record in black and white: stripped of colour, the structure of the land becomes much more apparent. Furthermore, you'll

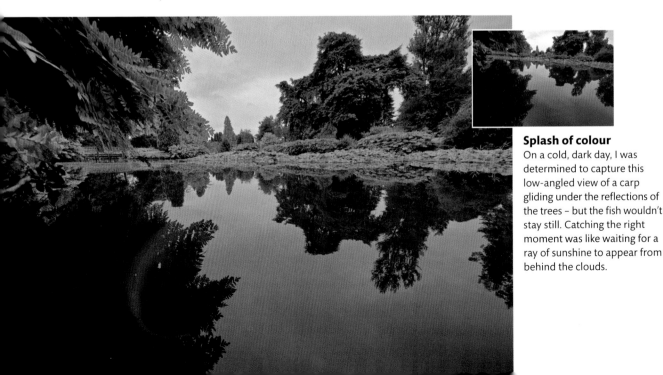

Splash of colour
On a cold, dark day, I was determined to capture this low-angled view of a carp gliding under the reflections of the trees – but the fish wouldn't stay still. Catching the right moment was like waiting for a ray of sunshine to appear from behind the clouds.

A single lens can prove highly versatile, if you're prepared to put in the legwork. The variety of scale and perspective in these images belies the fact that they were all shot with a 100mm lens. Increasing the scale of the foreground emphasizes the receding space, creating a "wide-angle" view, whereas distant foregrounds tend to compress space, suggesting a long focal-length view.

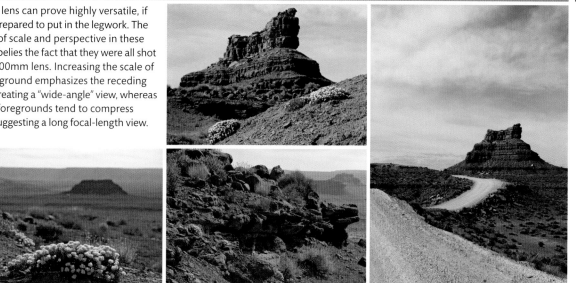

have to work with the fact that some colours that look very different to the naked eye – such as greens and dark reds – may be rendered as very similar tones of grey. For example, the picture of the carp opposite would lose almost all its impact in black and white; in this setting, you might concentrate on some other aspect of the scene, such as the outlines of the trees.

The long way round

A good way to sharpen your composition skills is by restricting yourself to using a single focal length for a day. This forces you to explore far more than you normally would, as you can't adjust how much of a view you capture simply by using the zoom control. You'll quickly learn that the most important element of landscape composition is not the field of view – which varies with focal length – but your perspective, which changes with every step you take. One step improves the composition; the next step isn't so promising, so you take another step in a different direction – if you want to capture fully what a landscape has to offer, you must be prepared to cover the distance.

Dramatic angle
It's difficult to photograph very tall trees without looking up; you can make a virtue of necessity by exaggerating converging verticals, with a wide-angle view and steep aim.

Modern zoom lenses offer focal length ranges that give you unparalleled versatility for homing in on details, or taking in the broader view. For the best ultra-wide-angle views, a specialist lens is better than a wide-angle attachment.

Urban discovery
For a brief moment, this normally busy road was empty, and revealed its grace with deft contrasts between man-made and natural elements, shown here in a sepia-toned black-and-white image.

Framing the scenery
Virtually all cameras are easier to hold for horizontal, or landscape, shots, and this is the format most people choose to convey a feeling of expansive space. However, even when photographing landscapes, it makes sense to turn the camera 90 degrees and shoot in portrait format if the shot demands it, for example when you're close to – and looking up at – a tall tree or building, or when you're gazing down into a void. Portrait format is especially useful for capturing a sense of receding distance, as it fits a lot more of the foreground and sky into the frame than a landscape-format view.

Don't be afraid to try shooting at an angle to the horizon, if it feels appropriate to the setting. This cinematic approach often works well with wide views in enclosed spaces, such as within a forest, because the angled lines and framing can create a strong disorientating effect, reminiscent of the dizzying sensation you feel when you spin around to take in a whole view.

Concrete jungle
More than half of the world's population live in cities, and to ignore the urban landscape is to deny yourself a host of exciting photographic opportunities. While built-up environments are totally different from open landscapes, the challenges they present are very similar. There's the ceaseless quest to refine your viewpoint – looking for ways around obstacles to reach the perfect position. And in cities as much as in the countryside, you'll have to wait for the changing light to work its magic. But you'll also have to deal with specifically urban problems, such as overzealous security guards, and the fact that, as a photographer working in a public place, you need to be aware of your surroundings and stay safe.

Rather than walking around with a dSLR mounted with a large lens, it's a good idea to use a compact camera when you're making pictures in urban areas in developed as well as less-developed countries, and in low-income or impoverished environments. This will help foster the impression that you're "only an amateur", shooting for fun – as opposed to a professional working for commercial gain, which may bring unwanted attention – as well as making it clear that you're not carrying a lot of expensive camera gear.

URBAN PEAKS

City skylines are the mountain peaks of the urban landscape, and they present similar problems – you need some distance to appreciate them, but not too much, or they become too small. But the big difference is that city skylines light up at night, and they can look beautiful against the light of dusk and early evening. Once I'd found this vantage point overlooking Singapore's skyline, I kept returning to it at different times of the day to explore the effects of changing light.

Contrasting ideas

It's easy to talk about the contrasts between different views of the same landscape, but rather harder to create them in photographs. One of the reasons for this is that, regardless of perspective, a landscape imposes a strong sense of its personality on the viewer – and this, after all, is why we're attracted to it in the first place.

▼ THE BRIEF

▷ Produce two images of the same location, taken close to each other. Use composition, perspective, and framing to make the two views as different as they can be.

▼ POINTS TO REMEMBER

▷ **Maintain the same format** – both should be either portrait or landscape orientation.

▷ **Use the same colour mode.** Whether you choose colour or black and white, make sure to apply this setting to both images.

▷ **Don't create differences** between the images through image manipulation; try to achieve difference solely through in-camera control.

▷ **Choose and maintain a style** for both images, such as high-quality colour, dreamy haze, or imitation pinhole camera black and white.

▷ **You can create contrast** with differences in perspective and scale through control of focal length and viewpoint.

GO GOOGLE

- ☐ **Neue Sachlichkeit**
- ☐ **Pictorialism**
- ☐ **John Blakemore**
- ☐ **Peter Dombrovskis**
- ☐ **Fay Godwin**
- ☐ **Per Bak Jensen**
- ☐ **Michael Kenna**
- ☐ **Shinzo Maeda**
- ☐ **Paul Raphaelson**
- ☐ **Brett Weston**

Chasing rainbows

Kaieteur Falls, in Guyana, is one of the great waterfalls of the world. Surrounded by rainforest, it requires an overland journey of several days to reach it, so most people fly to a small airstrip instead. This was not to be a leisurely landscape shoot. For a few seconds of intense concentration, all instincts for composition and control of the camera's technical functions had to work together. We also needed a bit of luck: all large waterfalls will have a rainbow, but only if the sun is shining.

▷ Canon 5D MkII, 28–135mm *f*/3.5–5.6 : 47mm *f*/5.6 ISO 400 -0.67EV 1/2000sec.

FROM THE SAME SERIES

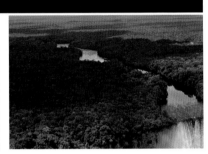

1 **Window of opportunity**
The aircraft offered limited views through the arc of the propeller blades from all but the co-pilot's seat. We would circle the waterfall just once, and it could be seen from only one side of the plane. I was on the wrong side, and my attempts to shoot through the co-pilot's window failed.

2 **Snapping at speed**
Fortunately my wife Wendy was seated in a better position. During the 97 seconds in which she had a decent view she managed to make 65 exposures. Most were spoiled by propeller blades, or were awkwardly framed because of the angle of the plane: but the shot on the right is hers.

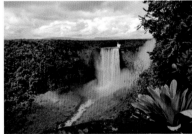

3 **Bird's-eye view**
As we flew directly overhead we had a vertiginous view of the sheer drop of the falls, and an exhilarating sense of the enormous power of the water. But this did not guarantee that our images would capture the drama and true dimension of the spectacle.

4 **At ground level**
On the ground there were several viewpoints from which to see the waterfall, but all were on bare, slippery rocks, without barriers to protect you from a massive drop. They gave splendid but static views; the best – very close to the falls – took more courage and energy than I had that day.

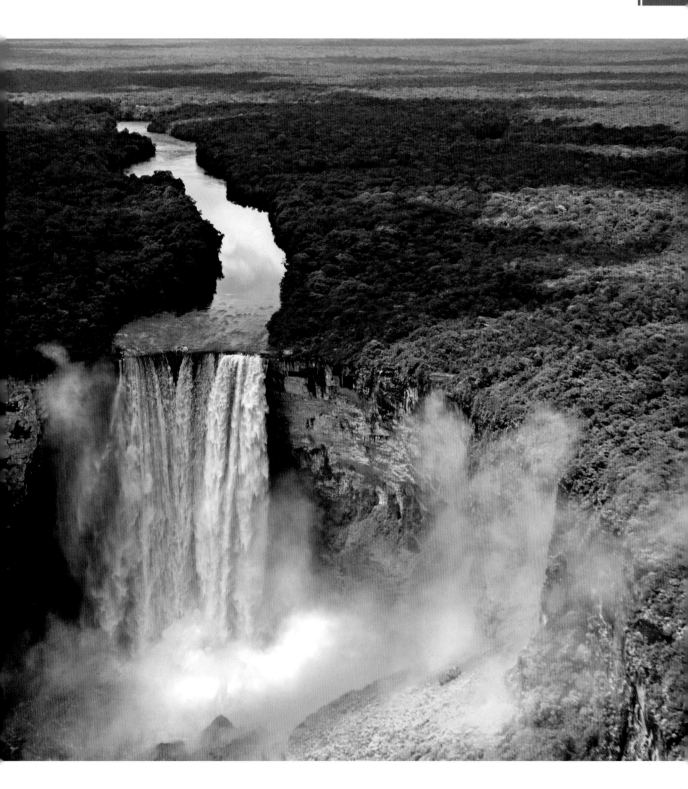

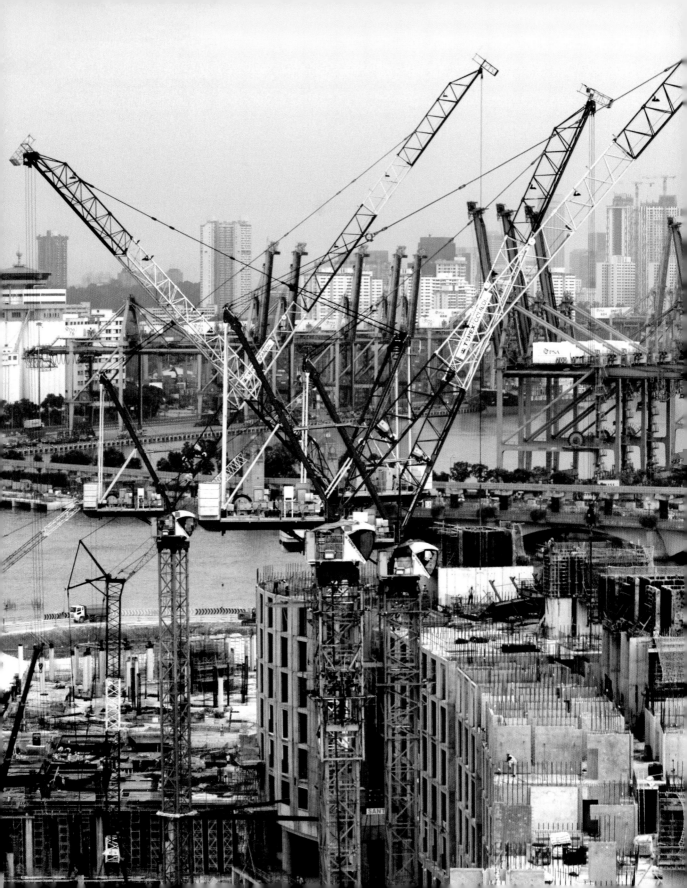

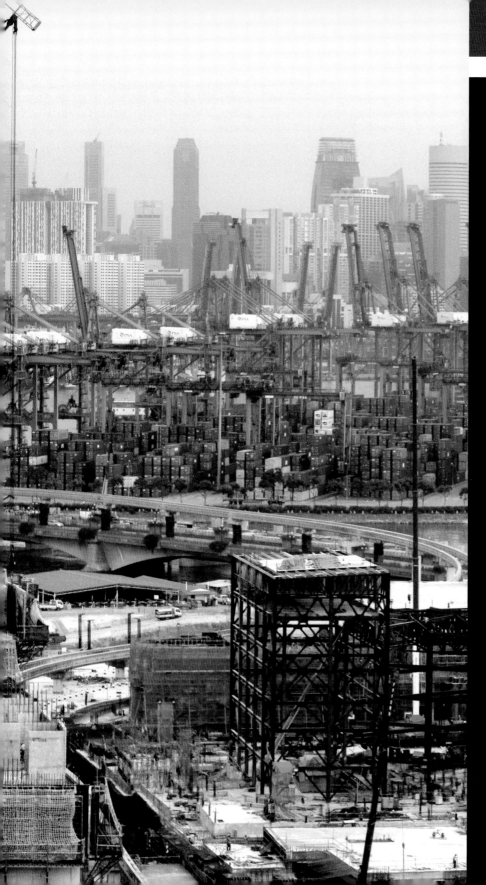

OPTIMIZING WORKFLOW

Workflow strategies

It is both exciting and daunting when you face a fresh batch of images. Maybe there's a prize-winning shot in there, or perhaps you forgot to photograph a key person. The temptation is to dive straight in to see what you've got, but if you're not to spend days in front of the computer scrolling back and forth through hundreds of images, an organized workflow is needed.

The preferred strategy is to match the flow of work to suit each project. If you shoot for personal use, you can work with a scheme that can fine-tune one image at a time. Much of the time, the simplest route is best, so start by setting up your camera so that you can use the images immediately – on photo-sharing and social networking sites, or for printing out – without any post-processing

INGEST

1 Upload images into a new folder. Add metadata such as date, location, and copyright. Rename the images with sequential numbering (for example Malta001, Malta002). Back up to a secondary disk.

INSPECT

2 Check a sample to ensure that they are sharp, well-exposed, and with accurate white balance. If your camera doesn't turn portrait images upright, do so now. Perform these two steps soon after you've taken the shots.

EVALUATE

3 Examine your images and apply ratings to rank the firsts, seconds, and rejects. Use a calibrated monitor for a careful evaluation of colour, exposure, and overall quality.

SOFT PROOF

7 Check how the image will look when printed out by examining the proof colours: view with an applied output profile for your printer. Look for out-of-gamut colours (see pp.178–79), and readjust as required.

CLEAN THE IMAGE

8 Examine the image closely and remove any flaws. Don't repair it before applying your adjustments, as increases in contrast, saturation, or sharpness may reveal clean-up efforts, and you'll have to do them again.

FINAL EFFECTS

9 Leave noise reduction to this step unless it was part of the RAW processing (see pp.184–87). Apply sharpening, if required. Check that no artefacts have been introduced, and contrast is not too high for portraits.

(see pp.20–21). Enjoy the benefits of this efficient workflow before you think about creating extra work for yourself: it's when you need to make increasingly stringent demands on image quality that the extra effort will be justified.

The flowchart below sets out the basic steps you can incorporate into your workflow – but, as you become more experienced, you'll want to tailor it to your preferences.

DID YOU KNOW?

One of the key decisions you'll need to make will be whether to use the same application (such as Adobe Lightroom, Apple Aperture, or ACDSee) to manage and correct your images, or whether to use different software for each task (see pp.176–77).

APPLY CAPTIONS

4 Write and apply captions while you can remember all the details. Add other useful data, such as geotags – though you should add geotags for holiday locations only, rather than reveal personal location information.

SET UP

5 Create a new folder for files in process. Save images with new filenames rather than working on the original. If possible, use a storage device different from that holding the original image. Straighten, crop, and resize.

ENHANCE

6 Correct exposure and contrast to normalize the blacks and highlights (note that colour adjustments and sharpening may heighten contrast). At this stage apply drastic changes, such as conversion to monochrome or sepia.

PREPARE

10 If you used layers, use "Save As" to keep the layered image in case you wish to modify the corrections you applied. Prior to export, flatten and resize the image, and save it in the required format – JPEG is a safe choice if you're not sure. Define a preset for exporting the images: for example, for a website portfolio, choose 720 pixels wide, medium quality, sRGB. Rename the images with a serial number so that they are readily identifiable by you, and as your work (for instance, "tomang_iwokrama_001.jpg").

EXPORT AND USE

11 Export directly to the target destination, such as from Adobe Lightroom into Facebook, so you don't make any unnecessary copies of files. If you can't export directly, create a folder before exporting the files into it.

ARCHIVE AND TIDY UP

12 If you have created any folders for temporary files or files for download, remove them from your main machine once you've completed the task. Store on back-up media such as portable hard-disk drives. Removing used files keeps your computer responsive and removes clutter, making it easier for you to work on current material. Double-check that you have two copies of images from your memory cards, then reformat the cards in your camera so that they are empty, ready for reuse, and working at their fastest possible speed.

File problems

ACCIDENTAL DELETION

PROBLEM
You have deleted some images. You'd like them back, but you're not sure where they are or how to retrieve them, because you cannot find them on either your camera or your computer.

ANALYSIS
If you deleted the images from your memory card, stop using the card at once and put in another: you can recover the files, provided you don't overwrite them with new images. If you deleted them from your computer, don't empty the Trash or save any new files.

SOLUTION
▷ Use image recovery or rescue software to retrieve files from your memory card. Some are supplied free with your card and are easy to use.

▷ Look on your computer in the Trash or Recycle Bin for your images. Drag likely-looking files onto your desktop.

▷ If you've already emptied your Trash or Recycle Bin, stop saving any new files immediately and use recovery tools, such as Unerase for Windows, or Data Rescue or R3cover for Mac OS X.

DAMAGED CARD

PROBLEM
Transferred images show strange colours, overlap one with another, or may not show up at all. The computer may have problems communicating with the memory card, or the card may misreport its capacity.

ANALYSIS
If the card is visibly damaged – bent, with scratched pins or misshapen holes – the cause is obvious. If there is no apparent damage to the card, it may have overheated in the sun (or been affected by another heat source) and become too hot, or been left near a powerful magnet, such as a loudspeaker.

SOLUTION
▷ If the card is obviously damaged, don't use it again: it could damage the camera's card reader, which will require a costly repair.

▷ If there's no visible damage, try downloading the images again using a different method, such as from another card reader or directly from the camera.

▷ If your camera has internal memory or has two card slots, transfer the problem files to the internal memory and re-transfer to a fresh card.

TROUBLE DOWNLOADING

PROBLEM
You have connected your camera to the computer, but your images won't download; your card reader may not be recognized by your computer; or images may be visible on the camera but don't transfer to the computer.

ANALYSIS
Your camera may not be set up for your computer to recognize it as a drive. If you recorded in RAW, the software may not recognize the format. The images may have downloaded to a different folder from the one you expected.

SOLUTION
▷ Set your camera to "USB device", "Data Drive", or a cognate term before connecting to your computer.

▷ Use the software supplied with the camera to download the RAW files, or update your image management software.

▷ Some systems ingest images as soon as a camera or memory card is attached: check the preferences panel to see where your files are being saved.

LOST IMAGES

PROBLEM
You can't find certain images; images you thought you'd downloaded don't appear to be where you left them; or you can see some images in a folder, but not all of them.

ANALYSIS
You may have inadvertently moved some images into another folder. You may have set your viewer to show only certain files, such as those with a one-star grading. You may have changed the order of file display, for example, with date descending rather than ascending.

SOLUTION

▷ Use the computer's file search utility to locate the image: refer to the file on the memory card for the number. You need only search for one image, as the others are probably in the same folder.

▷ Set your image viewer to show all images.

▷ Files can be displayed by filename, capture date, or modification date, and in descending or ascending order. Check your settings.

HARD-DISK DRIVE CRASH

PROBLEM
The hard-disk drive containing your images crashes, that is, it stops working, whirrs and clicks ineffectually, is not recognized by your computer, or makes your computer freeze.

ANALYSIS
Your hard disk may need software repair of the files used to manage the data and control permissions. Your computer may have developed a fault (in the connectors, for example). Your drive may need to be disassembled by experts in order to rebuild the files – a very expensive procedure.

SOLUTION

▷ Don't panic. Get a spare hard-disk drive in case you get the drive working again.

▷ Try using the drive on another computer: your connectors may be faulty.

▷ Run a disk-repair utility: you may need to do this two or three times. If the drive recovers, copy everything important to the new drive, but only copy what you need to.

▷ Maintain your drives regularly with utilities such as Disk Doctor or DiskWarrior.

MISBEHAVING CARD

PROBLEM
You have deleted all the images from your memory card but it appears to hold less memory than before. Perhaps the card is not recording as quickly as it used to, or it records fewer images than originally displayed.

ANALYSIS
Deleting images may not fully clean up a memory card. The camera displays only an estimate of the card's capacity, based on average file sizes for the resolution set; your "mileage" may vary depending on noise levels and other factors.

SOLUTION

▷ To prepare a card for use, perform a low-level format in your camera, using the maintenance menu settings. Do not format cards in your computer.

▷ Formatted cards work quickly because data can be added to them sequentially.

▷ Noisy images created by high sensitivity settings don't compress compactly, so the resulting files are much larger than images with low noise levels. Upload the images to your computer, then delete them from your card to free up space.

File formats

File formats define different ways of organizing an image's digital information. While the bulk of an image file is the image data itself, in order for software to read this, it needs to know how the data has been organized – rather like knowing how to recognize paragraphs and chapter headings in written text. This information is also contained in the file.

It's a sign of digital photography's growing maturity that there is a universal format for images, that all cameras record and all software can work with. Above all, it's the one the internet uses. This is JPEG (Joint Photographic Experts Group): it's the main format you'll use for publishing your images. Where more image data is needed, TIFF files are also used.

JPEG

JPEG is a way of compressing data. It trades small file size against lower image quality by the level of the quality setting – a range of 1–12 in most imaging software (see below). The higher the compression, the lower the quality. However, this is "lossy" compression (see box), and discarded data can't be recovered, so err on the side of caution. When capturing images, save at high quality (low compression) to give yourself plenty of data for image manipulation at a later stage. When working with large images (see pp.106–07) you can use a lower quality setting than with smaller ones. It's often

recommended that you don't save and re-save files in JPEG as each save loses more data. In practice, re-saves at mid- to high-quality settings make little difference to quality.

TIFF

TIFF files are high-quality images, popular with publishing professionals as they hold more colour information than JPEGs, but with much larger files. TIFF files can be compressed without any loss of data.

DID YOU KNOW?

Different types of file compression are needed because a file's data is structured differently when it's in storage and when it's in use. Consider how a shop would store its stock. Originally the items are tightly packed in boxes in the storeroom. But for use, they must be unpacked and displayed to be easily seen and conveniently reached. TIFF files compress data grouped together by type, in an organized manner and with a record of what's there – like a full, tidy, storeroom. This is a lossless scheme, because it retains the full range of data, but takes up more space. JPEG, in contrast, compresses data with different types mixed together, and when it "throws out" data to save space, certain elements are lost. This is known as lossy compression.

COMPRESSION AND QUALITY

Original image 1.1 MB
The source file was over 5,000 pixels wide, and is reduced here to 720 pixels. No loss of quality is visible, as 720 pixels are plenty for this reproduced size. The uncompressed TIFF file is 1.1 MB in size.

Quality 0: 112 KB
In JPEG at the lowest quality, the file size is one-tenth that of the TIFF version. Quality loss is apparent in the uneven green tones and lack of detail. Sharpening also creates artefacts – speckles at the petal edges.

Quality 3: 116 KB
A significantly better quality setting incurs a very small penalty in file size – just 4KB larger – but tones are smoother and more detail is showing up in the veins of the petals, with fewer sharpening artefacts.

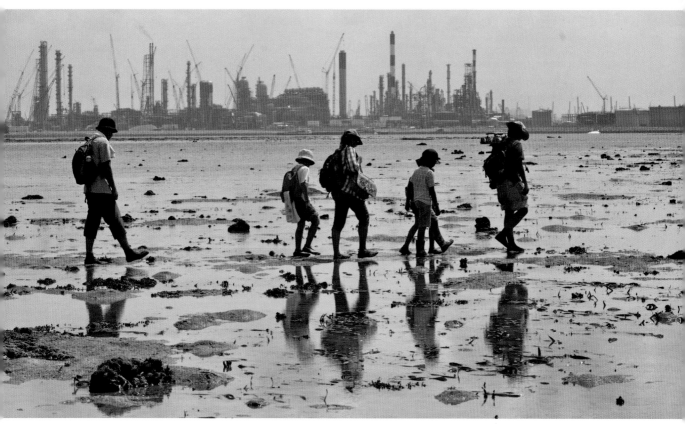

Colour depth

This image of a nature walk in Singapore appears to be lacking in colours with its pallid, overcast tones. Subtlety in colours, however, requires a lot of data in order to render truly smooth transitions in the tones in the water, and also to capture all the tiny details on the beach. To capture colour faithfully, at the bare minimum we need 256 levels, from deepest to palest, in each of the red, green, and blue channels. While an image may not use all the data, you will need the spare data space for tonal and colour adjustments.

Quality 6: 128 KB
At medium quality, artefacts are significantly reduced, resulting in fairly smooth dark tones and the veins in the petals becoming clearer. Although there are still some artefacts, the image is acceptable.

Quality 9: 148 KB
A further reduction in compression eliminates sharpening artefacts and provides more data to enable better results with adjustments, and the penalty in terms of increased file size is proportionally small.

Quality 12: 328 KB
At maximum quality, details are improved to the extent that noise in the shadows is becoming visible, but with only a subtle gain in mid-tone drawing. Tones are smoother, but at the cost of doubling the file size.

Imaging strategies

There was a time when we would have been relieved to load just a handful of images onto a computer without the system crashing. Now that we can routinely download hundreds of images at a time, we need to decide how to handle files efficiently to minimize the time spent at a computer, which will then allow us to enjoy as much time as possible out and about taking photographs.

How you manage your pictures depends on four main issues. The first is the number of images you capture: do you bring back thousands of images from a holiday or only a hundred? The next issue is the importance you attach to image quality: are your images for social networking sites or do you demand the highest possible quality? Then, decide whether the images are for your own pleasure or whether you hope to earn an income from them (see pp.294–95). Finally, how much do you want to manipulate your images?

Class distinction

If you use your photos solely for showing to friends and family – without manipulating them – you are a light user. Your file sizes will be small, which will make them easy to

JERRY UELSMANN

> It's equally hard and labor-intensive to create an image on the computer as it is in a darkroom. Believe me.

handle. The software provided free with your operating system, or other free software such as Picasa, is all you will need. Equally, if you enjoy photography and produce lots of images – but still mainly for fun – you will find free software such as iPhoto will meet your needs. While you may use better-than-average equipment, your file sizes should remain modestly sized. For any occasional image manipulation, you can use free online manipulation tools such as Picnik, FotoFlexer, and Pixlr.

Direct or proxy

When the number of images you have reaches a point at which you need to spend more than a minute locating a file, you'll know it's time for a different approach. You may

Convenience store
Image management software gives you far more ways to view and organize images than your computer's operating system. You can view your images at different sizes and arrange files in a variety of ways – even zooming in to check detail – then mark up images for future use.

The examples shown here are a small fraction of the potential variants of a very large, full-resolution image that you could keep on your computer, ready for use. Yet the previews and the small XML (Extensible Markup Language) set of instructions take up a tiny amount of hard-disk drive space. Keeping these variants as Photoshop files would occupy more than 100 MB.

continue to keep your files in folders on your computer's operating system and rely on the basic system tools to find your images. When you need to work on files, you can open them in image manipulation software, then save copies for use. This approach involves locating and working directly with the files themselves. It's convenient if you have only a few files and don't need to prepare them for professional use.

There is, however, an alternative method that, while it may sound long-winded, will ultimately save you time and disk space. It involves working on a proxy or low-resolution version of your image and using software such as Adobe Lightroom or Apple Aperture. You can create proxies by importing the files into the software's library or catalogue of images. Once in the library, you can enhance, manage, and re-purpose your images using a single piece of software. You can also enjoy features such as high-quality previews, and the ability to zoom into, collect, and group images, and apply ratings. Working with proxies also means that your master originals, whether they are JPEG, TIFF, or RAW files, remain safely untouched throughout.

Image architecture

When you import or register images with management software, you can either place them in a master collection or store them in another location on your hard disks. If you

have only a small number of images, it's more convenient to keep everything in one place. If, however, you have thousands of images, it's best to keep the library on a fast drive – perhaps the main one on your computer – and the master files on a separate, connected hard-disk drive. In this way, libraries can easily manage 100,000 images or more. Proxy-working software will apply only the basic image enhancement tools such as crop and resize, tonal, colour, sharpening, and Burn/Dodge. For more elaborate effects and for manipulations that require the use of layers, masks, and type, you will need to use manipulation software such as Paint Shop Pro, Photoshop Elements, and GIMP.

DID YOU KNOW?

Working with proxies means that all changes, including metadata entries, are applied to a catalogue entry for the image and saved as a list of instructions that is automatically updated with every change you make. It's only when you come to use the image, or "export" it, that all the changes are applied to the image. This means that you don't need to have lots of versions of different sizes littering your hard-disk drive – you only need to store the set of instructions with the proxies. Despite this, a library of 60,000 images can still be more than 45 GB in size – in addition to the master files.

Colour management

Managing colour is like dealing with currency. Depending on which country you're in, one unit can mean a dollar, a Euro, or a yen, and so on. Similarly, units of colour mean different things depending on whether they're being used by a camera, a monitor, or a printer. And like currency, you can convert from one type to another using recognized rates – colour profiles.

The same colour data can produce differing colours, because devices record and store colours in different ways – the differences may be obvious, or barely visible. Monitors shine light through coloured filters, while printed papers absorb some colours and reflect others; a colour monitor can display a greater range, or gamut, of colours for a given image than, say, an ink-jet print. If any colours are present on the monitor but not in the print, these are said to be "out-of-gamut". The extent of the colours used is called the colour space.

High profile

As a photographer, you need colours to look the same in-camera, on a monitor, or in print. Fortunately, the differences between devices are systematic, and can be defined precisely. This provides a structure for converting one colour "currency"

DID YOU KNOW?

A software's "rendering intent" setting tells it how to bring colours that are out-of-gamut in one space – such as your captured image – into a working gamut, for example an ink-jet print. If you choose the Saturation setting, the rendering maintains saturation levels, but colours may shift: this is used for graphics, or in office environments. The Perceptual setting is often used for photography as it squeezes the out-of-gamut space into the output space, but a lot of colours may shift slightly as a result. Relative Colorimetric is a good choice for general photography as it preserves colours that are in-gamut, minimizes the colours that change, and preserves whites.

to another: the colour profile (see opposite). Profiles are created by measuring how standard colours are reproduced by various properly set-up, or calibrated, devices.

Your monitor should be calibrated so that it has its own profile for the way it displays colours – as you'll be using it to review and adjust images, the accuracy of the screen's colours is central to your work. It's best to calibrate and profile your monitor using a hardware device (see p.334).

LARGE COLOUR LATITUDE

There are many ways to print landscape and travel images. A fully accurate reproduction is not the only permissible solution when the viewer knows what the true colours are likely to be, and so these are not colour-critical scenes – unlike, for example, fashion or equipment catalogues, in which colour repoduction must be more stringent. The interpretations shown here, from strong, dark colours to very soft tones and with different colour balances, are all acceptable. The most important thing is to avoid the temptation to make the colours highly saturated and bright, which may look good on a screen, but can be disappointing when printed.

Using profiles

A colour profile is a label that tells a given device how to process an image; this means that profiles must be embedded in your images. When you assign a new profile to an image, you leave its pixels intact, but its appearance will change when it's in use, as the new profile is used to process the data. But when you convert the image to a new profile, you change its actual pixel values in order to retain the colour appearance before conversion. Many colours that are visible on a monitor cannot be reproduced in print, so you also need to translate colours that fall outside one colour gamut into another (see box, opposite). However, large colour spaces use colours that cannot be seen in print, which can lead to disappointment and errors. This is why the sRGB profile, with its conservative colour space, manages expectations well and is recommended for beginners. The diagrams below show differerent three-dimensional colour spaces.

SCREEN

sRGB

PC MONITOR

The sRGB space uses the colours of basic colour monitors. As a standard set from the early days of photography, it's very conservative – the space excludes a vast range of colours, but it's sufficient for day-to-day photography.

For more advanced work, you can record in Adobe RGB (1998) space. The image may appear lively and full of vigour on your monitor, with bright and highly saturated colours: this is suitable for use on websites, but does not accurately reflect the printed result.

FINE PRINT

MATT GICLÉE

GICLÉE SOFT-PROOF

When you assign the profile of a high-quality paper and view Proof Colors or Soft-proof, the smaller colour space is reflected in the screen image. The weaker colours vanish and the appearance is more dull. Nevertheless, on a calibrated monitor the image will represent the print accurately; it is a "soft proof" of your image. Use Proof Color or Soft-proof to check your images prior to printing. You may notice that in Proof Color mode, if you increase saturation past a certain point, you see no change in the image because you have reached the limit of the output's gamut.

OFFICE PRINTER

GLOSSY PAPER

GLOSSY PAPER SOFT-PROOF

Printers designed for the office environment give strong, punchy results; assigning this profile renders contrasty, strongly coloured images. Notice that the colour space is much larger than that of the fine-print paper: this is to be expected, because outputs such as laser prints display more intense and saturated colours than ink-jet prints. However, they lack subtlety in their colour reproduction, which makes them less suitable for photography. This shows that a larger colour space is not necessarily a good thing.

Picture selection

Anyone can picture edit, if the task only involves picking the best shots from a selection. But it's actually a lot more interesting than that: deciding which is the best shot depends on what you want to do with it. In a creative sense, you're looking for potential: images that are easily only passed over may reveal their beauty and strength once properly enhanced and used.

The key to successful picture editing is to define realistic aims. Anyone who approaches their images wanting to find a world-class shot will simply depress themselves, but we all have images in our collection that we'd be happy to put on the wall or upload to our website. Pictures are as good as the purpose they are put to: define your purpose and you will find your photo.

DEFINE YOUR AIM

1 Establish your purpose from the outset. If you're editing images in a professional capacity, for example, as a wedding photographer, you need to work rapidly and edit loosely – it's more important that everyone is included than that your images are artistically perfect. For books or prints, you should work steadily and carefully to avoid the costly course of changing your mind later. Images for websites fall between these extremes, as you can easily edit a posting.

FIRST PASS

2 Run quickly through all the images to give yourself a feel for the whole shoot. Set the preview size as large as possible, while still allowing images to be seen in rapid succession. The aim is to end up with a manageable number of "possibles": don't attempt to choose between similar shots at this stage, but mark all of them; try not to be distracted by any winners, or waste time dithering over obvious losers. At this stage, award all the possibles one star: as you progress, apply more stars.

SECOND PASS

3 Once you've worked through the entire shoot, you're ready for the second pass. Award more stars to outstanding images, and pick the best shots from sequences or groups of similar images. Check for stylistic consistency, if appropriate, and for completeness of coverage – that is, check that you have featured all the people or locations you need to. If necessary, look over the set again to fill in anything that's missing.

ASSESS QUALITY

4 By now you should be working with only a small fraction of the original batch of images. If, after two passes, you still have an unwieldy number of images, you're probably not being sufficiently critical. For large or important projects, ask someone you trust for a second opinion. Next, conduct a quality assessment: assess the images for tone and colour, and zoom in to examine defects. Look at the set overall to see whether global tonal or white balance adjustments are needed (see pp.214–15, 218–19).

PREPARE IMAGES

5 Make any white balance, exposure, and tonal adjustments as required. Adjust shadow and highlight rendering and improve colours, or convert into toned black and white. Groups of images shot under the same lighting may benefit from identical adjustments. Use batch processing features in your software. Clean off any specks of dust, crop in, and correct slanted horizons. Cross-check a sample of the new images to ensure consistency.

ADD METADATA

6 Anticipate future image searches by applying captions and metadata to your images (see pp.188–89). Add tags that locate the image (where, and what occasion), and describe the image with keywords (such as "animal", "monkey", "forest", "Guyana"). If possible, add a caption that contains full information, for example, "Guyanan Red Howler monkey (*Alouatta macconnelli*), foraging in a mango tree, Iwokrama Forest, Guyana." You will then be ready to export your images (see pp.170–71).

Pick and choose

There's a subtle, but vital, difference between selection and elimination. If you search for images to be deleted, sooner or later you will discard a prize-winning shot (fortunately, you'll never know). If you aim to select images, you can always choose a different one another day, as – depending on the context – what is appropriate will invariably change.

Which shots work best will be determined by what you want to show and tell, and the intended usage. In this instance, I wanted a fresh interpretation of an iconic building. In general, when you have only a short time to dash around a landmark or famous site, you should shoot it from all angles in order both to take in the familiar and discover the unusual views.

20MM

✗ Postcard view
Situated on a promontory, the Sydney Opera House was designed to catch the light and look good from any angle. However, this image is generic, and one which everyone has seen: it records the sight, but does nothing to make it stand out from the crowd.

21MM

✓ Humourous take
Sometimes a bit of human interest can spice up a dry architectural or landscape shot. While scoping out viewpoints, I saw this girl struggling against the breeze: as she faced into the wind, her hood blew off, and as she pulled it back up it looked like one of the "shells" of the Opera House.

70MM

✗ Arty abstraction
Close-up to the building there were fascinating interplays between the glass, reflections, and interior. Here, the shape of the large window is mixed with a view to the quintessentially Australian landscape beyond, but in the end the combination is too abstract to be informative.

18MM

✗ Surrounding landmarks
A sign of effective architecture is the harmonious relationship with other constructions in the vicinity. This shot captures the details of sloping glass and contours that seem to echo the form of the Sydney Harbour Bridge, but isn't successful at showing the Opera House itself.

24MM

✗ Visual experience
I wanted to capture a sense of the overpowering, bold shapes by exploiting the distortions produced by wide-angle lenses and tilted horizons. With more interesting lighting – such as acutely-angled evening light – it might work, but not in mid-afternoon sun.

12MM

✓ In context
This image ticks a number of boxes: it shows one view of the Opera House clearly; it reveals the city of Sydney in the background; and the lines leading from the foreground to the figures in the distance build visual coherence. If I had to choose one image from the series, this would be it.

Pictures for a purpose

As your photographic skills – and your collection of images – grow, you might start to think about sharing your best pictures. You may want to enter a competition, or try to gain recognition or an award; further down the line, you could look into earning some money by selling your photos.

Whatever you plan on doing with them, it's a good idea to make sure the images with your name on are as good as possible. There are two sets of tests you can apply to your images to make sure they're the best possible quality. One is non-technical and largely objective, the other is technical: in both cases, as you gain experience much of this will come automatically. Remember, though, that a technically perfect picture may also be perfectly boring, while an image that's technically faulty could also be a prize-winning photograph.

"Amaze me!"

The legendary art director of *Harper's Bazaar* magazine, Alexey Brodovitch, would demand of his photographers, "Amaze me!", and you can use this as the basis for evaluating your own pictures. Look through your images to see if any of them have one or more of the following characteristics – if you find one with all of them, it may well be amazing:

- The subject is depicted in a revelatory, thought-provoking, or emotionally powerful way.
- The content is narrative; it tells a story.
- The location is unusual or, if well-known, the image has an inventive perspective.
- The lighting is beautiful, dramatic, unconventional, or strongly sets the mood.
- Faces in the image have compelling expressions, appropriate to the occasion or subject.
- The colours are bright or engaging, or the colour and tonal contrasts are strong.
- The composition is energetic, clear, and occupies the image frame appropriately.

Technical tests

In some commercial contexts – such as when submitting images to picture agencies, or to print-based publishers of books or magazines – your images must meet minimum technical standards before they can be used. Even if your photograph is striking, it may be rejected if it doesn't comply. While some of the technical elements in the following list can be fixed in post-processing, it's best to get all of them right in the first place:

- The focus is sharp with no motion blur, unless intentional.
- The exposure is correct and appropriate to the subject, and the contrast is suitable for the image content.
- The orientation is correct to the horizon, vertically, or to the subject, with adequate depth of field and no visible distortion or vignetting.
- The colour rendering is natural, with a neutral balance, without excessive saturation, and with no easily visible colour fringing.
- The image has clear highlights and shadows with detail, dense blacks, and mid-tones in the subject are reproduced correctly.
- Glare or veiling flare is absent; there is little or no noise, and no spots or easily visible artefacts, such as chromatic aberration (see opposite); tonal gradations are smooth, with no visible posterization.
- The file size is correct for its intended use.

Non-image data

When you submit a photo for consideration by an agency, a magazine, or the judges of a competition, give it a descriptive title (not fanciful or oblique), and a full and accurate caption. Include the copyright symbol with your name and contact details – your email address and website.

DID YOU KNOW?

At the time of writing, there are in excess of 70 billion images on just six of the largest websites, including ImageShack, Facebook, Photobucket, and Flickr. And that's not including the images populating individual websites, which number more than 250 million. Perhaps more astonishing is the fact that pictures are being uploaded at the rate of well over one billion per month on the top three websites alone. As a result of this deluge of photographs, creating an image that gets noticed by anyone beyond your family and friends is no mean feat.

Defects to detect

There's a story about a group of great photographers who made a list of what could go wrong in photography: they gave up when they got to 200 items. The list, of course, is endless, but you can prevent most problems by avoiding the common, easy-to-miss errors below, excepting obvious capture flaws such as poor focus or camera shake. Some are easier to correct than others, and all are best avoided by sticking to the rules of accurate focus, precise exposure, control of lighting, and minimal post-capture manipulation. You may find these defects easier to correct if you record in RAW (see pp.184–87), but remember that RAW is for capturing images at the highest quality, not for correcting mistakes.

EXCESSIVE NOISE

Mid-tones and bright areas may be free of noise, but shadow areas can be very noisy, particularly after Shadow/Highlight manipulation. If the image depicts an event in a dark setting, noise may be acceptable – you can make a virtue of it by turning it into film-like grain with filters.

POSTERIZATION

Smooth gradients of colour and tone, particularly in skies, may break up into bands of colour as a result of excessive manipulation. It may look like a graphic effect, but it's a technical fault. Avoid excessive manipulation; work in RAW, or with the largest possible files in JPEG.

JPEG ARTEFACTS

The blocky appearance and loss of detail typical of JPEG artefacts may be evident only when an image is enlarged; the intrusiveness of this can be exacerbated by sharpening, and filling shadows. The problem most commonly arises if JPEGs are saved at lowest quality in error.

BLOCKED SHADOWS

Blocked shadows usually result from photographing in bright sunlight – an exposure that controls highlights may sacrifice shadow details. Once lost, it may be very hard to recover shadows without distorting mid-tones. In very sunny conditions, shoot in RAW.

BLOWN HIGHLIGHTS

When photographing in bright sunlight, be careful to steer between blocked shadows and blown highlights – pure white with no detail or colour. Small areas are tolerable, but large areas are not. These are unpleasant to view on-screen and give poor results when printed.

CHROMATIC ABERRATION

Inexpensive zoom lenses are prone to lateral chromatic aberration, which causes coloured edges on some types of detail near the periphery of the image. Usually evident only at high magnification, it can be at least partially corrected in advanced image manipulation applications.

Working in RAW

RAW files store the image data that comes directly from the camera sensor. In contrast, JPEG files pass through several image processing steps, and there is data loss from compression. The advantage of working with RAW, unprocessed files is that they are unadulterated, and therefore offer the best possible image quality.

RAW files offer maximum flexibility when adjusting image brightness and white balance, and avoid the limitations of automatic in-camera processing, such as sharpening, colour space, and noise reduction. You can save the converted file to 12-bit per channel colour, thus maintaining quality. Most importantly, RAW processing doesn't alter the original file, as you always save a new image file. This means that, as RAW converters improve, you'll be able to return to your old files and produce even better images from them.

Extra work
There are two potential drawbacks of working in RAW. Not only are RAW files several times larger than JPEG files encoding the same number of pixels, you'll have to do a lot of the work yourself. You'll have to set – by hand – white balance, exposure, brightness, contrast, saturation, sharpness, and so on. This is all work that the camera's automatic colour settings will do for you if you save in JPEG. Not surprisingly, photographers commonly complain that their images from RAW files are not as good as from JPEG files.

Learn how to work with RAW for occasions when you need the very best image quality. (Bear in mind that your RAW processor must support your camera's version, as RAW is not a universal format.) Some cameras allow you to save files as both RAW and JPEG, so you can use the JPEG as reference. Remember, if you make prints smaller than the maximum recommended size for your files, or show your images only on monitors, almost all of the advantages of working in RAW will be lost in the translation to output.

Baking in batches
A key feature of working in RAW is that it allows batch processing: once you determine the settings that work well with one image, you can apply them all to a collection of images taken in similar circumstances. Even if the results aren't perfect, you can tweak them further – saving you a great deal of time.

WHITE BALANCE FLEXIBILITY

RAW files give you a full range of colour values to work with, which is most beneficial when dealing with poor or strongly tinted light. The original file (below) shows white balance as shot. You can then experiment with the settings: Cloudy is warm (top right); Fluorescent is cool and pink (top far right); Shade is yellow-red (bottom right); and Tungsten is very blue (bottom far right).

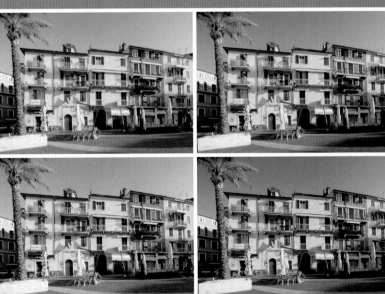

RAW converters

You have to look very hard at expertly processed output from RAW files to see any significant differences between RAW converters, so your choice will depend upon your preferences regarding interface design, ease of operation, technical support, and cost. Some offer particular strengths, such as noise reduction; others are built for specific lens systems, and offer distortion and other corrections for supported lenses. The most versatile are those that combine RAW conversion with file management, such as Apple Aperture and Adobe Lightroom. One thing is for sure: there's no ideal RAW converter that's clearly superior to all the others; the examples shown here are a selection from among the most popular.

APPLE APERTURE (DEFAULT)

The default processing in any RAW converter should result in an image that matches the JPEG file from the camera, but there are small variations between processors. Those from Apple Aperture for Canon tend to be a little light and undersaturated, as seen in this shot of the Canyon de Chelly, USA.

APPLE APERTURE (MANUAL)

Apple Aperture gives a high level of control over RAW processing. Shadows and highlights are easily recovered, but it's not easy to adjust the tint of shadows or highlights. Overall, once images are imported by the software, it gives excellent results very quickly.

HASSELBLAD PHOCUS

This powerful software is perhaps encumbered with too many features. A free download (at time of writing) with wide-ranging RAW support, it is poor at recovering either shadows or highlights. Still, with perseverance, it's possible to achieve superior results.

ADOBE CAMERA RAW

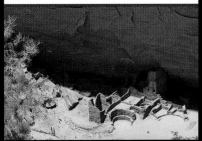

Available only as a Photoshop plug-in, this software gives crisp, satisfying conversions with good shadow fill. However, recovery of highlights requires three controls, as compared to the single control of other software. Nevertheless, it's easy to adjust the tint in shadows and highlights.

ADOBE LIGHTROOM

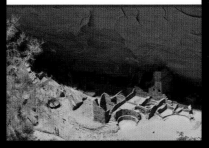

Giving essentially the same results as Adobe Camera Raw, Adobe Lightroom is nonetheless much simpler to use and highly responsive, enabling very pleasing results to be obtained with ease. Available on Windows or Mac OS, it's also a very powerful image management tool.

DIGITAL PHOTO PROFESSIONAL

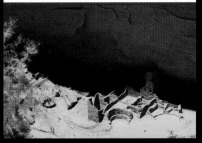

This is a piece of software dedicated to the RAW files produced by Canon cameras. Its performance disappoints in the limited range of its controls and its sluggish response. Results were not convincing, with poor highlight and shadow recovery. On the upside, it's free.

OPTIMIZING WORKFLOW

Processing RAW files

You may be dismayed the first time you open a RAW file. Used to the brilliance and sharpness of JPEG files, you might find the default setting for your RAW file lacking in personality – flat, with pale colours. Default processing is usually set conservatively, so the resultant image is close to its appearance at the time of capture – if it's pizzazz you want, you'll have to add it yourself.

In this image it was paramount to preserve the sheen of the bridal gown, so the exposure was centred on the highlights. This produced a very dark image, but in the RAW file there was ample image data to fill shadows and control colours. Instead of a realistic rendering of colours, I chose to accentuate the reds by reducing the strength of all the other colours.

ORIGINAL IMAGE

1 Low-key capture
With strong illumination from the window (just out of frame), it would have been very easy to lose the highlight details in the gown. To avoid this, I set an exposure two-and-a-half stops less than the metered setting – the histogram shows just how under-exposed the resulting image is.

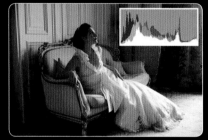

AUTO-LEVELS

2 Adjust exposure
Normally I'd check the white balance first, but as this image was so dark I wouldn't have been able to see what I was doing. The first step, then, was to check the auto-levels to ensure that the histogram was full of data, and look at the mid-tones in order to adjust the white balance.

WHITE BALANCE

3 Warm neutrals
As shot, the white balance is realistic but lacks character. I decided that the image needed to be much warmer, and raised the colour temperature to 13750 K, increasing the magenta tint for a strong orange glow. Next, I readjusted the exposure so that it was between the original and auto-levels.

FILL LIGHT

4 Lighten mid-tones
Lowering the exposure improved the atmosphere of the shot overall, but the lower mid-tones became too dark. To compensate, I used the Fill Light control to breathe air into these tones, which also greatly improved the skin tones on the shadow side of the model.

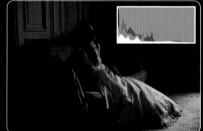

KEY BLACK

5 Focused darkening
Applying shadow fill to improve the lower mid-tones weakened the darker shadows. Fortunately, we can make black more dense independently of mid-tones with the Blacks or Key control. The side effect of this adjustment is increased contrast and saturation.

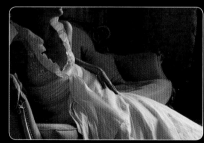

BRIGHTNESS, CONTRAST

6 High-tone lift
This process may seem overly complicated, but with practice you will learn how to balance out the effects of one setting with another. I increased brightness to bring sparkle to the highlights without losing detail, but lowered contrast as the colours were becoming excessively strong.

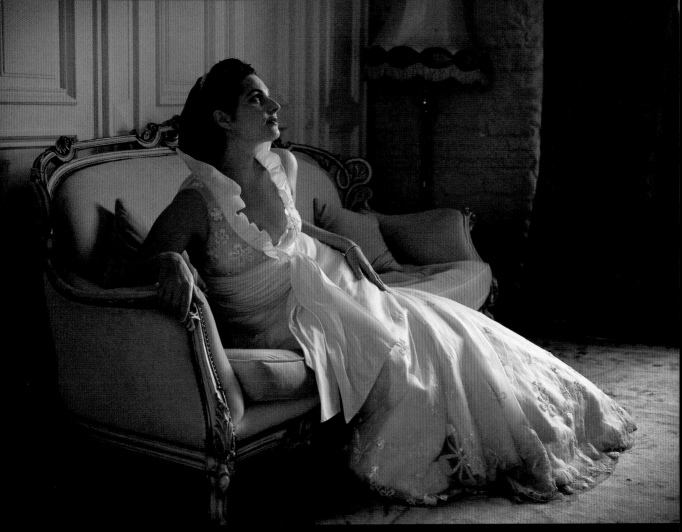

△ **FINAL** IMAGE

VIBRANCE

SHARPENING

LENS CORRECTION

7 **Moderating colour**
Bringing up heavily under-exposed images tends to increase the apparent colour saturation. The model's skin tone was now much too strong, which gave me the idea of knocking the saturation a long way down for a more retro look. I used the Vibrance control to preserve skin colours.

8 **De-sharpen**
Normally I would sharpen the image as one of the final enhancements, but the image was very sharp already. In this case I didn't want to draw attention to the small spot on the model's forehead, so I lowered the sharpening setting to zero.

9 **Darkroom work**
All that remained was to apply a basic "darkroom" manipulation to help guide the viewer's eye into the image. I used the Lens Correction control to apply a vignette, thus softly darkening the corners of the image – compare the carpet above with the image at Step 2.

Asset management

Whether you're a casual, amateur, or professional photographer, your photos represent a considerable investment. It's not just the cost of your camera and computer, but also the hours spent learning to use the equipment and software, not forgetting the time spent in chasing photos. And – no false modesty here – there's also the valuable input of your artistry and skill.

There are two sides to managing your photographic assets. One is ensuring you lose none of your images, and that they last for as long as possible. The other is to make them easily available, at least to yourself, and at most to anyone who wishes to use your photos. It follows that there are software and hardware aspects to asset management. In the current state of technology, no digital medium can match film-based

DEFINE FUTURE NEEDS

1 Asset management is about preparing for your future in photography. Pictures of friends and relatives or your neighbourhood may not seem important now, but in 20 years you'll be glad to have safeguarded your images. Plan and budget for realistic scenarios to enable you to find images easily and to profit from all your hard work. This means tagging all your images – with the emphasis on "all" – and storing them so they can be found by anyone should you not be available.

COLLECT IMAGES

2 Bring together all the hard-disk drives, CDs, and DVDs containing your images, and sort them into a rough ranking from the key portfolio images to the shots you may never use but should keep. It is a sound policy not to delete any shots – ever – as you have no idea what you may be destroying. Your taste in images may change, the significance of an "unimportant" shot may take years to become evident, and your eye may become more sophisticated over time – so what appear to be errors may in the future be seen as serendipity at work.

APPLY METADATA

3 Even a minimal tagging of your images will prove a great labour-saving effort in the long run. You've been to Venice several times, but can you locate all your pictures of Venice within seconds? If you fail to tag your images on download, the next best time to apply metadata is right now. In addition to where the shot was taken, use other identifiers, such as the name of the tour you went on, that will help you locate the images. Use image management tools that will apply keywords to a large number of selected images at a time.

ORGANIZE FOLDERS

4 Sketch out, on paper, a folder structure that will work best for you. If you don't travel much, you could organize them by year, month, and specific location or subject. Or, you could organize them by countries that you visit, with a folder for your home country. If you're photographing professionally, you may prefer to organize your folders by year, month, and client. If your projects are long-term, your root folder will be the project, followed by sub-folders containing your work in progress, finalized images, and so on.

MATCHING TO PRIORITIES

5 The least costly ways to preserve your images – laser-writeable disks, such as DVD and Blu-ray – are also the slowest to write and to read. If your budget is limited, keep the less-important images on these disks. Files that you need quick access to, such as those for current projects, or your best work, are best kept on hard-disk drives that are directly accessible from your computer.

NETWORK OPTIONS

6 If more than one person needs to access your images, or if you want to be able to access your files when you're away from your desk, a network-attached storage (NAS) device is now a relatively inexpensive solution. This is essentially a hard-disk drive or RAID (see box, opposite) with an Ethernet connection, so that anyone can access it if they are attached to an Ethernet router by cable or, if the router is set up for Wi-Fi, wirelessly. You can set the server so that it can be accessed on the internet: this is extremely handy.

images for archival safety – the ability to survive unchanged and easily useable for more than a hundred years. Those who would like their legacy to stretch into the next century may be best advised to return to shooting on film. For the more modest, the best strategy is to keep digital image files in multiple storage systems in multiple locations. For small numbers, use DVD or Blu-ray disks to archive your images.

Metadata and captions

If you intend to submit your images to a picture library or stock website, you need to ensure that your images will be easily found by the search engine. Locating a particular image from the tens of millions kept in picture stock libraries is very hard to do visually, but very easy when the search is text-based. Metadata or tags are descriptive words and other data embedded in an image. The caption provides further information in plain language. The following points will make your metadata and captions hard-working:

- Metadata should identify the subject or event, date, location, copyright holder, and photographer. Include contact details if providing images to an agency or microstock website.
- Many stock websites limit the number of characters you can use in a caption. You'll need to be concise yet include as many relevant details as possible to provide all the information that will drive the sale of your image (see pp.294–95).
- The key to an effective caption is to answer the questions, "who, when, where, how, and why?" Try to put all the information in a single, grammatically correct sentence.
- Use keywords to highlight the important components of the image, such as the overall colour, time of day, lighting, mood, location, environment, and, if possible, the species of any animal or plant included.
- Conceptual keywords are essential for images intended for sale if they show one thing, such as a portrait of a girl, but may be understood to illustrate abstract concepts such as melancholy, tranquility, thoughtfulness. Words such as "success", "motivation", "teamwork", and "inspiration" help sell images, where applicable.

COPY AND BACK UP

7 Work systematically and steadily to copy all your files onto your RAID or other chosen storage system without interruption. Use the time when files are being transferred to make a written list of the folders you have copied, and the number of files in each. This is your registry of work, which helps you double-check on your progress and may help to reconstruct files in case of any problems. Subsequent to this first copying, repeat the process as you acquire new files from new projects or travels.

REMOTE STORAGE

8 Making arrangements for the future includes planning for the unexpected: a neighbour's burst water pipe flooding your equipment, a lightning strike on the house, or worse. The simple precaution of keeping a copy of all files in two separate locations (the further apart your copies are, the better), means it's very unlikely you will ever lose all your files. You can also store key images online with photo-sharing sites or sites specifically operated as data warehouses that keep data very safe.

LONG-TERM ARCHIVE

9 There will be a small percentage of your images – the ones you'd save if you experienced the proverbial fire – that deserve the most reliable and archival storage. These images may number only a few dozen, but the problem is that if you want to pass them on in your estate or gift them to an institution, there is no assurance that any electronic means will keep working forever. In fact, museums are saving digital files in analogue form, that is, as prints, colour transparencies, or separation film (a greyscale printout of each colour channel).

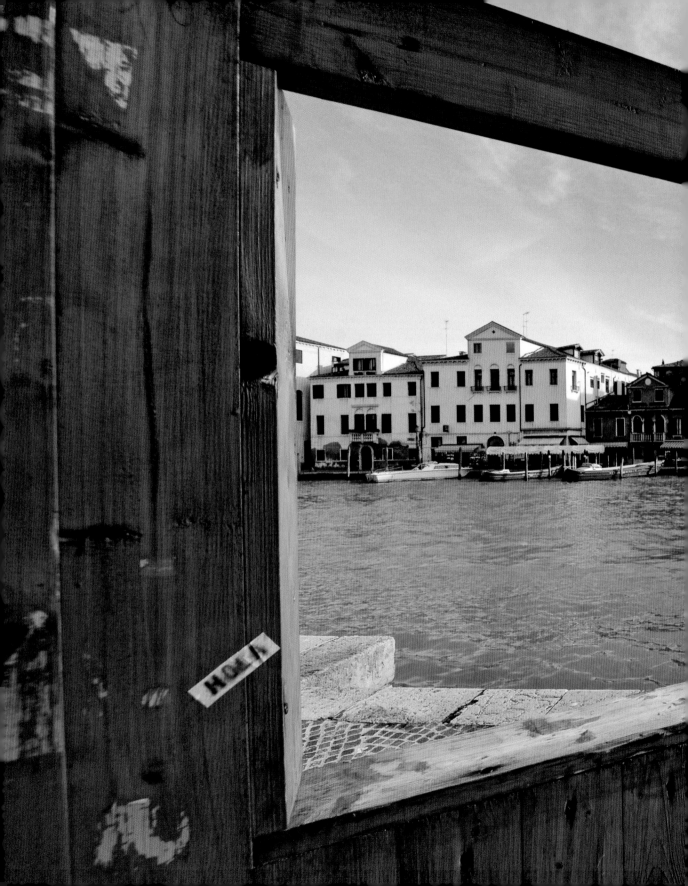

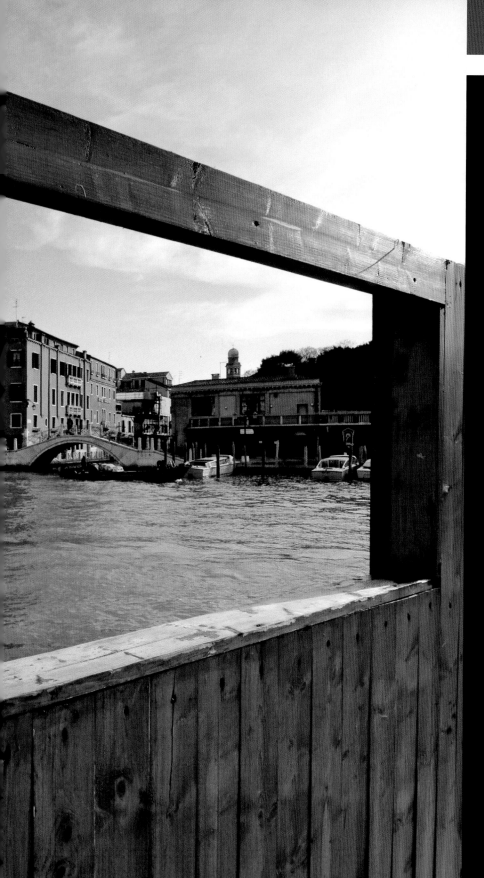

ENHANCING IMAGES

Processing pipeline

Many of today's photographers complain about having to spend too much time at the computer, and you may find this to be true of you. However, if your images consistently need extensive corrections in post-processing, the solution is simple, and is the basis of the whole workflow: make sure your images are as good as they can be when they come out of the camera.

Exposing and processing digital images is far more forgiving than working with film, but it's an invaluable discipline to work as though errors would be hard to correct. If you aim to capture your images with a camera that is properly set up – that is, with the correct exposure and white balance settings, as well as a suitable focus, and considered choice of aperture – you can produce images that require little or no correction.

SAVE A COPY

1 Never work on the original image. Software such as Adobe Lightroom or Apple Aperture operate using proxy images (see pp.176–77), but if you're using any other software, ensure you're working on a copy. Create a project folder, and when you first open an image, save a copy to the folder, giving it a new filename. This becomes the file you work on. Choose a name that will help you recognize the image – caiman001.jpg instead of DSC4321.jpg. If possible, save on a different storage device to the one that holds the original image.

CHECK SIZE AND LEVELS

2 Check the image is the correct size for the intended purpose: if it's much larger than needed, reduce the size only if you need to work quickly or if you don't expect to make extensive changes. Check the Levels settings.

CROP AND TRIM

3 If you need to, correct the angle of the horizon, and crop the image to remove unwanted areas, or to give it the proportions to fit its destination use (such as a page layout, or printing paper).

APPLY MANIPULATIONS

7 You can now perform the image manipulations. If it's a complicated job, save intermediate versions or make "snapshots" (if offered in your software) of different settings, to refer back to as needed.

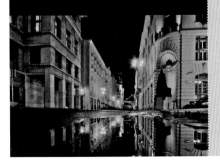

REMOVE DUST

8 Leave dust removal until after manipulations, because any artefacts you introduce when cleaning the image may be exaggerated by effects (see pp.194–95). If there are numerous dust specks, work on the file directly: remove dust and other small defects using Clone, Heal, or similar tools. Some software creates a "map" of dust specks which removes them automatically from a batch of images. Use this function if it's available – it saves a lot of time.

CHECK GAMUT

9 Use your software to display colours that are out-of-gamut and cannot be printed or soft-proofed (previewed using profiles from your printer). Don't worry if small, peripheral parts of the image are out-of-gamut.

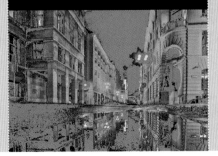

No long hours spent at your computer will be necessary. However, remember that if you choose to record in RAW (see pp.184–87), you will need time for post-processing.

If you process in a logical order, you reduce the need to go back and re-apply an effect, so monitor your post-processing carefully. Observe whether you repeatedly make the same adjustments – if so, adapt your camera technique to preempt that particular processing step. For example, if you find yourself darkening your images all the time, try under-exposing all your images in-camera by the same amount.

There are numerous and powerful ways you can improve your images without changing their content. The workflow outlined below will save you time, help preserve quality, and produce reliable results.

CHECK PROFILE

4 Check the image has the correct colour profile (see p.178), such as sRGB or Adobe RGB (1998). If not, assign your working colour space to it. If you intend to print an image with saturated colours, check its output appearance.

ADJUST EXPOSURE AND TONE

5 Use Levels or Curves controls (see pp.204–207) to adjust the overall exposure and contrast of the image. Aim to use less contrast rather than more, as subsequent colour adjustment and sharpening may heighten contrast.

ADJUST COLOUR

6 Correct the colour balance and saturation. To make heavy colour corrections, you may need to work in Lab mode. If your software allows, make these changes on Adjustment Layers as these don't affect actual image data.

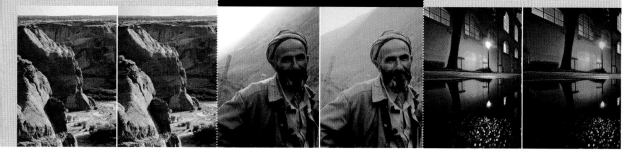

FLATTEN

10 For this step you render the different layer effects, including Adjustment Layers, onto a final image that occupies the Background layer. Save it with a new filename in case you need to return to it for fine-tuning.

SHARPEN

11 Apply a level of sharpening appropriate to the intended use: for print, view at 100 per cent, and for screen use, view at final size. Sharpen until the effect is just visible, and check that no defects have reappeared.

FIT FOR PURPOSE

12 Check your file to ensure that it can be used by its recipient without any further modification. Remove any elements that are not required, such as masks or paths. Resize it to its final output size if necessary, for example for use on a photo-sharing site. Embed a colour profile if you're sending it to an online print service. The majority of third-party services will accept 24-bit RGB colour files saved as JPEG, and compressed to good-to-high quality. Professional services may require the file as an uncompressed TIFF.

Removing dust

As cameras become ever more capable of resolving detail, so the ability of their sensors to capture the microscopic specks of dust that settle on them becomes truly, and counterproductively, excellent. Dust is now one of the greatest, if prosaic, technical problems facing digital photography.

Despite the various technologies employed to reduce dust on sensors, you will sooner or later be troubled by the randomly distributed specks of dust on images produced by dSLR cameras. One of the advantages of fixed-lens compact cameras is that their lenses are fitted in controlled "clean room" environments. But even so, the zooming action of a lens sucks air in and pumps it out, so the threat of dust is ever-present.

In-camera systems

There's another problem, too: the appearance on the image of the exact same dust specks varies with the change of lens and aperture (see box). This forces a limit on any automatic system used for dealing with them. For example, some cameras offer an image-cleaning mode. To use this function, you make an out-of-focus exposure against a plain, evenly

DID YOU KNOW?

Dust specks don't actually settle on the sensor itself. If they did, they would pose a much greater problem, as the specks would then appear very sharply defined in the image. Instead, dust settles on the various filters (infra-red and low-pass) and glass protective plates – which can be over 2mm thick – lying over the sensor. The appearance of dust specks depends on the quality of light reaching the sensor, which depends on the focal length of the lens used and the aperture, as well as how closely the lens is focused.

lit surface such as a white wall; this "registers" the dust specks. Using special software provided by the manufacturer, this register is applied on all images to remove the specks, but this only works if the same lens is used, at similar apertures.

Proxy-working software (see pp.176–77) have dust removal tools that can be applied to a whole batch of images. Before making any other adjustments, you use the tool to remove the dust specks from the first image in a series. Then you copy the adjustment, select all similar images, and apply the same dust removal adjustment to them all.

Summer wind
After two weeks' exposure to the Greek *meltemi*, my camera's sensor was covered in dust particles. A very small aperture of f/16 plus a focal length of 12mm brings them all out (inset). As there are no details in the sky, the simplest way to remove them all at once is to select the sky with the Magic Wand tool, and apply the Dust and Scratches filter, or a blur.

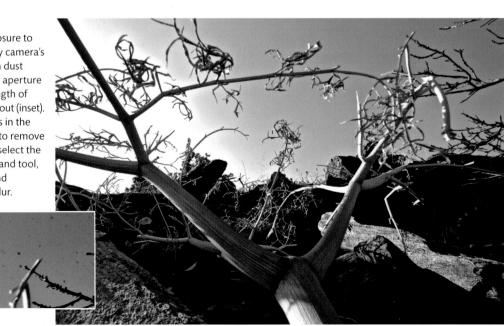

Lesser evidence
An entrance to a Greek church was taken with the same dust-covered sensor as the landscape opposite, but with the lens set to 40mm focal length. An enlargement of the top right-hand corner before cleaning (above) shows much less evidence of dust.

Avoidance behaviour

As ever with image defects, the best strategy is to avoid them in the first place. DSLR cameras use different mechanisms for reducing dust or avoiding it getting into the camera. The most common is simply to give the sensor a good shake: this is done at high frequency with tiny piezo-magnetic actuators. It's better if the shake happens when you turn the camera off, rather than when you turn it on, which delays the camera getting ready to work. Other systems reduce the tendency of the sensor to attract dust, which – because they carry up to 15 volts of static charge – is potent.

However, none of these techniques are 100 per cent effective, so it's a good idea to learn how to clean the sensor itself (see pp.338–39). It also pays to change your lenses in environments that are as dust-free as possible, and to practise changing lenses to speed up the process.

When the dust settles

Dust specks on dSLR images are usually not obvious unless you enlarge the image, and even then they are generally only visible where they occur over relatively bright, even tones such as sky, clouds, plain walls, and clear water. They tend to be more evident with wide-angle lenses and with smaller apertures. Dust is also more apparent in bright, sunny conditions, as the light will cause dust to cast sharper shadows on the sensor, just like the shadows in the scene. Tonal adjustments and sharpening procedures also make dust specks more evident (see right).

Dust detection

Even if you can't see any dust specks on your image, you can rest assured that they are in fact there (unless you're using a brand-new camera). Zoom in to 100 per cent or more, and create an adjustment layer to increase contrast and darken the image, or use the tonal controls: you'll be surprised at just how many specks suddenly make an appearance, particularly in the corners of the image.

This is a useful test because dust specks that are invisible prior to image manipulation may become alarmingly visible, particularly after an increase in contrast, decrease in exposure, and the application of any sharpening procedure.

ORIGINAL IMAGE

1 **Zoom in**
I examined the clear, bright areas near the corners of the image for signs of dust. Before making adjustments, only one or two specks of dust are visible.

HEAL TOOL

2 **Visible dust**
With an adjustment layer set to high contrast, more specks can be seen. I selected the image layer and applied the Heal tool, set to the same size as the specks.

CLONE TOOL

3 **Artefacts**
A Heal tool that is too large and used too close to details that are to be retained causes artefacts. I used the Clone tool to remove the specks close to such details.

Cleaning and clearing

LARGE, INDISTINCT SPOTS

PROBLEM
Images show large, light-coloured, or bright spots, sometimes in various colours. The spots are positioned randomly and the details in your image may show through or be obscured.

ANALYSIS
A bright source of light in view, or just outside your field of view, has caused lens flare or internal reflections. Not originating from details in the image, the resulting spots need to be reconstructed or filled with detail in order to disguise them.

SOLUTION
▷ Use the Clone tool to copy the same texture from unaffected parts onto the flare spot. Setting the tool to Darken may improve the blend.

▷ Reduce the colour of the spots with the Desaturate tool to make them less noticeable.

▷ If the spots occur in a part of the image with a large area of even tone – the sky, for example – use the Patch tool to blend over them.

DEBRIS ON THE SENSOR

PROBLEM
When your image is magnified, or if you've increased contrast or sharpness, tiny blurred dots appear. You may also see dark streaks, sometimes with a light halo around them.

ANALYSIS
Some image manipulations cause any debris on the sensor to become more apparent. As the debris lies above the sensor itself the marks it leaves are blurred.

SOLUTION
▷ If available, use the Heal or Repair tool to remove the mark. Blend the image surrounding it – set your brush size slightly larger than the average size speck.

▷ If you don't have the Heal or Repair tools, use the Clone tool set to aligned, and sample from the area as close to the speck as possible.

▷ Avoid the problem altogether by cleaning the sensor (see p.339).

UNIDENTIFIED HIGHLIGHT

PROBLEM
Large, bright highlights or specular reflections in an image divert attention from the main subject.

ANALYSIS
Our eyes tend to be attracted to bright areas, so any highlights, especially when close to important features (such as the catchlights in a portrait sitter's eyes), can compete. Burning-in is very tricky because the edges will get darker and deeper, and the highlight muddy.

SOLUTION
▷ Clone carefully to remove the highlight by using the surrounding colour to fill it in.

▷ Visually it may be best to leave a hint of the light – set the Clone tool to around 70 per cent.

▷ If the light is strongly coloured at the edges, use the Desaturate tool to reduce its impact.

DISTRACTING LINES

PROBLEM
Straight, narrow lines that don't contribute to the overall composition divert attention from the main subject.

ANALYSIS
Clean, distinct, and sharply defined lines make a big impression visually, especially if they sweep across the whole image, but in the wrong place they can interfere with the composition. Greater depth of field only increases the problem because the lines appear much sharper.

SOLUTION

▷ Remove the line with the Heal or Repair tool. Sample an area from as close to the line as possible.

▷ Use the Clone tool when working next to other details, or these will become blended.

▷ Work at 100 per cent or greater magnification to avoid artefacts.

▷ Set the tool diameter to just larger than that of the line.

▷ Draw a slightly wavy line to avoid creating a new straight one.

TOO MUCH DEPTH

PROBLEM
The background in your image takes away from the main subject because it's too sharp. The problem is worse where the background is highly detailed or brightly coloured.

ANALYSIS
Using a small aperture gives great depth of field and the resulting image may be too sharp. This is a frequent problem with compacts and wide-angle lenses where depth of field is extensive at almost any setting.

SOLUTION

▷ Apply local blur by masking off the important elements of the image (see pp.240–41). Put the distracting element out of focus – gradient blur gives the best results. Apply stronger blur away from the main subject by protecting larger and larger areas, or blur on an image map. The easiest way to do this is to use a plug-in.

TOO MUCH COLOUR

PROBLEM
A strongly saturated patch of colour behind your portrait subject drains colour from the face and distracts attention – even if strongly blurred and not identifiable.

ANALYSIS
Strong colours can be used to point to the main subject, but many bright and saturated hues (reds and yellows, for example) cause strong visual stimulus that take attention away from the more subtle, detailed parts of the scene.

SOLUTION

▷ Partially reduce the colour using the Desaturation tool. You can make the patch completely neutral, but leaving a hint of colour may be more effective visually.

▷ Some colours become darker as you Desaturate, and some will appear lighter. Adjust the brightness with Burn or Dodge tools to blend with the background.

▷ Burning-in darkens but deepens colours; dodging lightens and weakens them.

Working with noise

Noise has long been a bête noire for digital photographers, as it causes randomly coloured pixels or patterns that interfere with the purity of the image. In early digital cameras, noise very seriously impaired image quality. Today, with the availability of larger files and improved technology, noise is much less of a problem than it used to be.

Noise arises from the electrical nature of the camera's circuitry, from the properties of the sensor, and from image processing. It unequivocally reduces image quality in three distinct ways: because it's distributed randomly, it obscures fine detail; its grainy appearance reduces the smoothness of tonal changes and the purity of colours; additionally, an indirect effect of noise is that it increases the file size of compressed images.

Types of noise

All images exhibit noise: the important factor is whether it's visible and detracts from image quality, or whether it's invisible or is aesthetically acceptable. Noise may contribute to the texture of an image, and may help reduce banding artefacts during printing. But usually it's not welcome,

particularly if it occurs in fixed patterns such as stripes or bands (banding noise), or as large and irregular specks of colour. It tends to increase with higher ISO settings (see pp.102–03), longer exposure times, and with hot cameras – those with a high operating temperature. It's often worst in shadows, and not so bad in bright parts of an image. Noise also increases with image manipulation such as large exposure corrections, large colour changes, Shadow/Highlight corrections (see pp.214–15), and after in-camera adjustments such as Dynamic Range Optimization. Sharpening may also increase the visibility of noise, as will enlarging the image.

Reducing noise

Noise becomes visible when the affected pixels are about the same size as fine detail in the image. Any procedures you use to reduce noise may also reduce fine detail – software includes Topaz DeNoise, Noise Ninja, and PR Noise Corrector. Some work as plug-ins, some as stand-alone applications. They aim to distinguish details from noise in order to reduce noise selectively – making tones smoother without blurring details. Some software use "noise profiles" – descriptions of the noise patterns specific to a camera and ISO setting, derived from analysing sample images – to

NOISE REDUCTION

A dimly lit sculpture (below) exposed at ISO 3200 is very noisy (top right). A modest reduction (bottom right) improves tonal smoothness, but noise still breaks up the details. A stronger reduction (top far right) shows how smooth colours should be, but a lot of detail is lost. Allowing a little noise (bottom far right) recovers some detail and achieves the best balance.

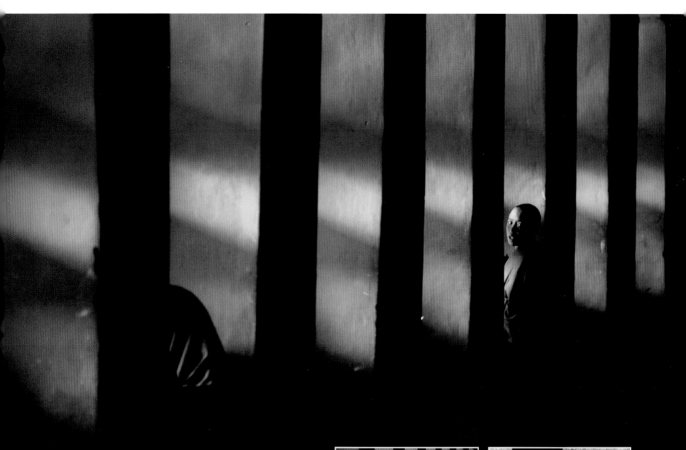

Noisy additions

Smooth and detailed images aren't always the best way to reveal a scene (inset right). Imitating the grain of the classic developer Agfa Rodinal (detail, inset far right) gives a better sense of the timelessness of this view of young monks reading.

improve the selectivity of noise reduction to reduce loss of detail. At the same time, these applications may apply sharpening and other adjustments, all of which you can control. Ultimately you need to strike a balance between tolerable loss of detail, and reduction in noise.

Increasing noise

Despite being digital photography's main enemy, noise can also be useful. For example, it's essential when you want to recreate the texture and tone of film-based prints; for the most realistic results, software from DxO Optics and Alien Skin can simulate film grain based on noise profiles obtained from actual film.

Trimming and resizing

There are many reasons to trim or resize an image. If the space for your image is fixed, you will usually have to trim or resize to make it fit; the poor match between image formats and printing papers dates back to the differing priorities of papermakers and photographers, and today the same issue has arisen with web standards. You can also use these tools to alter an image's content.

Trimming removes slivers from the edges of the image in order to make it fit a fixed space, such as printing paper or a website. Trimming is also useful for shifting the centre of an image to improve its composition or perspective.

If you have important detail at the edge of an image, it may be better to change the shape of the image overall, rather than crop it: to do this, un-tick the "constrain proportions" option in the resize or image size dialogue. A change of no more than ten per cent is usually not noticeable.

Interpolation methods

There are two ways to change an image's size: you can either change the output size (resizing) or the number of pixels (resampling). If you reduce the number of pixels, for example to make a smaller file to email, be aware that any

data you lose is irretrievable. If you want to increase the number of pixels, perhaps to make a larger print, you have a choice of methods, called "interpolation", because you're asking the software to make educated guesses about what new data to add (interpolate) between existing data.

The aim is to obtain enlargements that retain detail as well as smooth tonal transitions. There are different methods of achieving this; generally the more computation used, the better the results. Bicubic interpolation (see caption, opposite) is widely used, while methods based on mathematical patterns can generate even better results.

DID YOU KNOW?

The difference between resizing and resampling is important. Resizing changes the output size without altering the pixel count or file size – the resolution changes. You resize when you or the printer driver fits an image to a certain page size. Resampling changes the pixel count – the output size may either remain the same or change, and so the resolution may also change or remain the same. Resampling requires data interpolation, whereas resizing does not.

TRIM FOR PERSPECTIVE

In this space inside a cruise liner, I couldn't retreat far enough to capture the full height of the atrium. An ultra-wide-angle lens captured just enough of the scene without pointing upwards, but there is too much foreground. The bottom half of the image is unnecessary, so it can be cropped off (you can also use this as an opportunity to correct any inaccuracies in keeping the camera level). This moves the centre of the image upwards, as if shot on a lens with shift movements (see p.108) and takes in the whole height of the scene while keeping the verticals parallel. As this kind of processing discards much of the image, it's best to capture at the highest quality settings available.

INTERPOLATION RESULTS

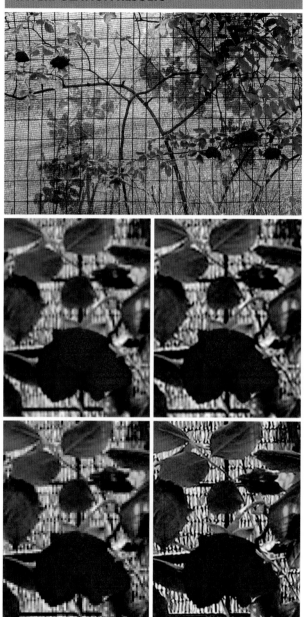

These images compare different ways of enlarging the 3,000 pixel image (top) to 15,000 pixels wide. Using the Bicubic Sharper and Bilinear options (middle left and middle right respectively) gives blurred results, but smooth gradients in the rose are well presented. Using the Nearest Neighbour option (bottom left) gives crisp-looking results, but jagged edges. By far the best results are achieved with the Bicubic Smoother tool (bottom right). Bicubic methods analyse more pixels than Bilinear or Nearest Neighbour, so tend to produce smoother – but not necessarily sharper – results.

Free cropping

Normal cropping maintains right-angled corners, so there's no change to the shape of the image's contents. However, by setting the corners of the crop independently of the original image shape, you can correct tilted horizons and converging parallels. Here the applied crop will be an irregular shape, and so the selected area must distort to form a rectangle.

To do this, select "perspective crop", and place the corners of the crop so that the frame outlines are parallel to the detail you want to align with the image frame. This might almost be classed as image manipulation – but you're not significantly changing the image's meaning.

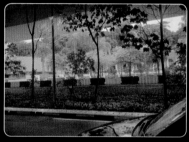

ORIGINAL IMAGE

1 Angled view
The original image was snatched from a car, but I wanted to present it more formally, square-on to the subject, and without a tilted horizon.

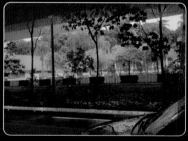

PERSPECTIVE CROP

2 Crop
I set "perspective crop" and placed the corners of the crop so that the frame outlines were parallel to the flyover and the road.

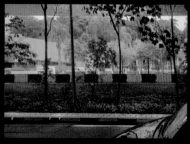

FINAL IMAGE

3 Correction
Applying a perspective crop forces image features to enlarge or shrink as determined by the crop outline, and straightens the horizon.

Refining shapes

In digital photography we have great freedom to redefine the shapes of images. By changing the shape of the image within the confines of the rectangular frame, we can correct distortion problems. These occur where magnification, or scale, varies across the image, and can be caused in two ways, both of which may occur on an image at the same time.

Lens distortion causes magnification to vary across the image. Where the magnification is lower towards the centre, compared to the corners, the image appears pinched in the middle, like a pincushion; where the magnification is higher in the centre, the image bulges out like a barrel. In contrast, projection distortion is the result of the way you aim the camera at a subject – best known as converging parallels. It is more easily seen, but is usually only a problem with geometrically-shaped subjects such as buildings or paintings.

Distortion correction

Lens distortion is usually minimal and not easily visible. It is easily corrected by the lens correction, or the distortion filters of image manipulation applications, if the variation changes in a regular way. If the variation is irregular – if it rises and falls

DID YOU KNOW?

While small changes in shape have no visible impact on image quality, large changes will reduce sharpness. As with cropping, the greater the resolution of the original image – broadly measured by the size of your file – the more dramatic the changes you can make to the image shape without visible loss of quality. If you suspect that you may need to make major shape corrections, shoot in RAW (see pp.184–85).

in different places – the only way to correct it is by using specialist software specifically tailored to the lens; this solution is used in some high-end professional equipment. Remember that distortion is seldom easily seen, and needs correction only for critical uses, such as architectural photography.

Projection distortion occurs whenever the camera is not square-on to a flat subject. The parts of the subject further away appear smaller in the image than the parts nearer the camera, so any rectangles become distorted into a keystone shape, forcing parallel lines to appear to converge. With buildings, this misrepresents their shape, so it's important to be able to correct it (see opposite).

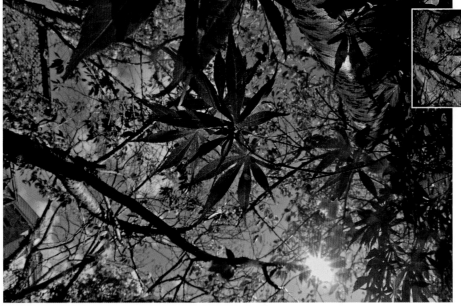

Fish-eye correction
With its swollen centre, fish-eye distortion is not natural and is usually uncomfortable to view (inset). Even small corrections made to the most curved lines improve the image, without losing the essential sense of an extremely wide-angle view.

Correcting convergence

When you point your camera upwards to take in the tops of buildings, you cause a change in the magnification of the image from top to bottom – the top appears smaller, and all parallel lines on the building appear to converge. Any surfaces "running off" at an angle to the camera will exhibit a similar convergence. You can correct convergence in image manipulation software by changing the overall shape of the image within the frame. If a building appears to lean back, apply a correcting distortion by enlarging the upper part so that it's the same size as the lower part. This will keep any parallel lines parallel. Invariably, however, there'll be further elements in the image to correct.

ORIGINAL IMAGE

1 **General view**
Here, the buildings and trees lean back precariously as I was using a very wide-angle lens too close to the scene. I had pointed the lens upwards in an attempt to capture the full height of the building and to include the moon.

FREE TRANSFORM TOOL

2 **Upper stretch**
I selected the whole image and applied a distortion that stretched the top half of the image so that it was almost twice as wide as the original. This corrected the verticals and made the trees and buildings run parallel.

INTERMEDIATE STAGE

3 **Lost portions**
The upper stretch straightened the building but it is now too squat. Due to the secondary enlargement of the sky, the moon is almost lost from the image, and the tree trunk on the left has disappeared.

LENS CORRECTION FILTER

4 **Elegant correction**
Some software (such as Adobe Photoshop and DxO Optics) offer a lens correction filter that corrects in two directions – up, and across. I applied this filter to give the building more natural proportions, but I also had to stretch the image upwards again.

PERSPECTIVE CROP

5 **Tilted horizon**
These corrections revealed an imperfectly level horizon. I used a perspective crop, allowing me to reposition the corners so that the frame outline was parallel to the detail I wished to square up to the frame. This distorted the features so its contents met the required shape.

FINAL IMAGE

6 **Naturalized**
Close examination of the upper half of the image will show defects, as it has been enlarged by nearly 100 per cent in order to accommodate all these corrections. However, this is an acceptable cost for an image that looks more natural than when it started out

Correcting Levels

Your main control over correcting an image's exposure – its overall brightness – is the Levels control. With it you can manipulate the distribution of pixel brightness, from dark to light. Levels also enables you to adjust contrast – how quickly dark tones transition to light tones. The controls are intuitive and easy to learn: it's the most used image manipulation of all thanks to its simplicity and effectiveness.

All you need to do is click on the tool, push the sliders while watching the changes to your image, and stop when you see what you want. The basic features of the Levels control are largely the same in most applications. There are sliders that set the black and white points, effectively controlling contrast, while the central slider is best regarded as setting the image's exposure, or overall brightness. There may also be sliders that set the output black and white levels. You can use this for clipping – setting the outputs at slightly less than maximum.

Population chart

If you want to take a systematic approach, work with the histogram display. This presents statistics about pixel brightness: for a given brightness, the more pixels there are of that level of brightness, the higher the histogram display at that point. Conventionally, dark pixels are on the left of the display, and bright ones on the right. A good-quality histogram shows pixels throughout the range, with a hump or two around the middle, indicating that the exposure correctly captured a full range of values, and that the larger part of the image consists of mid-tones. Usually, however, the histogram display shows pixels starting a short way from the left and ending a little way from the right.

The fundamental setting has three steps: first, place the left-hand slider so that it just touches the histogram as it rises from the left. This sets the black point: as you do that, the image becomes darker. The next step is to slide the right-hand slider until it just touches the histogram as it rises from the right-hand side. This sets the white point: as you do this, the image becomes lighter. Next, you adjust the central, mid-tone slider to produce the exposure you require.

Black or white

You may notice another effect of moving the left-hand (Black) and right-hand (White) sliders away from their start positions: as the distance between them reduces, the image becomes more contrasty. The reason for this is that if the

Rescuing levels
This image languished for years because the over-exposure at the moment of capture (grabbed from a moving bus) hid its qualities (inset). But using Levels to create true blacks has brought out the colours and given strength to the shadows, revealing a charming scene of Bhutanese children returning from school.

AVOIDING EXTREMES

Scenes with a large luminance range tend to produce dense blacks and very white highlights (top). You can reduce output blacks (to about 20) and output whites (to about 235) to lower the overall contrast, for a more manageable image (bottom). Slightly boosting saturation often helps improve the tonality of colours.

darkest pixels were not touching the extreme left-hand side of the histogram, they were not true black: moving the Black slider up to them redefines their values as black. Likewise with the White slider. This has the effect of squashing all intervening pixels into a smaller space, forcing the transition from dark to light to be more abrupt, creating higher contrast.

Advanced uses

All but the simplest Levels controls allow you to adjust the colour channels separately. This enables you to alter colour balance – although this is tricky, it's useful where other methods have failed, and for creating strong colour effects. When preparing images for print or picture agencies, you may be required to set the output levels, though this may vary; it's best to check in advance whether adjustments are needed.

Dropper tools

The dropper tools apply a tone, and force all other tones to be remapped according to its values. Click the Shadow dropper on the original image and it sets all pixels of the same brightness as the sampled point to black, and everything else shifts in proportion. If the sampled area is coloured, the shift also remaps colours. The Highlight dropper has the opposite effect: the sampled point is taken as being highlights. The Mid-tone dropper remaps the image taking the sampled area as corresponding to neutral grey. This provides a quick way of colour balancing, provided you have a reliable neutral grey to work with.

SHADOW DROPPER

1 Shadows
The Shadow dropper clicked on a mid-tone tells the software that the sampled point should be dark, so the image changes in proportion.

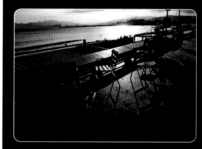

MID-TONE DROPPER

2 Mid-tones
If you choose the Mid-tone dropper and sample an area of mid-tone, the exposure will change little, if at all.

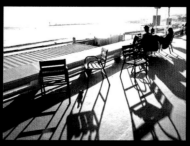

HIGHLIGHT DROPPER

3 Highlights
The Highlight dropper clicked on a mid-tone tells the software that the sampled point should be bright; so the image changes in proportion.

Adjusting tone

The control that adjusts tone was originally known as "Curves", for want of a better term, but the label has stuck and it continues to cause confusion. The name is a shortened version of "transfer function curve", referring to the line that defines how an image's input values are changed for output.

The Curves control manipulates the quality of transitions between light and dark. When first opened, the "curve" is a straight line inclined at 45 degrees, showing that the selected channel's output is the same as its input. When you change the shape of the line – by clicking on it and dragging – you alter the relationship between input and output. For example, you can force light tones to become darker, and shadows to become lighter, with other tones falling in between.

Colour flexibility

The usual practice is to alter the combined RGB curves – all three colour channels – together. This changes overall brightness and tone quality, or contrast – how quickly or abruptly bright tones transition into dark tones.

But you can also adjust curves for each individual colour channel. If you change the curve for one or more of the colour channels separately, you'll alter both colour balance (see pp.218–19) and tone, with the possibility of restricting changes to shadows, mid-tones, or highlights.

Limits to control

A steep gradient on a whole or part of a curve always indicates a rapid change in contrast, or high contrast, with lively tonality. A shallow or flatter curve indicates more gradual

You can set brightness or ink (darkness) for the Curves control in advanced applications such as Adobe Photoshop. If Curves controls the brightness of the output (usually in RGB mode), the starting line heads upwards from zero brightness or maximum darkness. The further along the line, the brighter the pixel. Raising a part of the curve makes the image brighter. If Curves controls the ink or pigment output (usually in CMYK mode), the scale is reversed so that the line starts at minimum ink, creating white, leading up to maximum ink, creating black. Lowering a part of the curve makes the image lighter.

changes, or low contrast, with softer tones. When you change the shape of the curve, some parts of it will be steep, creating rapid tonal changes; others will be more shallow, with lower contrast in between. Try to develop your skill in setting the contrast at the level that works best for your image.

Drawing very steep curves places tough demands on your data: what was sufficient data for normal contrast now has to cover a larger range of output values. Any gaps in the data will be revealed; bands or stepped changes in colour or tone may appear (see p.228). Note that the portions of a curve in which it changes direction often create unnatural-looking tones in the image.

If you expect to make large tonal or colour changes, it's best to record in RAW at 12-bit (36-bit RGB) per channel or more, then save and manipulate the image in the same colour space (see pp.178–79). The extra data in these very large files will help keep tonal transitions smooth and un-banded.

ALL-IN-ONE CORRECTION

Curves can be relied on to solve virtually any tonal or colour problem. There are easier ways, but no single control matches the versatility and power of Curves. This image (right) was flawed by poor white balance and flare, and it shows a blue-cyan cast and low contrast. A combined curve boosts contrast, while manipulation of the blue channel's curve corrects the colour (far right).

Curves survival kit

You can save yourself a lot of work by creating your own set of curves that you can load whenever you need them. A set of six favourites will cover the majority of situations: they may not give perfect results with every image, but will provide quick fixes, and can make a good basis for further refinement. If you use more than one camera – say a dSLR

and a compact – you may find that you need different sets of curves to suit the way each camera processes its images. And when you travel abroad, images taken in unfamiliar lighting conditions may require you to create new curves. The graphs below assume you set the scales to ink (see box, opposite); reverse the shape if you have set them to lightness.

INCREASE EXPOSURE

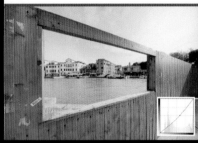

You increase the exposure by dragging the mid-point down (for ink) or up (for light) to boost the mid-tones. This is because the darkest and lightest parts of the image are unaffected, remaining black or white. More shadow detail is revealed, and colours become paler.

DECREASE EXPOSURE

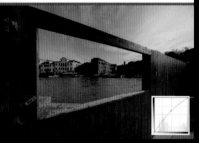

Dragging the mid-point up (for ink) or down (for light) drives mid-tones towards shadows. Light areas are a little darker – as are shadows – but the mid-tones show the most change. Colours are intensified and contrast may appear improved.

SHADOWS AND HIGHLIGHTS

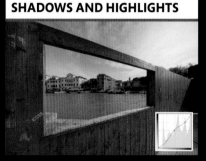

A click in the middle of the line holds it in place when other parts of the line are changed. Dragging the shadow part of the curve lightens the shadows, and dragging the highlight part darkens the highlights, while maintaining useable mid-tones.

MID-TONE CONTRAST

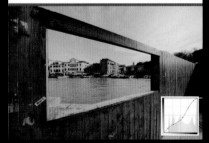

A bow-shaped curve, which slightly darkens highlights and gently lifts shadows, causes the mid-tone area of the curve to be steep. This adds sparkle and energy to the image by boosting contrast in the crucial mid-tones. It's a very useful shape for cheering up dull, lifeless tones.

LOWER CONTRAST

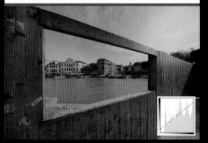

If the highlights are made darker and shadows lightened with a straight transfer curve between the two extremes, the result is a dramatically lowered contrast with weakened colours. This is useful for outputs with increased contrast, such as laser prints.

HIGHER CONTRAST

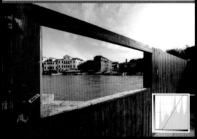

If highlights and blacks are clipped – that is, if some dark grey pixels are forced to be black, and some light grey pixels are made white – the overall image gains contrast, with much stronger colours, solid shadows, and pure-white highlights. This is useful if you're printing on low-quality paper.

Levels and Curves effects

The best way to appreciate different Levels and Curves settings is to assess them all together. When working with these controls, take a screenshot of the result of each change or save each version, named by a summary of the settings you use. This builds a library of visual effects which you can refer to and apply again and again.

When you find a setting that works well for your purposes, save it as a preset. These are useful for batch processing: collect all the images with similar lighting into a folder, then apply the setting to them all using the Batch or Automate features. Soft-proof images to ensure that the adjustments will be within gamut when printed, and check for a full range of values before making heavy adjustments to avoid aliasing, or posterized tones.

▼ ORIGINAL IMAGES

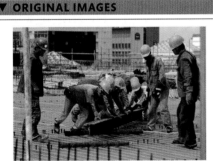

ROWS 1 AND 2

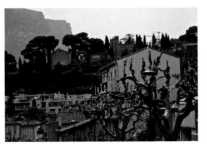

ROWS 3, 4, AND 5

LEVELS: TONAL ▷

The Levels control is used not only for optimizing the image, but also for tonal modifications with special uses. Use Levels when you want to achieve a faded look, or to make colour unnaturally vivid, without changing the image's content.

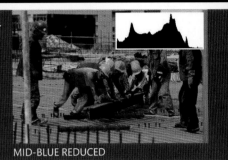

INCREASED INTENSITY

LEVELS: COLOUR ▷

Colour balance is easily adjusted by fine-tuning the colour channels separately: it enables you to make global changes quickly, with separate, if limited, shadow and highlight control. Best of all, you can choose which colour to use as the target mid-tone.

MID-BLUE REDUCED

CURVES: TONAL ▷

Tonal adjustment is where the Curves control really comes into its own, and here you can create effects both subtle and strong. But its real power becomes apparent when you apply different curves to each channel, with small differences for colour balancing effects.

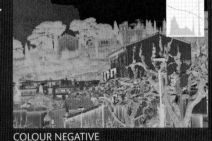

COOL HIGHLIGHTS

CURVES: SIMULATIONS ▷

As well as creating film-grain effects, Curves can simulate the appearance of old film, characterized by variations in tonal rendering, contrast, and colour balance. Expect to make slight variations each time to adapt to the original image.

COLOUR NEGATIVE

CURVES: REVERSALS ▷

Curves can be used to produce dramatic changes in an image without affecting its content and outlines. By freely distorting each curve separately within each channel, an infinite variety of colour-based and tonal effects is possible.

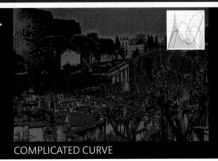

COMPLICATED CURVE

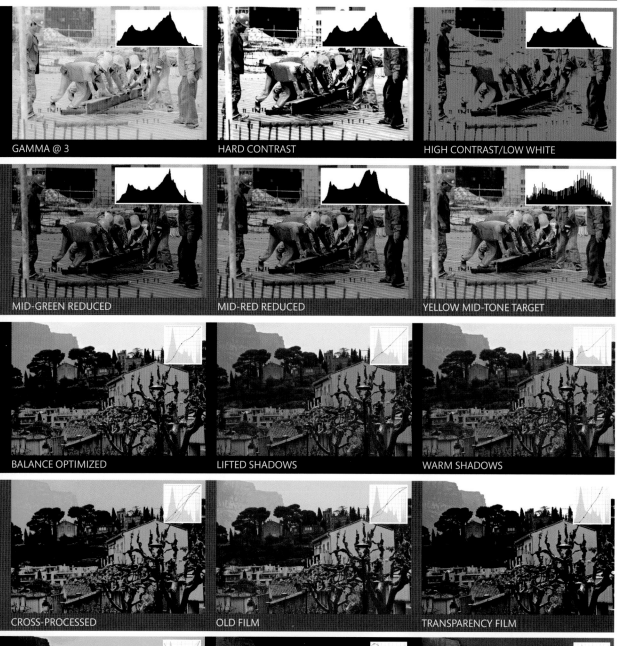

GAMMA @ 3

HARD CONTRAST

HIGH CONTRAST/LOW WHITE

MID-GREEN REDUCED

MID-RED REDUCED

YELLOW MID-TONE TARGET

BALANCE OPTIMIZED

LIFTED SHADOWS

WARM SHADOWS

CROSS-PROCESSED

OLD FILM

TRANSPARENCY FILM

INVERT SHADOWS

INVERT TONES AND COLOURS

M-SHAPED CURVE

Burn and Dodge

You'll use the Burn and Dodge tools so often they'd wear out if they weren't digital. Burning darkens bright areas so they don't distract, and dodging lifts shadows to help bring out details, such as the shine in a subject's eye. As locally applied effects, they increase contrast only in the selected area, which makes them the visual equivalent of emphasizing certain words when speaking.

Your aim here, as with other enhancement tools, is to make discreet changes. When working on large areas, use soft-edged brushes that are a little larger than the area you wish to cover. For small areas, use harder-edged brushes about the same size as the area you're working on. Start with low pressures – around three per cent is a good starting point, and don't go higher than ten per cent – and build up the effect. If you can see your strokes as soon as you apply them, you're working too quickly.

Non-intuitive settings

Burn and Dodge is one of the simplest enhancement techniques to use, but choosing the correct tone-band to work on can be confusing. If you want to darken the shadows you might expect to choose the Shadows control, but a little

experience will show you that this darkens these areas too quickly. And if you want to lighten them, and choose to dodge Shadows, you'll quickly end up with ugly grey smears. By the same token, choosing the Highlight control to work on highlights also gives rise to problems: working directly on the tone-band actually changes the wrong tones. For example, if you wish to darken a bright area, you need to darken any mid-tones that are present: this alone may be sufficient to reveal detail. If you darken highlights directly, there may be no detail to reveal, so all you get is a grey smudge.

To darken shadows, burn the Midtones; to darken mid-tones, burn the Highlights or Shadows; and to darken highlights, burn Midtones or Shadows. To lighten shadows, set to dodge Midtones or Highlights; to lighten mid-tones, dodge Highlights or Shadows; finally, to lighten grey highlights, dodge Midtones.

Colour changes

The tools work by changing all three RGB values equally. This means that while small changes don't change colours, large changes do (technically you've removed the grey component) – another reason to make soft, gradual changes. Often a barely noticeable effect can lift your image to stellar quality.

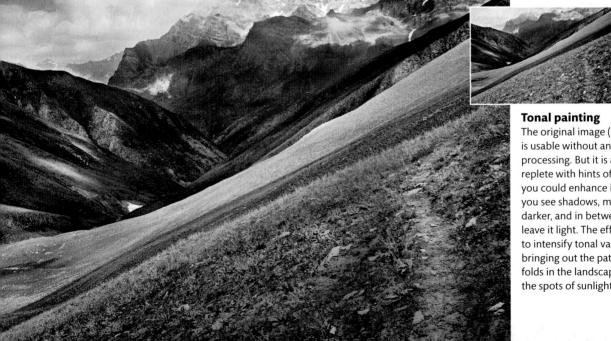

Tonal painting
The original image (inset) is usable without any post-processing. But it is also replete with hints of how you could enhance it: where you see shadows, make it darker, and in between leave it light. The effect is to intensify tonal variations, bringing out the path, the folds in the landscape, and the spots of sunlight.

Tonal rescue

This over-exposed shot of sheep being herded was the result of a mistake in setting up the camera. The image is worth trying to salvage, although the chalk cliff and grass in the bright sun have lost almost all detail. The strategy is to darken the image overall – to give the over-bright areas some "body" – then dodge or lighten it locally to bring out the sheep. I aimed to return the scene to how I saw it, which means allowing some highlights to burn out. The image is so over-exposed that global corrections weren't sufficient to rescue it. But applying localized burn and dodge operations helped to rescue the image, because the over-exposed areas retain just enough detail to work with.

ORIGINAL IMAGE

DARKEN WITH GRADIENTS

COLOR BURN

1 **Levels adjustment**
The first step is to darken the image overall using Levels to lower the mid-tones, and also reduce the output whites to a very light grey. I avoided the temptation to make the image too dark, as I could always increase density at any point in the proceedings.

2 **Apply gradients**
Choosing the Gradient tool, I set it to around 30 per cent, created a new layer, then applied gradients to cover the lower portion of the darkened image. This darkens the chalk cliff rather indiscriminately, but it can be refined. The layer's blend mode is set to Color Burn, to increase contrast.

3 **Burn for texture**
In order to improve the texture in the blank areas of chalk, I applied grey strokes to the layer, painting in Color Burn mode to apply texture where it had been burnt out. Color Burn increases contrast and saturation, both helping to pull out any colour in the highlights.

DODGE

SHADOWS

WHITE BALANCE

4 **Pick out sheep**
With the Dodge tool set to Highlights, I applied a small brush with light pressure to the sheep to bring them out from the now-darkened background. This has the effect of making the background appear darker than it is, which is why it is wise to avoid over-darkening in the first step.

5 **Lift shadows**
As a result of the combined Levels and Gradient effects, some shadows among the trees now appear too black, so I applied the Dodge tool set to Midtones to reveal detail. In addition, I dodged tree branches here and there to bring out the light on them.

6 **Final adjustment**
The sequence of adjustments had the effect of showing that the original white balance was too slanted towards reds. So I applied Color Balance to reduce the mid-tone and shadow red. This brings out stronger green tints present in the scene.

Writing with light

The Burn and Dodge tools enable you to underline the key points of your visual writing: they make the light areas of an image more visible, and tone down differences to reduce distractions. Here the original image showed promise, but it seemed more of a bland itemization of the features of the Valley of the Gods, USA. Judicious but firm use of burning-in and dodging transformed it into an eloquent description of the landscape.

▷ Canon IDs MkIII, 12–24mm *f*/4.5–5.6 : 12mm *f*/14 ISO 200 -1.33EV 1/250sec

1 Dramatic sky
Darkening the sky with a gradient from the top left-hand corner not only draws attention to the land, it also helps to emphasize the structure of the clouds. I further enhanced the streaked effect by burning-in the sky between the clouds on the right-hand side of the image.

2 Textured ground
In conversion to black and white, the green brush became a similar shade of grey to the red soil, so definition between them was lost. I carefully dodged between the clumps of brush, and burnt-in some of them, to separate them from the ground.

3 Highlighted flowers
When I made the image, the yellow blooms of the flowers were accentuated by the diffused backlighting – perfect. But in black and white, they are nowhere near as striking. I carefully applied the Dodge tool, set to Highlights, to restore them to their true, dazzling glory.

4 Shining rocks
Finally, I used Burn and Dodge to create an effect only hinted at in the actual scene. The rocks were matt and reflected little light, but small areas were shiny. Taking this as inspiration, I dodged the rock as if all of it were reflective, and burned-in the shadows to maintain contrast.

IN DETAIL

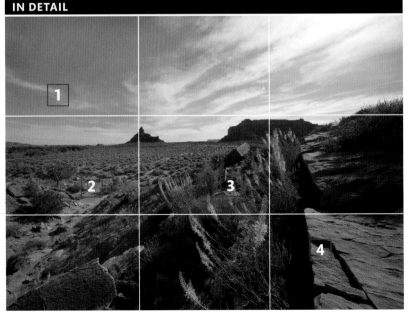

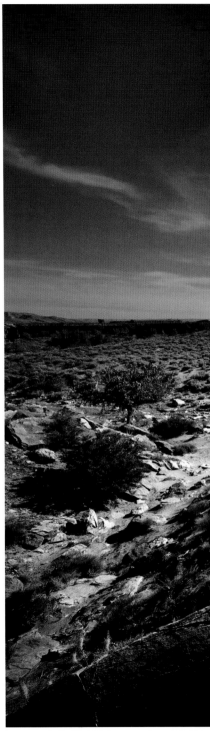

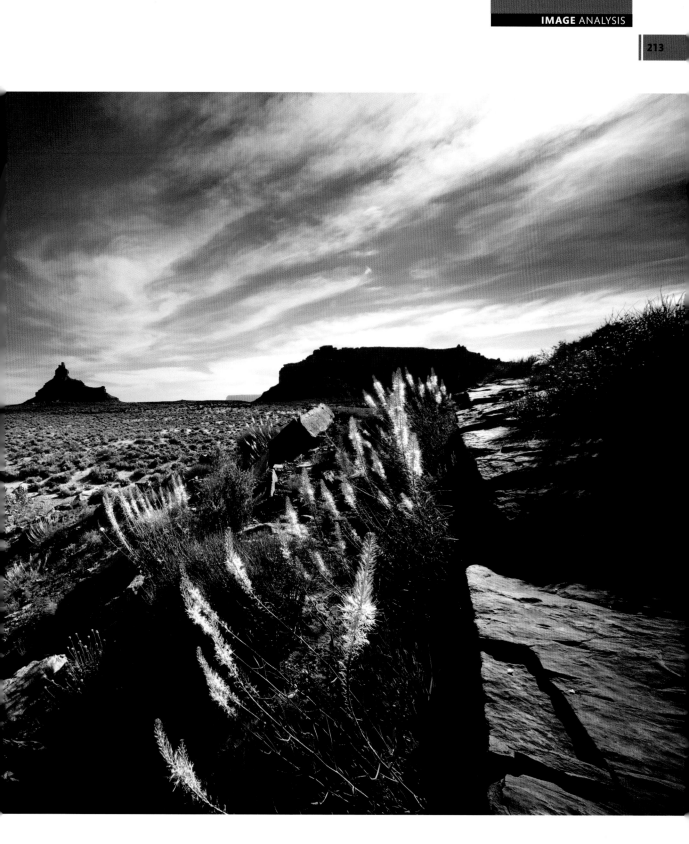

Controlling shadows and highlights

The world offers many brilliant scenes with greater brightness ranges than can be captured or displayed by cameras, monitors, or prints. To reproduce scenes the way you experienced them, you need to recover details in the highlights, and "fill" or lighten shadows.

Shadow and highlight recovery is a processing step applied after image capture. If you record in JPEG, it can be done in-camera. Manufacturers provide various methods for this, under a variety of names, such as "highlight priority". In some cases the camera analyses one portion of the image at a time, and applies a tone curve appropriate to the selected area: this produces superior results but may substantially increase noise (see pp.102–03). Other cameras may under-expose to capture highlights, then brighten shadows and mid-tones.

Image processing

Even after in-camera processing, and certainly for RAW images (see pp.184–85) and other files, you may find yourself using the Shadows/Highlights control frequently. Your aim in this is to reveal some details in burnt-out highlights or deep shadows, but to avoid removing the essential character of their brightness or darkness. Unlike controls such as Curves

or Levels (see pp.204–07), which affect pixels irrespective of their neighbours, Shadow and Highlight controls are adaptive: they work on groupings of pixels. So, to get the best results, you need to tell the software what to look for.

To start with, set low values for the amount or strength of the effect. The tonal width sets the range of tones to be adjusted: start with 50 per cent, and increase or decrease to suit. The Radius control tells the software how large a group of pixels to examine, so set a size about the same as that of the important features in your image – too large a radius tends to darken the image overall.

Adjustment limits

Beware of extreme adjustment. This can cause reversal of some tones, particularly at the edges of features; it can also cause halo effects, and images with rich mid-tones may appear unnaturally painterly (see pp.216–17). Over-correction of highlights creates flat areas of grey tone with no detail, while in the shadows, over-correction leads to dull colours, low-contrast detail, and increased image noise.

The guide opposite shows how you can use the Highlight, Shadow, and Radius controls to get different results out of an image with a high brightness range.

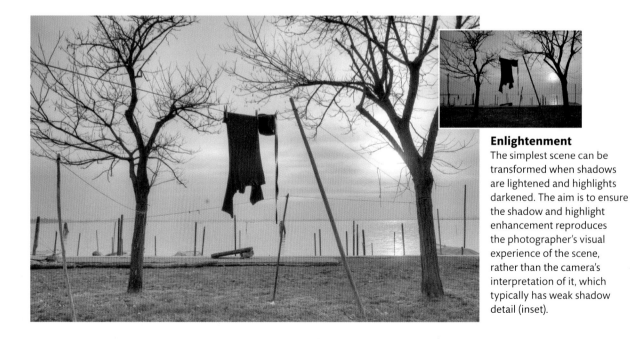

Enlightenment
The simplest scene can be transformed when shadows are lightened and highlights darkened. The aim is to ensure the shadow and highlight enhancement reproduces the photographer's visual experience of the scene, rather than the camera's interpretation of it, which typically has weak shadow detail (inset).

EXCESSIVE DYNAMIC RANGE

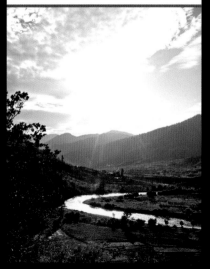

A low afternoon sun puts stress on the sensor, with the camera's attempt to ignore the sun leading to burnt-out highlights and deep shadows.

HIGHLIGHT 50 SHADOW 100

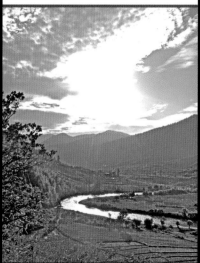

I could easily recover details in clouds where there is density, but burnt-out areas were more difficult. The deep shadows are lifted but, if the Radius setting is a low 100, this is at the expense of making the mid-tones flat and lifeless.

RADIUS 1000

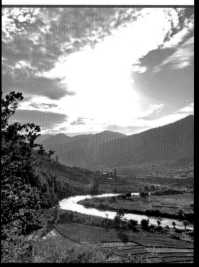

I set Highlight to 50 and Shadow to 100 as before, but I increased the radius, causing the algorithm to look at a much wider area. This improves the tonality of the shadows and mid-tones, but overall the image has lost its original vitality.

TONE WIDTH 100

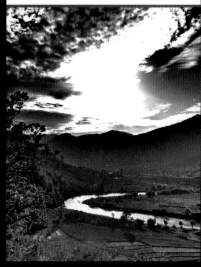

With the same settings as before, I increased the tone width – the range of brightness that the control works on. This has a dramatic effect on the clouds, but introduces a halo in the hills.

MAXIMUM SETTINGS

I used maximum settings – including highlight recovery which puts density even into burnt-out areas – to produce a dramatic image. But it's perhaps too heavily manipulated, with visible halos and dense shadows.

HIGHLIGHT 100 RADIUS 100

There is no single "ideal" setting, as the relationships of highlights and shadows are open to interpretation. This setting uses a maximum recovery of highlights only, with a relatively small radius in order to preserve the quality of the mid-tones.

Tone-mapping brilliance

Where you encounter lighting conditions that are out of your control and produce a dynamic range that's beyond the capacity of your sensor to capture, you can turn to HDR (high dynamic range) techniques. This involves combining a series of different exposures of the same scene, then translating shadow and highlight details into mid-tones in a process known as "tone-mapping". The result is less an accurate record of the scene, and more an interpretation – one that often resembles a painting, because of the predominance of mid-tones. The technique works best with static subjects and with cameras that can bracket exposures in rapid series; to do this you'll also need specialist HDR software.

NORMAL EXPOSURE

1 Brilliant day
A cold wind had cleared the skies and the light was crystal-clear, with clouds backlit beautifully by the sun. Here, a normal exposure tries to capture the brightest and darkest elements, but leaves a sky that is too pale and shadows that are dark and featureless.

EXPOSED FOR SHADOWS

2 Favouring shadows
An exposure based on a reading aimed at the shadows shows them to have a surprising amount of colour. This shows it will be worth trying to capture not only the shadow details but also their colour. However, at this exposure the sky is almost entirely burnt out.

EXPOSED FOR BRIGHTS

3 Highlight detail
The gorgeous patterns of light and shade in the sky are key to the image, so it's important to retain the highlights. Even within the confines of the sky area, the exposure range is so high that it is almost beyond the power of the sensor to capture.

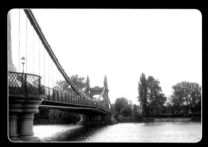

BRACKETING SEQUENCE

4 Stacking capture
You need a very wide range of bracketing exposures, so set your camera to manual exposure mode and measure the basic exposure. Using the shutter control, set to under-expose by four stops, then make exposures at one-stop increments until you've over-exposed by four stops.

COLLECT FILES

5 Organise project folder
When you experiment with tone-mapping, it's useful to separate the working files from other images, and to keep work-in-progress files together. This speeds up your workflow. For the work itself, use specialist HDR software such as Photomatix Pro.

HIGH DYNAMIC RANGE

6 Preliminary image
The initial processing is not likely to produce a useable image unless you view it with special HDR monitors. Don't be disheartened: there's a lot more information both in the shadows and the highlights than initially appears, because the data from each exposure is still on board.

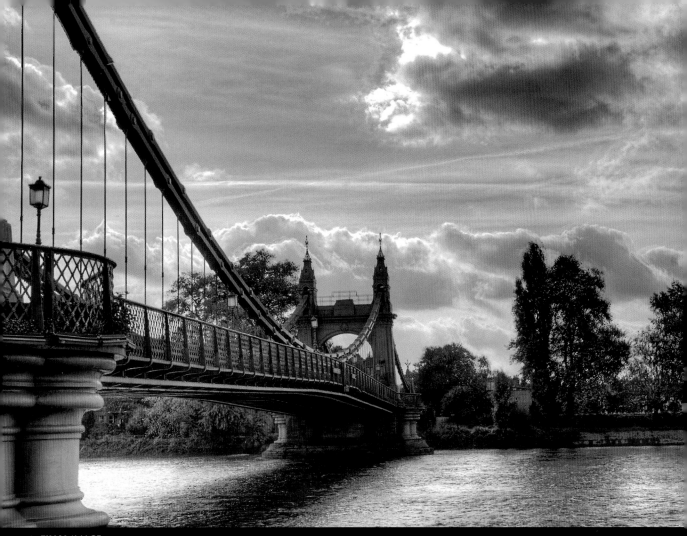

△ **FINAL** IMAGE

START TONE MAP

OVER-BRIGHT

FINAL ADJUSTMENTS

7 **Default tone map**
The default settings produce an image similar to a normal exposure, but with the difference that all the information that's needed to retrieve full colour and detail throughout the image is held in the file. It is now a case of adjusting all the controls to make the data visible.

8 **Conservative conversion**
This is the key step: compressing the tonal range so that the shadow and highlight details fall in the mid-range. Do this by reducing contrast between elements globally – over the whole image – and locally. Exposure may not be perfect, but tone and colour corrections come later.

9 **Curves and levels**
The final step is to fine-tune the output from the tone-mapping software. By making conservative settings when converting, you enjoy more room to adjust the final image. Improve tonality and exposure with Levels or Curves, and burn and dodge to touch up local tones.

Correcting white balance

In film-based photography, colour balance was limited to just three options at best, and white balance was obtained by using clumsy filters. Now, navigating a few menus in your camera gives you access to settings for any lighting situation. But there's still plenty of room for error, both by camera and user.

If you make a mistake with your white balance settings, it's not a disaster, though there are limits to how fully you can correct it. (For more information on the distinction between colour and white balance, see pp.104–05). In the majority of lighting situations – ranging from a sunny or overcast day, to an interior lit by table lamps – JPEG files will have sufficient "headroom", or colour data, to allow you to improve on a camera's preset or automatic balancing in post-processing. The presets use nominal corrections, so you often need to fine-tune the results. Extreme lighting situations, such as nightclubs with multiple, coloured light sources, are harder to correct; here you wouldn't want full correction, as this would affect the mood created by the coloured light.

Colour rendering index (CRI)

Far from being an obscure technicality, the colour rendering index (see p.104) proves its importance in white balance correction. If a scene's lighting lacks certain colours – that is, if it's of a low colour rendering index – and if you want to reinstate these colours to make a full colour correction, your image quality will suffer. This shows up as broken or stepped gradients of tone, or blocks of similar colours. The types of light cast by sunsets, domestic tungsten filament bulbs, street lamps, and certain long-life bulbs are all susceptible to this;

DID YOU KNOW?

Colour itself may not have a temperature, but many things that emit light do. Very hot (or "incandescent") objects emit light that is more blue-tinted than that from cooler ones, and so an object's temperature is used to define the main colour emitted by it. In the days of colour film, all main light sources were incandescent, producing colours varying between the extremes of blue and yellow/red, so it was necessary only to balance colour reproduction for the colour temperature of these light sources. However, modern sources of light, such as the fluorescent tube, emit two or more main colours, so extra filters are needed for full correction. This is the origin of white balance, with which you can correct not only for blue-yellow but also for green-magenta.

for example, blue clothing under tungsten lighting can't be fully corrected if your camera's white balance is set to compensate for a daylight source (see opposite).

Mix and match

Lights from mixed sources, such as warm tungsten light from a lamp combined with daylight from a window, can limit your ability to achieve an accurate white balance. In cities, mixed sources are the norm, often with neon, fluorescent, sodium, and tungsten halogen lamps in a single shot. If one colour cast is in the shadows, and the other in the higher mid-tones, you may be able to correct them individually using Curves for separate channels (see pp.206–07). If they are in the same tone band, you may have to brush in corrections by hand.

A FINE BALANCE

It's challenging when a subject is lit by two sources with very different colour temperatures. Here the model was lit by a blue sky through a window, and yellow lamplight. To make the dress appear white, the rest of the image shifts towards yellow to compensate. However, if the lamplight is made to appear white, the rest of the image becomes strongly blue. The best result would be somewhere in between.

Colour balance settings

Many cameras offer preset colour balances for specific conditions, such as Daylight or Cloudy Day, as well as automatic colour balance, which is a standard feature on digital cameras. Using presets does not necessarily give better results than the automatic setting, but they do ensure a more consistent colour rendering, so that images shot in the same situation look similar. This is important if you want to process lots of images together, and for techniques such as panorama stitching that demand consistent colour. The extent to which you can correct errors depends on both the illumination and the degree of correction needed; to get the best results, remember to change the preset when the lighting changes.

TUNGSTEN FOR DAYLIGHT

If I choose the Tungsten preset of the camera's white balance for a scene lit by daylight, I'd expect a strong blue cast. This is not always unpleasant; it's sometimes used in lifestyle and fashion photography.

COLOUR BALANCED

This full correction to neutral, with no visible defects, is possible because the lighting is full in all wavelengths. This means the camera collected enough data for full correction of the image, and I only have to extract it from the file.

WARM BALANCED

Thanks to the sunlight, the image is so data-rich that I can achieve a much warmer rendering without any visible loss of image quality. Indeed, colour differentiation in blue areas – such as the jeans – is improved by this very warm balance.

CLOUDY DAY FOR TUNGSTEN

In contrast, using the Cloudy Day preset under tungsten lighting creates an unnaturally warm, over-saturated effect. The blue material of the model's top appears almost green, and skin tones are unrealistic.

PART-BALANCED

A partial correction of the colour cast just about produces acceptable results. Note the black patches in the blue fabric – blocked shadows – and appearance of noise in the background, as a result of the attempt at white balance correction.

FULL BALANCE

If I attempt a full correction, the image severely deteriorates, because the original lighting's low colour rendering index results in many gaps in colour data. If I'd captured the image at the correct setting, or in RAW, it would have a satisfactory colour rendering here.

Colour refinements

White balance alone is not enough to ensure fully
satisfying colour reproduction. This is because each
camera's sensor has its own strengths and weaknesses
relative to different colours. And at the time of capture,
lighting conditions may vary, and sources may be mixed.

While accurate colour is a necessity in certain industries
– textiles and house paints, for example – photographers
are not so demanding. But we do care about the overall
visual effect. This calls for an artistic, rather than objective,
adjustment of the relative strengths of colours. For this,
you need controls for colour refinement, rather than white
balancing – which shifts white to neutral, simultaneously
remapping all colours (see pp.218–19). Colour refining limits
its changes to selected bands of colours; the differences in
these depend on how the band of colour is selected.

Color Balance control

Available in almost all image manipulation software, the
Color Balance control alters broad bands of colour, sorted
by exposure. For example, you can warm up cold shadows
and simultaneously cool down warm highlights, both of
which occur on sunny days. By offering all three channels
of colour in the same control, Color Balance is easy to use
and enjoys freedom from artefacts (see p.183). It can also
be used to create split-tone effects (see pp.256–57).

Hue/Saturation control

Controls combining hue and saturation are available in all
image manipulation software. The hue or colour part of the
control shifts the entire range of colours in an image by an

equal amount; it's a very blunt tool for obtaining colour
balance. The Saturation control lowers or increases the
saturation, or richness, of a hue (see pp.226–27), either overall
or limited to specific colour bands. In the majority of software,
you can further narrow or widen the range of colours you
want to change. This can result in a complicated-looking
control, but one that offers a high level of precision.

Replace Color control

The Replace Color control, best known in Adobe Photoshop,
allows you to alter bands of colours selectively by their
location, as well as by their colour (see opposite). You can
use a dropper tool to "pick" colours from different parts
of the image. The range of affected colours similar to the
chosen colour can be adjusted with the Fuzziness control.
This is useful for reducing the saturation of over-saturated
colours, so that they will print as they appear on screen –
this is known as bringing colours into gamut (see p.178).

BALANCING HUE

Where an image is very strongly coloured
but not in balance, a global change in hue
can provide the answer. Any balancing
control would leave the original image
(right) largely untouched, thanks to
the large areas of blue and red, which
compensate for each other. But a global
change in hue (far right) shifts the reds to a
more accurate yellow, and simultaneously
moves the blue to a more truthful mauve.

Selective refinement

Your refinement of the colour reproduction in an image may have to be in proportion with the complexity of lighting that you've recorded. The trickiest situations are when two sources with different white balance are blended smoothly, as seen in this shot of dancers in rehearsal. In this scene, the subjects were illuminated by diffused daylight from an overcast sky coming in through the windows, so the balance is somewhat cool. This blends seamlessly with the illumination inside the dance studio, which was a strongly-tinted green from fluorescent lights. The differences in colour balance that appear in distant parts of the image are not differentiated by exposure, which will make colour refinements tricky.

CAMERA BALANCE

The camera's auto-colour balance has attempted to warm the bluish balance of the tutus and skin tones, which were illuminated by daylight. But this leaves the walls – illuminated by fluorescent lights – distinctly greenish.

AUTO-LEVELS

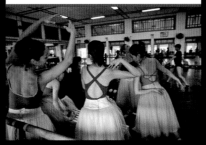

In correcting the walls, I didn't want to lose the colour correction elsewhere. Applying auto-levels brightens the image with improved contrast, but also increases the colour imbalances by making the green tint of the walls even more obvious.

DROPPER ON TUTUS

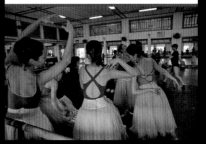

The mid-tone, or grey, dropper from Levels only applies corrections to pixels similar to the sampled point: it turns the selected area to mid-grey, and remaps all the other colours by the same amount. Clicking on the brightest of the tutus makes them neutral, but causes a strong yellow cast overall.

DROPPER ON WALL

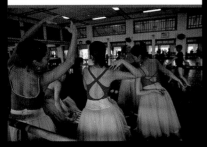

Clicking the mid-tone dropper on the walls renders them nearly neutral, but at the cost of making the whole image strongly magenta – an unacceptable result. I was discovering that the light green tone of the walls needed a great deal of correction.

DROPPER ON FLOOR

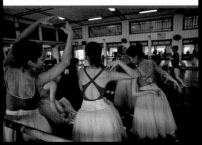

Centering the colour balance on the floor renders the tutus nicely, and gives a good overall result. This shows that careful choice of sample area can provide a rapid solution very easily. This result is acceptable, but could be better.

REPLACE COLOR

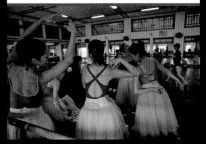

As the trouble-spot is the green tint on the walls, I decided to use Replace Color, which restricts corrections to similarly coloured pixels. I selected the walls, then reduced saturation and increased brightness, making them appear neutral.

Enhancing tone and colour

Modern cameras are so good at exposure control and extracting the best from your subject that most of the time you'll be perfectly happy with the results. But if you want your images to look a little special – with some standout character – then enhancing tone and colour is a necessity. Just as printing in the darkroom involved bringing out the potential hidden in a negative, so image enhancement is an exciting voyage of discovery: the process can inspire a continuing dialogue between the image and your artistry. This image was taken at a fashion shoot, and I could have stopped my adjustments after Step 3, as that version is entirely publishable. Allowing the image to reveal its promise, however, showed there were several ways to interpret its data.

ORIGINAL IMAGE

WHITE BALANCE

SIMPLE CURVE

1 Backlit contrast
Shot with a 135mm lens at its maximum aperture of f/1.8, the background is nicely blurred. However, the bright backlighting has biased the exposure, causing the model and her headdress to be under-exposed. The white balance is bluish and too cool.

2 Return to tan
My first move was to correct the white balance by reducing the cyan and blue in the image, bringing the model's tanned skin back to its true colours. The background has also taken on warm hues, which is welcome.

3 Soften contrast
In its true colours (Step 2), it's clear that the contrast between the model and the background is too high. I applied a simple curve to correct this: I darkened the highlights a touch and lifted the shadows by the same amount, then lightened the mid-tones.

GRADIENTS

LARGE DODGE BRUSH

SMALL DODGE BRUSH

4 Lighten background
Although the background is soft, the window frame and panelling are still distracting. I applied a gradient set to Lighten to the left and right of the image, taking care not to lighten the model. This improved matters, but the background still needed more work.

5 Reduce background
To reduce the background further, without affecting the model, I applied the Dodge tool set to Mid-tones at a strength of 5 per cent. I used a large size and soft edges to take the background down to the palest of lines and subtle high-key areas.

6 Brighten up
The next step was to work on the feathers and face. I could have used the Shadows/Highlight control, but that would have been too indiscriminate for my purposes. Instead, I applied the Dodge tool to bring out the lighter, brighter-coloured feathers and to lighten the tones of her face.

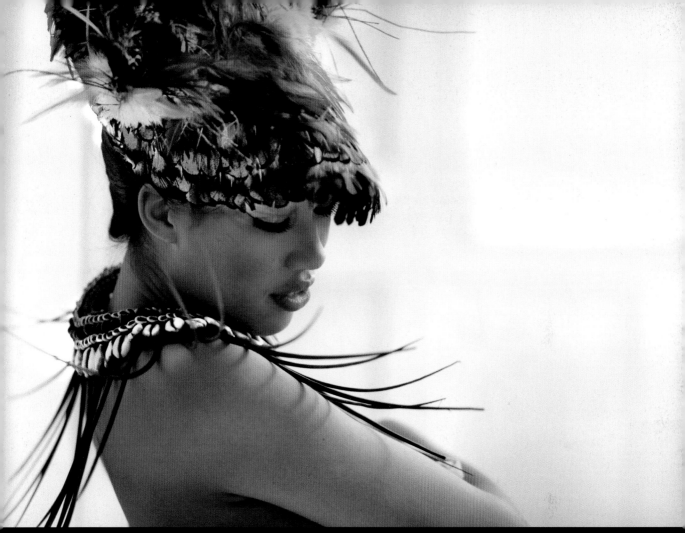

△ **FINAL** IMAGE

SMALL DODGE BRUSH

SATURATION

VIBRANCE, HUE/SATURATION

7 **Highlights**
The seashells in the necklace were off-white, but I decided to add a little sparkle by dodging them carefully too, making sure that I didn't lighten the surrounding skin. This brought some light to the back of the model.

8 **Intensify colour**
Areas that start with dark mid-tones and then lighten often appear too saturated. I toned down the shells slightly with the Saturation (or Sponge) tool, set to desaturate. But this made the darker feathers look undersaturated, so I used

9 **Final finesse**
I needed first to lighten the reds of the skin, because lowering the saturation of dark skin tones can make them look unattractively muddy. After lightening the reds in the Hue/Saturation control, I used the Vibrance control to lower the

Entrancing colour

At this modern hotel complex, reflective materials – glass, metal, and water – are integral to the resort's design. At night, the interplay of coloured lights brings the pool and these gleaming surfaces to life. The main image provides the best balance of colour and form compared to other shots in the series. I applied only enough white balance to bring out colour differences while preserving overall warmth. I boosted the blues and cyans to match what I saw, and then I burnt-in darker details to anchor the tone.

▷ Sony A900, 12–24mm *f*/4.5–5.6 : 12mm *f*/11 ISO 200 -0.5EV 6sec

FROM THE SAME SERIES

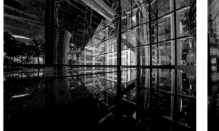

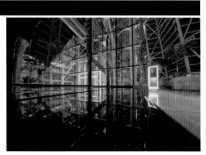

1 **Daylight promise**
A full vocabulary of structural forms makes every viewpoint and choice of framing interesting. Regular grids, curves, repeated lines, and flat tones are balanced by the presence of the trees, and all these elements are reinforced through their myriad reflections.

2 **A pedestrian conclusion**
This attempt at capturing the space takes in the foyer, but without much going on we're left with a hole devoid of activity. At the time I could see the light bouncing off the metalwork and glass and shining in a rainbow of colours, but the effect is masked in this image by a colour cast.

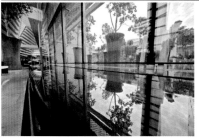

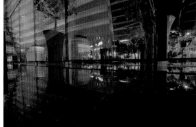

3 **Varying palette**
Exploring views from a different angle revealed a whole new range of colours. This shot, once its colour balance was corrected in post-processing, showed warm reds and yellows framing a central patch of azure, with hints of purple adding variety. Yet the bottom third of the image lacks interest.

4 **Strong stripes**
This image features strongly striped elements, but is unbalanced, with more features on the left than on the right. To capture both this shot and the main image, I gingerly held my camera out over the water – but to frame accurately, I'd have had to stand in the middle of the pool.

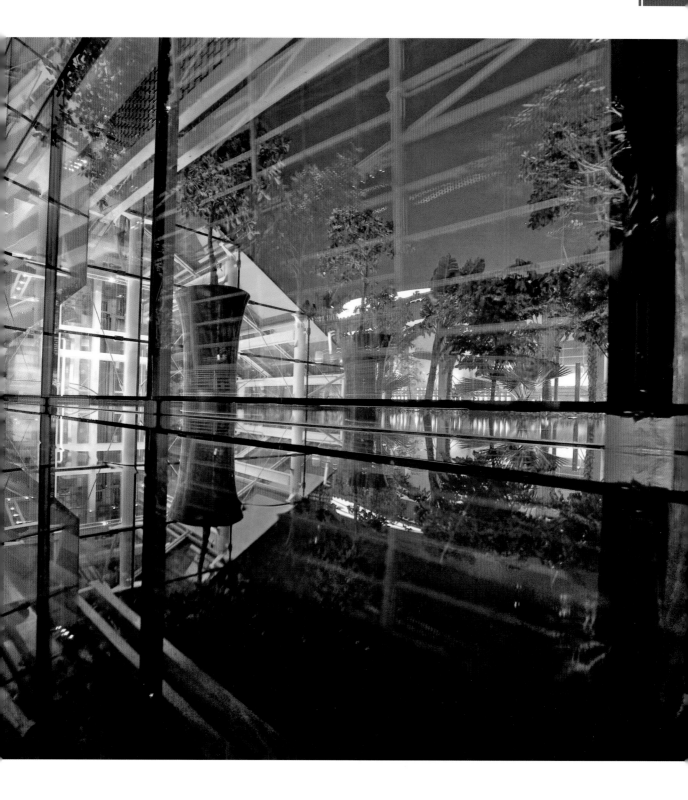

Saturation and vibrance

A look at the cultures of hot countries shows a universal love of saturated colours – bright, rich, and deep – that adorn buildings, clothes, and all kinds of goods. In the early stages of film-based colour photography and again in the early days of digital photography, high colour saturation was a much-desired goal. In both cases, once we obtained high-saturation results, we also learned that we can have too much of a good thing.

Technically, saturation is the colourfulness of something judged in relation to brightness. Light, low-saturated colours become darker as they increase in saturation, while well-saturated colours look brighter and livelier when their saturation is raised. This change in quality helps explain why there's a tendency to make images full of highly saturated colours: they look very lively on the screen.

Selective saturation

On the other hand, high-quality cameras tend to produce JPEG images that are not highly saturated. Manufacturers deliberately process images conservatively because over-saturation is hard to recover. When a colour is made too strong, varieties of the hue take on the same values, so even if saturation levels are reduced, differences in colouring cannot be recovered.

The key to improving colour saturation is to be selective: identify the colours that appear weakest. If you'd like a bluer sky, for example, instead of increasing saturation over the whole image, select Blues in your software's saturation control and increase saturation only for that band of colour. The result is powerful yet subtle at the same time.

Controlling vibrance

The Vibrance control, available in the majority of image manipulation applications, applies a different type of selective saturation. It changes the saturation of flesh tones less than the saturation of other colours. If a colour is already high in saturation, its saturation is not changed as much as areas with low saturation. If there are skin tones present in a low-saturation image, vibrance produces more attractive results than an overall increase in saturation.

Vibrance is also very useful for reducing the saturation of other colours while leaving flesh tones relatively unaltered. The pallor of the results chimes well with cool and aloof styles in portraiture and fashion.

BAND-LIMITED SATURATION

The character of an image changes markedly as different bands of colour are altered. The original (below) is already strongly coloured. A very strong red (top right) makes the scene fiery, while a reduced red (bottom right) is more tranquil. Reducing the blue (top far right) makes the reds stronger, while a very strong blue makes the reds yellowish (bottom far right).

VIBRANT TONES

The original capture (top) appears pale and watery, although some colours, such as the red shirt and the blue jeans, are acceptably bright. Increasing the saturation by 100 per cent brightens up the whole image (middle), but not only are the red shirts now too brilliant, the children's skin tones also appear much too tanned. In contrast, applying 100 per cent on the vibrance (bottom) brings up the weak colours of the stonework without making the clothing too bright and, most importantly, without over-saturating the skin tones.

Emphasizing choice

If the most effective way to increase saturation in images is to be selective, the opposite holds equally true: the best way to lower saturation is also to be selective. In any image, some colours are more important than others. You can choose to emphasize them by raising their saturation or you can bring them forward by lowering the saturation of all the other colours.

In this image, I wanted to retain the skin tones of the model and the colour of the corset, while at the same time lowering the saturation of the background so that its colour didn't detract from the model.

ORIGINAL IMAGE

1 **Warm balance**

The colour balance is very warm due to the use of tungsten halogen lamps for the lighting. This results in an unwanted tint in the background.

VIBRANCE @ 70

2 **Minus vibrance**

A strong reduction in vibrance turns the wall neutral and gives an attractive pallor to skin tones, but the corset has lost too much of its golden colour.

YELLOW DESATURATED @ 0

3 **Retaining red**

Reducing yellows very strongly gives a perfect result: lovely skin tones, golden corset, and grey walls that allow reds to tone the skin and corset.

ENHANCING IMAGES

Digital corrections

NOISE

PROBLEM
Your images are grainy and speckled, peppered with irregular clumps of colour. There are no true blacks. The problem is most obvious when the image is enlarged and after exposure adjustments.

ANALYSIS
The image is noisy as a result of an exceedingly high ISO being set in low-light conditions, or because a very long exposure time was used. An overheated camera can also cause high noise levels, which can be made worse by exposure and shadow corrections.

SOLUTION

▷ In low light, reduce the need for high ISO by setting under-exposure of -1 or -2EV.

▷ Avoid setting the highest ISO on your camera by improving the lighting or using flash.

▷ Reduce noise with specialist software, but don't try to eliminate all signs of noise as this will compromise fine details in the image.

BANDING NOISE

PROBLEM
For the most part, your image appears free of noise, but dark areas show a fine, patterned noise, particularly after exposure correction. At very high ISO, there are patterns of alternating dark and darker bands.

ANALYSIS
Your image suffers from banding noise, which is an artefact caused by errors in image processing of weak signals from low light. Usually hidden under the darkest shadow regions, below the "noise floor" of other noise, they become apparent when you make the image brighter.

SOLUTION

▷ Avoid shooting at very high ISO settings, and take care not to under-expose.

▷ Use specialist software that can target banding noise.

▷ If banding noise is a serious issue, you may need to upgrade your camera: new cameras are less prone to this problem.

FRINGING

PROBLEM
The fine detail in your image shows green, red, or purple fringes, particularly in the corners. When objects are against a white, light, or plain background, coloured fringes are most easily visible.

ANALYSIS
Fringing is caused by a combination of chromatic aberration in the lens, capture artefacts from the sensor, and image processing errors. Chromatic aberration can be alleviated by software because the red, green, and blue images vary minutely in size.

SOLUTION

▷ Use lens correction features in image manipulation software to reduce chromatic aberration. It may not be possible to remove all traces if some of the fringing is caused by processing errors.

▷ Crop the image to lose the extreme corners.

▷ If fringing is a serious problem, you may need to use a higher-quality lens and avoid using lenses at full aperture.

DISTORTION

PROBLEM

Straight lines in your image appear curved. Horizons appear to slope gently down on both sides, and rectangular objects aren't represented accurately.

ANALYSIS

All lenses suffer from distortion, where straight lines are not represented accurately because of slight changes in magnification from the centre of the image to the periphery. Most distortion is small and invisible, but large amounts can be visually disturbing.

SOLUTION

▷ Use a prime (single focal-length) lens, or set your zoom to around the middle of its range.

▷ Avoid placing straight edges or lines, such as the horizon, close to the edge of the frame (as above).

▷ Use the distortion filters in image manipulation software to correct the problem by introducing a compensating distortion.

DARK CORNERS

PROBLEM

The corners are darkened in some of your images, but not all of them. The darkening varies, being subtle in some cases and strong in others. It is particularly unwelcome for views with a lot of sky.

ANALYSIS

Darkening in wide-angle lenses is caused by a much smaller amount of light reaching the corners of the image than the centre. In zoom lenses, the lens intrudes into the light bundle, causing vignetting, which is usually worse at the longer focal-length settings. Misaligned lens hoods can also darken corners.

SOLUTION

▷ Check that your lens hood is on the right way and that the dots line up.

▷ Use smaller apertures to avoid dark corners in all types of lenses.

▷ Avoid using the extreme long focal-lengths of a zoom when photographing large expanses of empty sky.

▷ Use the lens correction filter (also available in RAW converters) to reduce vignetting, that is, to make the corners lighter. If software doesn't offer these features, use a light circular gradient to lighten the corners.

MOIRÉ

PROBLEM

Bands of unexpected colour appear in your image, especially when you're photographing subjects with regular patterns, such as roof tiles, railings, or herringbone or tweed fabric.

ANALYSIS

The regular patterns in the subject become superimposed on the regular pattern of the sensor, in which the pixels are held in a grid or raster. At certain sizes and frequencies, this creates a pattern of alternating bands of new colours, known as a moiré pattern.

SOLUTION

▷ Avoid all subjects with fine repeating patterns which are known to cause moiré.

▷ Reduce depth of field by using a larger aperture to blur the pattern.

▷ Moiré can be reduced by introducing blurring to the image in image manipulation software: sometimes blurring confined to one channel reduces moiré without reducing too much detail.

▷ Some plug-ins are designed to reduce moiré without reducing sharpness.

Sharpness and blur

Not only does the level of acceptable sharpness in an image vary according to individual quality standards, whether an image is sufficiently sharp also depends on its intended use. Indeed, for our purposes, sharpness and blur are best understood as two sides of the same coin.

It is good practice to capture the sharpest image possible when making your exposure, because you can always blur a sharp image in post-processing, while there are limits to how much you can sharpen a blurred image.

Sharpening your images

We determine how sharp an image looks according to how much fine detail we can see, and how easily we can see it. The latter depends on micro-contrast – the tiny changes in light and dark that define the lines and textures that make up the detail in an image. Digital sharpening is unable to increase the amount of information in an image, but it can make the information present more visible by increasing the micro-contrast between the elements in the fine detail.

The most popular method to sharpen images is Unsharp masking (USM). USM settings function via three different values: Amount, Radius, and Threshold. These settings are

DID YOU KNOW?

Blurring occurs when the representation of an object is at a lower contrast or retains less detail than is present in the original scene – which is inevitable, due to the technical capabilities of sensors and camera lenses, and any movement at point of capture. Thus, all digital images suffer from blurring, and all digital images benefit from being sharpened – although the choice of when this process takes places calls for careful judgement.

easy to control when you want to vary the strength of an effect and match subjects with differing amounts of detail (see Unsharp masking, opposite).

When you encounter blur in an image, it is tempting to apply sharpening immediately. However, this method actually destroys image data, which may be needed for processing; in particular, tonal changes in the highlights may be lost. In general, it's best to leave USM until after you've made all other necessary adjustments. By the same token, it's advisable to turn off any in-camera sharpening, as this can seriously damage image integrity, particularly when it comes to low-resolution images.

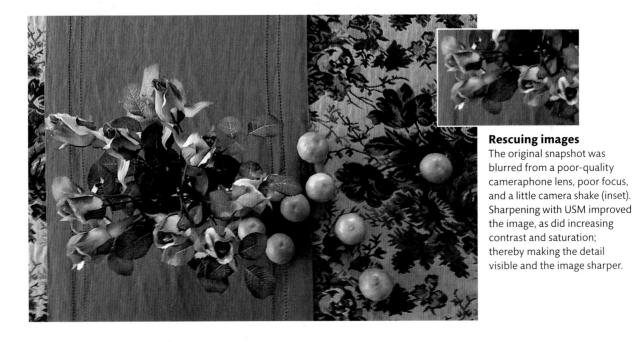

Rescuing images

The original snapshot was blurred from a poor-quality cameraphone lens, poor focus, and a little camera shake (inset). Sharpening with USM improved the image, as did increasing contrast and saturation; thereby making the detail visible and the image sharper.

SHARPER BY OMISSION

Shot at maximum aperture, the background of this image is very soft, but still too detailed to bring enough attention to the cocktail (top). By masking the glass (or selecting the background) and applying a strong blur, I improved the balance of sharpness to blur (bottom). I was careful not to apply too much blur, as this would make the glass and hand appear disembodied.

Applying blur

It's not often that we need to blur an entire image – perhaps when we wish to create a background image (for example, if you were going to use it as a "wallpaper" for a website). However, it's often useful to apply blur to a selected area, as this can help direct attention to the subject in focus; or, put another way, this can reduce the distraction of backgrounds that are too detailed, usually because of a depth of field that's too extensive. Use plug-ins, or make the selection and apply one of the many blur filters available. Select the area to be protected with a high feather setting, invert the selection, and apply Gaussian Blur at the desired strength. Protect a larger area and apply a stronger blur for a graduated effect.

Unsharp masking

USM settings can be confusing as the variables interact with each other, making it possible to obtain similar effects with different settings. If your image contains mostly fine details, set a high Amount, small Radius, and low Threshold (for example, Amount: 200; Radius: 1-2; Threshold 0-5). This improves all boundaries in the image over a small distance, but increases noise. If the image has large areas of even tone, set a medium Amount, large Radius, and high Threshold (for example, Amount: 90; Radius: 40; Threshold: 20). The high threshold ignores noise while the high Radius compensates for the moderate Amount.

ORIGINAL IMAGE

1 Indistinct focus

A shot taken closer to the subject than the closest focus of the lens produces a soft result, but with most essential detail intact.

USM 250-2-0

2 Detail priority

A high Amount setting and small Radius brings out the rose motif in the cup, but the sugar cubes and table are perhaps over-defined.

USM 90-40-20

3 Preserving tone

With a low Amount but high Radius the table and sugar cubes are rendered naturally, while some detail in the rose appears, giving a fair compromise.

Adaptive sharpening

Sharpening your images calls for delicate work. Too much is not a good thing, and neither is applying it equally across the whole image. Technically, normal sharpening takes into account density differences, but not frequency (that is, the amount of detail in the area in question).

Unsharp masking (USM) settings can be used to sharpen your images. These settings favour images with fine details or large areas of tone, but not both at the same time. Yet the majority of images contain both fine details and areas of even tone, so indiscriminate sharpening will sharpen areas we wish to keep blurred, such as flesh tones or blur. It may also sharpen noise. The solution is to use methods that are sensitive to the frequency of detail, that is, that adapt to the amount and quality of detail: these are called adaptive, smart, or edge-localized sharpening methods.

High Pass

A High Pass filter masks out large areas of tone and allows only fine detail to be visible. The idea is to locate the fine detail, then limit sharpening to this area by use of a blending mode, which works with the masking effect of the High Pass filter. First, duplicate the background image and change the blend mode of the duplicate layer to Overlay. This sets up the interaction between the top layer and the background. Next, apply the High Pass filter: the layer itself looks like an embossed grey layer, but the image is likely to look immediately sharper. You can adjust the Radius setting of the High Pass filter to control the amount of sharpening obtained, as well as its Opacity to control the tonal qualities. You may also try different blend modes, such as Soft Light or Pin Light for softer effects, or Hard Light or Linear Light for stronger sharpening.

Selective sharpening

When it comes to images depicting large areas of sky or water, you can use selections or masks to restrict sharpening to chosen areas of fine detail. It's easiest to select large areas of even tone first, then invert the selection so that the sharpening applies only to the foreground landscape. Selective sharpening works well when working on eyes. In Quick Mask mode, use a soft brush to paint round the eyes; exit Quick Mask and invert, so that the selection covers the eyes; then apply gentle amounts of USM to sharpen the eyes and eyelashes, leaving skin tones smooth.

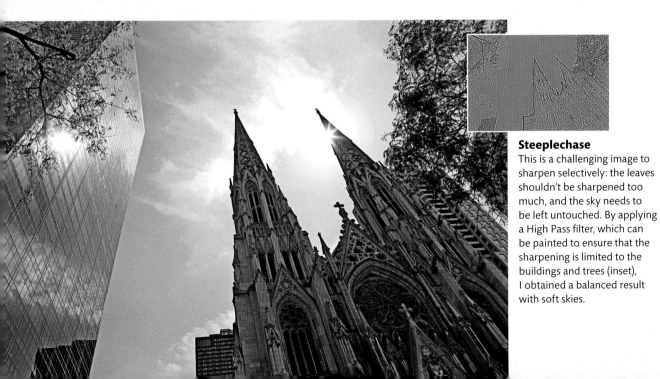

Steeplechase
This is a challenging image to sharpen selectively: the leaves shouldn't be sharpened too much, and the sky needs to be left untouched. By applying a High Pass filter, which can be painted to ensure that the sharpening is limited to the buildings and trees (inset), I obtained a balanced result with soft skies.

Touch and go

Find Edges is another useful filter for performing adaptive sharpening on your images. You can use it to mask an image, so that sharpening applies only at major edges, or you can blend it with the original image to bring out edges. The important point about this filter is that in creating an intermediate step, you can alter that step to improve its accuracy. In particular, you can paint or erase the result of Find Edges to prevent unwanted edges from being sharpened. As with all techniques, first duplicate the background layer, then apply the Find Edges filter. Next, you can use the Find Edges layer to create a mask before applying sharpening, or, as shown here, use a suitable blend mode.

ORIGINAL IMAGE

UNSHARP MASK

FIND EDGES

1 **Abstract arrangement**
An arty shot of a table setting in a glitzy restaurant needed to be sharper, as the auto-focus mode focused on a stalk instead of the orchids.

2 **Overall sharpening**
Applying Unsharp Masking settings to the image brought out the flowers and stalks. However, the reflection of the sky in the table top – the blue shape – looks too sharp. At small scales, as here, such a result is acceptable, but at larger sizes the differences would be less welcome.

3 **Edges include noise**
I duplicated the background to a new layer and applied the Find Edges filter. This usually produces an immediately attractive graphic image. In this case, there was an unwanted side effect in that noise levels were significantly increased.

ERASER TOOL

SHARPEN EDGES

DARKER COLOR

4 **Remove edges to soften**
I painted over the noise and the edges of the reflection – so that these elements wouldn't be too sharp – with an Eraser tool brush loaded with white set to 60 per cent.

5 **Further sharpening**
Next, I strongly sharpened the Find Edges layer using Sharpen Edges. This brought out some noise, so I painted over these details with a brush loaded with white, set to 100 per cent.

6 **Final touches**
To finish, I turned the Find Edges layer into the Darker Color blend mode, making the image much sharper. You may want to adjust the Levels, opacity, or fill of this layer to fine-tune the result for exposure and sharpness.

MANIPULATING IMAGES

Cloning techniques

An ideal method for repairing or refining your images, cloning is one of the most useful tools in your image manipulation kit. The Clone tool replaces part of an image (the target) with new material (the source). The source can be located elsewhere on the same image, or come from another image altogether.

Broadly, you have two different ways in which to clone. You can replace pixels, that is, substitute one image for another (for example, you could change a person's eyes for a cat's eyes). For this, you take pixels from another image or a different part of the same image, and use them to overwrite or "paint over" the pixels you wish to change. If you work at 100 per cent opacity and 100 per cent flow you'll completely eliminate the target pixels with the source pixels. By reducing opacity and flow, and by increasing feathering, you can shade off and soften the cloning; most usefully, this can be done on the margins of the cloned area to simulate out-of-focus blur.

Displacing pixels

Alternatively, you can displace pixels, that is, change their position. For example, you might like to move a flower from one spot to another. The clone will consist of the part of the image you wish to reposition, and some of its background. Try cloning with different blend modes – set to Lighten, for instance – so that the parts of the image being repositioned that are lighter than the target location will be cloned.

Handling techniques

The Clone tool is applied with a brush, so you can adjust the appearance of the cloned area by varying opacity and, in some software, whether the source pixels are applied in normal mode or with some interactive blending such as Darken or Lighten. The Clone tool may be known under another name in some programs, but it will perform the same task. Follow these techniques for best results:

- Use the aligned mode when correcting defined defects.
- Choose the non-aligned mode when fixing irregular details.
- Match the tone and contrast of the source image before starting to clone.
- Use soft edges (large feather setting) in areas of smooth tonal or colour gradations.
- Use a hard edge (small feather setting) when working close to sharp (clearly defined) detail or boundaries.
- Avoid smudging by applying a clone with 100 per cent opacity in as few strokes as possible.

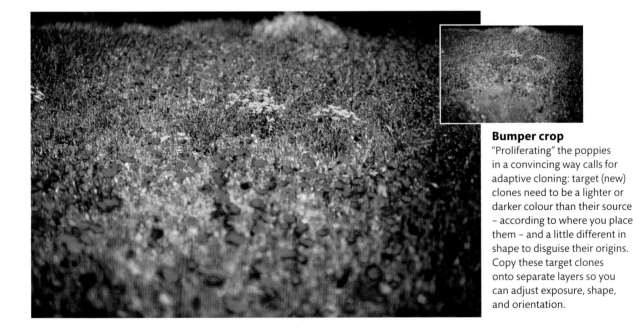

Bumper crop
"Proliferating" the poppies in a convincing way calls for adaptive cloning: target (new) clones need to be a lighter or darker colour than their source – according to where you place them – and a little different in shape to disguise their origins. Copy these target clones onto separate layers so you can adjust exposure, shape, and orientation.

Repairing an old print

It is only right that digital technologies can now come to the rescue of images that laid photography's foundation stones. Cloning techniques are ideal for repairing damage and fixing flaws caused by fungal growths, paper deterioration, and stains resulting from poor chemical processing. The first step is to make a high-quality copy of the print that needs repair: use a scanner, or take a photograph (light the print with shadowless illumination, and use the highest quality settings). The undamaged parts of the print are the source of pixels for repairing the damaged parts. Large areas are best repaired by selecting, copying, and pasting a whole area of pixels, as this method best preserves quality.

ORIGINAL PRINT

CLONE TOOL

CUT AND PASTE

1 Make a copy
This print of an ancestor's wedding was found in a box, having fallen out of its album. It was badly torn and had been creased, which cracked the emulsion coating. I made a copy on a flatbed scanner, which gave me an excellent facsimile to work with.

2 Remove scratches
I selected the Clone tool, set to non-aligned mode with a small radius and medium feathering. Starting in one corner, I sampled an area that matched the surroundings of each crack and cloned over the white marks, working steadily across the image.

3 Replace torn edges
I patched the torn areas by selecting, copying, and pasting parts of the existing image over the missing areas, choosing areas with a good match of tone and detail. I blended the edges of the source pixels with the target pixels, using layer masks as needed.

BRUSH TOOL

MARQUEE TOOL

FINAL IMAGE

4 Patch and blend
I took particular care to blend the new patches seamlessly with the existing background, using a soft brush to apply the masking. This was made easier by the generally low quality of the image.

5 Borders and backgrounds
Clean-cut borders are not appropriate for this era of image, so I selected the image with the Marquee tool and cut it from its original border. I created a new background, added some tone, then pasted the image on to provide a narrow cut-matte border.

6 Increase details
After a last clean-up of small defects, I flattened the image and applied a little sharpening to improve the rendering of details. I then gave the image a final once-over to check that my restoration work was imperceptible.

Selection methods

When you want to apply effects selectively, or to specific portions of an image, you can choose between two main methods. The most obvious way is to use a "brush" that applies, or "paints", the effect with whatever brush size you've selected – but this isn't good for covering large areas. Alternatively, you can apply the editing effect to a selected group of pixels, called the "editable area".

For example, if you wish to raise the contrast of the shadows, but not of the whole image, you can select the shadow region before applying the adjustment. The selection can be defined manually with the Lasso tools, or with other tools that select parts of an image based not just on their location, but also on their appearance and other properties (see pp.242–43).

Lasso skills

The Lasso tools are the most intuitive selection controls to use: you simply draw the edges of the area you want to select. These tools are best for selections that require artistic decisions about their precise shape and extent. Work at high magnification to ensure reliable results.

When you make a selection, the editable area is usually enclosed by a perimeter of moving black and white dashes known as "marching ants". Once you've drawn it, you can

modify and refine a selection to any required level of precision. If you need to add to your selection area, pick a selection tool and hold down the Shift key when you apply it: when you define an area, you'll add it to the overall selection. On the other hand, if you selected too large an area, you can subtract some of it. To do this, hold down the Option (or Alt) key while drawing the area you want to cut, using a selection tool. These methods are commonly used across different software applications.

Some applications also allow you to expand or shrink a selection by adding or subtracting a number of pixels all the way around its edges, or to change its shape.

Feathering

You can also alter how sharply the editable area transitions into the rest of the image. This is vital for ensuring the edges, or boundaries, of features in the image appear realistic. When you adjust the feathering of a selection, you adjust the zone of transition: feathering measures how many pixels lie between the area of full selection and the area of zero selection. It also measures how many pixels lie between full effect and zero effect. In the majority of software applications, the marching ants define the halfway point of the feathering range: imagine there's a zone of gradually changing levels of selection running parallel either side of the line of marching ants.

WORKING WITH BACKGROUNDS

Busy backgroud
Separating subject from background in an everyday scene usually calls for manual Lasso techniques. It can be tricky to locate the selection boundary where subject and background are similar in colour or tone, such as at the lower left of this image.

Neutral background
A plain or bright background may appear to be the best choice if you intend to separate a subject. It can work well for dark colours in the subject, but light colours, in this case the white t-shirt, may blend into the background.

Green screen
The best way to to isolate a subject from the background is to use a green screen. For portraits, the colour is complementary to skin tones, so it's easily excluded – but take care that green light from the background is not reflected onto your subject.

Selective memory

Selection is essentially the definition of boundaries between the elements of an image. A typical photograph may contain clear, sharp boundaries, and also regions where the differences are blurred. In practice, you may not keep changing the selection tool as you move from one type of boundary to another, but you'll find that using the tool best matched to the detail will speed up your work. Selecting pixels automatically, for example with the Magic Wand tool, works with large areas of similar colour, while the Lasso tool is best for free-hand selections. Magnetic Lasso is useful for ensuring the selection area is accurate, while the Polygonal Line tool is excellent for outlining regular shapes.

ORIGINAL IMAGE

1 **Snapshot**
A shot of a tourist out enjoying the sights has placed the clock tower directly behind her head. If I can separate her from the background, I can enlarge her so that she appears to be closer to the camera and obscures the tower.

MAGIC WAND TOOL

2 **Removing sky**
The cloudy sky is made up of similar tones and occupies a large area. I easily selected this using the Magic Wand tool: I set a relatively low Tolerance so as not to select too much at once, held the Shift key down, and clicked on different parts of the sky until it was all selected.

LASSO TOOL

3 **Freehand outline**
I drew this selection of the subject's head using the Lasso tool, which draws like a brush or pen. Good results rely on a steady hand – using a graphics tablet (see p.332) tends to be easier than using a mouse. Any errors can be easily corrected using the Shift and Option (Alt) keys.

MAGNETIC LASSO TOOL

4 **Steady state**
Magnetic Lasso is a refinement of the Lasso tool: it analyses adjacent pixels and keeps the selection line on the boundary, even if your hand wavers. I used it where details were sharp and distinct, such as the outline of the girl.

PEN TOOL

5 **Straight lines**
Where the outlines are straight, you can use the Polygonal Line tool by clicking at each end of a straight line to define the boundary. For more precision, and to follow curves, as above, I used the Pen tool; the resulting path then needed to be converted to a selection border.

FINAL CUT OUT

6 **Lift-off**
In a complicated selection, you may inadvertently click the image, making the selection disappear. Immediately undo – Command (Control) + Z – and the selection should re-appear. Once my selection was complete, I copied and pasted it onto a new layer, ready to transform it for use.

Protective masks

The relationship between masks and selections illustrates a salient point about image manipulation: there are usually at least two ways of doing anything. Although different from selections, masks have essentially the same effect: they control where you apply adjustments on an image.

A mask works by protecting an area from an effect – like a parasol shading someone from the sun. This is the opposite of a selection, which limits an action to the area it encloses – like scattering seeds within the confines of a flowerbed. Additionally, a mask can be seen as a solid area of colour – red, black, or white, depending on your settings – whereas a selection appears as a line on the perimeter of an area.

Tricky selection

In applications such as Adobe Photoshop, you can draw or paint masks directly in Quick Mask mode, using normal brush tools. The mask is often displayed in red (this is called a "rubylith", from the darkroom practice of applying red paint to areas of negatives, to make them print as white). The part of the image not covered by the mask is the editable area (see pp.238–39), which receives the full force of the manipulation, while the area under the red "paint" is protected, or masked, from editing. The Quick Mask mode is well suited to selecting

DID YOU KNOW?

Selections differ from masks in several ways: a selection hovers over the entire image and is usually effective over any active layer or layers, including any channels. Masks, in contrast, limit their action to the layer on which they were created, although through layer interactions the effect may extend further. Masks are a good choice in situations where it's easiest to use painting or erasing tools to alter their shape.

softer or more complex shapes, such as faces or landscapes. When you exit Quick Mask mode, the rubylith is turned into a selection, which can then be re-transformed back to a mask.

Using masks

While masks can be used like selections, they come into their own when used to apply a part of an image to another, on different layers. Before you use masks to reveal or hide parts of images, the image that's going to be masked needs to be placed on a layer. Masks can also show, by gradations of black through white, how strongly a change is applied. Black conventionally indicates unaffected areas, while white shows those that are fully selected, and greys show corresponding degrees of alteration – in short, a mask is a greyscale template.

SOFTENED MASKS

Botanical emphasis
The red leaves and young pineapple already stand out from the green leaves, but it's possible to create even greater contrast. To do this, you could mask the red leaves and pineapple before applying de-saturation to the leaves.

Painted mask
Using selection methods based on colour would miss out the yellow parts of the pineapple. Painting it in Quick Mask protects the required areas.

Colour contrast
If you apply de-saturation to the image with the mask in place, the unmasked portions become de-saturated, and the fully masked portions are protected.

Creating a depth mask

Masks enable you to counteract the tendency of cameras with small sensors, particularly point-and-shoot models, to capture images with too much depth of field. An excess of focus can make composition tricky, because the viewer is not sure where they should direct their attention. By introducing a gradated blur, you can point the viewer to the important elements of the image. For the best results, the type of mask you use should match the subject matter. Broadly, the technique is to isolate fully or mask the parts of the image you wish to remain sharp, then apply gradually less opaque masks to the areas you want to blur. These can then be softened, to varying extents, by the application of a blur filter.

ORIGINAL IMAGE

1 Sharp shopfront
I made this shot on a compact camera with short focal length, and even with a relatively large aperture, the depth of field extended too far, from the front *matrioshka* to the back row.

GRADIENT MASK

2 Sharpness fall-off
As a quick way of achieving a shallower depth of field, I placed a gradient mask over the image, and made its transition from black to white relatively rapid. When I applied a Gaussian blur, the result was a gradual change in sharpness from foregound to background.

SELECTING ELEMENTS

3 Graduated blur
A gradient mask works well with images such as landscapes, where details are similar in size. But where there's a mix of types and size of detail, it results in misplaced blurs. To distribute the blur in distinct steps, I began selecting the different rows of dolls.

DEPTH MASK

4 Preparation
I copied the image, then created a mask. I then isolated the various elements of the image by making selections, and painted on the masks with progressively lighter shades of grey. The most strongly protected elements will be sharpest, and those with weaker masks will be blurred.

SHIFTING FOCUS

5 Experimentation
I decided that it might be interesting to shift the focus to the second row of dolls. This was easily achieved by changing the density of the various parts of the mask: I changed the front row to a mid-grey, and the second row to black, leaving the others as they were.

FINAL IMAGE

6 Balanced blurs
By trying out different types of blur with the mask applied, I achieved a very convincing result: it looks like an image made with a large sensor and limited depth of field. By adjusting the shades of the masks, I was able to fine-tune the amounts of blur for each row.

Selecting pixels

SPECIFIC COLOURS

PROBLEM
You need to make a selection of a colour or a range of colours, for instance to identify out-of-gamut colours in order to modify them. Or you need to retain a range of colours while you alter others, to, say, turn them monochrome.

ANALYSIS
The selection should be based solely on colour value and not the position of the pixels, and you should be able to add to the selection by sampling additional colours. Once you have made the selection (shown here as a White Matte), you can save it.

SOLUTION

▷ Use the Color Range control in Adobe Photoshop, or equivalent. Tick "Localized Color Clusters" to add to your selection (Shift+click), and vary "Fuzziness" to select more pixels. "Range" determines how much of the image is examined to make the selection.

▷ If the colours you wish to select make up the majority of the image, it may be easier to select the colours you don't want, then invert the selection to catch the ones you do.

IRREGULAR AREAS

PROBLEM
The areas you want to select are not precisely defined, with free-form shapes offering varying colours, densities, and levels of sharpness.

ANALYSIS
Automatic selection methods work by measuring similarity, so if such uniformity is lacking, human judgement is called for. Some selections may need to vary their hardness of outline to respond to variances in the depth of field. These, too, are best done by eye.

SOLUTION

▷ Use Quick Mask mode to paint on the areas you wish to select, erasing as needed to correct errors. Use a brush and vary the hardness, flow, and size according to the characteristics of the detail.

▷ Work very carefully at the edges. Remember that partially covered areas will be partially selected.

▷ Exit Quick Mask mode to turn the painted area into a selection.

SCATTERED SIMILAR AREAS

PROBLEM
You want to select many separate areas of similar colours, but other areas with the same colour are not to be included – so you need to be able to adjust the selection with precision.

ANALYSIS
Color Range is too blunt a tool for this job, as it's not possible to remove unwanted areas from the selection if they are exactly the same colour as the areas you wish to keep. You could select the areas directly yourself (with the Lasso tool, for example), but this would be extremely time-consuming.

SOLUTION

▷ Use the Magic Wand tool, which selects areas of similar colour as the area sampled.

▷ Turn on "Contiguous" for a selection that extends only to similar colours that touch each other. Turn it off for a selection that looks for similar areas throughout the image.

▷ Shift+click to add new colours to the selection. Set low "Tolerance" to narrow the selection.

▷ Use the Lasso tool and hold down the Option key to remove unwanted selections.

COMPLICATED SELECTIONS

PROBLEM
The boundary between two areas of the image is full of intricate detail, such as the branches of a tree. The sharpness of detail may vary, and translucent areas may be present (for example, if you photographed objects behind glass).

ANALYSIS
It is possible to make the selection pixel by pixel, but not only does that take a long time, it also requires great skill to make it convincing – particularly when it comes to soft detail and partial transparencies. Instead, it would be better to work with layers, contrast, and masks.

SOLUTION

▷ Increase the contrast using an Adjustment Layer to make it easier to find subject boundaries using normal selection tools. Delete the Adjustment Layer after use.

▷ Use computed selections supplied by third-party software (for example, Topaz Labs Remask 2). Such software will calculate a mask from your selection, defining the area to be kept, the area to be cut, and the transition in between.

▷ The more you wish to alter the selected area, the more accurately you will need to define the mask.

STRAIGHT-EDGED OBJECTS

PROBLEM
Presented with a geometric and sharply defined subject from which to make your selections of different colours and densities, you need to lay down straight lines to ensure clean selections.

ANALYSIS
Selection tools based on finding pixels that match certain pixel-based criteria won't work, because the selection you need to make is based entirely on location. The tool you use has to ignore transient softness or noise.

SOLUTION

▷ Use the Polygonal Lasso tool (or equivalent), which draws straight lines between points that you define by clicking.

▷ Examine the image at 100 per cent to assess sharpness. Adjust the Feather tool to suit the subject. Set low to zero Feather amount for extremely sharp images, and a larger Feather amount for softer images.

▷ Save the selection if you may have to alter it or re-apply.

SIMPLE IRREGULAR OUTLINE

PROBLEM
A face or figure needs to be separated from the background quickly: speed and ease of manipulation is more important than precision.

ANALYSIS
A person presents a variety of colours and densities, calling for a selection to be applied by eye. For speed, you need a method that's forgiving of slips of the hand: it needs to recognize when pixels are too dissimilar, in order to snap back to the proper selection.

SOLUTION

▷ If it's available, use the Magnetic Lasso tool, as it tries to match newly selected pixels with ones that have already been selected. Otherwise, use the Lasso tool.

▷ Set a Feather amount that's appropriate to the image sharpness – at least 5 pixels wide – to avoid too sharp a transition.

▷ Start with the whole image in view, then zoom in to refine the edges. Use the Quick Mask mode to paint or erase as required.

Removing image content

There are many ways in which photography's move to digital has changed the way we take pictures. One of the more subtle of these is the fact that being able to remove unwanted elements gives you more freedom in framing your images. You may find you shoot and frame compositions differently when you know that, for example, telegraph wires can be removed, or that other unwelcome objects can be disguised.

While the easy removal of unwanted details can liberate your photography, over-reliance on it can tie you to the computer. It's always worth making the effort to exclude an unwanted element when composing the shot, which may lead to a stronger image – or you might even try framing to make a feature of it.

Strategic changes

You can deal with small defects effectively using Heal or Clone tools (see p.236). However, these tend not to work well on large areas, because your control over the area of application is limited. There's also the danger that using many small strokes will smudge the image's detail, and alter the appearance of textures. For larger areas, apply the selection tools to copy source pixels that match as closely as possible – in size, tone, and colour – the target area you wish to cover. Tools such as the Patch tool automatically blend source pixels at the margin of the selection with contiguous target pixels.

Safe working

While many ways of removing image data have been invented, there are none that can restore data that has been erased or cleaned off. It's important to keep in mind that there's a certain finality to this process. Always work on a duplicate file or proxy, so that when you save as you work, you don't change the original file.

Good practice

Before you start, choose global exposure, tone, and colour settings. Set a narrow or zero feather when working with very sharp, distinct details or very high-resolution files, but use a larger feather when working on indistinct elements, or on small files. When you clone or copy, do so onto a new, empty layer, if possible, as you can then adjust exposure and colour to make seamless matches. Work at high magnification to ensure all joins are invisible at the image's final size.

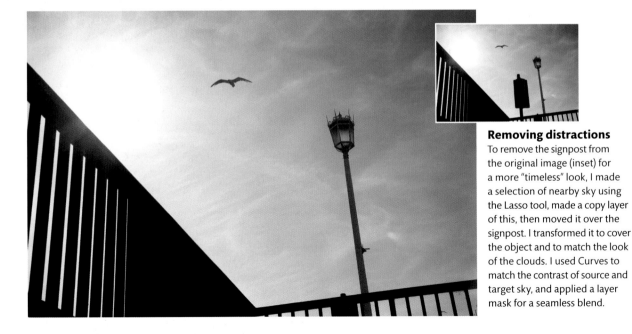

Removing distractions
To remove the signpost from the original image (inset) for a more "timeless" look, I made a selection of nearby sky using the Lasso tool, made a copy layer of this, then moved it over the signpost. I transformed it to cover the object and to match the look of the clouds. I used Curves to match the contrast of source and target sky, and applied a layer mask for a seamless blend.

Blurring background
You can soften distractions by blurring them, or making them either very light or very dark. Here, I reduced background clutter using blur and increased exposure.

Healing blemishes
To deal with large, indistinct areas, such as the baby's rash, use a combination of the Heal tool – for working around the edge of the area to make it smaller – and the Clone tool.

Improving composition
The hand holding the baby doesn't make visual sense within the image. I selected an area of background in the same proportions as the hand, then copied and pasted over it.

Minor surgery

There may be many images in your archives that didn't make the grade; you may have rejected an image because of peripheral detail interefering with the composition, or other unwanted elements in the frame. Assuming you've kept your "also-ran" images, it's likely that some of them could be radically improved with only minor repair.

▼ THE BRIEF

▷ Search through your archives for images that have their potential reduced by a minor defect that you could repair with Clone or Heal tools, combined with the usual image enhancements.

▼ POINTS TO REMEMBER

▷ **Make a duplicate of the file** and work on this, rather than making changes to the original image – as with any manipulation.

▷ **Practise your techniques** by making fairly rough or approximate corrections; don't expect to make precise, seamless repairs if it's your first time.

▷ **Learn, and practise using, the shortcut keys** for changing brush size and strength settings; this is a good way to speed up your work and save yourself unnecessary effort.

▷ **The finer corrections may be easier to do** using a graphics tablet (see p.332) than with your computer's mouse.

▷ **Try to work towards an "ideal" version** of the image as you would have preferred it to be at the time of capture.

GO GOOGLE

☐ **Feathering**	☐ **Tibor Kalman**
☐ **Opacity**	☐ **Nick Knight**
☐ **Thomas Barbey**	☐ **Bert Monroy**
☐ **Steve Caplin**	☐ **Jeff Wall**
☐ **Erik Johansson**	☐ **David Lorenz Winston**

Retouching faces

RED-EYE

PROBLEM
When you photograph people in low light, the flash causes a bright red spot to show up in their eyes. Flash exposures in brighter conditions don't suffer from the same problem.

ANALYSIS
In low light, the iris of the eye opens up, allowing the flash to enter the eye. It then reflects off the back of the retina which is blood-red, giving rise to the red spot. This occurs when the flash is close to the lens and is aimed straight into the eye. Animals' eyes, due to their different anatomy, may show up as white, green, or yellow.

SOLUTION

▷ Use the red-eye removal tool found in the majority of image manipulation applications.

▷ Manually select the red dot, desaturate or darken with Hue/ Saturation control, or use the Desaturation tool. This method is best for animals' eyes, because it works with any colour of eye; the red-eye tool only searches for the spot of red.

▷ If your camera can be set to remove red-eye automatically, use this function.

SKIN COLOUR

PROBLEM
Your subject's skin tones look unnatural or unwell, or their flesh tones take on a different tint – this may happen if they are under a canopy of leaves or an awning, or if they are positioned in front of a strongly coloured background.

ANALYSIS
We are highly attuned to skin tones, and notice even very small variations from the norm. Pale skin, in particular, easily takes on the tint of any illuminating light.

SOLUTION

▷ Reducing the overall saturation usually improves skin tones.

▷ If there is an area of natural skin colour, use it as the sample mid-tone to correct the others (see pp.204–05).

▷ Define a target tone manually: start with CMYK values of 5, 25, 30, 0 for pale skin tones, 10, 30, 50, 0 for medium skin tones, and 15, 50, 70, 5 for darker skin tones; then click on different points of the subject to find the best result.

▷ For more precision, use single-channel Curves to set CMYK values.

SHINY SKIN

PROBLEM
Your subject is prone to very shiny skin, which is distracting at best and unflattering at worst.

ANALYSIS
Dark or tanned skin can reflect strong highlights. The effect may be aggravated by the exposure used for dark skin, which can allow highlights to become too bright. If caused by perspiration or oily skin, the reflection can be surprisingly hard.

SOLUTION

▷ Reduce, but don't entirely remove, the reflection: select a Clone tool set to about 50 per cent to clone adjacent skin tones onto the shine. Use a soft brush or feathered setting.

▷ Don't use a burn-in tool, as this can create grey patches and increase the saturation of contiguous areas.

WRINKLES

PROBLEM
Your subject's face has character, but wrinkles seem exaggerated, deeper and more numerous than they are in real life.

ANALYSIS
Today's cameras and lenses are sufficiently advanced to be able to resolve sharp detail. Often difficult to see on your camera's screen, wrinkles become all too obvious when the image is enlarged. Wrinkles can be exaggerated by sharpening processes and increasing contrast in-camera.

SOLUTION

▷ Use soft lighting from the camera position; avoid focused side-lighting.

▷ Turn off in-camera sharpening.

▷ Use a soft-focus filter on your lens and avoid using extremely sharp lenses.

▷ Deliberately blur the image at point of capture.

▷ Use plug-in filters to speed up smoothing.

▷ Use strong noise reduction to blur details and soften wrinkles: select an area with a feathered lasso.

SPOTS

PROBLEM
Blemishes on your subject's face and body appear more visible than at the time the shot was taken. Spots appear more obvious than in real life.

ANALYSIS
Photographic processes designed to create the sharpest images have had the side effect of making unwanted detail more visible. As with wrinkles, spots weren't as much of a problem when cameras and lenses were low in resolving power.

SOLUTION

▷ Turn off in-camera sharpening.

▷ Use a Clone tool set to about 80 per cent with a soft brush just larger than the spots to clone clear skin onto the spots.

▷ Use a Heal tool with a diameter just larger than the spots to remove them directly.

▷ Convert the image to black and white, as this can make spots less obvious.

▷ Bear in mind that it looks more natural for the subject to have a few slight imperfections.

HAIR

PROBLEM
Your subject's hair looks untidy and may intrude upon important details, such as the subject's eyes or the side of the face. There may be more white areas than were apparent when you made the exposure.

ANALYSIS
A strand of hair appears broader when it is out of focus. Hair is also rather reflective, especially if oily or greasy, so it easily catches highlights, which creates very visible white lines or areas.

SOLUTION

▷ If possible, tidy your subject's hair before taking the shot: it's very tricky to correct for stray hair in post-processing without introducing artefacts or making the result look unnatural.

▷ Use soft lighting and small aperture to maximize depth of field.

▷ View the image so you can see individual pixels, and slowly and carefully clone or heal one strand of hair at a time.

Working with layers

The ability to work with layers – images laid on top of one another – is the mark of a truly versatile image editing application. Layers enable you to apply a range of effects that cannot be matched by software that limits you to working with a single image.

Using layers also allows for non-destructive manipulation in which the original image data is not changed. This is possible in two ways. First, you can apply adjustments through Adjustment Layers: these can be stored with the image and re-adjusted at any time. You can also experiment with different effects on separate layers and store the entire stack of effects: you can make a layer visible or turn it off, and you can re-open the image at a later date to continue experimenting with the layers at your leisure.

Adjustment Layers

In applications such as the Adobe Photoshop family and Paint Shop Pro, it's advisable to use Adjustment Layers to apply effects such as Levels, Curves, and Hue/Saturation. The layer contains instructions for making the adjustment: if you turn the layer off, the adjustment is instantly removed. As these layers don't alter the image's data itself – only its

on-screen representation – you avoid the progressive loss of image quality that results from applying a series of changes to the image. This is particularly valuable with small or highly compressed files that can deteriorate rapidly. As with other layers, Adjustment Layers can be stacked to create a cumulative effect.

DID YOU KNOW?

If you use software that offers Layers but not Adjustment Layers, you can try a simple workaround that has the advantage of offering a straightforward way of applying localized effects. This involves you creating a new empty layer above your background image, which you then colour with a mid-grey fill. By adjusting the density of the grey, together with trying different blend modes, you have an indirect control over your image's tonality: the Darken blend modes not only darken the image but increase the contrast; while the Lighten modes decrease the contrast and lighten the image. You can paint a darker or lighter tone or colour on the layer for local effects. To weaken the effect, reduce the layer Fill setting.

Gradient map Adjustment Layer
A nondescript shot of stonework (inset) can be made more striking by applying a coloured gradient map on a layer – without having to touch a single original pixel. Colours on the gradient can be easily changed at any time.

One new from two old

It's easy to become confused when working with layers and their multiple effects. Just two layers can lead to an extremely varied set of results, with a seemingly simple task quickly becoming complex. Here, for example, I wanted to create an image that combines the precision and gloss of the new buildings with the irregularity of nature.

Combining the picture of a wall of glass with a silhouette of birds on wires requires some experimentation to obtain a satisfactory balance between the blue of the new building and the crisp detail of the birds. The key is to define blending options based on the pixel values themselves, as that preserves colour and detail.

ORIGINAL BACKGROUND IMAGE

ORIGINAL FOREGROUND IMAGE

CROP, CLEAN

1 Urban colours
The reflections of sky and cathedral in a building in New York offer up an urban abstract. The image, however, is perhaps *too* abstract, lacking in life and a sense of randomness.

2 Contrasting silhouette
A shot of pigeons gathered on wires around a lamp post offers a nicely haphazard pattern, but the image is untidily framed. I needed to isolate the birds and prepare the image for blending with the background.

3 Improve clarity
First I cropped the image to its essential elements and cleaned up details, such as the two street lights. Using an Adjustment Layer, I increased contrast so that the sky became paler while the silhouettes of birds and lamp post were made darker and clearer.

NORMAL 50% OPACITY

HARD LIGHT 100% OPACITY, 88% FILL

NORMAL 60% OPACITY, BLEND IF BLUE 120

4 First blend
The first basic blend I tried was Normal mode and half opacity: this told me the main challenge was to keep the silhouette strong. I then tried different blend modes: some made the silhouette too light; others made the background too strong, drowning the silhouette's shape.

5 Clear silhouette
The Hard Light blend mode gives a good result that's improved by reducing Fill – the strength of the blend – by a small amount. This had the effect of keeping some of the blue of the background without weakening the silhouette.

6 Strong blue
As I wanted more blue, I duplicated the modern building and placed it on top in Normal blend with opacity reduced to 60 per cent. This wasn't enough, however, so in Layer Options I set Blend if Blue to 120, which combined a stronger blue with a clear silhouette.

Layer blend modes

Familiarize yourself with the effects of layer blend modes by experimenting with a variety of images. Choose two contrasting images – one with defined shapes, and one with more abstract content. Select all of one image, and copy and paste it onto the other. Then select the top image and change the blend mode.

Blend modes combine the upper, or blending, layer with the lower, or base, layer. With each change of blend mode, try altering the colour and tone of one of the layers. Often a small change in Levels or Hue/Saturation turns an unpromising blending effect into a visually entrancing image. You can also achieve different effects by varying the opacity of the top layer. This toolkit shows a selection from the range of modes available.

▼ ORIGINAL IMAGES

UPPER LAYER IMAGE

LOWER LAYER IMAGE

NORMAL ▷

Opacity varies the extent to which the lower layer shows through the upper layer. As opacity is decreased, brighter patches on top resist showing the lower layer, while brighter patches in the lower layer appear first. Dissolve breaks the image into transparent dots.

OPACITY 80%

DARKEN ▷

By emphasizing darker pixels in the blend, these modes create moody images dominated by shadows. Darker Color blends both layers equally (producing the most balanced results), while the other modes give preference to the upper layer.

MULTIPLY

BRIGHTEN ▷

These modes simulate the addition of light, tending to produce lighter images lacking deep shadows. Colours are also weakened, with an overall loss in contrast, but they can be strengthened by adjusting their Levels or Curves.

SCREEN

INTENSIFY ▷

These modes make bright areas brighter and dark ones even darker, with corresponding increases in colour saturation and local contrast. They create brilliant, graphic effects which can be balanced out by playing with the level of opacity.

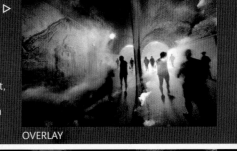

OVERLAY

CALCULATE ▷

The most sophisticated modes use data from both layers to reverse tones or colours, or apply one parameter (such as Hue) from one layer to the other, depending on the relative values in the two layers. The results are tricky to predict.

DIFFERENCE

OPACITY 60%

OPACITY 20%

DISSOLVE 50%

LINEAR BURN

COLOR BURN

DARKER COLOR

COLOR DODGE

LIGHTER

LIGHTER COLOR

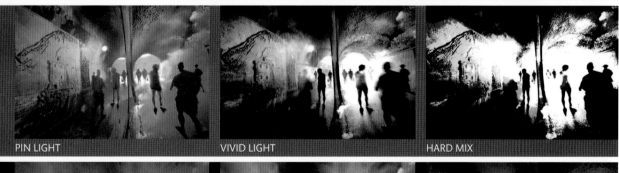

PIN LIGHT

VIVID LIGHT

HARD MIX

EXCLUSION

HUE

LUMINOSITY

Cut-out and composite

252

In the days of film-based photography, combining two black-and-white images was an extremely taxing job that could go wrong at every turn (and you could forget about combining colour images, unless you had a corporate budget at your disposal). Now, compositing two or more images calls for modest skill and patience – but the old principles of cut and blend still apply.

There are two principal steps to follow. First, cut one image to mask another (this used to call for a steady hand and great skill). Then, blend the images together: this is where artistry and imagination come into play to ensure the final result looks wholly convincing. To create this image, I enhanced the magical qualities of an exotic building by adding a cinematic sky.

FOREGROUND IMAGE

BACKGROUND IMAGE

MAGIC WAND

1 **Regency pleasure palace**
A shot taken at twilight captures the extravagant orientalism of the Royal Pavilion in Brighton, England, but the impact of the glowing lights evaporates against the summer evening sky.

2 **Selecting a background**
I searched my image database for a suitable sky to bring drama and mystery into the scene. I was looking for an image with a suitable amount of activity and appropriate colouring to complement the foreground image.

3 **Cutting out the sky**
It was hard to tell which sky would work best until I could place it against the foreground image, so I cut out the original sky: this was straightforward, as the sky was so even and the building was sharply defined. I used the Magic Wand tool to select all the blue pixels.

COPY AND PASTE

COLOUR BALANCE

LEVELS, CURVES

4 **Combining images**
I turned the background into a layer, then turned the selection into a mask. I opened one of the candidates, selected all and copied, then pasted it on the pavilion. I moved the mask from the pavilion to the sky layer and evaluated the result, selecting the dark sky as having the most potential.

5 **Colour correction**
The dark, bluish clouds contrasted too strongly with the hot yellows and reds of the lights, so I applied two colour correction layers, one with a stronger effect than the other, masked so they applied their effect locally. This dramatically improved the balance and composition of the image.

6 **Darker foreground**
The contrast and exposure of the clouds did not quite gel with the ambience of the pavilion, probably because of the softer contrast in the clouds. Using Levels and Curves, I adjusted by eye until the images worked together.

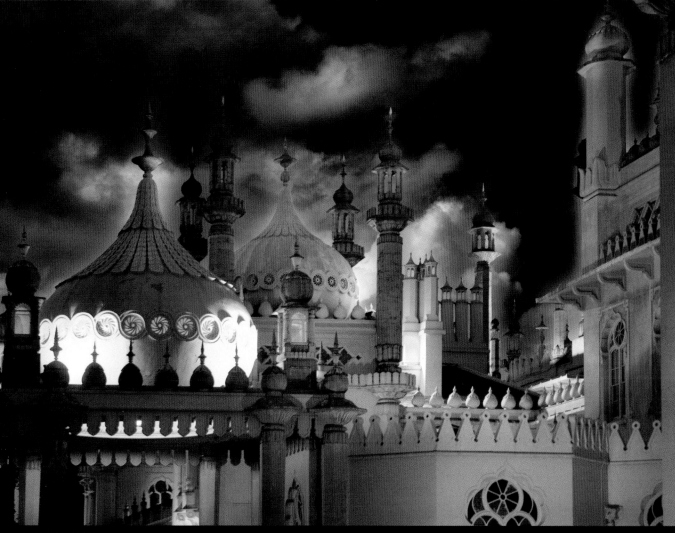

△ **FINAL** IMAGE

CURVES

GAUSSIAN BLUR

CURVES, SHARPENING

7 **Cloud highlights**
With the overall balance looking good, I now needed to make some refinements. Darkening the clouds made them start to loom rather menacingly, so a small adjustment in Curves brightened the mid-tones, giving them their highlights.

8 **Soft-focus glow**
The sharpness of the building now looked too clinical, so I applied a soft-focus blur, to the building only. I blurred the masked building with the Gaussian Blur tool until the "glow" was visible beyond the edges of the building, most obviously against the black sky.

9 **Final brightening**
To make the glow slightly more visible, I brightened it by selecting just the underlying blurred layer and applied an adjustment layer in Curves to brighten it gently. A final round of sharpening (to bring out details in the building) and flattening completed the composite.

Converting to black and white

Although it can be done automatically, the conversion of colour to black and white is an act of creative interpretation. There is no single, definitive black-and-white version of a colour image: instead there are many possible renderings. There is no objective reason why, for example, a certain shade of green should be darker than a red after they've been converted, or a yellow brighter than a blue. This opens up a rich avenue of photographic expression to explore.

At its heart, the digital capture of colour is black and white: each colour channel is a greyscale image – one image each for red, green, and blue. In the early days of digital photography, conversion to black and white or monochrome was based on the behaviour of photographic film; however, modern tools for conversion are infinitely more flexible.

Adjusting colours

You can manipulate the original colour image in preparation for conversion: changing the colour values will affect the outcome, so use this to your advantage. For example, if you know you'd like to make the blues and purples bright in the final image, it's good practice to boost these colours before converting. Experiment in software such as Adobe Lightroom or Apple Aperture until you obtain the result you're aiming for.

Channel mixing

To convert to black and white, use the channel mixer to set the weighting of the different colour channels – this converts their colour values to varying brightness values in the new, monochrome image. If you want your reds to remain bright in the converted image, assign high values to all reds. Accordingly, if you want blues to be dark, you assign low values to the blue channel – and so on. The resulting black-and-white rendering may be encoded as an RGB image with three channels of data (appearing as greys), or as a greyscale image in a single channel. In either case, all information about colour differences is lost.

Depending on how the software calculates the conversion, the overall image brightness may remain the same, or may vary according to the values you apply. At the same time, you can expect contrast to change, as different colours may be equally bright and so may translate into the same shade of grey. As a final step, make an adjustment to the overall exposure and tonality of the finished image.

BASIC CONVERSIONS

Select a colour image (below). If you desaturate all colours equally (top, right) you'll usually get dull, dark results. A blue filter (top far right) holds back warm tones, creating dark tones reminiscent of old film emulsion. A green filter (bottom right) enhances details and brightens foliage. A red filter (bottom far right) is most dramatic, with bright skin tones, and dark skies.

Interpretative conversions

The standard greyscale conversion assigns brightness values to colours according to their perceived brightness. A patch of blue will appear darker than one of yellow, even if both are emitting the same flux of light. Greyscale conversion also takes into account the difference between RGB values and perceived values.

We can lead this homogenous process into more interesting territory by converting colours arbitrarily – for example, instead of making greens brighter than purples, reversing the relationship. The results can be surprising and rewarding. Because today's large files allow for extensive manipulation, the possibilities are limitless.

FULL COLOUR

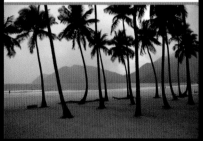

ORIGINAL IMAGE

On a stormy day in Trinidad, palm trees loom dark over an empty beach. In the low light, the only colour appears to be in the sand but, paradoxically, after I converted the image to black and white, subtleties of colour not evident to the eye revealed themselves.

RED FILTER

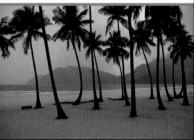

DARKEN GREENS AND BLUES

I applied a strong red filter which reduced, or darkened, blues and greens, resulting in a relatively bright beach. The weak darkening elsewhere in the image shows there is little other colour present.

BLUE FILTER

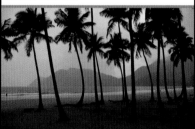

DARKEN REDS

Here I used a blue filter, which had the effect of darkening much of the image because it lowered the values of reds and greens, leaving only the pale blue of the sky untouched. The result has a dark, gloomy feel.

COMBINED

BLOCK BLUE, LIGHTEN GREEN

I tried combining a strong green filter with suppression of blues: this brings out the palm leaves against the almost-black sky. Details in the hills round the bay are also showing up, but the foreground is dull.

EXPOSURE ADJUSTMENT

WEAKEN REDS

Here increasing exposure would improve tonal balance, but since I wanted to apply it only to the beach, I used another method: weakening the reds so that the green filter allowed more light through. This lightened only the sand.

CHANNEL ADJUSTMENT

BOOST GREENS

The beach now looked better, but the palm leaves were looking dowdy and bedraggled. I livened them up by boosting the greens, which had a useful side effect: parts of the sky were lightened, nicely balancing the image.

Working in duotone

The neutral greys of a perfectly balanced monochrome image often look mechanical, impersonal, and lifeless. Adding the tiniest hint of colour can not only make the image more attractive, it can also add depth and richness to lower and mid-tones. This is well-known in the print industry, where the use of two inks is known as "duotone" printing.

There are different digital methods of achieving the duotone effect. With a monochrome image in RGB mode (see pp.178–79), use the Color Balance tool to introduce colours into the shadows, mid-tones, and highlights. You can also use coloured gradient maps (see pp.264–65) to add an overall tint: this method is flexible and non-destructive to image data.

Dual process

Alternatively, you can work directly in duotone mode in software such as Corel Photo-Paint and Adobe Photoshop. To do this, you must first convert your image into greyscale (see pp.254–55), and enter duotone mode. There are two steps to setting up a duotone. First, load the two ink colours: you can choose any colour from the software, or from other palettes. Black is not obligatory. Next, manipulate the ink-

> **OLIVER WENDELL HOLMES**
>
> A mind stretched by a new idea never goes back to its original dimensions.

load, or transfer curve: this is essentially a gradient map that tells the software how much ink to distribute according to the varying brightness across the image.

The transfer curves are much like those of the Curves control (see pp.206–07): they can be any shape you choose, with correspondingly wild results in the image. As a simpler approach, more subtle presets are available, many of which are based on print industry standards. Save ink and curve combinations that work well so you can apply them again.

For results of even greater richness, you have the option of working with three, and even four, colours – tritone and quadtone (see pp.258–59) respectively. You can choose any combination of colours, and you can apply ink to each of them according to its own curve.

TONAL PROGRESS

The original image (first right) is close to duotone in any case, with blue skies and brown concrete. A conversion to black and white (second right) is no great improvement, as the neutral greys tend to flatten the strenuous dynamic of the sweeping lines. A warm duotone applied with relatively shallow transfer curves (third right) enlivens the image, although it's tonally rather flat. Varying the ink colour and transfer curves leads to a brighter, livelier result (far right).

Developing multitones

Duotone and its variants are among the most satisfying image manipulations. Since you have control of between two and four separate colours and their corresponding transfer curves, the scope of the changes you can impose on your image is infinite. And because the inks tend to blend into an overall tone, there is an in-built tendency towards harmony and balance. Experiment with a variety of settings until you find the required effect; if you're preparing for print, be sure to make trial prints on your chosen paper, as the more subtle effects and gradations may be difficult to reproduce. Also, check for any differences in output between printing in duotone mode and in RGB mode.

ORIGINAL IMAGE

1 **Simple promise**
The original image, shot on a high savannah, is a simple composition, but one that has lots of activity, with the receding road and the fluffy clouds.

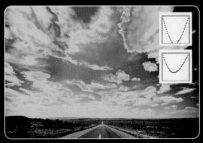

CHANNEL MIX

2 **Convert to black and white**
Here I used the channel mixer to convert the image to black and white. It darkened the foreground, and brought out the contrast between the clouds and the blue sky. The original conversion was a little light, so I used Levels to increase the overall density.

DUOTONE MODE

3 **Pale colour, low inking**
Using a light bluish colour in duotone mode, with the transfer curves set to apply less ink than average, makes the image lighter than its greyscale rendering, resulting in less separation of the clouds from the sky. However, the foreground is improved.

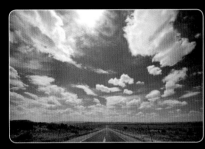

TRANSFER CURVE

4 **Add more colour**
Even with strong colours and a basic black ink added, the images retain an essential coherence. The transfer curve for the blue favours the highlights, giving a strong tint overall. The curve for the green gives little ink to highlights, which are correspondingly bright.

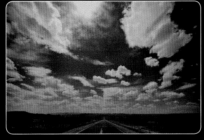

REVERSED CURVES

5 **U-curves**
With U-shaped curves, tones are reversed for part of the tonal range, flat around the middle, and normal in the remaining densities. This produces fringes, and sometimes other unpredictable effects. But the image retains its natural look, except in some cloud detail.

TRITONES

6 **Heavy inking curves**
Using three inks created interesting effects – I assigned one colour to the highlights, and a contrasting hue to the mid-tones and shadows. These images show promise for further work, perhaps making one tritone a pale colour, leaving the others strong.

Evocative tones

Quadtone allows you to apply an unlimited range of colours to a duotone picture's tonal bands, using custom transfer curves. It enables split-toning – applying subtle shades to highlights, mid-tones, and shadows – beyond the wildest dreams of darkroom workers. The sunny deck of this villa is an ideal subject for quadtone treatment: picturesque and elegant, it is bathed in many layers of pellucid light.

▷ Sony A900, 24–70mm *f*/2.8 : 24mm *f*/16 ISO 100 -1.7EV 1/100sec

1 Cool mid-tones

The cyan that I chose to nuance the mid-tones reacted with the red to produce shades of purple, so I switched to a hue with a slight green tint. The transfer curve is tuned to favour the lighter mid-tones to create a cool appearance.

2 Warm deep shadows

The darker tones just above black seem to work best as warm tones, so I chose a strong red. The transfer curve shows no reds in the highlights (indicated at the bottom of the curve), which helps to increase contrast.

3 Golden high tones

Although gold can naturally enhance highlights, here the transfer curve imparts only a little of the colour to them. Instead, it peaks in the middle, ensuring a strong colouration in the mid-tones, and drops to zero for the shadows.

4 Neutral deep tones

The black, or key tone, underpins a picture's tonality by defining its maximum density. Thanks to the contrast created by the cyan and red, the transfer curve can be pulled back from full density to reveal detail in the shadows.

IN DETAIL

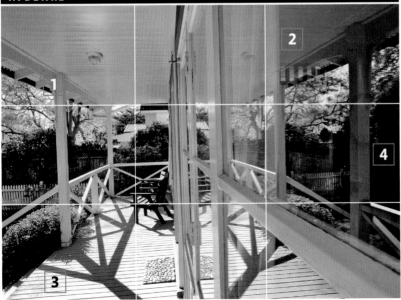

Emulsion-based effects

There are, broadly, two approaches to replicating the visual vocabulary of effects based on the emulsion of film or print. You can aim for a facsimile of the processed result, trying to reproduce the tints and tonality precisely; or, you can be inspired by their properties and style and go on to create your own versions.

Whichever route you take, you'll find it very helpful to view some real prints in a museum or an art gallery first. You will discover that old prints are virtually all soft greys, with only subliminal suggestions of colour. We adore their understated charm, their ability to say so much with so little. The most subtle, such as platinum prints, are extremely hard for digital processes to match. However, the more up-front processes are rewarding to recreate (see pp.262–63).

Digital darkroom

Many darkroom effects can be imitated in any image manipulation software that offers the Levels or Curves controls. For best results, use Levels or Curves that allow separate manipulation of the red, green, and blue channels – ideally, all three should be available at the same time – as well as the combined curve. As you gain experience, you'll

find that working in the duotone mode (see pp.256–57) is one of the best ways to create subtle effects. This is because you can define up to four different colour inks, each with its own curve, and, in some applications, even a fifth overprint colour. By combining a black ink with two or more inks of adjacent colours, such as a dark brown and a light yellow, you can create the most delicate of tones. However, you will be testing the limits of what your computer monitor can display. Not only are darkroom imitations best enjoyed as prints, it is advisable to print out your experiments for proper evaluation.

Principles of imitation

The method for replicating darkroom effects of all kinds falls into three principal steps. First, you reproduce the tonal range and quality of the print: high-contrast in the case of lith prints, soft in the case of platinum or calotype prints. To achieve this, use the Curves and Levels controls. Next, you match the colours, which may be split-toned, that is, the tints may vary with image density (see pp.256–57). You can use any colour control that works, or control colours from the duotone controls. Finally, you apply grain or textures typical of your chosen process by using noise filters or specialist film-grain effect software.

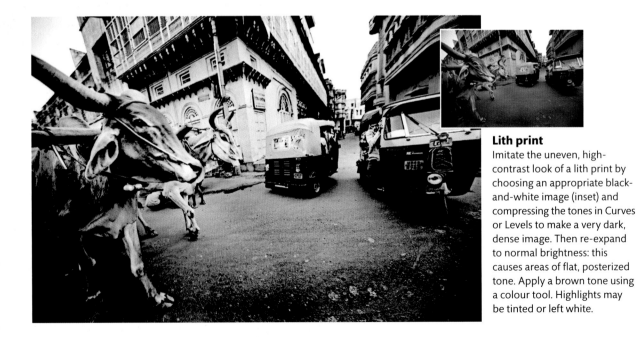

Lith print
Imitate the uneven, high-contrast look of a lith print by choosing an appropriate black-and-white image (inset) and compressing the tones in Curves or Levels to make a very dark, dense image. Then re-expand to normal brightness: this causes areas of flat, posterized tone. Apply a brown tone using a colour tool. Highlights may be tinted or left white.

THE SABATTIER EFFECT

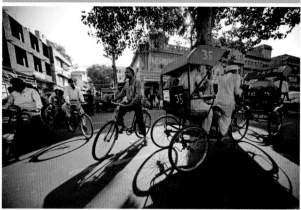

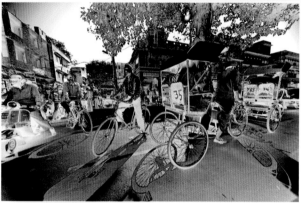

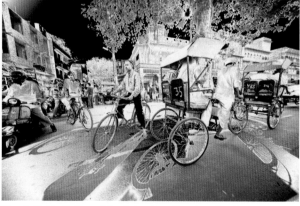

The digital imitation of the Sabattier effect is a simple matter of applying arch- or U-shaped curves. The curve shape means that half the tonal range is reversed, while the remaining half stays the same, with a transitional zone of flat tone. With Curves set to pigment ink, an arch-shaped curve applied to the original image (top) lightens dark tones (middle). Reversing the curve to a U-shape delivers darkened light tones (bottom). By adjusting the turning point of the curve, you can adjust overall exposure and bring out shadow detail as required.

Imitating infra-red

As real film becomes a distant memory, so the special character it gave to images is increasingly treasured; none more so than black-and-white infra-red. This film was most sensitive to light just beyond reds, and relatively insensitive to other colours, with no sensitivity to blues. It rendered foliage brightly, while skies were very dark, and results were grainy and high-contrast. To fully imitate the effect, however, calls for another manipulation: normal photographic lenses could not focus in infra-red, which resulted in a blur around a sharp central core – so we also need to reproduce this halo blur.

SATURATION

1 **Original image**
Images showing lots of blue sky and green foliage provide the easiest basis for conversion. Lift greens by increasing their saturation.

INFRA-RED

2 **Conversion**
Using a preset for infra-red, convert to black and white: blues become very dark, and greens and reds are converted to high values.

LIGHTEN BLEND MODE, BLUR, GRAIN

3 **Gaussian blur**
Duplicate the layer, change the blend mode to Lighten (or similar), then apply a strong blur. Add grain to complete the look.

Recreating darkroom effects

Although it has to be admitted that the results lack the finesse and subtlety of chemicals working on paper, for most purposes the digital process does a good job when it comes to recreating the traits of darkroom effects.

We can simulate just about anything that used to be done in the darkroom, and we have great control compared to the darkroom processes of old: we can zoom in for precision work, and we can take our time. Digital processes are also highly repeatable, in that we can save the settings and apply them to new images.

Digital processing has another great advantage: you can play around and test a variety of effects. Experiment freely: the slightest tweak in a curve or minor change of colour can make all the difference.

▼ TRICKS OF THE TRADE

▷ **Work with the largest file size** and greatest bit depth to avoid posterization or breakup of the image. The exception is if you want to produce grain effects, when it's best to use the file at working size.

▷ **For duotone effects,** your image needs to be in black and white; for other darkroom imitations, your image needs to be in colour.

▷ **Ensure your monitor is calibrated** and profiled for accurate results (see p.334).

▷ **If you're using very strong colours**, soft-proof the results (see pp.288–89) to ensure that the colours will print out.

▷ **Work with adjustment layers** so that you can make numerous changes without eroding the image data.

DUOTONE ▷
You can create the duotone, or two-ink, effect with the duotone mode, gradient maps, or the Color Balance control. Although you use only one colour against black, the range of results gains strength from subtlety and restraint.

BROWN

MULTITONE ▷
Working with three or more coloured inks offers you an enormous range of effects: be inventive about your choice of colour and inking curve. It is important to test-print multitone results to ensure that the stronger colours print accurately.

BLACK-MAGENTA-YELLOW

FILM EFFECTS ▷
Film processing effects are popular for their nostalgic tonalities and grain. Processing slide film as print film and vice versa is a favoured effect, as is the reconstruction of black-and-white film grain and the recreation of the faded tonalities of old prints.

PRINT FILM AS SLIDE

PRINT EFFECTS ▷
Darkroom processes using poisonous chemicals and hit-and-miss methods are now replaced by clean digital methods. The prime tool is Curves: apply separate curves for each colour channel to replicate processing tonalities and colour.

REVERSED SABATTIER

APPLIED BY HAND ▷
For utmost control, combine curves and other adjustments with colours, masks, and distortions, applied by hand. Film-based processes offer a rich repertoire of effects: it's worth studying original prints for instruction and inspiration.

HAND-TINTED

RED

GREEN

PURPLE

BLACK-BLUE-YELLOW

BLACK-BLUE-ORANGE-YELLOW

BLACK-BLUE-GREEN-ORANGE REVERSED

SLIDE FILM AS PRINT

FAST BLACK-AND-WHITE FILM

OLD PRINT FILM

SABATTIER WITH GREEN TONE

GOLD TONE

CYANOTYPE

GUM DICHROMATE

HAND-COATED

EMULSION BRUSH

Changing colours

Image manipulation methods can be divided into two broad categories: colour and non-colour effects. Non-colour or monochromatic effects change the spatial relationship of pixels. This includes cropping, reshaping, distortion, and changing the resolution. Colour effects, which make up almost every other image manipulation technique, are concerned with either increasing or decreasing the visual impact.

At one extreme are the subtle changes of white balance, vibrance, grain, sharpness, and blur. At the other extreme are the more drastic changes that so entranced the early generation of digital photographers. While some lead to gaudy – and seldom useable – results, others are less dramatic but still visually striking.

Nifty brushwork

The most rewarding changes are those that are locally applied. You can tone down colours by applying the Saturation or Sponge tool with a large, soft-edged brush set to desaturate: the result resembles an old postcard. In applications that offer a History Brush or a way to "paint" back a previous state, you can desaturate the image, then

apply the brush to return just the desired coloured areas. The areas you don't touch remain greyscale. Yet another variant is to desaturate the image, then load your brush with a colour and paint on the image or on a new layer with the brush or Layer mode set to Color.

In fact, there are several other ways to create the hand-tinted look, such as with the Clone Stamp tool or layer masks. Each produces slightly different results and you should experiment to see which method suits you best.

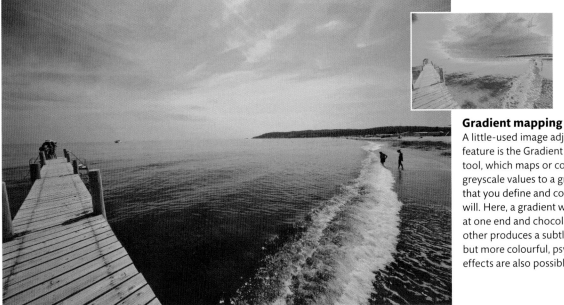

Gradient mapping

A little-used image adjustment feature is the Gradient Map tool, which maps or converts greyscale values to a gradient that you define and colour at will. Here, a gradient with blue at one end and chocolate at the other produces a subtle result, but more colourful, psychedelic effects are also possible (inset).

Here, I applied delicate hand-tinted effects to the original image (below) by converting it to black and white and then gradually returning the colour, using the History Brush with a soft edge and set to a very light pressure. If you don't have a History Brush, first copy the image onto a new layer, then lightly clone back the original. The results will be the same with either method.

Global warming

There are also a number of ways to make more dramatic changes to the colours of your image. Exploring the various menus and adjustments available in your software is a fun pastime. If you come across any effects you particularly like, save the image together with a note in the image caption detailing the steps you took to arrive at the result.

Manipulating Levels or Curves separately for each colour channel is the most direct – and universally available – way to cause drastic changes to the colour of an image (see pp.204–07). Other methods such as tone mapping, and image adjustments such as posterization, channel mixing, and the Hue control can all change colours drastically without changing the positions of pixels.

The other class of change are those from filters that combine dramatic changes of colour with changes in the spatial relationships of pixels within the image. These belong to the arena of special effects: you very rarely need them, but it's useful to know they're available. As always, there's no substitute for trying these out for yourself (see pp.276–77).

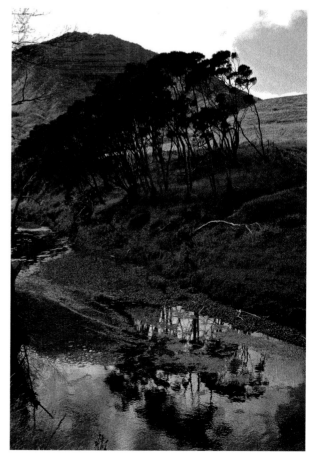

Altered realism

The original, full-colour image has been changed to the indexed colour image mode using the "Black Body" option. This translates RGB values onto a limited palette, or index, of just 256 tones of reds and yellows, leaving the tonality largely unaltered.

Embellishing reality

At one extreme, you manipulate images in order to change their content and meaning radically. At the other, you do so to bring out their potential, to present a view that could well have been seen and captured in real life. Unlike a fantastical construction, you aim for an entirely realistic result and to leave no clue as to its artificiality. In this image, a misty dawn is uplifted with a plausibly richer evening sky and circling gulls.

▷ Nikon D3x, 24–70mm *f*/2.8 : 55mm *f*/6.7 ISO 640 -0.5EV 1/8sec

1 Removing human traces
The pathway betrays a suburban location. I wanted a sense of being in deep countryside, so I cut the areas of grass closest to the path and stretched them over to conceal this sign of human habitation. I made a copy of the joined-up grass for further blending to make an invisible join.

2 Shepherd's delight
I created a mask to protect the foreground and trees of the base image, then copied and pasted the sky from a second image into the unmasked area, adjusting its size and position. I doubled the strength of the Overlay blend mode by duplicating the layer, with adjustments.

3 Roosting time
Next, I separated the birds from the sky: a colour selection mask from the blue channels did the trick. Once the birds were on a separate layer, I changed their layer mode to Multiply with reduced opacity and a little blur – this helped them "sit into" the sky and look more authentic.

4 Depth of feeling
The foreground looked neglected and dark, so, on a series of adjustment layers, I worked light into parts of the grass to open up the detail, and added warmer colour to the image with the Saturation tool. A very soft vignette on the sky helped frame the whole scene.

IN DETAIL

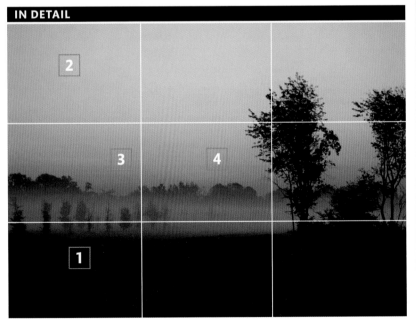

Cropping for effect

There are photographers who maintain that images are too sacred to be cropped – that you have to get them right in-camera, so there's never a need to crop. This point of view is based on the belief that you weaken the image's integrity, and that of the whole process of creating the image, if you hack chunks off it.

By cutting out peripheral parts of an image, cropping shifts its emphasis and presents its content selectively. Fact-driven branches of photography, such as documentary photojournalism and news, are right to avoid cropping, as it is a powerful way to change the meaning of an image.

Trimming to fit

You can use cropping to remove unwanted elements from behind the main subject, such as other people, or strong highlights. Or you can remove large portions of the image to zoom in strongly on a face, or other detail.

There are times when you have no choice but to crop The most common of these is when you want to have a higher-magnification view of the subject, but you can't get closer, or use a longer focal-length lens. Capture the image

JOE ROSENTHAL

> The act of cropping a photograph …
> is at its heart a moral decision.

anyway, and crop to emphasize the detail later. It's best to record at the highest quality and resolution settings, to ensure you have plenty of data in reserve to maintain sharpness. You may also need to take special care with focusing, and to keep the camera steady, as any unsharpness will be magnified. After the crop, elements that no longer appear sufficiently sharp may require a little extra sharpening in post-processing (see pp.230–33).

In image manipulation software, you can set the size of the crop, use preset sizes, or draw it by hand. The cropped area is usually shaded, and you can move the crop around, or make fine adjustments to its margins. Remember that if you set the crop to the same proportions as the master image, moving one side of the crop will resize the other as well. Crops made in this way, then resized to the same pixel

Long road
By cropping off a large section of sky, and performing a little tightening at the bottom, I revealed the core shape of the image as stretched along the road, emphasizing the activity – selling small bottles of petrol – and the varying scale of the cars and people.

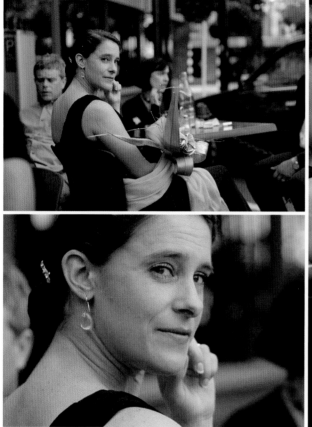

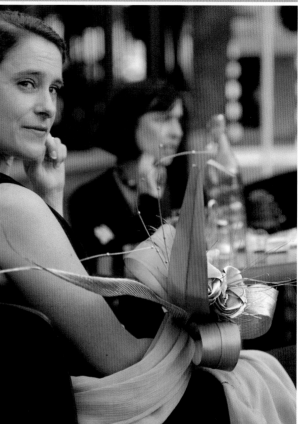

A snapshot of some friends, taken at a full zoom extension of 70mm, doesn't get close enough to the main subject, resulting in a mish-mash of background details (top left). These are blurred thanks to the *f*/2.8 aperture, but are still a distraction. A tight crop

(bottom left) in the same proportions brings the face closer, but loses the gown and the flowers. A crop that changes the picture's orientation (right) reveals the bouquet, but also draws attention to the person in the background.

dimensions as the original (see p.201), may be very difficult to detect if done properly, except by direct comparison to the original, full-sized image.

Shape and space

An image is comprised of two elements of shape: its format, or its outer shape, and the structure of its content – the shape of the subject matter. Because the Crop tool can alter the orientation of the image – from horizontal to vertical or, more radically, from vertical to horizontal – you have the ability to change the shape of the image to better represent its content. For example, with landscapes, the sky and foreground are often not as interesting as the middle ground; in this case, a crop that removes the sky and foreground to produce a long,

letterbox shape can bring emphasis to the middle ground. This shape would work well with an image depicting a line of trees on a horizon, reinforcing the overall effect of the broad sweep of a vista. These kinds of crops involve removing a substantial portion of the image, so, again, it's best to use the largest possible files to avoid losing too much resolution, and then sharpen in post-processing if necessary.

You can experiment with alternative shapes, too: an oval crop – so popular with early studio photographers – can work well for informal portraits. You can keep the image's rectangular shape, but vignette, or darken, the corners to create a central circle or oval: this is functionally a crop as it cuts out unwanted detail and concentrates the viewer's attention on the main focal point of the image.

Ageing an image

With the billions of squeaky-clean, ultra-sharp, and high-resolution images pouring onto the internet, coming across a scruffy old image can be a nice surprise. You can give one of your modern, sharp images a vintage look very easily. There are two key elements: the uneven textures of chemical-and-paper processes, with defects from ageing or deterioration,

and the tonality of analogue processes, which were generally based in mid-tones, with limited rendering in highlights and shadows. For this image, I borrowed textures from a mottled, cracked card that framed an old print. To imitate the soft contrast and tone of a sepia print, I experimented with different layer modes until I was satisfied with the effect.

ORIGINAL IMAGE

CREATE BACKGROUND

GREYSCALE CONVERSION

1 Choosing an image
This colour image is a good candidate for ageing because it is simply composed, and it has an incipient sense of mystery that will be heightened by a loss of definition. Only the subject's modern hairstyle might give away the true age of the image.

2 Finding a frame
Rummaging through some old materials, I came across an ancient card window-mat that I had saved for precisely this purpose. You can photograph or scan your frame material, but if you want to minimize shadow effects from side lighting, scanning is best.

3 Greyscale and red channel
Converting all the colour channels would result in modern looking tones, which I wanted to avoid. The image is composed mostly of reds, so I displayed the colour channels and selected, copied, and pasted the red channel (see pp.254–55) onto a new background.

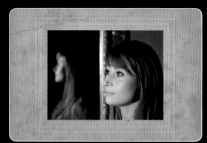

CUT AND PASTE

SOFT LIGHT

56 PER CENT FILL

4 Framing the image
With the facsimile of the picture frame open, I pasted the greyscale image of the red channel into the frame. I then used the Transform tool to adjust the image to fit the frame; as this frame was made for 35mm format, the shape perfectly matched the image.

5 Using layer blend modes
With the greyscale image in place, I ran through the range of layer blend modes, trying different effects at varying opacities and levels of fill. I settled on the Soft Light effect, because it brightens, flattens contrast, and confers the frame's colour and texture to the image.

6 Adding detail
While the tonality of the Soft Light layer blend mode gave the right results, too much detail was lost. I restored it by duplicating the layer; however, this produced too much detail, so I reduced the fill to 56 per cent to arrive at an effect somewhere between the two.

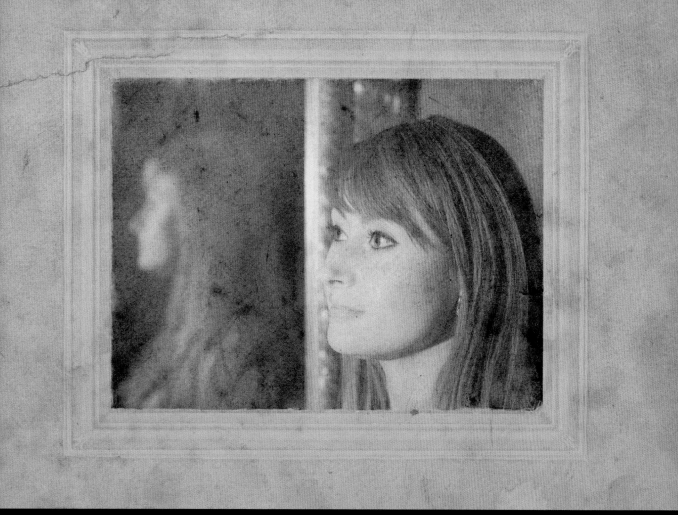

△ **FINAL** IMAGE

LAYER MASK AND ERASER

HEAL AND BLUR TOOLS

LEVELS AND CURVES

7 Distress edges
With the two layers in place, I grouped them together, and added a layer mask to the group. This allowed me to distress the edges of the image with a rough brush. I also added an adjustment layer in Levels to boost the overall density of the portrait.

8 Refining specks
One of the randomly placed blemishes, recreated from the frame's texture, ended up on the subject's eye. I decided to clean it using the Heal tool; at the same time, I slightly reduced the image's overall sharpness using the Blur tool.

9 Finishing the image
I applied Levels to improve the black areas, then used Curves to lower contrast. But because of similar exposure levels the frame was no longer well separated from the picture, so I selected the frame only, and again used Levels to lighten it a touch, providing tonal separation.

Text effects

Text and image have long been engaged in a battle for dominance. The current preference is for images to be free of text, although this hasn't always been the case. Equally, the digital "conquest" of letterforms has had just as dramatic an effect on printing as the digital revolution has had in photography. The combined power of the two phenomena leads to a new and exciting focus for creative energy.

The power of combining text with image is a field ripe for experimentation, as it's still relatively unexplored. You could delve into the art of typography, for example, or simply use text as a graphic element in its own right. Furthermore, learning to work with text and images is an excellent preparation for applications as varied as book design, web page animations, and title sequences for movies.

A cocktail of combinations

Start with a simple image without too many shapes and colours, as this will allow you to gain experience in how text and images interact. As you gain confidence you can work with more complicated images. Copy some text or type directly into a new type layer above your image. You may need to change the size of the type so that it's legible, but it should also be in balance with the size of the image.

DID YOU KNOW?

There are two fundamentally different ways of describing text for use in computers. One method derives from the way we write, describing letterforms in terms of the strokes used – up, down, or curved, and thick, thin, or tapering. These are called vector graphics and their advantage is that they exploit the highest resolution of any device that can read the graphics. This ensures smooth letterforms at any size. The alternative to this is to describe letters by pixels, as if they were normal images. These are called "rasterized graphics" and their resolution is fixed at the time of creation.

Move the text around and observe the way in which it interacts with features in the image: in some places the image may obscure the letters, in others the contrast between the letters and the natural features may make both equally visible. Try applying different colours to each character, and experiment with different blend modes for the text: it doesn't have to be a single colour against the image. Some powerful types of software will create text effects such as embossing, glowing text, and drop shadows (which make it look as if the letters are raised above the paper and casting a shadow).

FOR STARTERS

Layer styles
Even when restricted to sober effects such as embossing (for a three-dimensional look) or overlaying (by applying colours), you still have an infinite range of options. You can vary the strength and blend mode of each effect and control the overall opacity.

Embellishments
With the addition of decorative effects, such as glowing colours and distortion, you can achieve striking results. The best strategy is to use as few effects as necessary to avoid your results becoming exaggerated.

Solid text
You can extrude flat text into three-dimensions and light it as if it is made up of solid letters with real substance. Rotating and moving the text produces changes in the reflections and shadows, providing a foundation for creating animated effects.

Creating a watermark

It's a delicious irony that a method favoured by photographers to protect their work imitates a method used from the 13th century by papermakers to identify their products. On paper a watermark is a design of slightly less thickness than the rest of the paper: it is visible because it lets through a little more light. The mark is discrete and doesn't interfere with using the paper but is extremely difficult to remove. On digital images, exactly the same principles apply: we need a watermark that identifies ownership clearly but doesn't interfere with the image. At the same time it should be difficult to remove to discourage stealing. Any software allowing text in images can create a useable watermark.

ORIGINAL IMAGE

1 **No attribution**
An image placed without protection on the internet is exposed to copying and use without your permission (see pp.286–87). While a copyright notice doesn't mean the image can't be freely used, it does serve as a warning.

BASIC TEXT

2 **Simple solution**
I created a type layer above the image and typed in the copyright sign "©" and my name. I made it quite large so that it could be seen easily. I changed the colour to about 50 per cent grey so that it didn't obtrude into the image too much.

DIFFERENCE BLEND

3 **Layer effects**
The watermark was visible but it wouldn't be too difficult to remove by cloning from other parts of the image – particularly as, in this case, there are large areas of fairly even tone. I changed the blend mode to Difference and relocated the text.

DROP SHADOW, EMBOSS

4 **Text effects**
As I didn't want to have to reposition the mark every time I used it, I needed to design one that would work for all images. I created a semi-transparent type using Drop Shadow and Emboss with reduced opacity in Difference mode. This kind of watermark will be visible on any kind of image.

REDUCE SIZE

5 **Still removeable**
A large watermark will dominate the image, which is counterproductive if you're hoping to sell it. I tried reducing the size of the watermark and placing it in a more discreet position. This will work well for many images, but in this case it could still be cloned out too easily.

MULTIPLE MARKS

6 **Beautifully small**
One solution for minimizing the interference to the image, while making the mark difficult to remove, is to place lots of small watermarks all over the image. Once satisfied with your watermark, save the text layer so you can apply it to other images.

Art effects

Filters that imitate artists' materials such as oil paints, pastels, and crayons are some of the most rewarding to experiment with. They work by using the image's colour data combined with effects based on an analysis of drawing and painting techniques. For example, some filters will look at a group of pixels to identify the bright colours, then apply these colours in parallel lines to simulate brush strokes.

Different image manipulation software approach this class of filters with varying degrees of success. Some software only allows you to apply the effect over the whole image, while other programs allow you to build up the effect stroke by stroke. The problem is that close imitation of art effects requires randomization, and this takes a lot of computation.

Global or local changes

Filters that apply an effect globally take account of local image data, but the result can be rather indiscriminate. Much more versatile and convincing are the filters that apply effects across the entire image, enabling you to build up the effect by hand, which allows you to vary the strength and quality of the brush strokes. This can

be deeply satisfying and lead to a more convincing effect, but it's more time-consuming. With either method, the trick is to select the right kind of image: those with clear shapes and simple outlines are the easiest to work with.

Improving authenticity

You can maximize the effect of art filters by first applying a pixelating or texturizing filter (see pp.276–77) to simplify the image detail into clear, simple shapes. You can also utilize an art filter that provides a texture, such as cross-hatching or painted strokes, and then employ another filter to improve the look. For example, the addition of only a few painted strokes added on top of a universally applied filter is surprisingly effective at disguising the fact that the effect is computer-generated.

Another trick is to apply the filter at slightly varying strengths to different parts of the image by using selections, which leads to a slight variation in stroke quality. Further, it's worth bearing in mind that the on-screen image may not be the final product: if you print your image onto highly textured paper, the interaction of art strokes with the paper texture can enhance the impression that the image has been created using genuine art materials.

ART FILTERS

The effects available with art filters are many and varied. With this everyday image (below), I experimented with the following filters: cross-hatching (top right); rough pastels (top far right); stained glass (bottom right); and cut-out (bottom far right). Following this step, further filters can be applied (see pp.276–77).

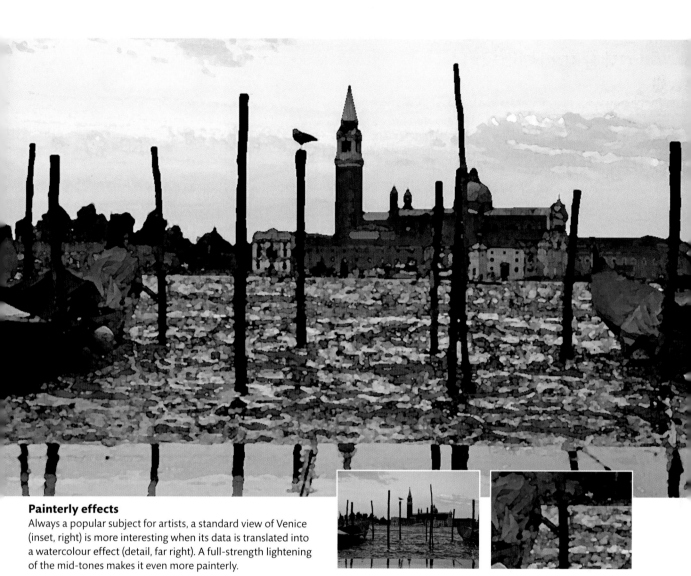

Painterly effects

Always a popular subject for artists, a standard view of Venice (inset, right) is more interesting when its data is translated into a watercolour effect (detail, far right). A full-strength lightening of the mid-tones makes it even more painterly.

Applying the effect by hand

Art effects filters are like special colours with which brushes may be loaded. The difference is that, instead of merely being a brush with a single colour, this tool is loaded with instructions. These instructions might specify, for example, that the colour or intensity of the effect shall decrease if the stroke is applied quickly, and that it will remain strong if the stroke is slow and steady. In addition to this, you control the properties of the brush with its usual parameters such as size, shape, and feathering.

The brush colour can be based on the colours of an underlying or source image; this offers you a powerful shortcut to a radical modification of the original image.

Alternatively, you can choose to sample a colour from your original image, which changes it more subtly in response to the individual details in the image.

Art in mind

While art filters are a very effective way of transforming your existing images, there's another strategy that will ensure successful images: shoot with the aim of using art filters in post-processing. Look for subjects with clear lines, simple colour schemes, and strong composition. Interestingly, visualizing your images in this way is likely to enhance your general photographic skill, as it encourages you to think about the properties of a scene or subject in a new way.

Digital filters

Rather than being "filters" in the usual sense of the term, the special-effects filters used in post-processing apply a set of mathematical rules to pixel values and locations.

Filters can be used for their effect alone, but they're also useful for combining multiple effects, and for performing intermediate steps prior to the application of other filters or adjustments. For example, some filters provide ways to control sharpness, while others tend to improve the effect of art effects filters (see pp.274–75). Many filter effects require a final Levels or Curves adjustment to perfect the image.

The examples in this toolkit are all from Adobe Photoshop, though other software have filters that perform similar functions.

▼ ORIGINAL IMAGES

▷ **Match the type of image** with the type of filter: distorting filters tend to work best on images with large, clear features, whereas texturizing filters work well with fine detail.

DISTORT ▷

These filters move the position of pixels to a greater or lesser extent – allowing you to warp, twist, and twirl your image – while generally maintaining the brightness and colour values. They are useful for imitating distortions seen through water, or glass.

DIFFUSE GLOW

PIXELATE ▷

Pixelate filters sample groups of pixels and take an average as the value for the whole group, which may vary in size and shape. They can be useful as precursors for art effects filters. The Mosaic tool is best for simplifying images to their essentials.

POINTILLIZE

RENDER ▷

This type of filter applies another image or an effect to the original image. You may have extensive control over the interaction, as with the Lens Flare or Lighting Effects filters, or the impact may be random, such as with Clouds filters.

CLOUDS

STYLIZE ▷

Stylize filters apply both a distortion and a tonal or colour effect based on the source pixels, but maintain the overall image content. They produce a wide range of effects which offer controls, usually over the distortion component of the filter.

EMBOSS

TEXTURE ▷

A cross between the Pixelate and Stylize filters, Texture filters use groups of pixels as an average for the new pixels, but also apply a little distortion. They are effective at mimicking the printing of images onto certain materials, such as canvas or tiles.

PATCHWORK

GLASS

TWIRL

WAVE

MOSAIC

CRYSTALLIZE

COLOR HALFTONE

DIFFERENCE CLOUDS

LENS FLARE

LIGHTING EFFECTS SPOTLIGHT

EXTRUDE PYRAMIDS

FIND EDGES

EXTRUDE BLOCKS

GRAIN SPECKLE

MOSAIC TILES

TEXTURIZER CANVAS

Redirecting the image

The ultimate test for the digital photographer is the composite image. You need good technique to produce images that can be blended easily; you need clear thinking to ensure the changes in meaning and content mesh well. And you'll need every image manipulation skill in the book to construct the image using layers, masks, and myriad small adjustments.

In this composite, four images are brought together in such a way that each assumes a different meaning, as a part of a new whole. It may take a moment for a viewer to realise there is the light of three suns in the scene presented here – but if you have to look twice because its superficial appearance is convincing, it's a successful redirection of not one, but four, images at once.

ORIGINAL IMAGE

SECOND LAYER

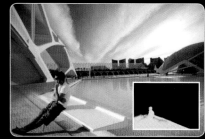

PASTE AND MASK

1 **Seeing potential**
With its clean lines and large areas of clear space, this image, with its faintly otherworldly look, is an excellent basis for a composite.

2 **Richer skyline**
For the background I selected an urban skyline seen from above, as this conveys the feeling of height. For the time being, I set the image to one side. But it's useful to know what the final skyline will look like.

3 **Adding a figure**
I found a picture of a man sitting on a stone bench making a call, and copied and pasted the image onto the background layer. To remove unwanted parts of the scene, I created a layer mask to keep just the area of the man and the seat that I wanted, using a soft brush for a seamless blend.

COPY AND PASTE, DISTORT

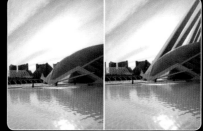

LAYER MASK

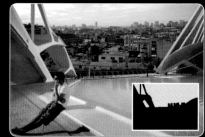

COPY AND PASTE, LAYER MASK

4 **Extending the bench**
To make the new bench fit more comfortably in the image, I extended it by copying a small area, and then pasted it a few times, being careful to try to match the patterns for a good join. I used a touch of distortion to correct a perspective error.

5 **Adding structure**
The right-hand side was looking too empty, so I cut a section of yet another image and pasted it in. After adjusting the shape and postion, I created a layer mask to hide the unwanted background. Working with a layer mask allows me to edit the hidden areas if needed.

6 **Incorporating the skyline**
I opened the skyline image, and copied and pasted it in. I hid the foreground by making a selection of the lower part of the image, which I then converted to a layer mask. After a little experimentation, I decided the skyline image would work better flipped left to right.

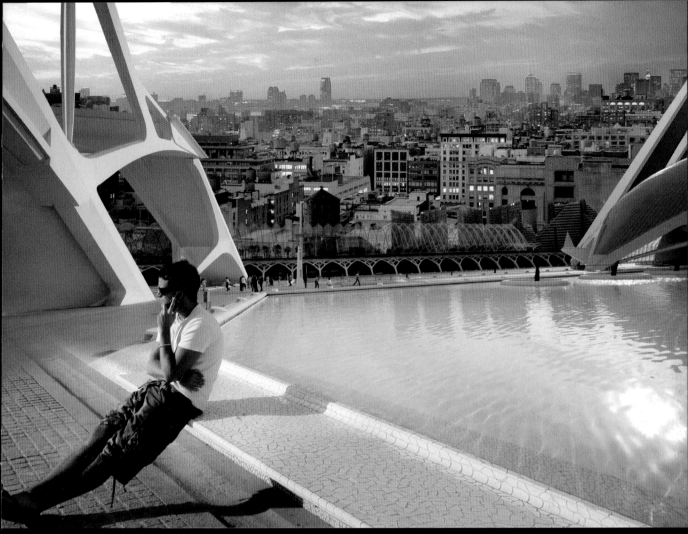

△ **FINAL** IMAGE

LEVELS, CURVES

7 Enhancing tones
The sky now looked too pale and watery, so I used Levels to add density to some of the lighter areas. I added weight and colour selectively to the burnt-out sky by using the Curves layer adjustment on certain selections.

BLEND MODES

8 Show through
After adding a glass roof structure (above) in the same way that I added the building in Step 5, I used Multiply to make the lower layer show through. The effect was too weak, so I duplicated the layer of the roof, and applied Screen mode for the strong but transparent effect I wanted.

LAYER MASKS

9 Final adjustments
With all the elements in place and roughly masked, I used more layer masks to make final adjustments, giving sharper edges to some joins, greater blur to others, and fine-tuning the darkness and lightness in various places for a convincing overall balance.

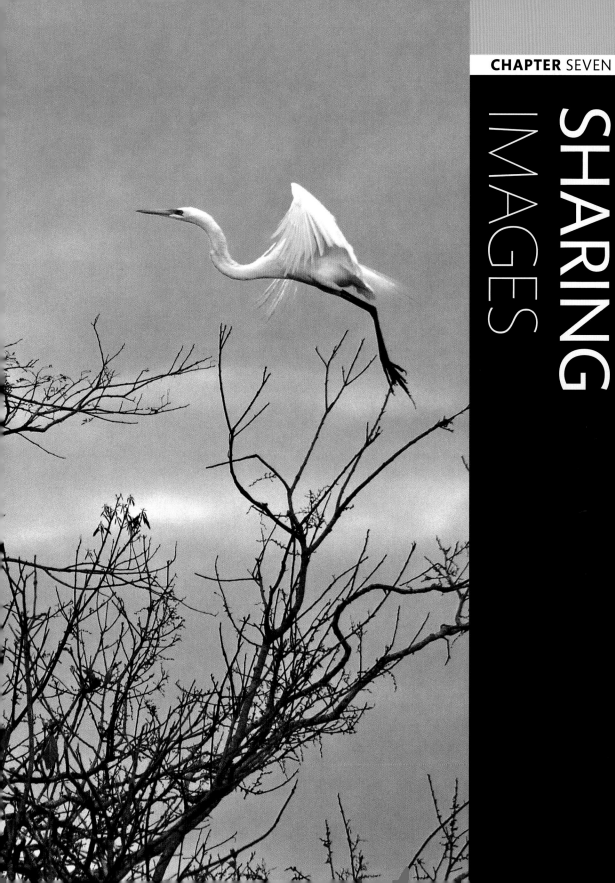

SHARING IMAGES

Showing your images

The widest significance of photography's digital revolution is in the liberation of the image from the physical into the virtual. This has impacted not only on the way we make photos, but on the way we show them. In the past, when we developed film and made prints, we shared images one-to-one. Only very few photographers reached a wider public through having their images published in magazines, newspapers, or books.

Now, in just a few mouse-clicks (or taps on your smartphone) you can send your pictures anywhere. What is perhaps even more revolutionary is the fact that if you have a computer and access to the internet, the means of dissemination and production are in your hands; you can do it all by yourself. And millions of photographers do, every day. And if all this excitement wasn't enough, the digital revolution has also greatly multiplied the ways in which we can share our prized images.

To have and to hold

Real photographic prints – that you can hold in your hand – remain a thoroughly satisfying way to enjoy pictures. Their physical presence, the ease of viewing and the quality of their colour cannot be matched by any method of digital display.

Printers are now relatively cheap, with many mid-range models capable of professional-quality results. You can make top-class prints affordably at your own desktop but you need to maintain supplies of ink and paper, and set up the printer (see pp.288–89). Buying your own equipment is a good solution if you expect to produce

many prints. Alternatively, if you print only occasionally you can order prints from the many online services available. And even if you have your own printer, many websites can offer high-quality, exhibition-grade or poster-sized prints should the need arise.

An increasingly popular option is to design your own photobooks featuring your own photos. You can design your book using free software from a book-printing site or log on and use webware – applications that you use via the website. The applications are all easy to master, but vary in the flexibility of layout and use of text. Once you're satisfied with your final design, you order the book, specifying the paper quality and binding and other details (see pp.292–93).

Virtual album

Digital photo-sharing falls into two broad categories: one is the modern equivalent of handing out prints, when you show your pictures to someone using a display device. The other is the virtual distribution of your photographs to a remote display device.

Smartphones and tablet devices such as the iPad are changing the way we show and view images. Many different albums – each containing hundreds of photographs – can be carried on a single device. Sets of pictures from, say, different holidays or events, can be uploaded directly without the need for further work. Another good way to show images is the stand-alone digital photo frame: like a picture frame but with an LCD screen, it can run a continuously looped slideshow to brighten up a corner of a living room.

VIEWING AND SHARING

While the viewing of individual prints is fun, and the one-to-one exchange encourages careful inspection and discussion, the digitization of images liberates viewing techniques. With your laptop or tablet device you can view images with ease, and if you have a Wi-Fi or 3G-enabled device you can send images as soon as you've uploaded them.

Big impact prints
It's exciting to make the occasional poster-sized print. You can get so used to looking at tiny images on the back of a camera or, at best, on your computer monitor, you may fail to see the potential of your images to make large prints. Choose subjects with clear lines and shapes, strong colours, and dynamism. Ensure your image measures at least 3,000 pixels on the long side: this allows large prints to be made even if the resolution is a little low, as you'll view large prints from a distance.

One-to-many

The print and screen-based displays are all one-to-one: I show, you look. With virtual display the sharing becomes one-to-many. This wider audience could be anywhere in the world, and the same image could be seen on hundreds of screens at once. There are several ways in which you can disseminate your images so that they reach many people: these progress from being fully under your control to being almost completely out of your control.

Sending your friends HTML emails featuring your images is a process entirely under your control. You can easily illustrate your emails using formatting for internet pages. Many designs – which you can use "off the shelf" or adapt to your own needs – are available free for download. However, if you wish to reach others beyond the confines of your address book, the next level is a personal website over which you have full control of content.

Your internet presence

Now that "everyone" has an email address, it's becoming obligatory for photographers to have a web presence – and it's hard to think of a better way to showcase your work. With a website, your gallery of photos is open 24/7 and can be visited from anywhere in the world by anyone with access to the internet. In return, however, you have no control over who visits, nor what use they make of your images (see pp.286–87).

When you decide to join the 300 million other websites on the internet, the amount of work you put in is up to you; you may choose to do very little, or commit to a lot. The first issue is what to call your site. The obvious choice is to use your name or, if that is taken, a variant easily associated with it. If you have a photographic trading name, register that. In fact, it's a good idea to register a suitable name even if you don't intend to launch your own website in the near future.

Websites are created in HTML code and the easiest way to code website pages is to have your image manipulation software automatically design and write one for you. You simply point the web-creation actions to a folder of your images and the site is created in minutes. You have only to upload the site to your internet service provider (ISP), following their instructions.

Photo-sharing

One of the most obvious wonders of the digital age has been the nuclear explosion of pictures on photo-sharing sites. Photo-sharing grew out of the online printing services (see pp.292–93) of the 1990s. You uploaded your image for printing, and they stored your file in case you wished to reorder. A natural extension was to allow others to be able to view the stored images, and even order prints themselves.

Almost all sites are free to start with: some offer a trial period, others a limited, but still very useful, service. The registration is usually minimal too. In short, the barrier to

entry is set very low: anyone can join in and upload their images, subject to the site's terms of use. Paying a small subscription allows you to access greatly improved features, and to add as many images as you wish.

Picture blogs

Instead of a website that offers mainly static content, blogs are constantly changing – and can change as often as you, the blogger, care to write and upload new material. The best will post new pictures once a week, with news, comments, and links to items the blogger has found interesting. If you can meet a niche need in an interesting and informative way, you will encourage visitors to return.

Most blogging software is easy to use and with it you can create sites that are easy to maintain. Concentrate on what you know and what's available to you – your "day" job, other hobbies and interests – it doesn't have to be all photographic. Add voice and video to enliven your content.

Generating interest

However, creating a website or picture blog is only the beginning of your work. You'll want to have plenty of visitors to your site. Publicise it, and any updates or new material to all your friends on the social networking sites that you use. Inform all your contacts on photo-sharing

sites. Use the tools available to you to encourage them to "like it". Invite other people to link to you, and to mark your page as one they rate as worth visiting or even to bookmark. You can also set up subscriptions so that visitors can choose to be informed of any updates. Above all, keep your website ever-fresh so that you attract a constant stream of returning visitors.

Spreading the word

All this is immensely exciting, but with these new freedoms come many new responsibilities. You are accountable for the regularity, quality, and legality of all you do. And you're directly responsible for your own reputation. An error of judgement could lead to embarrassment on a worldwide scale, and failure to allow for the porosity of international borders could land you in a lot of trouble if your photographs offend the local law or religion in other countries.

The opportunities are enormous for those who meet a need or pique wide interest, who maintain a consistent, high standard, and who regularly put out new material. There are international reputations to be won for the price of your time and your internet connection; there are incomes to be made if you prove able to generate sufficient internet traffic to your website – if your visitors like what they see, they'll tell their friends.

Personal website

Website authoring software, such as WordPress, are now easy to use, with a vast range of expertly-designed templates to give your site a balanced colour scheme and attractive layout. You can update with new images very easily, add text, and invite visitors to comment or discuss issues of common interest.

GETTING NOTICED

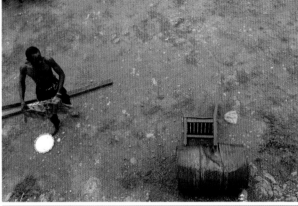

Uploading your images to photo-sharing sites is a good way of getting like-minded people to take notice. Join groups on the site – active participation in the picture-loving community can provide a great deal of encouragement, help, and inspiration. Shots with human interest (top) are popular, but those with an unusual or quirky angle (middle) are more likely to cause ripples. Well-composed shots demonstrating sound technique, particularly of somewhat unfamiliar subjects (bottom) also tend to stimulate interest.

The world is your gallery

Building your first website can be a little daunting, like making your first exhibition or book. You have many decisions to make – which typeface to use, what colours work best, and which images to show at what size. Making trial websites will give you the confidence to launch the real thing on the world when the time is right.

▼ THE BRIEF

▷ Create a website showcasing 20 of your best images, starting with your all-time favourite. Give each one a basic title and provide caption details, using the automatic website creation features of your image manipulation or management software.

▼ POINTS TO REMEMBER

▷ **The picture selection process** is a mission in itself. Begin with a folder of possibles and edit carefully until you have your top 20 (see pp.180–81).

▷ **You should check your images** for consistency of exposure, colour, sharpness, and overall quality.

▷ **There are many different website designs available,** so experiment to see which works best for you. You can review them on your internet browser; it's not necessary to upload sites to your ISP.

▷ **Show your site** to family and friends to get their feedback.

GO GOOGLE

☐ **HTML**	☐ **Reddit**
☐ **Wordpress**	☐ **StumbleUpon**
☐ **Blogging**	☐ **Digg**
☐ **RSS feeds**	☐ **Flickr**
☐ **Delicious**	☐ **1x**

Preserving your rights

When you disseminate your images in the virtual world you cease to be in control of them. Whether sending images by email, uploading to your website, or posting onto social networking or photo-sharing sites, in order for your image to be seen online it must be copied.

In fact, reproducing the image is an essential step for virtually every stage of internet use; copying is needed in order for the digital age to function. This leads naturally to the idea that what has been copied can be freely used. But if you think that, you'd be wrong: almost everything you might want to do with a copied image is an infringement of the rights of the person who owns it.

Exceptional infringements

Some legislations allow exceptions – such as use for study or research, criticism, or news reporting – to certain infringing acts. This means that you can copy and print images if you're doing it for a course of study or if you wish to illustrate a critical essay. But even if you have no commercial aims in using someone else's image, by the measure of the image having features that make it useful to you, you are unfairly

exploiting another person's artistry and skill. Before you use someone else's image, apply the simple test of considering how you would feel if someone were to use one of your images without your permission to, say, illustrate a personal project, or use as a background image for manipulation.

Reproducing any part of a copyrighted work of art that does not belong to you is also an infringing act. If you use part of another work in yours without attribution, not only have you copied illegally, you have changed it without authority, which is illegal in some jurisdictions. Furthermore, you may be guilty of failing to attribute the source. And if you claim the whole work as yours, you will also be guilty of false attribution, because part of the final work is not actually yours. The highly restrictive terms of copyright legislation has led some to propose a looser system, the best-known being that of the Creative Commons (see box, opposite).

A tighter rein

The fact of the digital era is that any number of people could be using the images you put on your website: they will do so without your knowledge and beyond your control. In the main, they will not be infringing your rights,

Point of contact
Specialist subjects, such as insects, collectable objects, and rock formations, are less likely to be illegally copied than shots with obviously wide appeal, such as cute animals, supercars, and fabulous sunsets. Nonetheless, it helps to make it easy for a potential picture-buyer to contact you. If they do, reply promptly and ask for details of the intended usage. You can find help on the internet and in discussion groups to work out how much to charge.

Using other people's pictures to improve your own is a temptation that's always been present in all art forms. In digital photography, the temptation is even stronger because it's so easy to copy other pictures. My dull shot of a kingfisher (top right) is vastly improved with a closely cropped section of a sunset view shot by my wife (bottom right). There would be at least two copyright infringements involved here: illegal copying and illegal adaptation, and, if I claimed the resulting work to be entirely mine, a third offence of false attribution. The resulting image (far right) is so coherent and convincing the original photographer may never notice that a part of her image has been used: how much more difficult it would be to spot if it was uploaded to join millions of other images.

but there are no guarantees to that effect. The only effective way of preserving your rights when a copy of one of your images is held by someone else is their sense of right and their knowledge of obligations under their country's copyright legislation.

Despite this, there's a lot you can do to avoid giving away rights unnecessarily. The following tips will help you protect your images:

- Ensure that you assert your copyright at all times, for example in caption information and in image metadata.
- Don't upload any images larger than 1024 pixels wide to any websites where they could be saved in their full size.
- Read the terms of use or terms of service of photo-sharing sites carefully to ensure that in uploading images you aren't waiving any rights to them.
- Abide by the rules of the photo-sharing website, or you may find your images deleted without warning.
- Always keep a copy of any images that you upload to another website: you never know if or when they might shut down.
- Don't enter competitions that require you to give up your rights.
- Use watermarks to identify your images: these are best applied discreetly in several places over the image to make them difficult to remove, yet not interfere with its impact (see p.273).

- For professional users, there are invisible watermarks that can be placed and detected in images using specialist software. These watermarks survive all changes to the image, short of severe cropping. Better still, the watermarks can be detected by software robotically searching through the internet.

DID YOU KNOW?

Creative Commons is an organisation that strives to find a middle way between restrictive copyright control and a free-for-all in which anything can be copied and used. It offers a scheme of licences that allow the distribution of copyright works at no charge, provided certain conditions are met. The chief condition is attribution: the user should display the copyright, home site URL, name of work, or other notices as required. Other conditions may be set: that the use is non-commercial, that the work should not be used to create derivative works, and so on. If these conditions are met, licensees may copy, distribute, or show the image free of charge. Suppose you copy an image licensed under "Attribution – Noncommercial." If you credit the photographer, you can use it to show off your Photoshop skills to your camera club. But if you use the image to, say, illustrate a magazine article, you breach the terms of the licence.

Print set-up

The modern printer is an extremely sophisticated piece of machinery that combines nanotechnologies for placing ink on paper with microscopic precision with the larger-scale mechanics that enable it to handle paper effectively. At the same time, the software control of a printer's functions is highly complicated. It therefore takes only the smallest mismatch between what the software expects to be coming out of the ink nozzles and what is actually reaching the paper for the most obvious flaws in print quality to be visible. Printers can print their own system test, but this only checks that everything is working normally. There are other important checks you can do yourself to ensure a good-quality final image.

STANDARD FILE FOR TEST

1 Before you make full-size prints, it's a good idea to produce a test print from a small colourful image so you can check its appearance against the picture on-screen.

- Check that the image's output size matches that of the paper and that resolution is sufficient for its scale.
- If landscape format, turn it on its side so that it fits the paper (many print drivers do this automatically).
- For comparison, place three versions of the same picture side-by-side on the same piece of paper – one lighter; one normal; one darker.

CHOOSE PAPER

2 The quality of the paper has an enormous influence on the quality of the image. Ink-jet colours are made in such a way that on normal paper, the ink spreads out and details are blurred. Use specific ink-jet paper: gloss gives the brightest colour and sharpest results; semi-matte papers are great all-rounders; and matte paper is good when you want softer tones.

- If the paper has a printer profile, choose it in proof set-up. If not, use a generic profile with a similar name.
- Print the same image on other papers to see how they react with the ink.

PRINT OUT

3 Check the printer is on and connected to your computer. Load it with paper, making sure it's the right way round. Open the picture in your image manipulation software and press "print". It may take more time than a spreadsheet or text document.

- If the paper tray is on the same side as the slot for the finished print, the paper is usually placed with the printing surface facing down.
- If the print comes out at the back, the paper is placed print-side up.

ANALYSE

4 When the print is ejected it's ready for your critical eye. Hold the paper by the edges as the ink may still be wet. Examine it in daylight or under a low-voltage tungsten lamp.

- Check not only for the colour and density of the image but also for any defects – these indicate that the printer needs cleaning or servicing.
- If the print doesn't match the screen, assess whether it's darker or lighter. Check the hue of the colour cast saturation to see if it's more or less than on-screen.

ADJUST IMAGE

5 If necessary, adjust the image accordingly – for example, if saturation is too low in the print, you will need to increase it on-screen; if the print is too red, you will need to reduce the screen hue. This process suits those who make only occasional prints and where there is no profile available. Reprint and reassess.

- If you print with profiles, the adjustments should be minimal.
- Make only small corrections if differences are not obvious.
- With experience you may find you repeatedly use the same corrections.

GAMUT CHECK

6 When you print regularly, there are two checks that should be made if you want reliable results. The first is to soft proof or do a test print. The second is the gamut check. This ensures that all the colours in the image are within the printer's range. Turn on "gamut warning" when you view the picture – out-of-gamut colours are shown as a red or white overlay.

- If a large area is shown out-of-gamut, reduce saturation to lighten the area.
- It's not necessary to remove every out-of-gamut colour.

While modern printers have made big technological advances, it still pays to proceed steadily and carefully to obtain the best-quality results and to avoid wasting ink or paper. Before pressing "print", make sure you preview the print or proof colours first. View your image on a computer screen that has been calibrated and profiled with your printer to ensure that what you see on-screen is the same as the final print (see p.334). This check also guarantees that an output profile, matching the printer and paper, is applied.

You need to set the resolution of your picture for printing. Resolution is measured in dots per inch (dpi). Images from your digital camera may be at 72 dpi but should be set to 300 dpi, which ensures high-quality results from the majority of printers. Divide the number of pixels by 300 to determine the size (in inches) of the print.

Minimum standards

Follow these technical guidelines to ensure your printer is properly set up and maintained. In return, you'll be rewarded with consistently good prints.

- The most reliable prints come from printers that are regularly used and not left to stand for months without seeing paper. Run a test print from time to time to avoid leaving the printer idle for long periods.

- If the printer refuses to print anything at all, you may have updated your operating system and neglected to do the same for the printer driver. If you're printing on a network, make sure you have the correct printer selected in the profile, that the network is working, and that the appropriate driver is installed.
- If the colours are just off the results you expect, you may have applied an incorrect paper profile or used an inappropriate paper for the printer. It's also worth checking that the colour is set to be handled by the system; if so, try setting it to be handled by the printer.
- If the colours are badly out-of-kilter, one or more nozzles on the ink cartridge may be clogged. If the picture is very blurred, you've used the wrong side of the paper.
- If the final printed image is not the size you expected, check the resolution and output size and adjust as needed. You may need to resample the image (see p.200).
- It's best to connect the printer direct to the computer – plug the USB lead into the USB port of the computer instead of via a multi-port connector.
- If you have tried several times to print without success, check the print queue in the print control panel so you can delete any unprinted jobs. Failure to do this may result in lots of unwanted prints when you do get the printer working again.

APPLIED PROFILE

7 When printing for an exhibition, gifts, or sale, high-quality papers are best. Before selecting one, ensure that it offers profiles that work with your printer. While these are only approximate, they make a big difference to the overall quality. Use the supplied profile to adjust and check your prints.

- Make sure your monitor is situated in low light before you evaluate.
- For critical work, invest in a colour-correct viewing light.
- Calibrate and profile your monitor regularly – LCD screens can change colours significantly in a month.

REPRINT

8 In setting up for a large print, make sure that your image has sufficient resolution for best results. This varies with the paper used – use a higher resolution to make the most of glossy paper. Matte papers can produce excellent prints with a lower resolution. In general, 300 pixels per inch (118 pixels per centimetre) is enough.

- Use print preview to ensure the image is the right size for the paper.
- Higher resolution doesn't necessarily improve print quality or sharpness.
- Applying the USM filter may improve sharpness, but artefacts detract.

NEW INK OR PAPER

9 Changing either the ink or the paper calls for a new set of tests, as even minuscule variations can cause visible changes in colour reproduction. A single test can save you a lot of ink and many wasted sheets of paper.

- Store your paper carefully, particularly if you live in a humid or arid environment – the water content of paper affects its take-up of ink.
- For best results, make test prints from standard files and send them away to an image service be profiled. Or do it yourself with a print calibration system.

Presenting your prints

Contrary to popular belief, the capabilities for digital display has not made paper-based display extinct. For the first time in photography's history, we have two distinctly different ways to show prints. The result is that we enjoy the best of both worlds.

From wandering around galleries to leafing through glossy picture books, people have always enjoyed looking at the printed photograph. Prints are ideal for use in conditions where light levels are high, and in situations where we need the highest image quality.

Photo finish

The majority of paper-based prints are made with ink-jet printers. The big advantage of ink-jet prints is the wide range of paper textures available. From a metallic, hard gloss to big-grained watercolour papers and canvas or rag, the resulting print quality is also very varied. This means that you can match the paper surface to the type of picture you wish to produce. For example, a bright, colourful image with lots of detail would be greatly enhanced with a high-gloss paper, while a dreamy still life might work well on a lustre or matte paper.

Whether you're hanging an exhibition, or just putting your favourite prints on the wall, the way they are mounted also makes a big difference to the impact they have. Choose simple frames that complement rather than overpower.

You may also want to use a border or "window-matte" to separate the edge of the image from the frame. There are many types available but choose the colour with care – off-white will support most pictures. However, if the walls you want to hang your images on are plain white, prints that come right to the edge of the frame are simple and stylish.

Display essentials

If you're hanging pictures somewhere for others to see, the order that they are viewed in changes their impact. When hanging images think of telling a story – you may want to save the best till last, once you have built up expectations, or the narrative may follow a natural cycle, such as tracking a day from dawn until dusk.

As images are viewed one after another, it helps give the viewer a sense of progression. To begin with, err on the side of simplicity. The key is to locate your prints so they can be viewed easily. Keep the eyeline constant, hang with consistent gaps, and ensure they're hanging straight.

PAPER CHOICES

Each model of printer will have its own strength or weakness: some produce well-balanced black-and-white images, whereas others may produce punchy, richly coloured results. However, the choice of paper also controls the quality of the result. For fine art images with soft colours, dependent on subtlety of tone (top right), a silk or lustre print that's mounted unglazed (without glass) works well. For black-and-white portraits (bottom right), a gloss print mounted under glass simulates traditional gelatin-silver prints. Matte surfaces work well for landscapes with long tonal ranges (far right) which are printed large, as these are easy to light and to view as they are free of hard reflections.

VIEWING IN SEQUENCE

It is instinctive to try to construct a story or narrative from a sequence of images. If you make it easy for them, viewers will reward you by being more responsive to your images. Work with a travel narrative, or create a sequence based on dominant colour or a tonal spectrum – for instance, from light to dark. The sequence can be uneven or even reverse itself at some points. In the example above, we begin at the bungalow, journey into the jungle, and discover local wildlife.

Home viewing

It's fun and rewarding to put on a photographic exhibition, but many people never do because they set their sights too high. It's not necessary to find a public space such as a library, let alone a gallery – you could show in your very own "pop-up space". Convert your largest room at home into a gallery for a while, or utilize your friends' garage or the local café.

▼ THE BRIEF

▷ Put on an exhibition of your favourite images and invite your family and friends around for a private view. This could be an opportunity to repaint and tidy up a room. Make some large prints, say, no fewer than 10, and not more than 20. You may also like to make a slideshow to run in parallel on a television or laptop. Music in the background will further set the mood.

▼ POINTS TO REMEMBER

▷ **You can upgrade room lighting** by bringing in extra lamps. Add drama with spotlights.

▷ **Create an invitation** using your best picture as the lead image. Give the show a title, date, and location – circulate it by email.

▷ **Provide refreshments** at the private view to reward your visitors for making the effort.

▷ **Think about prices** you'd like for selling any prints before anyone asks you.

▷ **Invite other photographer friends** to join in to showcase a variety of work.

GO GOOGLE

☐ **Window-matte**	☐ **Curating an exhibition**
☐ **Paper grade**	☐ **Family of Man**
☐ **Picture framing**	☐ **Intertextuality**
☐ **Display lighting**	☐ **Semiology**
☐ **Hanging pictures**	☐ **Pop-up gallery**

Online printing

One of the biggest casualties of photography going digital was print. Almost overnight, photographers went from printing nearly every image they shot to printing fewer than one in a thousand. Apart from the question of how long digital images will last, it means that whole generations of photographers have no idea just how beautifully modulated, delicate, and fine prints can be.

In place of the dying photographic print business, hopes were pinned on a compensating growth in desktop printing. But reliable and consistent results were difficult to obtain (see pp.288–89) and alternative printing services sprung up. At the top end, experts maintain professional-quality printers, giving you the best of both worlds. At the lower end, you enjoy value for money and convenience.

Local prints

If you live in a city, the local photography shop may have print booths installed, allowing you to select and print images from your own memory card while you wait. These services are quick and inexpensive, and generally only set up to produce small prints. However, the quality may also be compromised and the permanence of the prints variable.

Remote prints

Online printing services offer an excellent resource for the occasional user. You need only visit the website, upload your pictures, and make the order. Many provide clear instructions regarding your image's colour space, resolution, and format. You can also choose the type of paper used – high-quality services will print on giclée (exhibition-grade

archival) papers and provide print profiles for you to check or "proof" the image before ordering. Once your payment has gone through, the print is automatically placed in the print queue. Services offered include rapid turnaround, courier delivery, and posting abroad. As always, it's a good idea to check the printer's website for guarantees of satisfaction and customer reviews.

Photobooks online

The options for printing pictures has diversified in a most exciting way. You can design and print books of your pictures online and have them delivered to your door. This amazing development enables you to make desirable gifts that present your work in the best possible light.

The process is a little more involved than printing single photographs, as you have to design the book (although some software automate even that). It's a good idea to organize your images into the order that you want them to appear and number them sequentially. Perhaps do a rough sketch first – some pictures could stretch across the whole spread, while others may be grouped or paired.

After choosing your service, you can start designing. Many websites allow you to do this online; some require you to first download the design software supplied (programs such as Adobe Lightroom and Apple Aperture also provide design modules). You'll then need to select the size of the book, paper, and type of cover. Upload your images straight into your chosen design or follow the instructions provided with the downloaded software. Then place your order – multiple orders usually attract a discount. Within a few days your book will arrive, expertly bound and presented.

CREATING A TEMPLATE

The easiest way to design your own books is to base them on a model you admire. Search through your bookshelf or local library for designs you like and which may work with your images. Photocopy or scan sample pages, and use these as templates for your book design. Give your images enough space to "breathe" on the page.

PRINTING CHALLENGES

A black-and-white image (top) offers a good challenge for an online printing site. This is because even a very small colour imbalance will show up as a tint on a monochrome image. In contrast, a landscape or view with many colours tolerates relatively large variations in colour balance and saturation, and can still deliver acceptable results (bottom).

Test sites

There are numerous online printing services and many reviews on the internet – but nothing beats your own evaluation. It's worthwhile checking out a few services before you have a serious printing task to complete. Place small orders to test the service. Find out how easy it is to make changes, how friendly the service is, whether it's value for money, and how quickly you receive your goods.

▼ THE BRIEF

▷ Review the speed, quality, and cost of three or four different online services by ordering small prints of four of your typical images. Try to include different types – for example, a portrait with soft pastels; a black-and-white landscape; a travel shot with intense colours; a standard colour chart.

▼ POINTS TO REMEMBER

▷ **Upload the same image** to all of your chosen websites on the same day.

▷ **Order prints on the highest-quality paper** and opt for the highest-quality service; but choose the smallest prints to keep costs down.

▷ **Keep the paper quality** as similar as possible – all glossy or matte. Avoid lustre or silk surfaces as these vary considerably.

▷ **When you receive all the prints,** evaluate them yourself by all means; but also ask others for their opinion.

GO GOOGLE

☐ **Giclée**	☐ **C-type print**
☐ **Print profile**	☐ **Photobox**
☐ **Ink-jet**	☐ **Graham Nash**
☐ **Lambda print**	☐ **Free photo printing**
☐ **Dpi**	☐ **Storing photos**

Earning with photos

The great explosion in the number of photographers able to make exceptional-quality images has turned the world upside down: it's been a boon for the amateur, but close to disastrous for those professionals unable to adapt. There are more skilled photographers in the world than ever before, and the opportunities for earning part or all of your living through photography couldn't be more diverse.

Competition for scarce clients is also increasing. It's not easy to get noticed amid a crowd of hundreds of millions of other photographers, but it is possible. The key way to attract attention is through the quality and innovative nature of your work, while the key to keeping clients is professionalism in all aspects of your dealings. It's not difficult to earn a little money from your images, but it can be very hard indeed to earn a living, let alone a comfortable one.

Getting noticed

Before you can sell your pictures they need to be seen. The obvious route is to place your very best, highest-quality pictures on your website. But creating secure transactional elements that allow visitors to buy licences to use your images and to download high-resolution copies is not easy.

One way to get around this is to upload your images onto a host site that uses expertly-designed page templates. With these elements you build your own microsite contained within it – rather like a photo-sharing site. As these host sites are designed for professionals, they include search engines to locate pictures by keywords, support transactions for selling rights, and allow very large files to be held and downloaded by paying clients. You can customize the look of your own "site" and manage its contents yourself. The host site may also promote members, for example, by running blogs that market photographers to potential clients.

Another way is to approach local businesses with a portfolio. You may want to contact restaurants or shops with a view to exhibit, or perhaps greeting card suppliers. Your portfolio can take the form of a slideshow on your laptop, tablet device, or smartphone. Show work that's appropriate to the potential client. Ensure you leave a card, and try to take away a new contact from each call you make.

Microstock sales

Anyone with fair skills and care can join the microstock business. These organizations sell picture rights for as little as one US dollar a time, or less. The buyer gains lifelong use of the picture without further fees or royalties payable, even if they use it for commercial purposes. More accurately, then, these are stock micro-sales, but fortunes can be built on these tiny transactions.

Like it or not, this model has taken over what was once a profitable big business, because for many uses an image needs only to be good enough for the job. Microstock meet that low requirement perfectly. This means anyone can earn a little money from their pictures, provided they are sharp, clear, well-exposed, and tonally convincing.

The microstock business is an open house to anyone who can shoot to standards that pass the tests of reviewers who monitor quality and content – and these criteria are not demanding (see pp.182–83). The more shots you take and place onto a microstock sales website, the more money you

SALEABILITY

Successful stock photographs are usually those which show their subject clearly, in sharp focus, well-lit and with strong colours. This is not a recipe for innovative, abstract, or intriguing images. The shot of piggy banks (right) isn't inventive, but it is saleable. The shot of parasols and blue sky (far right) is attractive but very unlikely to sell.

Space for rent
Images that provide space for text to be dropped in are prized by designers. This image also works when cropped to a vertical format – which gives buyers even more flexibility.

can make. And the market for simple and pleasing images is growing worldwide. Besides, pictures on these sites need to be constantly renewed, so even if someone has a successful image, there's always a market for a similar alternative.

Competitive field

Entering competitions is a good way to show off your best work and test yourself against other photographers. You can shoot specifically for a competition or search through your archives for images that match competition standards. If possible, go somewhere different: competitions receive pictures from a surprisingly narrow range of locations. But if you do find yourself in a popular location, try to be original. Research how others shoot the famous sights (look on Flickr or Photobucket) and see if you can work out how to do things differently. Avoid imitating last year's winners: it's useful to learn from them, but don't send in similar shots. Look at the past winners so you can work out what not to submit.

Primarily, winning shots are fabulous shots. But this is seldom sufficient. Taking top technical quality as a given, there are other points to bear in mind. You must follow the competition rules to the letter, observing every detail of the instructions and brief. Don't over-process or manipulate. Send in good time: avoid joining the last-minute rush that crashes the organizer's server. Read between the lines: if the competition is for a book cover, send in portrait-format shots, even if not stated in the rules. And don't worry about entering competitions sponsored by a camera manufacturer: most are open-minded about images taken on competitors' cameras.

The money shot

It's a confidence boost when someone expresses pleasure in your work, so think how exciting it is when they like your image enough to pay for it. Microstock sites such as Fotolia, Shutterstock, iStockphoto, and so on have democratized the selling of rights. With the preference for straightforward, clear shots, it's worth a try even if you doubt your skills.

▼ THE BRIEF

▷ Collect sufficient images from your best work to meet the submission criteria for your selected site. Submit them with the aim of having them accepted to be offered for sale.

▼ POINTS TO REMEMBER

▷ **Read the terms and conditions** to make certain you agree with them; don't simply click the "accept" button.

▷ **Examine your images** carefully at high magnification to ensure they are clean, sharp (but not over-sharpened), well-exposed, and correctly white-balanced.

▷ **Make sure they meet the site's rules** for size, resolution, and acceptable content, and model releases, if relevant.

▷ **Follow every instruction carefully** regarding captioning and providing keywords.

▷ **Some sites will make you wait** weeks or even months before allowing you to reapply if you fail the first evaluation. The top five or six sites work more stringently than the smaller ones do.

GO GOOGLE

☐ **Microstock**	☐ **Tags**
☐ **Royalty-free**	☐ **Keywords**
☐ **Licensed image**	☐ **Corbis**
☐ **Model release**	☐ **Shutterstock**
☐ **Stock library**	☐ **Artists' copyright**

MAKING MOVIES

The film-making revolution

So what's all the fuss about? It would be easy to overlook just what a major change has happened in the dSLR market over the last few years, given how accustomed we are to products becoming cheaper, better, and smaller. However, a fundamental change has now transformed the landscape of film.

Although dSLR cameras have been able to shoot reasonable quality film for some time, only since the Canon 5D Mk II is the quality and resolution of the footage good enough to be used professionally. In the past, one of the frustrations for film-makers was that even "prosumer" (between consumer and professional) cameras came with fixed lenses, which made obtaining a shallow depth of field very difficult and limited the look of the footage. All that has now changed.

Don't panic!

If this is your first day on the job as a film-maker and director, you may wish that you'd gone to film school (for some consolation, see the box, opposite). If you're daunted by what lies ahead, you should take comfort from the knowledge that, thanks to the internet, it's never been easier to learn about film-making or how to shoot and edit films on a budget. Historically, the process was expensive and laborious and the only way into a career as a Director or Director of Photography was to work your way up – from sweeping floors and stacking rolls of film to pulling focus.

While we're on the subject of historical practices, a word on the language used here. "Video" used to refer to footage recorded onto videotape, while "film" referred to footage shot on 16mm or 35mm film stock. Now that everything is digital, when we talk about "filming" or shooting "film" or video, we mean recording moving images on your camera.

A new beginning

You can shoot professional-quality footage on video-capable dSLRs using a wide range of lenses of your choice. In fact, these cameras are now so good at shooting film that professional studios regularly use dSLRs instead of equipment that cost a hundred times more. From feature films to the final episode of the award-winning US drama series *House*, dSLRs are being used in productions across the planet and, while they still have some limitations, they have certainly changed the art of film-making for good.

SLOW REVEAL

These images are taken from two very different films. The top strip is from a commercial for an investment bank, while the bottom strip is from a documentary about a charity operating in Malawi. Both these sets of images reveal their story to us sequentially. Although there are only five images in each strip, every image reveals a little more about what is happening.

The top strip is a conceptual film that doesn't make sense in a conventional way. However, each stage imparts slightly more information about the ball, concluding with the revelation that it is navigating a "brain maze". Similarly, your film should gradually reveal its secrets to your audience.

High and standard definition

Television has two main standard definition formats: PAL (Phase Alternate Line), which covers most of Europe, Asia, and Australia, and NTSC (National Television System Committee), which covers North America. The rest of the world is divided between these two formats and a third: SECAM (Séquentiel Couleur à Mémoire – French for "Sequential Colour with Memory"). These standards are rapidly becoming obsolete as the world moves towards High Definition (HD), but the frame rates (number of consecutive images per second) still differ between countries: PAL countries shoot at 25 frames per second (fps), and NTSC countries shoot at 30 fps.

TV standards vary in many ways and one of these is the amount of pixels in a frame. There are two types of HD – a full version, which has 1920 x 1080 pixels (known as 1080p) and a smaller version with 1280 x 720 pixels (known as 720p). Standard Definition (SD) refers to PAL or NTSC, depending on the country in which you live. While all this may sound very dull, it's important to have a basic grasp of these formats and frame rates as it will help you ensure that your camera is set up correctly when shooting a film.

Building your kit

The good news about shooting film with a dSLR is that, at the most fundamental level, you can use the equipment you already have to do just about everything. The sound might not be perfect, and you might not win any major awards for your work, but you'll still be able to get good results.

The new breed of dSLRs are perfect for shooting quality footage on a budget, although their on-board microphones are generally of a poor standard. You may also face other problems, such as background noise (see p.305), which you won't be able to overcome with a built-in microphone. If you want to raise your game and shoot a better-quality documentary or short film, or even simply make a good job of recording your child's first words, then you may want to consider investing in some specialist equipment.

Audio equipment

If your camera has the option, your first investment should be a decent pair of headphones. Sound is something that many amateur film-makers forget about, but it makes a huge difference to the quality of your final production. Headphones will also reveal just how terrible your on-board microphone really is. You may want to invest in a separate microphone, since even cheap ones will make a big difference to the overall sound quality.

Unfortunately, many budget cameras don't have a separate microphone (or headphone) input, so to improve the sound quality of your footage it might be worth considering an audio/MP3 recorder as well. If your budget stretches further, a boom pole will allow you to precisely position the microphone for optimum sound quality.

Camera stability

A tripod is the film-maker's best friend. With a tripod locked off (in a fixed position), you'll be free to direct, interview your subject, or take care of the sound recording. A tripod is great for shooting time-lapse footage and will also allow you to perform fast (crash) zooms in a controlled way.

You can improvise a tripod by balancing your camera on a platform, but you'll be placing your equipment at risk and this doesn't give you the flexibility to set up the shoot exactly as you want. However, the real benefits of a tripod

DID YOU KNOW?

The first thing you should do with your new equipment is find out if there are any firmware updates available (firmware is the software that runs on your camera). Firmware updates will provide improved functionality for your camera and will often resolve any bugs. Visit the manufacturer's website: updates are usually posted regularly.

come with movement. Film is all about movement – whether you're following a person who's running or panning across a scene to reveal something that's out of shot, it's an invaluable tool. If you do decide to invest in a tripod, look out for a model with a "fluid head". This means it will move extremely smoothly and evenly.

Monopods are lightweight and versatile, and are a good alternative to the tripod. They are often used in a different way for filming than they are for stills photography. For example, with the leg contracted, monopods are ideal for hand-held camera work, giving a natural feel to your production. With the leg extended, they provide enough stability to pan and tilt without you having to set up a tripod in a fixed position. The new breed of monopods from Manfrotto even come with a fluid head, allowing you many of the benefits of a tripod with only a third of the weight.

Data rates and memory cards

Each dSLR has a different data rate (the amount of digital information that is processed per second and recorded onto the memory card). Generally, the higher the data rate, the better the quality of the image recorded. DSLRs can use up data cards very quickly so it's useful to have as many cards as you need for your shoot. As a rule of thumb, an 8 GB card will give you about 20 minutes of footage, although this varies depending on your camera model and settings. Branded cards can be extremely costly, but you don't need to go with the big names. Having spare cards will, however, make your life a lot easier as you won't need to spend time backing up data when you want to be filming. The most important consideration is to find out the data rate for your camera to ensure that the card is compatible. Check the manual for details about this.

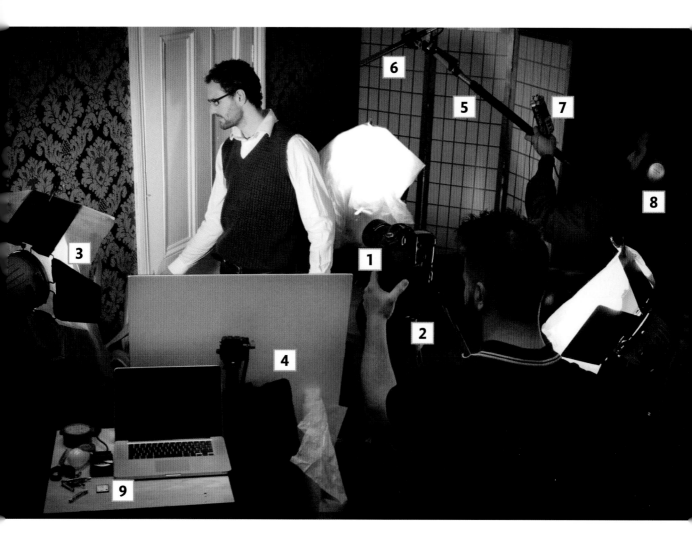

EQUIPMENT ON SET

1 DSLR
The Director of Photography (DOP) is using the zebra stripes on the display of his dSLR to determine the correct exposure for this shot.

2 Tripod
With one hand on the tripod handle, the DOP can follow the action as it happens while using his other hand to change focus as needed.

3 Lighting set-up
This is a basic three-point lighting set-up using 800 watt lights, or "Redheads", with the barn doors fully open and diffusers attached with crocodile clips.

4 Lighting accessories
A board is used to reflect light back onto the subject as an extra "fill light". The spare diffuser and blue gels can be used to correct the colour if needed.

5 Boom pole and pistol grip
These items cushion the microphone from any vibrations and allow the sound recordist to capture quality audio while staying out of shot.

6 Microphone
This is a highly directional microphone that picks up most of the sound from directly in front of it in a heart-shaped, or super-cardioid, pattern.

7 Audio recorder
You could use an audio recorder when filming with a dSLR, as most built-in microphones are poor. An XLR cable connects the microphone to the recorder.

8 Headphones
An essential piece of equipment, headphones must be used at all times when recording sound, even if just recording through your camera.

9 Essentials
Other items that always come in handy include duct tape, bulbs for lights (and gloves, as they'll become hot), memory cards, batteries, and crocodile clips.

Adjusting to shooting video

Welcome to a brave new world – one not measured in inches and megapixels but in seconds, minutes, and frames. Video now accounts for nearly half of the traffic on the internet and, as Director and Director of Photography, you're one step closer to shooting, editing, and distributing your first film.

When you shoot stills you're capturing a single moment, but with film you're capturing entire passages of time. Most programmes for television are filmed at 25–30 frames per second (fps), but many dSLR cameras will allow you to film at 50–60 fps or more.

Slow-motion footage

If you shoot at a high frame rate and then play the footage back at half speed you'll have beautiful-looking slow-motion footage, which is a fantastic way of bringing gravitas to any production. This is especially effective for emotional scenes or action sequences. However, you'll probably find that you can't shoot full HD at higher frame rates, so there's always a trade-off between frame size and frame rate. As a general rule, aim to shoot everything in full HD unless you're filming material for slow motion or as cutaway footage.

Shutter setting

As with stills photography, adjusting the shutter setting can help you achieve different looks when shooting film. Usually, you'll want to set the shutter to 1/50sec (PAL) or 1/60sec (NTSC), but by increasing it to 1/30sec (or even longer on some cameras) you'll notice that your footage appears blurred. This is an effect often employed to suggest that a subject has been drinking or is under great stress.

Conversely, when shooting at short exposure settings, the image will look very crisp and strobe-like – a technique used to great effect in the combat scenes of *Gladiator* and *Saving Private Ryan* – and is ideal for maintaining sharp footage when panning across a scene.

Getting the light right

Your first decision when setting up a shot is which lens to use and at what *f*/number. As you may not have much flexibility to change the shutter setting on your camera

DID YOU KNOW?

Correctly focusing your camera when shooting film is a very different process to focusing for stills photography. For example, sometimes the act of zooming in and out with a lens will cause the focus you have pre-set to change, so it's a good idea to use the digital controls to enlarge the shot and check that it's still fixed to your desired setting.

Auto-focus can be counterproductive as your subject may move and the camera may then refocus on a different subject or background object. Where possible, try to set this up manually for your shot. However, even under these conditions your subject may still move out of focus, so you may find it better to set up a more extensive depth of field for your shot.

to get the exposure absolutely right, you'll need to use other tools. Neutral density filters are your best choice for a shallow depth of field or if you're shooting in the midday sun, but adjusting the ISO will give you a lot more control. However, if you're using an ISO of 800 or higher you may notice grain on your footage – and film is a lot less forgiving in this area than stills photography. Given the lower resolution of film and due to the compression used by the camera, there is only so much you can do to repair footage at the edit stage.

Using zebra stripes

If you're shooting outside, the light conditions may change or you may pan to another position where the light is different. Some cameras come with the option to include zebra stripes on the display. These will show you which areas of your shot are over-exposed and provide real-time feedback when filming. If you can adjust the zebra stripes manually, set these to an IRE of somewhere between 70 and 90. Zebra stripes are particularly useful when filming people as you can ensure that skin tones are exposed properly. They are more accurate than histograms and the display on your camera, so do use them if they're available.

Sound levels are also constantly fluctuating, so if you have headphones and audio meters, always use them to monitor the audio quality.

Common issues

Modern dSLR cameras offer immense opportunities for shooting quality footage, but they still have a number of limitations that you should be aware of. This means that it pays to be very organized when it comes to shooting, particularly if you don't have a crew to help you. However, if you put enough time and thought into your shoot, there's no reason why you can't achieve good results. As a general tip, ensure that your firmware is updated regularly as this will help keep your camera performing at its best (see p.300). Although some of the issues dealt with here are specific to the new breed of dSLRs, many equally apply to digital video cameras as well.

FLUORESCENT LIGHTS

If you're shooting under fluorescent lights and don't have a professional lighting set-up, your footage may be marred by a banding effect pulsing across the image. This is especially problematic with fast shutter settings. To avoid this, aim to keep your shutter setting to 1/50sec or 1/60sec.

ZEBRA STRIPES

As with stills photography, knowing your camera and using the manual controls wherever possible will give you greater control over the quality of your footage. If available, always use on-screen zebra stripes to monitor the exposure, and audio meters to monitor the sound levels.

FOCUS

Maintaining focus can be difficult when your subject is moving around, so either set up your shot with an extensive depth of field or try to limit their movement. As the focus rings on dSLR lenses can be clunky, you'll need a specialist adaptor to follow the focus of your shot smoothly.

ISO AND GRAIN

Avoid using high ISO levels as you may get compression artefacts if you try to bring out the detail in post-processing. While you can tweak the colour and levels, remember that you have fewer options with footage than with high resolution photos or shooting in RAW.

DATA LIMITS

Shooting film on a dSLR will use a large amount of data, so make sure you have plenty of spare cards with you. Many dSLRs will only record a maximum of 4 GB of data before shutting off. This equates to approximately 10 minutes of footage at HD, so keep an eye on the time.

ROLLING SHUTTER

When panning quickly, or when something passes your camera at speed, you may see a "rolling shutter" or "jelly" effect where objects appear as if they've been pushed to one side. The best way to avoid this is to perform a slow pan, and then speed up the footage if required.

Lighting for video

You may have experimented with lighting set-ups when taking photos, but there are significant differences to take into consideration when you're shooting film. The most obvious of these is that you can't use flash guns, as you need a constant light source.

In some situations, such as when shooting outside, you won't be able to control the source of light very easily. However, you'll still need to be aware of any changes happening around you, as your footage will look odd if, for example, one shot is filmed in bright sunshine and the next when it's overcast. Shooting indoors brings its own problems, such as those associated with fluorescent lights (see p.303), so it's a good idea to set up your own lighting. Not only will this allow you to control your production environment, but it will also help you achieve the look you want.

Three-point lighting

The basic set-up when shooting film indoors is known as "three-point lighting". You don't need expensive lights as you can use a mixture of natural light (if there's a window), reflectors, and any lights that you might have at home or at work. The most important and powerful light source is

DID YOU KNOW?

Using a diffuser and gels will make a noticeable improvement to the look of your production, so keep these to hand. You should also have spare bulbs for your lights – 200 watt bulbs, which are inexpensive, will give you lots of lighting options. Other essential items to carry include crocodile clips, duct tape, and, if you can afford them, clamps. These are all extremely useful for holding diffusers, gels, and props in place.

known as the "key light" (you can use a window for this), which should be located to one side of the subject. A second light, known as the "fill light", is then set up on the other side. The fill light evens out the shadows – for this you can use a reflector instead if you prefer. Then, place a light behind your subject to create definition and separate him or her from the background. If you're using strong lights, you may want to use a diffuser to achieve a softer look. Use a blue gel to balance the colour of your artificial lights so that they match any natural light. Finally, remember to white balance your camera.

Budget lighting set-up
This is a very basic three-point set-up but it does the job well. The window provides the strongest light (the key light), while the reflector board bounces the light back across the subject (the fill light). A 50-watt desk light provides just enough power to backlight the subject, and produces a slight rim around his arm, shoulder, and head.

Recording sound

The importance of sound is easy to overlook until it ruins your production and you are left at the edit stage with few viable options. Recording good-quality sound is an art form in itself, but there are a number of simple and inexpensive techniques you can use to improve your sound quality.

The on-board microphones found on the majority of dSLRs are poor, and you should avoid relying on them if you can. If your budget will stretch, purchase a cardioid microphone, as this will pick up most of the sound from the direction in which it is pointed.

 If you have a friend to help out when shooting, ask him or her to monitor the sound quality (ideally using headphones and audio meters). Using a boom will get the microphone as close as possible to the action. You can make an improvised boom by attaching your microphone to a branch or pole. Remember to take great care when booming sound, as any finger movements or grip changes may be picked up by the microphone. Ideally the microphone should be held less than 1m (3ft) away from your subject and be directed towards his or her mouth.

Environmental conditions
The environment in which you're filming is just as important as the equipment you're using. When filming indoors, make sure that any air conditioning is turned off, the doors are closed, all mobile phones are switched off, and there are no obvious sounds in the background. When filming outside, and especially when it's windy, make sure you use a windshield and try to avoid uncontrollable situations. Simply turning your subject and microphone away from traffic or crowds will make a big difference.

Wild track
Once you've finished filming, record a minute's worth of sound separately without any dialogue. Even if you're in a quiet environment, there will be subtle sounds in the background you may not notice at the time but that are present nonetheless. This "wild track" will come in very useful during your edit when you need consistency of sound but where complete silence would be noticeably different to the recording of your subject.

Minimizing background noise
In this situation, there are a two ways you can limit the noise of the background traffic. Either point the microphone from a low position towards your subject's mouth, or use a boom to get the microphone as close as possible and then frame a tighter shot.

DID YOU KNOW?

If your dSLR doesn't have a microphone input, your ability to record good-quality audio will be limited. Whenever possible you should use an external audio device to record your sound. Even though the on-board sound on your camera may not be perfect, you'll still be able to use this soundtrack to synchronize your separate audio when editing. When recording sound separately, always synchronize the time and date on your camera and on your audio unit, and use a clapperboard (or clap your hands) just before filming to produce a spike in the sound for synching your audio and video files later.

Camera techniques

A solid understanding of when to use a particular shot is essential for making films. The good news is that you'll already have an intuitive feel for when something works – or doesn't – as the conventions are so fundamental that you'll have seen them many times before. However, as with many rules, they are there to be broken: as your understanding improves, so too will your desire to experiment with different set-ups. You may find it useful to storyboard your sequences first – even simple sketches will help you to clarify in your mind what it is that you're trying to say through your shot (see pp.316–17). You would also be well advised to shoot your scene using a few different set-ups so you have options when it comes to the edit.

GENERAL VIEW

The general view (GV), or establishing shot, is used to explain the location of your scene and place the action in context. The shot often shows the exterior of a location or wherever the main action is taking place. It's a good idea to include a new GV each time the location changes.

WIDE SHOT

The wide shot is a scene-setter that will provide your audience with a broader variety of information than the GV. In terms of framing the shot, the height should be roughly the same as your subjects when they stand up.

MEDIUM SHOT

The medium shot brings us closer into the world of your subjects and is widely used for dialogue scenes (generally shot from about waist- to head-height). When two subjects are shot together, as shown here, it's known as a "two-shot".

CLOSE-UP

The close-up really pulls us into the action and is often used to reveal the emotion that your subjects are experiencing as we become more absorbed in their world. Fast, or crash, zooming from a wide shot into a close-up is a great technique for building tension.

EXTREME CLOSE-UP

The extreme close-up shows a specific detail and provides your audience with further clues about the story. This might be a bead of sweat running down someone's face, or your subject nervously fiddling with a pen, indicating an anxious state of mind.

POINT OF VIEW

The point of view shot transports us into the world of your protagonist and allows us to see the scene around them through their own eyes. It's an excellent technique for putting the viewer right in the middle of the action.

Camera movement

Camera movement is all about revealing information that wasn't available to the viewer before. Imagine a young boy, looking upset, standing on a jetty looking out to sea: why is he sad? Has he missed the boat? Perhaps he has just lost his football and it's floating out to sea. Whatever the reason, moving your camera and changing the focus or focal length of your lens are important ways of dramatizing your event. You could pan around from a close-up of the child's eyes to a wide shot of the boat leaving, or pull focus from behind the boy to the ball in the water. Whatever your choice, camera movement will be essential to your production. Most of these techniques are easier to perform from a good tripod.

Panning and tilting
Panning is when you move the camera across a horizontal axis to show, for example, a 180-degree panorama. Tilting is when you move the camera on a vertical axis, such as from your subject's face to her hands. Used in conjunction, these are powerful tools to support your story.

Zooming
In principle, zooming when filming is the same as zooming in to take a photograph. However, achieving a smooth zoom on a dSLR can be difficult without the use of a specialist unit. You should also watch out for exposure changes when zooming as this can seriously impact on your shot.

Pulling focus
Another great technique for subtly revealing information is pulling focus. Simply ensure that your two subjects (or focal points) are reasonably far apart, and that you are relatively close to your nearest subject, then change focus between the two.

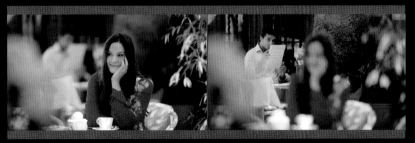

Shooting on the move
Sometimes you'll want to abandon the tripod and shoot on the move. The image on the right was shot from a moving car with the camera balanced on the window. The image on the far right shows a monopod with the leg contracted, offering stability while moving with the camera.

Downloading and importing

Getting organized and having a good workflow is even more important when making films than when shooting stills. There are more stages to consider and each element presents its own challenges. Until recently most cameras that shot film used tapes. One benefit of this system over the use of memory cards was that as long as you had the original tapes to hand, had exported your capture list to a log file, and had a back up of your edit file, you knew that little could go wrong if a hard-disk drive corrupted. Despite the benefits of shooting on memory cards, there's no failsafe, so you need to treat your data with respect. The workflow outlined below will not only help speed up the way you work, but will also ensure you're covered if things go wrong.

LOOK AFTER YOUR CARDS

1 Memory cards are robust but they can still malfunction. Often data can be recovered, but you can help prevent the need to do this by taking good care of them.

- Keep cards away from damp and dusty environments.
- When not in use, keep cards in their plastic cases.
- Number or name your cards so you know what data they contain.
- Be careful when pushing cards into cameras or readers as the pins can bend or snap off, which will make them unusable.

TRANSFER AS YOU GO

2 Unless you have the funds to buy a dozen high-capacity cards, you may find that you run out of data storage while shooting. This can cause problems as you may be forced to delete shots that you later depend on.

- An inelegant but useful solution is to transfer your data as you shoot.
- To do this you'll need a laptop and possibly an external hard-disk drive.
- This process will require good organizational skills but can often get you out of a tight spot.

MEMORY CARD READERS

3 You can generally take the data directly from your camera via cable if you need to, but you should consider investing in a card reader if you don't have one already.

- This will give you an alternative access point should anything happen to your camera's interface, and will give you increased flexibility if you are transferring as you go.
- With two memory cards and an external card reader you can free up your camera and continue to shoot while transferring the data from your other card.

FRAME RATES

7 As a general rule, you'll be shooting your footage at a rate of 25, 30, 50, or 60 frames per second (fps). For slow-motion footage, this will increase to 50–60 fps.

- Some cameras now film at 24 fps, giving your footage more of a "film look".
- Ensure your editing program is set to the same settings as the ones that you used on your camera, so that your footage plays at the right speed.

TIME CODES

8 Your editing program will record a time code onto every clip. This allows you to navigate easily across the footage.

- At any point on your clip you will see the exact point in time referenced like this: 00:10:23:04.
- Reading from left to right, each pair of digits refers to hours, minutes, seconds, and frames respectively.

IMPORT YOUR FOOTAGE

9 Now that you're set up correctly you can start to import your footage. At this stage it pays to be well organized – it could save you hours of work later on.

- Set up separate folders, or bins (so-called as this is how film stock is stored), within your editing file to keep similar footage together.
- You could categorize bins by person, location, or topic.
- Ensure that all your clips have copied across correctly.
- Check that each file plays properly before deleting data from your card.

Shooting HD footage on modern dSLR cameras uses up data incredibly quickly. For example, an 8 GB memory card can hold as little as 20 minutes of footage, or even less. At the very least you should have two 8 GB cards to hand so that you can switch between them when shooting. That way you'll always have one in reserve should the other malfunction. Most importantly, you should ensure that the write speed of your card is suitable for your camera. This varies with the model so you must check that your dSLR isn't processing more data than it can record onto the card (this is known as "buffer" problems). Equally, there's no reason to spend money on top-of-the range cards when lower speed and lesser-known brands may perform perfectly well for your needs.

BACK UP YOUR DATA

4 Your data is valuable and once it's gone, it's gone. Always make a full back up onto a different hard-disk drive as soon as you can.

- Small, portable drives are affordable and many don't require a power source, so you can use them on the move. However, the read and write speeds are often relatively slow, which may cause your editing software problems when editing larger projects.

SEQUENCE SETTINGS

5 The first decision you have to make when setting up a new editing project is which frame size to choose.

- You can work in either High Definition (720p or 1080p) or Standard Definition (576p).
- Your options may be limited, depending on the settings you chose on your camera or those available in your editing software.
- You may also decide to work in SD if your film is intended for the internet or a TV that isn't HD-ready.

SHOOTING HD, EDITING SD

6 Although the world is moving rapidly towards HD, there are some benefits to working in SD. Shooting in HD but editing in SD allows you the additional frame size to be able to use the same footage at different scales without losing any quality.

- To fit the full frame of your 1080p HD footage into a SD sequence, scale your clip to 55 per cent of its original size.
- This clip will now cut perfectly when played back to back with footage from the same sequence that is 100 per cent of its original size (see p.318).

INTERPRET YOUR FOOTAGE

10 Your editing program may offer you the facility to "interpret" your footage, which allows you to control how clips appear. You may never need to use this but it can be very useful if you're mixing footage with different frame rates, for example, if you have shot some clips at 50 or 60 fps. In this instance you can force them to play back at the normal speed of 25 or 30 fps, halving their playback speed and achieving great-looking slow-motion footage. This facility also allows you to scale images and footage from other sources to the display correctly.

ORGANIZE YOUR FOOTAGE

11 As well as putting your footage into separate bins, you may find that splitting them into separate timelines, or sequences, is a convenient way of keeping relevant material together.

- Rename individual clips with an appropriate title to make identification as easy as possible.
- If you have filmed any interview footage, split it up into individual sentences on your timeline.
- You can then rename each clip with a description of what's being said, which will speed up your edit.

PROXY FILES

12 The joys of shooting HD on a dSLR can be marred by the problems caused at the edit stage. Most computers just aren't fast enough to edit this type of footage without causing playback problems, making editing a frustrating process.

- To avoid this, render, or export, all of your clips to a lower resolution and data rate and substitute these clips into your sequence for editing.
- Replace the high-resolution clips back into your project before you export your final movie.

Video editing

It is said that you write one film, shoot a second, and edit a third. Each stage of the film-making process demands a different way of thinking, planning, and execution, but the edit stage is where all your hard work starts to pay off and your film begins to develop a personality of its own. Good editing is a skill that takes time to develop but if you have planned well up to now,

the process should be enjoyable and explorative. But be warned – good editing will go unnoticed, while bad editing will stick out like a sore thumb.

Be critical with every shot you select and ask yourself how it's supporting your story. Your audience will bore quickly, especially if the pace starts to drag. As a rule, keep your edit

TIMELINE

1 The user interface is similar across most of the major editing applications and incorporates a timeline to visually edit the clips. Generally, multiple clips of mixed content (including videos, images, illustrations, and audio files) can be dragged onto the timeline and stacked to create different effects.

- Your timeline can quickly become a mess, so keep similar types of media on the same layer.
- Clips can be dragged, moved around, and duplicated from layer to layer, and their start and end points trimmed, frame by frame, using the handles at their sides.

JUMP CUTS

2 A common mistake is to put two clips together that don't work. An example of this is the jump cut, in which the camera position or action has changed only slightly and the edit appears to jump (top and middle). Avoid this by using a cutaway in between (bottom).

FINE-TUNING

3 The real skill in editing lies in knowing exactly where to start and end a clip. This takes practice but will make your edit a lot more slick once you get the hang of it.

- In a documentary, don't leave too much time before your subjects start talking – you may want to start just two or three frames before the first sound is emitted.
- As a general rule, don't leave too much time before any action actually starts, as this will frustrate the viewer and add time to the final edit.

under five minutes if you're releasing it onto the internet. Although timing and pace are key considerations, don't be afraid to be experimental with your film-making. It's often the changes we notice that have the most impact, and breaking the rhythm is just as important as continuity. For example, cutting quickly between a few different shots then holding on a single shot of your subject can be very powerful.

DID YOU KNOW?

If you're keen to develop a better understanding of the psychology of editing, you must read Walter Murch's *In the Blink of an Eye*. Winner of an Oscar for the sound mix of *Apocalypse Now*, and nominated for the edit as well, there's no better reference available.

CUTAWAYS

4 The cutaway is your best friend when it comes to editing. It allows you to stitch together two clips (or parts of the same clip) without the edit being obvious. The key with cutaways is to cut to something relevant to maintain the flow of your story and to not distract your viewer.

TRANSITIONS

5 Transitions are the way in which you move from one clip to another. There will probably be a number of presets to choose from in your editing software, so test out different types. However, the most useful transition is the cross-dissolve – fading from one clip to another.

EFFECTS

6 Effects can make a huge difference to the feel of your production but they should always be used in moderation. Applying colour effects to footage can be especially impactful, helping to inject emotion into your story. For example, the only colour used at all in *Schindler's List* is of a little girl in a red dress, making that particular sequence especially resonant.

- A greyscale effect is commonly used to denote memory in film.
- A blue cast is often used to indicate cold or fear.
- A warm cast can be used to suggest anger or emotion.

Working with sound

When the sound design of a production is carried out properly it helps to highlight emotion, support the rhythm of the film, and accentuate the action. When the sound design is poor it can, at best, be off-putting; in the worst examples, it will confuse your viewer and render your production unwatchable.

As with editing, sound often only becomes noticeable when it's poorly produced or is incongruous to the footage. Good sound design should be subtle and should help reinforce every scene of your story.

Key elements

The sound in your production can be broken down into three main components: dialogue, music, and effects. Each element is important to the emotional impact of the moment, and their relationship to each other is absolutely crucial. You'll need to choose not only which sounds are appropriate for your scene, but also which element should take precedence at any given moment. Sound design is not just about laying down a track at a particular point. It's also about making sure that the volume levels are perfectly balanced, for example, to shock in the right places, nurture in others, and be solely ambient when necessary. As with the entire editing process, experimentation is key, so try out a few options and see what works.

Editing dialogue

If there's unwanted background noise in your production you may be able to improve the quality by using a bandpass filter in your editing package, although it's often impossible

> **DID YOU KNOW?**
>
> **Including music in your production** can be very expensive, even if you're just using production or stock music. The price is determined by the length of time for which you require the licence and the medium in which the music will be distributed, with commercial TV usage typically being at the top end of the price scale and internet usage at the bottom.
>
> The costs of stock music are minimal when compared to licences for popular music, such as chart tracks. Here, fees can run into tens, if not hundreds, of thousands of pounds per track. Luckily, if you're uploading videos to YouTube, you can avoid this expense, as YouTube has an agreement with many of the major labels allowing the use of their music.

to recover bad audio. If you have recorded your audio separately through a specialist unit you'll now need to synchronize it to the sound recorded through your camera. This involves simply matching up the spikes in the two audio tracks where you clapped before recording (see p.305).

Adding music

The choice of music for your production will have a big impact on the overall feel of the piece and you should make sure that the audio and visual elements work well together to achieve the right effect. Music also plays a pivotal role in marking the transition from one scene to another, or when you want to make your audience aware that something fundamental has changed in the story.

RECORDING FOLEY

Sometimes it isn't possible to record the sound effects you need for your film during shooting. You may be able to find what you're looking for online, but often you'll have to recreate the sounds yourself – a process known as "foley". Fred Ginsburg, a foley artist in Hollywood, suggests "walking" your fingers across a bowl of rice to create the sound of footsteps through a forest.

USING THE RIGHT MUSIC

Making a soundscape

Sound effects are the third element of your audio trinity and can help to create an immersive "soundscape", or acoustic environment, for your viewers. A good soundscape should be constructed from a number of different sounds. The most important factor is that it should feel natural and integrated into your production.

▼ THE BRIEF

▷ Imagine that you have recorded an interview in a park on a summer's day, but you didn't have an opportunity to record any wild track at the time. Create a 30-second soundscape for the piece and include suitable sounds, such as children playing in the distance, birdsong, and dogs barking.

▼ POINTS TO REMEMBER

▷ **If downloading sound effects from the internet,** make sure the quality is good enough for your production. Ideally, the sample rate should be 44.1 or 48 kHz and the bit rate should be 128 kilobits per second (kbps) or higher.

▷ **If you're recording your own sounds,** use a windshield when working outside, or at least block the wind with a piece of card or a jacket.

▷ **You can repeat sounds,** but try to vary the volume or change the balance from the left to right speakers to simulate objects, people, or animals moving past the microphone.

▷ **Remember that your sounds need to work together subtly** – the soundscape should enhance your production, not overwhelm it.

Your audience will undoubtedly have watched thousands of hours of film and television and will have an intrinsic understanding of the conventions of how music and the moving image should work together. Therefore, it's crucial that your choice of soundtrack complements the footage you've chosen and feels relevant to the emotion and pace of the scene. The three images above are all from separate projects and required very different styles of music, from classical through to high-tempo.

GO GOOGLE

☐ **Audio balance effect**
☐ **Budget sound design**
☐ **Filmsound**
☐ **Sound fx library**
☐ **Soundscape**

☐ **Super-cardioid**
☐ **Walter Murch**
☐ **Worldizing**
☐ **YouTube Universal agreement**

Making your first film

Now it's time to put your film-making skills into practice – this is the moment you've been waiting for! This is your chance to shine as Director or Director of Photography (and producer, runner, caterer, and driver, to name but a few of the roles you're likely to play). You may be brimming with ideas for your first film, but before you launch into shooting the next box office blockbuster, you need to be fully prepared.

Energy, creativity, and determination are the key factors underpinning every successful film. Your first piece doesn't have to be a labour of love, but it will require the right degree of planning and commitment.

The first, and often overlooked, task at hand is to ensure you have an interesting story that is worth pouring your heart and soul into. Many people don't spend enough time working through this crucial stage, but it's important to resist the temptation to start shooting immediately. Make sure that you've prepared as thoroughly as possible during pre-production (story writing and planning), as the production (filming) and post-production (editing and colouring) processes often take longer than anticipated. As a result, you will have little opportunity to resolve any underlying problems with the script once you start shooting. Even with the highest production standards in the world, if your story isn't engaging, no-one will want to watch it.

Interpreting a story

Don't worry if your idea doesn't feel original, it's your interpretation and presentation of the idea that counts. Robert McKee – an expert on screenwriting – summed up the essence of film-making when he said: "story is not what you have to say, but how you say it".

Most storylines are simple reinterpretations of well-trodden plots. For example, "the hero's journey" storyline involves the hero leaving home to head off into the unknown, often joined by a sidekick. Along the way the hero encounters a number of challenges, culminating in a major confrontation, before vanquishing his or her nemesis and returning home. This is the basic premise of, among many other films, *Star Wars* and *The Lord of the Rings*.

McKee describes the key point of any fiction as an "inciting incident" – a moment where the life of the lead character is thrown out of balance. It is the hero's desire to restore this balance that drives the narrative forward.

CROSSING THE LINE

Given that we're discussing story and dialogue it's useful to understand the 180-degree rule, also known as "crossing the line". You will have already encountered thousands of occurrences of this protocol and on a subconscious level you'll know instinctively how it works. If you imagine that there is a line connecting your two protagonists, you can film from one side or the other, but not from both sides in the same sequence. This convention is nearly never broken and it will just look odd if you ignore it.

In these examples, all the shots work together, except for the image on the top far right which has been shot from the wrong side of the line.

Pre-production planning

The day or days of your shoot are likely to be very busy and, as Director or Director of Photography, you'll be working flat out. Pre-production is incredibly important because it allows you to plan for all the things you'll need during production and resolve any issues before they happen. The last thing you need while shooting is to be "shut down" by the authorities for filming without a permit, or to find that your equipment doesn't work. It's certainly not the most interesting part of the project, but a little effort at this stage will save you some serious headaches later on. Think of your film as a meal you're cooking for a loved one – without good ingredients, it's a recipe for disaster.

LOCATION RESEARCH

Your chosen locations will have a big impact on the feel of your production. However, filming on location can be problematic. If you're filming outside or in public, check whether you need a permit, work out how to power your kit, and decide how to light the scene after dark.

PAPERWORK

Paperwork is perhaps one of the most tedious – yet crucial – parts of the job. You may need to arrange location permits, consent forms for anyone in shot, and, in some circumstances, insurance cover. Thoroughly research how to ensure that your production is legal and safe.

SCHEDULE

Allow plenty of time for your shoot and plan for every eventuality. For example, is your location accessible all day, or only at certain times? Are there set times when you have to get a particular shot, such as dawn or dusk? What contingency plans do you have if it rains or your shoot overruns?

CAST AND CREW

Filming on a shoestring is difficult so it's likely you'll be enlisting the help of friends and family – at least initially. Ensure that your cast know their lines and that your crew are familiar with their roles, what will be expected of them, and the equipment they'll be using on the day.

PROPS AND COSTUMES

There's no faster way to ruin a film than to feature, for example, a Roman gladiator wearing a wristwatch or a pair of trainers. While they don't have to be expensive, props and costumes can make a big difference to your production, so allocate enough budget for key items.

EQUIPMENT

Check every piece of equipment the day before your shoot. Make sure that batteries are fully charged, memory cards are cleared, and all cables and accessories are in good condition. Write a full inventory of your kit and check each item off the list.

The day of the shoot

At last the day has arrived. You've organized your cast and crew, all the equipment has been checked, the birds are singing, and the sun is shining. Hopefully you're feeling prepared for the shoot and are eager to start. Remember, this is your day and everyone else will be taking their lead from you. Try to stay calm, even if you feel as though you don't know what you're doing and your heart and stomach are both in your mouth. Remember, every great director was once in your shoes.

Pre-shoot checklist

Before you shout "Action!" or start your interview, here are a few questions you should ask yourself:

- Is the deckplate securely attached to the base of your camera?
- Is the deckplate locked into the head of the tripod and is the head tight so it won't wobble around?
- Are the legs of the tripod locked and the bolts tightened so the tripod doesn't collapse?
- Check the spirit level (if you have one) on your tripod. Is the tripod perfectly level?
- Are your batteries fully charged, your memory cards clear, and spare batteries and cards to hand?
- Is the lens clean?

- Have you checked the white balance of your camera using a piece of white card?
- Have you made sure that you're shooting at the frame size and frame rate that you want?
- Are you focused correctly? Don't zoom in to check the focus, use the digital controls.
- Have you checked for background noise and made sure that all air-conditioning units and mobile phones are switched off? If you're shooting in a shared space it's a good idea to put up notices informing people that you're filming.
- Have you checked the audio levels? Make sure you're wearing a pair of headphones.

During the shoot

Once you've run through these final checks and your cast and crew are all in position, it's time to press record on the camera and, if you're using one, the audio recorder. Wait for three seconds and then shout "Action!"

During the shoot, never be afraid to ask actors, crew, technicians, and anyone else around you for their opinions. At the same time, be strong enough to stick to the decisions you make. You should have no qualms about reshooting scenes if you're not happy with them, or asking for changes to the set or lights. If mistakes do occur – and they probably

DRAWING A STORYBOARD

The primary purpose of a storyboard is to provide a reference point when you're deciding on your choice of shots and, subsequently, as a checklist when you're shooting. Don't worry if you're not an accomplished artist, as storyboards are purely functional (although some can be quite beautiful – the director Akira Kurosawa is renowned for the detail he includes in his storyboards).

If you want to see how your shots will work together, and to check if the pace of your film is right, you can scan your storyboard and create a rough edit using the individual images. This is known as an "animatic".

will – just acknowledge them and move on. For example, if the camera runs out of battery or the microphone isn't switched on, apologise to your interviewee or cast and ask them to do it again. Everyone wants the best result possible and it's much better to deal with a situation when it happens than to think that you can live without a shot or that you can improve poor sound in post-production.

If you're shooting on your own, you'll have to monitor the sound, focus, and light, as well as listen to and direct your cast or interviewee. Keep an eye on how many minutes you've filmed, as many cameras will automatically shut off after around 10 minutes.

Be creative

Perhaps the most important thing to remember during your shoot is to enjoy the experience and give yourself the opportunity to explore your creativity. Use your storyboards as a guide but feel free to try out some more experimental options. Try changing the camera angles, framing, and lenses, and make sure you've got each scene covered from a couple of different positions.

Once your scene or interview has finished, leave a few seconds of silence at the end before you stop recording. If you're using an audio recorder, turn it off. That's a wrap! You're now ready to move onto the final stage of your production.

DID YOU KNOW?

There are a few trusted techniques for a successful interview. Your first decision regards who to interview. This is not simply a case of who is best equipped to help you tell your story, but who will communicate well on camera. Even top CEOs have been known to "clam up" when interviewed, so it's advisable to do a dry run with them first, or determine if they have any reservations about the shoot. Try to make your subject feel at ease – if they are nervous, try interviewing them in their home or talk through the questions informally beforehand.

Familiarize yourself with the subject you'll be discussing so you can ask pertinent questions, but don't interrupt your interviewee – ask them when they've finished talking. Avoid making any encouraging noises (such as "okay" or "hmm") when your interviewee is answering, as this will cause you major problems during the edit. You may also find that your subject loosens up and becomes more confident over time. You could ask them to answer the first few questions again at the end.

It's also important to ask your subject to include your question as part of their answer. For example, they could begin their response by repeating your words back to you: "My favourite place to stay in France is … " This way you can remove your question in the edit and your subject's answer will still make sense.

The top image shows HD footage being used in a SD sequence – the footage is scaled at 100 per cent, so much of it is not displayed. The bottom image shows the footage scaled at 55 per cent – the two shots cut together perfectly.

Grading: before and after

The left-hand side of this image shows the original footage shot without any colour enhancement applied through the camera. The right-hand side has been graded using Red Giant's Magic Bullet software.

The edit

So you've finished shooting, your footage is "in the can", and all that stands between you and the finish line is the edit. Unless you're working to a deadline, the pressure is now off and you can take things at a more leisurely pace. However, there's still a lot of creative work to be done.

If you storyboarded your film then you have a great starting point for your edit. While you probably didn't shoot exactly as you'd planned, with luck you'll have enough options to play around with. The edit is where your story really comes alive and where you can breathe life into your film. More importantly, it's where you can experiment with your story to see what does and doesn't work.

Linear and non-linear narrative

One option you might consider at the edit stage is to change the timing of events by portraying them out of chronological order. This is a compelling editing technique that has been used to great effect in films such as *Memento* and *Pulp Fiction*. Of course, your film may simply stop making sense if you do this, and you will be limited by your storyline, but now is the time to have some fun with the sequencing.

This also holds true for documentary storytelling, as few people will be interested in a straight chronology of your subject's life – the most interesting events may well have happened to them later on in life, by which point in the film your viewers have stopped watching. It's better to start with an event or incident that affected your subject deeply and that will make him or her of immediate interest. Once your audience is hooked you can build up the rest of your protagonist's life story.

Ending your film

Your storyline and dialogue will broadly dictate the footage you use to end your film, although there are still several options open to you. As the last passage of your film will have a huge impact on your audience you should choose your shots carefully. For example, do you end on the shot of the girl looking wistfully into the distance as the train pulls away? Or do you choose the shot of the dejected-looking young man sitting in the carriage seat? Each editing decision affects the emotional impact of your scene, never more so than at the end of the film.

Ending a documentary can be just as tricky as starting one. If you've been following a particular subject it may be that your film has been leading up to a particular event, which means you have a natural device for concluding your story. If not, try to find some dialogue that summarizes the position of your protagonist and leaves your viewer feeling educated about, or moved by, him or her.

However you start or finish your film, the tempo running through it is very important. And if you're putting your film online you should keep it under five minutes long, or else your audience may lose interest or avoid watching it altogether.

Grading and titles

The term used for any final colour changes made to your film once the edit is finished is "grading". This is where you can really enhance the look of your footage; just be careful not to go overboard. Most editing packages come with a basic tool set for re-colouring, but you may find that extensive corrections compromise the technical quality of your film.

Titles are a great way of acknowledging everyone who helped you get this far and, in themselves, can contribute to the overall feel of your production. For inspiration, look at some of the work from legendary designers Saul Bass (*Casino*, *Goodfellas*) or Kyle Cooper (*Se7en*, *Twister*).

Export and deployment

Congratulations, your film is finished! But what now? Many editing packages have a direct export option to Vimeo or YouTube, which removes the need to deal with video formats. Don't worry if your software doesn't have this option – just make sure that you export your film in a high enough quality to be watchable online. Check the settings in the export box and make sure that the frame rate and frame size are the same as when you created the sequence, that your audio data rate is set to a minimum of 84 kbps, and that your video data rate is set to a minimum of 800 kbps. Most of the main formats are supported by Vimeo and YouTube, but if you're in doubt, export your film to a Quicktime (MOV) or Windows Media (WMV) file.

Next steps

If you've caught the film bug and want to learn more, watch as many films as you can and listen to the directors' commentaries. Analyse each film from the standpoint of story, camera movement, sound design, and editing, and ask yourself why the director has made each decision.

Two-minute short film

There's no time like the present to throw yourself in the deep end. Sharpen your pencil and boot up your computer, because it's time to bring everything you've learned together to create your first "short". Take time to plan what to do at each stage and you'll find there are no nasty surprises waiting for you – well, not too many, anyway.

▼ THE BRIEF

▷ Create a two-minute short film with the title "A New Dawn". Your film can be executed in any way you want – as fiction, documentary, or even stop motion – as long as it stays on brief.

▼ POINTS TO REMEMBER

▷ **Don't bite off more than you can chew –** this isn't a feature film, so make sure you have enough budget and time to achieve what you want. It's better to execute a simple idea well than make a hash of something complicated.

▷ **Get your story right** before you start. There's no such thing as over-planning in the early stages, especially when refining your script. Find enough space from the project to stay objective and ask your friends to read and comment on early drafts.

▷ **It's a short format,** so if you're making a documentary you may have to stick to just one interviewee.

▷ **If other people are helping you** (actors, crew, or interviewees), make sure there is food and drink available while they're working and that they're reimbursed for any expenses.

GO GOOGLE

☐ **Short films**	☐ **Guerilla film-making**
☐ **Future shorts**	☐ **Robert McKee**
☐ **Rottentomatoes**	☐ **Shootingpeople**
☐ **IMDb**	☐ **YouTube**
☐ **Budget film-making**	☐ **Vimeo**

EQUIPMENT AND RESOURCES

Selecting a digital camera

KEY CONSIDERATIONS

You may think you have a good idea about what sort of camera would suit you best, but try to keep an open mind while you're in the process of choosing, and consider the following points:

Subjects
Perhaps the main thing to consider is what kind of photos you're likely to take. For example, if you're going to use the camera mainly for photographing friends and family and taking holiday snapshots, size and ease of use are more important than the highest picture quality or creative options.

Size
The greatest physical distinction between compacts and dSLRs is size. The latter's bulk and weight will be the price you pay for the highest picture quality and better creative flexibility. However, it's worth considering that having a smaller camera might mean that you take it out with you more than you would a larger camera.

Picture quality
Although megapixels are a key selling point in digital cameras, these days even the cheapest cameras have enough to produce excellent prints as large as A3. Also, you shouldn't think that more megapixels means better photos, as lens quality and image sensor size play just as important a role.

Ease of use
Although most dSLRs have automatic modes, and some have mode settings for different subjects, they can't compete with compact cameras on ease of use. As well as the fully automatic, switch-on-and-shoot modes, many compacts offer automatic image-enhancing features.

Control for creativity
While some of the high-end compacts have manual control settings, dSLRs offer by far the greatest versatility. With interchangeable lenses, fully manual controls, and advanced shooting features, a dSLR is the obvious choice for the enthusiast and the professional.

Although your budget will always be an important factor when choosing a digital camera, the current range of cameras, boasting sophisticated technology and features at every level, means that, whatever your requirements, the ideal camera is well within your grasp.

However, having an almost limitless choice doesn't make selecting a camera any easier. While knowledgeable recommendations and the advice of experts is invaluable, there are a few key considerations that will improve the process (see panel, left). Taking each of these into account should also help you choose between a compact digital camera and a dSLR.

Compact digital cameras

With picture quality in some cases rivalling that of dSLRs, the latest compact digital cameras offer excellent value for money. Virtually all offer zoom lenses, some with very wide ranges, to vary image magnification. Unlike most dSLRs, compacts feature an LCD screen that can be used to frame shots as well as review images. They also have a range of automatic modes and features that, along with their size, makes them a very attractive option.

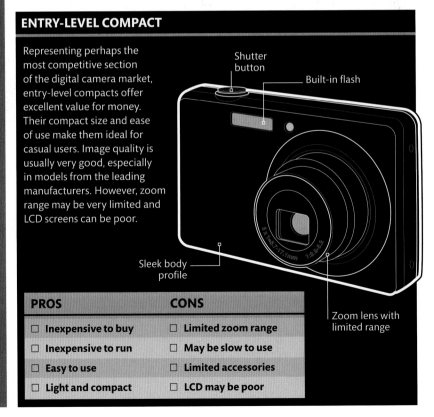

ENTRY-LEVEL COMPACT

Representing perhaps the most competitive section of the digital camera market, entry-level compacts offer excellent value for money. Their compact size and ease of use make them ideal for casual users. Image quality is usually very good, especially in models from the leading manufacturers. However, zoom range may be very limited and LCD screens can be poor.

Shutter button

Built-in flash

Sleek body profile

Zoom lens with limited range

PROS	CONS
☐ **Inexpensive to buy**	☐ **Limited zoom range**
☐ **Inexpensive to run**	☐ **May be slow to use**
☐ **Easy to use**	☐ **Limited accessories**
☐ **Light and compact**	☐ **LCD may be poor**

ENTHUSIAST COMPACT

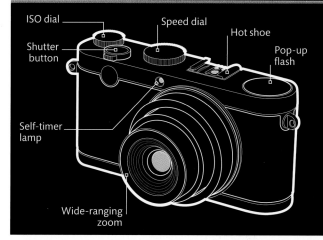

ISO dial

Speed dial

Hot shoe

Shutter button

Pop-up flash

Self-timer lamp

Wide-ranging zoom

Aimed at the keen photographer who doesn't want a bulky dSLR, enthusiast compacts offer high performance and versatility in a top-quality package. Some are fixed focal-length, but where zoom is available, it often has wide focal ranges. Most importantly, they offer the user complete manual control over exposure and focus.

PROS	CONS
☐ Excellent build quality	☐ Can be expensive
☐ Superb image quality	☐ May be tricky to use
☐ Wide zoom range	☐ Lens fixed
☐ Allows manual control	☐ Can be heavy

INTERCHANGEABLE LENS COMPACT

Also known as "compact system" cameras", these counteract the limitations of the built-in zoom by allowing you to switch lenses. Interchangeable lens compacts also offer dSLR picture quality, fast shooting speeds, and full manual control for greater creativity.

PROS	CONS
☐ Compact and light	☐ Costly to buy
☐ Lens flexibility	☐ May be hard to use
☐ Allows manual control	☐ May feel unbalanced
☐ Good image quality	

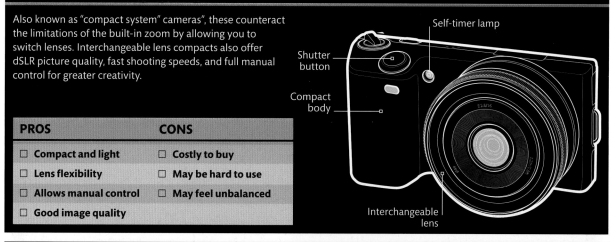

Self-timer lamp

Shutter button

Compact body

Interchangeable lens

HYBRID ZOOM

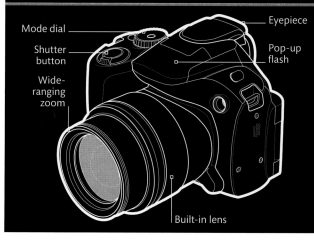

Mode dial

Shutter button

Wide-ranging zoom

Eyepiece

Pop-up flash

Built-in lens

Hybrid cameras are also known as "bridge" and "prosumer" cameras. They fill the gap between consumer and professional models by producing good images without the size and weight of dSLRs. They also lack the build quality of dSLRs and the facility to change lenses.

PROS	CONS
☐ Good image quality	☐ Lacks dSLR build quality
☐ Wide zoom range	☐ Lens fixed
☐ Accepts flash units	☐ Bulkier than compacts
☐ Rapid performance	

dSLRs (digital single-lens reflex cameras)

The choice of most enthusiasts and professional photographers, the dSLR offers the best in control, versatility, and image quality. The ability to interchange lenses and use any combination of accessories is matched by the complete control over exposure, depth of field, and focus that a dSLR provides. Unlike compact digital cameras, most dSLRs rely on the use of a viewfinder, which gives a more accurate preview of both framing and depth of field. dSLRs range from inexpensive entry-level models to those clearly aimed at professionals.

What is a dSLR?

Just as in a non-digital SLR, a dSLR uses a mirror system and prism to direct light from the lens to an optical viewfinder at the back of the camera. Before exposure the mirror moves upwards, and then the shutter opens, allowing the lens to focus light onto the image sensor. A second shutter then covers the sensor, ending the exposure.

Prism

Lens

Viewfinder

Mirror

Image sensor

The introduction of high-definition

movie modes into some dSLRs has given them an extra creative dimension. In fact, the quality of movies shot using HDSLRs surpasses those shot on amateur camcorders, so they offer a great way to combine two devices. The first dSLRs to offer HD recording were high-specification models, but HD is now a feature of many entry-level cameras. The fact that HDSLRs have interchangable lenses has made them a very attractive option for filmmakers. Below is a comparison of HD formats.

1920 pixels

1280 pixels

640 pixels

480 lines

720 lines

1080 lines

SD-480p

HD-720p

FULL HD-1080p

FOUR THIRDS dSLR

Four Thirds refers to the 4:3 aspect ratio of the sensor in these cameras, which makes it different to those in most other dSLRs. Although Four Thirds cameras are produced by just a handful of manufacturers, they are usually very well specified, even at the entry level, and packed with features.

PROS	CONS
☐ **Relatively compact**	☐ **Slower auto-focusing**
☐ **Good image quality**	☐ **Viewfinders often small**
☐ **Very well specified**	
☐ **Lots of features**	

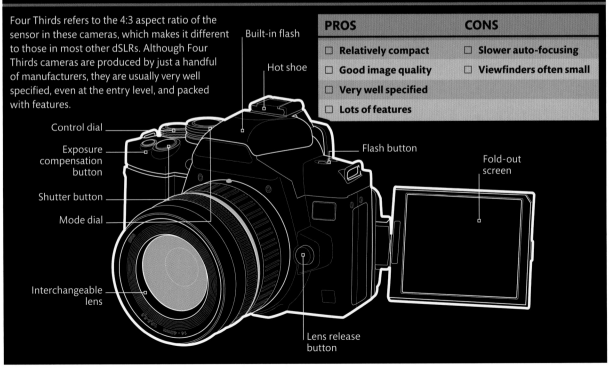

Built-in flash

Hot shoe

Control dial

Exposure compensation button

Shutter button

Mode dial

Interchangeable lens

Flash button

Fold-out screen

Lens release button

ENTRY-LEVEL dSLR

Even the most affordable dSLRs now boast image sensors of at least 10 megapixels. This means that any model is now able to produce high-quality pictures. Entry-level dSLRs lack the build quality of professional models, but they are lighter and more compact, and often offer extra features, such as a live view LCD screen that you can use to frame shots.

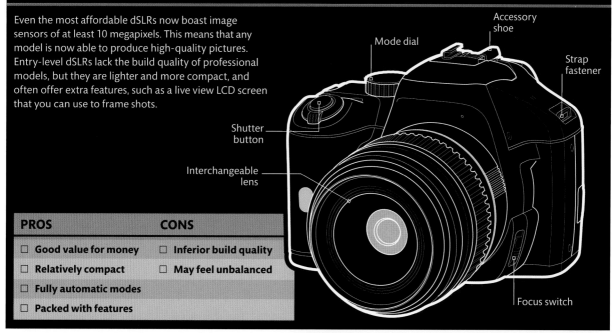

Mode dial

Accessory shoe

Strap fastener

Shutter button

Interchangeable lens

Focus switch

PROS	CONS
☐ **Good value for money**	☐ **Inferior build quality**
☐ **Relatively compact**	☐ **May feel unbalanced**
☐ **Fully automatic modes**	
☐ **Packed with features**	

PROSUMER AND PROFESSIONAL dSLR

At the top of the range, prosumer and professional dSLRs offer the very best in build quality and performance. The larger cameras in this category, aimed at professional photographers, are built for rigorous work in difficult environments, and respond very quickly with rapid motordrives and auto-focusing.

While most dSLRs have image sensors that are smaller than the 35mm film format (APS), some professional dSLRs have full-frame (35mm) sensors. This produces very high-quality images.

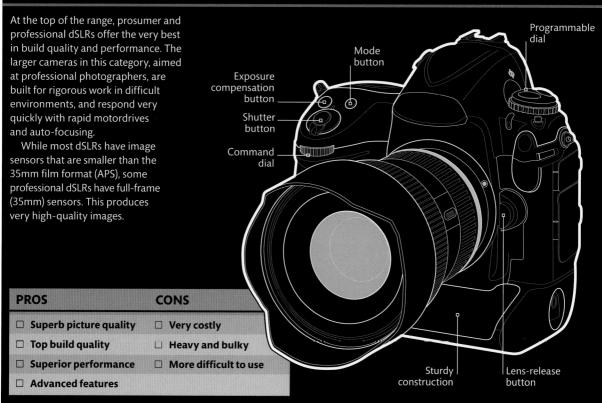

Programmable dial

Mode button

Exposure compensation button

Shutter button

Command dial

Sturdy construction

Lens-release button

PROS	CONS
☐ **Superb picture quality**	☐ **Very costly**
☐ **Top build quality**	☐ **Heavy and bulky**
☐ **Superior performance**	☐ **More difficult to use**
☐ **Advanced features**	

Choosing the right lens

DID YOU KNOW?

The term "fast glass" refers to lenses with large maximum apertures that allow you to use shorter exposures. Lens speed is important for maintaining image quality in low-light conditions, and also in controlling depth of field. You can compare lens speeds by looking at the maximum f/numbers for lenses of similar focal length.

As in the human eye, in most lenses aperture size is controlled by an iris diaphram. This is made out of a series of two or more blades. The number and shape of the blades determines the shape of the aperture, which affects the quality of the out-of-focus areas in a photo, called "bokeh". A rounder aperture produces softer and better blur.

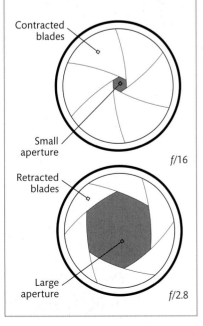

Contracted blades

Small aperture

f/16

Retracted blades

Large aperture

f/2.8

The latest generation of camera lenses boasts advanced technology and excellent performance, even at the lower price points. However, a basic lens with more solid construction and higher-quality optics will always outperform lightweight lenses with more ambitious specifications.

When buying a lens for your dSLR, the key consideration will be its focal length. This determines its field of view. A long focal length magnifies a small section of the subject; a short focal length produces a wider but reduced view. Another consideration is the speed of the lens, measured by its maximum aperture. The larger the aperture, the more light the lens collects, allowing for shorter exposures or better-quality sensitivity (ISO) settings. Almost any combination of focal length and speed is available (see opposite).

LENS DESIGN

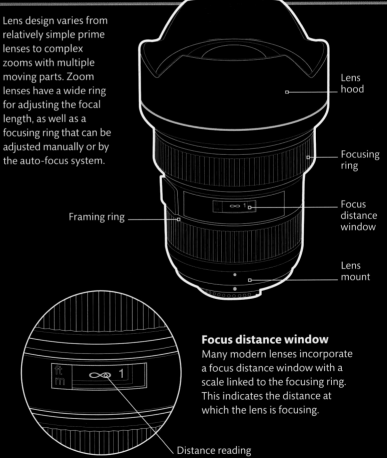

Lens design varies from relatively simple prime lenses to complex zooms with multiple moving parts. Zoom lenses have a wide ring for adjusting the focal length, as well as a focusing ring that can be adjusted manually or by the auto-focus system.

Lens hood

Focusing ring

Focus distance window

Lens mount

Framing ring

Focus distance window
Many modern lenses incorporate a focus distance window with a scale linked to the focusing ring. This indicates the distance at which the lens is focusing.

Distance reading

Lens types

There are two main types of camera lens: zoom lenses and prime lenses. Zooms are by far the most popular type of lens, as their focal length can be varied – producing different angles of view – while remaining focused on the subject. This versatility makes zooms a convenient and cost-effective option as one lens can cover a wide range of focal lengths.

Prime lenses have a fixed focal length, which means that the only way of changing the angle of view is to move towards or away from the subject. Although less versatile than zooms, prime lenses are usually lighter, much faster, and of superior optical quality. Also available is a range of specialist camera lenses that are made for extreme types of photography.

STANDARD ZOOM LENS

Commonly sold as "kit" lenses with dSLRs, standard zooms typically cover a range between wide-angle and medium telephoto – for example, 35–135mm. This makes them suitable for shooting a wide variety of subjects. Their versatility is usually matched by a compact design that makes them good walkabout lenses.

WIDE ZOOM LENS

Wide-angle zooms provide a range of focal lengths that are considerably shorter than standard zooms – for example, 12–24mm. This makes them a versatile option for shooting subjects such as landscapes and architecture, for which a wide angle of view is preferable. They can be quite bulky because of their complicated construction.

LONG ZOOM LENS

Zoom lenses that cover a range of long focal lengths are particularly useful for capturing moving subjects positioned at some distance, such as birds and other wildlife. Long zoom lenses are commonly known by the ratio of their longest to shortest focal lengths; for example an 80–320mm lens is known as a "4x" zoom.

WIDE PRIME LENS

Although wide-angle prime lenses lack the versatility of their zoom equivalents, they will usually make up for this in their compact size and the very high quality of the pictures they produce. Wide-angle prime lenses are usually modest in specification, and, in most cases, much faster than wide zooms.

LONG PRIME LENS

Long prime lenses – 300–600mm – are used extensively by professional sports and wildlife photographers who demand the very best in performance and image quality. They also need to make them pay as they are very costly. At the higher focal lengths, these lenses are extremely bulky and heavy, and require a very good tripod support.

SPECIALIST LENS

The range of specialist lenses include ultra-wide-angle lenses that dramatically expand the field of view, very long telephoto lenses to capture subjects at long distances, macro lenses for shooting small objects at close range (see pp.54–55), and fish-eye lenses for barrel distortion. Tilt-shift lenses enable you to control the plane of best focus by tilting the lens forward or back.

Lens range and sensor size

Most dSLRs accept lenses made for 35mm film cameras. However, because most dSLRs have sensors that are smaller than 35mm, the field of view is reduced and the focal length of the lens is effectively increased. On APS format cameras this is by a factor of about 1.5x, and on Four Thirds cameras, about 2x. This table shows the different focal lengths that are needed to produce roughly equivalent fields of view.

TYPE OF LENS	SENSOR SIZE		
	35mm	APS-C	Four Thirds
Ultra-wide-angle	12mm	8mm	6mm
Wide-angle	35mm	24mm	18mm
Standard	50mm	30mm	25mm
Telephoto	70mm	50mm	40mm

Accessories

A limited number of well-chosen camera accessories will help you to get the most out of your digital photography. The choice is vast, so identifying which items will best suit your needs and interests is key.

Camera accessories range from the essential, practical items such as bags and cases, to optional, creative items such as coloured filters. Although it's tempting to expand and personalize your photographic kit with numerous accessories, having too many can slow you down and get in the way of your photography.

LENS ACCESSORIES

The focal lengths and zoom ranges of both permanently attached and interchangeable lenses can be altered using accessories that fit on the front or rear of the lens.

Lens glass

Lens mount

No optical element

Lens mount

Lens mount attaches to camera

Extension tube
Rear mounted extension tubes increase the focusing extension of an interchangable lens, which enables it to focus on very close subjects.

Converter lens
For cameras with built-in lenses, a converter lens can be used to change the focal length. This attaches to the front of the fixed lens, often via an adaptor.

Teleconverter
A teleconverter is a secondary lens that can be used to multiply the focal length of an interchangeable lens. It's mounted between the camera and the lens.

LENS FILTERS

Filters give you extra control over the light entering your camera lens. Some, such as graduated filters, can be used to produce special effects, while others produce more subtle changes. One of the most useful accessories is a polarizing filter, which reduces glare and darkens skies.

Threaded or mounted
Lens filters can be rectangular and mounted on an adaptor sitting on the front of the lens, or, more commonly, a circular disk that screws to the front of the lens.

Adaptor on front of lens

Threaded edge

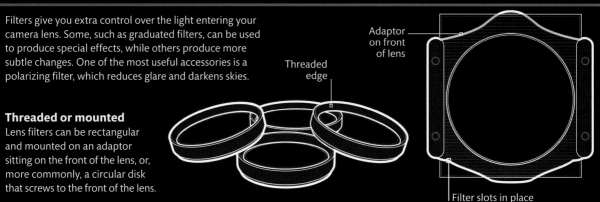

Filter slots in place

CAMERA SUPPORTS

Often overloooked or under-appreciated by the amateur photographer, the tripod is the accessory that can make the largest difference to the quality of your photos. A tripod head attaches the camera to the tripod and enables you to direct it. Specialist supports come in various shapes and sizes.

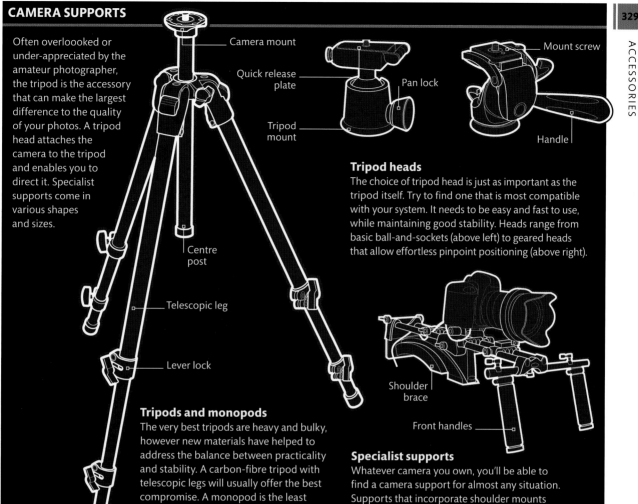

Camera mount

Quick release plate

Tripod mount

Centre post

Telescopic leg

Lever lock

Mount screw

Pan lock

Handle

Tripod heads

The choice of tripod head is just as important as the tripod itself. Try to find one that is most compatible with your system. It needs to be easy and fast to use, while maintaining good stability. Heads range from basic ball-and-sockets (above left) to geared heads that allow effortless pinpoint positioning (above right).

Shoulder brace

Front handles

Tripods and monopods

The very best tripods are heavy and bulky, however new materials have helped to address the balance between practicality and stability. A carbon-fibre tripod with telescopic legs will usually offer the best compromise. A monopod is the least stable solution, but the most practical when a speedy set-up is of the essence.

Specialist supports

Whatever camera you own, you'll be able to find a camera support for almost any situation. Supports that incorporate shoulder mounts and handles are particularly useful for shooting video, and in situations where you're on the move.

BAGS AND CASES

Camera bags and cases range from simple, soft pockets for compact cameras to rigid shock-proof cases that can transport a complete dSLR system. Whatever type of camera you have, your bag should be water-resistant and padded, to protect it from day-to-day accidents and knocks. Backpack designs feature internal padded dividing systems that can accommodate a camera, lenses, and accessories, and some even have tripod compartments.

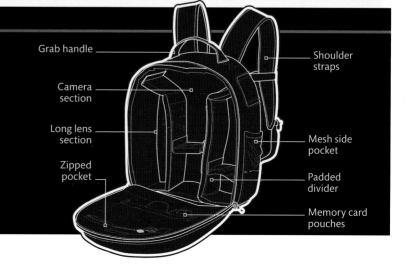

Grab handle

Camera section

Long lens section

Zipped pocket

Shoulder straps

Mesh side pocket

Padded divider

Memory card pouches

Flash lighting and accessories

Although the effects of natural sunlight can rarely be improved upon, there will be occasions when your photography needs the help of accessory lighting. In most cases this will come via an in-built or on-camera flash unit.

Most digital cameras, especially compacts, come with a built-in or integrated flash. While these are very convenient and usually adequate for day-to-day use, most are quite limited. Some on-camera flash units, mounted on a hot-shoe bracket, may have tilt-and-swivel heads, which enable you to "bounce" light and soften its effects.

Off-camera flash units attach to a camera through its flash-synchronization socket. Multiple remote flash units can be triggered by slave units that are equipped with sensors to detect when the master flash has been fired. Adding a slave unit to your system is not expensive, and as you progress you can add accessories such as softboxes, reflectors, and specialist flash units, which can be used to create different visual effects.

The guide number of a flash unit is an indication of its power and range. The higher the guide number, the more powerful and effective the flash will be. A flash's guide number allows you to adjust the aperture setting on your camera for correct exposure (if you're using the manual mode). The required *f*/number can be calculated by dividing the guide number (usually given in metres or feet) by the distance between the flash and the subject. For example, using a flash with a guide number of 40m (120ft) on a subject 10m (30ft) away requires an aperture of *f*/4 at the setting ISO 100.

Slave flash
A slave flash works in conjunction with a built-in camera flash, to fire a separate flash unit that's not attached to the hot shoe.

ON-CAMERA FLASH GUNS

On-camera flash guns offer an effective lighting option, and, at the top end, a definite improvement on built-in flash units. While advanced units offer directional flash and control of light intensity, using a mini softbox or diffuser can help to soften the effect. When choosing a flashgun, it's usually best to follow your camera manufacturer's recommendations.

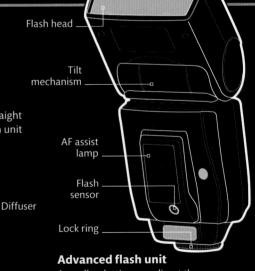

Flash head

Tilt mechanism

AF assist lamp

Flash sensor

Lock ring

Advanced flash unit
As well as letting you direct the flash using a swivelling turret, many advanced flash units enable you to adjust the coverage, or the angle over which the light is spread.

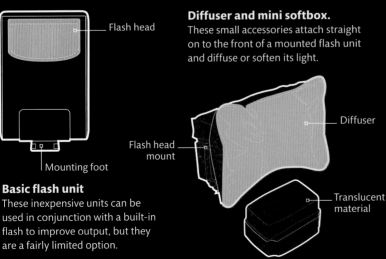

Flash head

Mounting foot

Basic flash unit
These inexpensive units can be used in conjunction with a built-in flash to improve output, but they are a fairly limited option.

Diffuser and mini softbox.
These small accessories attach straight on to the front of a mounted flash unit and diffuse or soften its light.

Diffuser

Flash head mount

Translucent material

STUDIO FLASH AND EQUIPMENT

Placing your subject in a studio gives you complete control over lighting and exposure. The standard studio set-up consists of at least two units angled at the subject, and possibly one lighting the background. The least expensive option, monoblocs (below), combine the lamp, switches, and power supply all in one unit.

Reflectors

Softbox

Lighting brolly

Unit contains battery

Light-stand connector

Reflector

Reflectors, brollies, and softboxes

Reflectors come in a large range of sizes, colours, and textures, each with its own effect; through reflecting light they can also change its tone. Softboxes create a large light source, producing a correspondingly soft light, with low contrast and diffused shadows.

SPECIALIST FLASH SOLUTIONS

Some portable flash units are designed for specialist uses, such as macro photography. For tiny subjects, a close-up flash, such as a ring flash or an adjustable macro flash, is the only way to freeze inadvertent movements while letting you set the aperture to the widest depth of field.

Adjustable macro flash

The most flexible solution for close-up flash photography, two or more small flash units can be fixed around the lens and set to different positions.

Twin flash

Shoe-mount unit

Circular flash lamp

Swivel attachment

Ring adaptor

Mini flash unit

Ring flash

Ideal for taking shadowless shots of small subjects, such as flowers and insects.

Computer hardware

Whether you have a Mac or a PC, a laptop or a desktop, your computer will be the hub of your digital photography. In fact you'll probably spend more time reviewing and managing your photos on your computer than you'll spend capturing them with your camera.

As your digital photography expertise increases and the number of images you produce grows, you may want to invest in hardware and accessories that will make storing, reviewing, and managing your photos easier and more efficient. The workroom of the serious digital photographer might contain up to a dozen devices, each with an individual role, but collectively working towards optimizing workflow. You can achieve better results by knowing what computer hardware and peripherals are available, and understanding how they can improve your workflow. For example, a memory card reader is a time-saving option for downloading images, while graphics tablets are favoured by many photographers for manipulating images, as they offer a high level of precision and control.

Electromagnetic and pressure-sensitive surface

Stylus

Graphics tablet
Used to replace the mouse as the navigation device on desktop computers, graphics tablets can make working with images much easier and more precise due to the pressure sensitivity of the stylus.

PHOTO STORAGE

As the vast volumes of data that your digital photographs represent fill up the hard-disk drive of your computer, you'll need to seek an external storage solution. While most external hard-disk drives require the use of a computer, some are designed with their own memory card reader and screen that allows you to review and show your photos.

Desktop drives
These are the maximum volume storage option for your photographs. As well as being very fast in use, they offer huge capacities, with some models ranging into multiple terabytes (TB) – 1 TB is 1,000 GB, or 1 million MB.

Power light

Protective casing

Portable drive
Portable hard-disk drives are becoming ever more compact while offering huge capacity. This makes them ideal for backing up your photos. Most devices can be powered from a laptop via its USB or FireWire port, making them a good option for working on location.

Memory cards are also used in mobile phones, MP3 players, and laptop computers. They are re-recordable, can retain data without power, and with their ever-increasing capacity this makes them ideal for storing digital images. Their contents are accessed either while the card is still in the camera, or via a memory card reader.

CompactFlash Card
This is the most widely used type of memory card for digital photography. CompactFlash cards are available in a range of capacities (up to 128 GB) and speeds, to suit every budget.

Secure Digital (SD) Card
SD cards are very widely used in both compact cameras and dSLRs. Standard SD cards can store up to 4 GB, while SDHC (High-Capacity) cards have a larger maximum capacity of 32 GB.

xD-Picture Card
These cards, with capacities of up to 2 GB, offer good performance with low power consumption. However, they are not widely supported, and are proprietary to Olympus and Fujifilm.

Card reader
A memory card reader enables you to download photographs to your computer without connecting your camera. It transfers the data from your memory card directly to the computer using a USB 2.0 or FireWire cable (see p.334). Some computers now come with memory card slots, bypassing the need for a card reader.

Card slot

Media storage viewer
These portable multimedia devices not only enable you to review and show images as you shoot, but also let you store and manage your digital photos, movies, and music on the move.

Lock

USB connector

Card slots

Navigation wheel

Display screen

Menu and display buttons

USB flash drive
Also known as a USB "stick", USB flash drives fit directly into the USB socket of a computer. They are easy to use and have become a very popular way of transferring files from one machine to another. For their size, some models have very impressive storage capacities.

UPS, surge protectors, and cables

Electrical fluctuations can damage your hard-disk drive or your computer system, so it's a good idea to have some kind of protection against the possibility of power surges or outages. An uninterrupted power supply (UPS) acts as a backup battery for your computer: it cuts in if the mains power fails, and allows you time to save your work and shut down the computer properly. Surge protectors, on the other hand, prevent sudden rises in power from damaging your equipment.

As you acquire different electronic devices, you're certain to accumulate various leads and cables for connecting them to your computer and each other. USB and FireWire are the most common types of cable.

DATA SPEEDS

The table below shows the maximum speeds at which data is transferred through different cables. Although FireWire 800 is almost twice as fast as USB 2.0, the arrival of USB 3.0 promises speeds of up to 3 GB/sec.

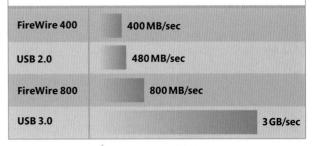

FireWire 400	400 MB/sec
USB 2.0	480 MB/sec
FireWire 800	800 MB/sec
USB 3.0	3 GB/sec

A

B

MINI B

USB 2.0
There are several types of USB connector. The mini B connector, shown here with the standard A and B connectors, was introduced with USB 2.0.

4-PIN

6-PIN

FireWire 400
The original FireWire specification, FireWire 400 uses plugs and sockets with 4-pin and 6-pin configurations.

FireWire 800
FireWire 800 cables use a 9-pin configuration, but are backwardly compatible with the FireWire 400 system. The high capacity of FireWire 800 cables makes them great for high-speed photo storage and video capture.

HDMI
High-definition multimedia interface cables are used to connect audio-visual devices, including some digital cameras and camcorders, to displays and sound output units. They are commonly used in connecting games consoles to TVs.

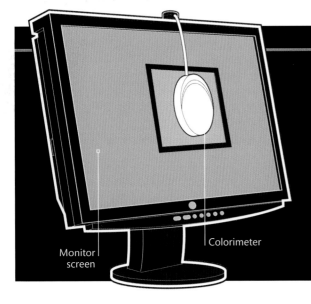

Monitor screen

Colorimeter

CALIBRATING AND PROFILING

By calibrating your computer monitor and printer, you can reduce any inconsistencies in colour and make sure that what you print is consistent with the colours you see on your screen (see pp.178–79).

Monitor calibration functions are offered by computer operating systems, but the best solution is to use a monitor calibrator, called a colorimeter. This is a hardware device that sits on the monitor screen and instructs it to display a range of standard colours. It then measures and compares them with target values, before creating a monitor profile specifically tailored to your computer.

Printer calibration can be carried out by printer calibration devices in a similar way. However, visual calibration – simply comparing printed colours to those on your calibarated monitor – is usually adequate.

Ink-jet printers are the most popular type of printer for the home user. They are highly reliable and easy to use, and require practically no warm-up time; they are also inexpensive to buy, but usually produce excellent prints when used with good-quality papers.

Although they were once used mainly by professional printers and print shops, dye-sublimation printers are becoming very popular in the home. The method used by these printers means the dots they produce are less visible (despite being lower resolution than ink-jet printers), and when printing photographs they usually produce superb results. "Dye-sub" printers are easy to use and maintain, and their compact designs take up very little desk space.

Dye-sublimation printer
These printers use a system in which heat is applied to a ribbon dye, transforming it from a solid state straight to a gas without becoming a liquid. The dye then diffuses onto the printing medium before it re-solidifies.

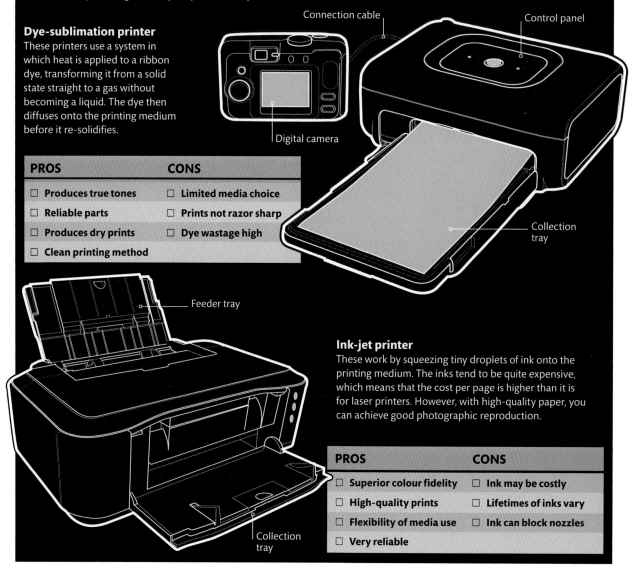

Connection cable

Control panel

Digital camera

Collection tray

PROS	CONS
☐ Produces true tones	☐ Limited media choice
☐ Reliable parts	☐ Prints not razor sharp
☐ Produces dry prints	☐ Dye wastage high
☐ Clean printing method	

Feeder tray

Ink-jet printer
These work by squeezing tiny droplets of ink onto the printing medium. The inks tend to be quite expensive, which means that the cost per page is higher than it is for laser printers. However, with high-quality paper, you can achieve good photographic reproduction.

Collection tray

PROS	CONS
☐ Superior colour fidelity	☐ Ink may be costly
☐ High-quality prints	☐ Lifetimes of inks vary
☐ Flexibility of media use	☐ Ink can block nozzles
☐ Very reliable	

Photographic software

Software is the lifeblood that enables you to use your computer to bring your digital photogaphy to life. In addition to the utility software that enables your camera, printer, and computer to communicate, you'll need an image manipulation package, or a combined photo editing and management application.

The best software to use for your digital photography is whatever best suits your workflow. Modern software development has concentrated on improving efficiency, and the most successful packages are those that combine functions. The leading software packages, Adobe Lightroom and Apple Aperture, combine powerful management tools with image enhancement features, and also offer automated export functions for the creation of web pages, slideshows, and more.

Entry-level image editors
There are many image manipulation applications that are designed to be easy to use, and most are inexpensive, if not free (see chart, opposite). However, the quality of results may vary: less expensive software may use less precise computation, or less rigorous techniques when manipulating images, than professional applications. Adobe Photoshop Elements, the consumer version of Adobe Photoshop, is easy to use and offers a feature set that will take you a long way. It also provides a good starting point from which to progress to the complexities of Photoshop.

Adobe Photoshop
The most widely used software by both amateurs and professionals, Adobe Photoshop is the leading application in this field. Its extensive and powerful range of features offers almost limitless control and creativity. However, the features it offers are so extensive that few of even the busiest professionals could say they regularly use, or are familiar with, the full extent of the tools and controls available in the software.

Experienced users perhaps most appreciate the ease with which Adobe Photoshop may be customized, so that working with its numerous features can become a highly streamlined and efficient process. Additionally, you can greatly increase the power of this application with the many software plug-ins that are available. These can extend the capabilities of its features, from the specialized saving of JPEG files, all the way to correcting lens distortion. Adobe Photoshop also has an unrivalled ability to manipulate numerous layers and masks.

Comparing software

When deciding what photographic software to buy, the most important thing to consider is what you want to do with your photos. If your main focus is on organization and speed of processing, a workflow-oriented package such as Aperture or Lightroom might work best for you. On the other hand, if you are particularly interested in editing and manipulating your photos, you might be better off choosing a software package that includes a more comprehensive range of enhancement and correction tools. You should be able to find a package that suits your requirements, whatever your budget.

Software features

Here is a comparison of the features and compatibility for some of the most popular image editing and management packages. Some of the free packages compare very favourably.

Key □ No ■ Yes

	APPLE APERTURE	ADOBE LIGHTROOM	MICROSOFT PHOTO EDITOR	APPLE IPHOTO	PICASA	COREL PAINTSHOP PRO	ULEAD PHOTOIMPACT	GIMP	PAINT.NET	PHOTOSHOP ELEMENTS	ADOBE PHOTOSHOP
Free	□	□	□	□	■	□	□	■	■	□	□
Windows	□	■	■	□	■	■	■	■	■	■	■
Mac	■	■	□	■	■	□	□	■	□	■	■
RAW file imports	■	■	□	■	■	■	■	■	■	■	■
RAW file conversion	■	■	□	■	□	■	□	□	■	■	■
Image library	■	■	□	■	■	■	■	□	□	□	□
Slideshow	■	■	□	■	■	□	■	□	□	■	■
Web optimization	■	■	■	□	□	■	■	■	□	■	■
Plug-in support	■	■	■	■	□	■	■	■	■	■	■
Re-sizing	■	■	■	■	■	■	■	■	■	■	■
Layers	□	□	□	□	□	■	■	■	■	■	■
Selection editing	■	■	■	□	□	■	■	■	■	■	■
Noise reduction	■	■	■	■	■	□	■	■	■	■	■
Sharpening	■	■	■	■	■	■	■	■	■	■	■
Colour correction	■	■	■	■	■	■	■	■	■	■	■
Contrast correction	■	■	■	■	■	■	■	■	■	■	■
Brightening	■	■	■	■	■	■	■	■	■	■	■
Highlight and shadow correction	■	■	■	■	■	□	■	□	□	■	■
Histograms	■	■	□	■	■	■	■	■	■	■	■
Lens correction	■	■	□	□	□	□	■	■	□	□	■

Looking after equipment

Digital photography equipment, apart from a few accessories, is high-precision, high-technology and highly vulnerable to damage. The smallest fracture, distortion of shape, or stray electric charge can render an item unusable.

However, as all equipment is constructed to take day-to-day wear and tear, following a few common-sense precautions will allow you to enjoy using it without a constant fear that you'll break it. For all equipment, it's best to avoid dust, dampness or water, extreme heat or cold, and strong magnetic fields. It also pays to keep lenses and dSLR sensors scrupulously clean: any defects on these immediately reflects on the quality of your images.

Cleaning a lens

Work under a bright, concentrated light that shows up dust. Puff the glass surface with a silicone puffer to remove the biggest, movable specks: these could scratch the surface if you try to wipe them off. Examine the lens closely, holding it against the lamp and looking for flecks and marks on the surface. Use a magnifying glass to get really close up.

To remove a smear, use a clean microfibre cloth. Fold the cloth a few times. Using a circular action, wipe around the smear. After one or two wipes, refold the cloth to use a new, clean part. The circular action is to avoid creating a pattern such as a long streak that may affect optical performance. Random marks are less noticeable.

For persistent smears, roll a clean tissue into a cone like a pencil tip. Dampen the tissue with lens-cleaning solution – one drop is plenty. With small circular actions wipe the lens, taking care not to squeeze liquid out that could run into the edge of the mount. Allow any smears to evaporate before you apply more: the solvent may appear to mark the lens but disappears once it has evaporated. After the worst marks are removed, give the lens an overall wipe.

If you return a filter to the lens, remember to clean the inside surface of the filter before putting it on. Give the space between the lens and filter a puff or two just before screwing in the filter. Clean the rear mount by blowing dust off the rear element. If the rear element is dirty, clean as for the front element. Remember to clean both the front and rear lens caps before replacing them.

Handling memory cards and readers

Memory cards are remarkably sturdy and reliable for their cost and size. Problems are usually due to mishandling. If a problem occurs, stop using the card at once, then use rescue utilities to extract all images. Do not reformat the card or delete pictures. In general, observe these precautions:

▶ **CHECK THE WARRANTY**	▶ **PREPARATION**	▶ **EXPOSE THE SENSOR**
1 Some manufacturers void the warranty if you attempt to clean the sensor yourself, so check the terms of your camera's warranty first.	**2** It's essential to use proper sensor-cleaning materials and procedures, as damage to the cover glass will result in a costly repair.	**3** Following the instruction manual and observing any special precautions listed, set "cleaning mode" on the camera.
■ Clean the sensor only if dust specks are causing problems or just prior to a very important photographic engagement. If you're not troubled by dust specks on your image, don't expose the sensor.	■ Ensure the camera battery is fully charged. ■ Work in the cleanest environment you can access: for instance, in an air-conditioned office (preferably early in the morning or late at night, when dust is most settled), with the air conditioning turned off. ■ Arrange your tools around you. ■ Don't wear clothes that shed threads and dust. If possible, wear an apron.	■ Carefully remove the lens and set it front down. ■ Drop the lens' rear cap on the back of the lens; you don't want this to pick up any dust. ■ You'll see that the cleaning mode flips up the mirror and opens the shutter to expose the sensor.

- Do not remove a memory card from its device if any light is on or blinking: you could damage data.
- Avoid touching the contacts of cards that have flat pins.
- Ensure you insert your memory card into the correct slot of a multi-card reader, and in the correct way. If you have to force a card into a reader you're using the wrong slot.
- Reformat the card in your camera every time you download, saving, and backing up the pictures.
- Charge your batteries: failure during writing may result in damage to the card.
- Do not power down the camera while it's saving data to the card.
- If using Windows 2000 or XP, flush the cache before removing your card from the reader: right click on the green arrow in the system tray and eject your drive letter.

Cleaning the sensor

Sensors on compact cameras will need to be returned to a service centre should they need cleaning. There is no dSLR camera system that keeps the sensors perfectly clear of dust, and owners of dSLRs will need to overcome a natural fear of working directly on the sensor if they wish to clean the sensor themselves. To do so, follow the procedures in the flowchart below.

DID YOU KNOW?

A camera dropped into water can be rescued, with a little luck and decisive action. Photographers have even reported rescuing cameras that have fallen into seawater. This same process can also save laptops that have had water spilt on them.

- Switch the camera off as soon as it's retrieved.
- If dropped into seawater or mud, rinse the camera in clean water as soon as possible.
- Dry with anything handy, but not thoroughly.
- Remove the battery and the memory card, taking care not to allow more water into the compartments.
- Dry all surfaces thoroughly with a cloth.
- Remove the lens and any accessories, such as the eyepiece correction and filter.
- Dry the exposed surfaces of all accessories and store them somewhere safe.
- Keep the camera as dry as possible until you get back home.
- Place the camera and lens in a warm space, for example, a small room with the heater turned on. The area around a hot-water storage cylinder is ideal. Do not try to speed up drying by placing the camera in an oven or near a heat source.
- Take the camera to a service centre.

DRY CLEAN

4 Use a modern puffer to blow air into the throat of the camera. (Don't use old puffers as these can blow particles out.) Rest the camera on your desk, hold the nozzle in one hand and squeeze the bulb in the other. Use a brush to remove dust particles.

- Use only brushes specially made for sensors: keep these perfectly clean, and never touch the bristles with your fingers.
- When using a brush, don't let the hairs trail outside the sensor area as they may pick up lubricant and smear it over the sensor.

WET CLEAN

5 The most thorough way to clean is to use ultra-clean swabs with methanol-based solvents. This removes dust that's stuck on the sensor glass.

- Open the swab only just before use. Apply one or two drops of solvent and drag the swab in one even movement from one side of the sensor to the other.
- Turn the swab over and repeat in the opposite direction. The solvent should dry without leaving streaks.
- Turn your camera off; this usually exits the cleaning mode. Blow dust off the back of the lens and replace it.

TEST

6 Photograph a blank subject such as the sky or the white screen of your monitor to check for specks, or use a sensor inspection loupe (a magnifying glass with a light) to examine the sensor directly.

- Remember that images are inverted on the sensor, so a dust speck in the top right corner of the image is in the bottom left corner of the sensor.
- Don't expect to remove every last speck. All parts within the camera throat are extremely delicate: do not touch. Work steadily and carefully to avoid accidents.

Internet resources

WEBSITE DIRECTORIES

Software, blogs, photo-sharing:
http://mashable.com/2007/06/23
photography-toolbox
Selection of articles and newsfeeds :
http://photography.alltop.com
Courses, magazines, galleries:
http://www.photographydirectory
project.com
Galleries by theme, general resources:
http://www.photographysites.com
Galleries, blogs, software, and more:
http://www.prosphotos.com
Tutorials, guides, software, tools, tips:
http://www.urban75.org/photos/resources

GENERAL

http://www.amateurphotographer.co.uk
http://www.amateursnapper.com
http://www.aperture.org
http://www.beyondmegapixels.com
http://www.demystifyingdigital.com
http://www.digital-photography-
school.com
http://www.digitalartsonline.co.uk
http://www.digitalphotography.co.uk
http://www.diyphotography.net
http://www.dslrtips.com
http://www.luminous-landscape.com
http://www.photo-i.co.uk
http://photo.net
http://www.photography.com
http://www.photographycorner.com
http://www.photographywebsite.co.uk
http://photojojo.com
http://photonotes.org
http://www.photoradar.com
http://www.photoxels.com
http://www.smokinphoto.com
http://www.theshutter.co.uk

Online magazines:
http://www.1000wordsmag.com
http://www.apogeephoto.com
http://www.dphotographer.co.uk
http://www.ephotozine.com
http://www.geo.de
http://www.guardian.co.uk/artanddesign/
photography
http://www.illustratedphotography.com
http://jpgmag.com
http://www.lensculture.com
http://www.photoanswers.co.uk
http://www.photoclub.canadian
geographic.ca
http://www.photoeye.com
http://www.photography.ca
http://www.photographymonthly.com
http://pixsylated.com
http://www.professionalphotographer.co.uk
http://www.shutterbug.com
Art, design, fashion:
http://www.artreview.com
http://www.arturban.co.uk/blog
http://www.dazeddigital.com/photography
http://www.hautstyle.co.uk
http://www.okaygreat.com
http://omgposters.com
http://www.zonezero.com
Nature, landscape:
http://www.naturephotographers.net
http://www.naturesbestphotography.com
http://www.naturescapes.net
http://www.outdoorphotographer.com
http://photography.nationalgeographic.
com

PHOTOBLOGS

Bloggers' Choice awards picks:
http://bloggerschoiceawards.com/
categories/13

Travel, searchable by location:
http://www.coolphotoblogs.com
By theme and location:
http://www.photoblogdirectory.net
By theme:
http://www.photoblogdirectory.org
Most popular in the last ten days:
http://www.photoblogs.org
General list:
http://www.photography-colleges.org/
the-top-100-photography-blogs
General photoblogs:
http://www.aphotoeditor.com
http://blogs.photopreneur.com/
http://blogs.telegraph.co.uk/culture/kateday
http://exposurecompensation.com
http://www.fotohacker.com
http://framestop.net
http://heyhotshot.com/blog
http://www.iheartphotograph.blogspot.com
http://www.londonrubbish.com
http://www.mnemospection.com/blog
http://www.petapixel.com
http://www.photo-muse.blogspot.com
http://www.photographyblog.com
http://picture-of-the-day.com
http://theclick.us
http://www.thephotographsnottaken.com
http://thephotoletariat.com
http://wecantpaint.com/log
http://wvs.topleftpixel.com

PHOTO-SHARING

http://www.dphoto.com
http://www.dropshots.com
http://www.flickr.com
http://www.fotki.com
http://www.fotopages.com
http://www.imagehosting.com
http://imageshack.us
http://www.photobucket.com

http://www.photoshelter.com
http://picasa.google.com
http://www.pixyblog.com
http://www.smugmug.com
http://www.snapfish.co.uk
http://www.webshots.com
http://www.zoomandgo.com
http://www.zooomr.com

GALLERIES

Photos from Canada:
http://www.allcanadaphotos.com
Photography and culture:
http://www.americansuburbx.com
Magnum agency photos:
http://blog.magnumphotos.com
Photo-essays by new photographers:
http://www.burnmagazine.org
Galleries by photographer:
http://fjordphoto.org
Daily photographs:
http://flakphoto.com
Photo-essays from around the world:
http://www.jansochor.com
Life magazine's daily photos, archives:
http://www.life.com
Light painting:
http://www.luminarymovie.com
Travel photography/charity:
http://www.millionplacesonearth.com
News photos by timeline:
http://nachofoto.com
Photography Now portfolios:
http://photography-now.net
Street photography:
http://www.street-photographers.com
Portfolios from around the world:
http://www.theblacksnapper.net/archive
Upcoming artists:
http://theexposureproject.com

Photo-essays from Asia:
http://www.thephotoessay.com
User-submitted photos:
http://www.theworldsbestphotography.
com
Time magazine's photo-essays:
http://www.time.com/time/photoessays
City, town, and country photo galleries from the UK and beyond:
http://www.urban75.org/photos
City and urban photography:
http://www.urbanlandscape.org.uk
Urban exploration galleries:
http://www.forbidden-places.net
http://www.sleepycity.net
http://www.talkurbex.com/explore/gallery
http://www.urban-exposure.com

FORUMS

http://www.cambridgeincolour.com/forums
http://www.dcresource.com/forums
http://www.digi-darkroom.com
http://digital-photography-school.com/
forum
http://www.dpforums.com
http://www.dpreview.com/forums
http://forums.adobe.com
http://forums.photographyreview.com
http://www.lightstalkers.org
http://www.nikonians.org
http://photo.net/community
http://www.photography-forum.org
http://photography-on-the.net/forum
http://www.phototopix.co.uk
http://www.photozo.com/forum
http://www.talkphotography.co.uk
http://www.thephotoforum.com

GEAR REVIEWS

http://www.cameralabs.com
http://www.dcresource.com
http://www.digital-slr-guide.com
http://www.digitalslrphoto.com
http://www.dpreview.com
http://www.dslr.co.uk
http://www.dslruser.co.uk
http://www.imaging-resource.com
http://www.kenrockwell.com
http://nikonslrcamerareviews.com
http://www.photographyreview.com
http://www.radiantlite.com
http://www.whatdigitalcamera.com

ACCESSORIES

Shoulder mounts and supports:
http://bushhawk.com
Choice of 12 different tablets:
http://graphicssoft.about.com/od/
aboutgraphics/tp/graphicstablets.
whtm
Printable lens hoods templates:
http://www.lenshoods.co.uk
Infra-red conversions for cameras:
www.lifepixel.com
Sensor cleaning :
http://www.sensorcleaning.com/how.php

DSLR FILM-MAKING

General information, articles, resources:
http://www.brighthub.com/multimedia/
video.aspx
DIY solutions for dSLR video shooting:
http://cheesycam.com
dSLR video forum:
http://www.cinema5d.com

Forums, tutorials, magazine, and more:
http://www.creativecow.net

News, articles, video:
http://digitalslrshooter.com

News, reviews, tutorials:
http://www.dslr-cinematography.com

News and blog:
http://dslrfilm.com

General info and blog:
http://dslrhd.com

dSLR broadcast journalism:
http://www.dslrnewsshooter.com

General resources:
http://dslruniversity.com

Info, reviews, blog:
http://dslrvideoshooter.com

Online magazine:
http://www.dv.com

Guardian digital video content:
http://www.guardian.co.uk/technology/
digitalvideo

Guerilla Film Makers books:
http://www.livingspirit.com/books

**Magic Lantern firmware for
Canon dSLRs:**
http://magiclantern.wikia.com/wiki/
Magic_Lantern_Firmware_Wiki

Blog, features, guides:
http://nofilmschool.com

Film reviews, industry news:
http://www.rottentomatoes.com

**Independent film-makers' forum,
networking, job listings:**
http://shootingpeople.org

Digital video editing tutorials, reviews:
http://videoediting.digitalmedianet.com

Video editors' forum:
http://www.videoforums.co.uk

Articles, tutorials:
http://www.videomaker.com

Video upload/sharing:
http://www.vimeo.com/hd
http://www.youtube.com

ONLINE TUTORIALS

http://www.digital-photography-school.com
http://www.good-tutorials.com
http://www.lynda.com
http://www.naturescapes.net/072006/
rh0706_1.htm
http://www.photoshop101.com
http://www.photoshopdaily.co.uk
http://www.photoshopgurus.com
http://www.prophotoinsights.net

COMPETITIONS

Directories:
http://www.photocompete.com
http://www.photocompetitions.com
http://www.photographycompetitions.net
http://www.photolinks.com/Photo_Contests
http://www.shootexperience.com/events/
home/CMP

General competitions:
http://www.fotothing.com/competitions
http://www.onevisionphoto.org
http://renaissancephotography.org
http://shootnations.org
http://www.snapalley.com

Music photography competition:
http://www.billboardphotocontest.com

Garden Photographer of the Year:
http://www.igpoty.com

Wildlife Photographer of the Year:
http://www.nhm.ac.uk

Travel Photographer of the Year:
http://www.tpoty.com

World Photography Organisation:
http://www.worldphoto.org

World Press Photo:
http://www.worldpressphoto.org

PHOTOJOURNALISM

News stories in pictures:
http://www.boston.com/bigpicture

Photography for social change:
http://www.collectivelens.com

Citizen journalism:
http://www.demotix.com

Editorial Photographers UK:
http://www.epuk.org

Photojournalism e-magazine:
http://www.foto8.com

Global photojournalism:
http://www.gaia-photos.com

Portfolios, galleries:
http://greatphotojournalism.com

New York Times photojournalism blog:
http://lens.blogs.nytimes.com

The Nieman Foundation at Harvard:
http://www.niemanlab.org

London-based photojournalist:
http://www.photojournalism.co.uk

Picture essays, photojournalism issues:
http://www.rethink-dispatches.com

e-book on photojournalism ethics:
http://rising.blackstar.com/
photojournalism-technology-and-
ethics-whats-right-and-wrong-today

STOCK PHOTOGRAPHY

http://www.agencevu.com
http://www.alamy.com
http://www.corbisimages.com
http://www.everystockphoto.com
http://en.fotolia.com
http://www.gettyimages.com
http://www.magnumphotos.com
http://www.istockphoto.com
http://www.sciencephoto.com
http://www.viiphoto.com

MANUFACTURERS

http://www.canon.com
http://www.data-mind.co.uk
http://www.epson.com
http://www.fujifilm.com
http://www.hasselblad.se
http://www.hoyaoptics.com
http://www.hp.com
http://www.kodak.com
http://www.konicaminolta.com
http://www.leica-camera.com
http://www.minox.com
http://www.nikon.com
http://www.olympus-global.com
http://www.panasonic.com
http://www.pentax.com
http://www.polaroid.com
http://www.ricoh.com
http://www.rollei.com
http://www.samsungcamera.co.uk
http://www.sigmaphoto.com
http://www.sony.com
http://www.tiffen.com
http://www.tokina.com
http://www.voigtlaender.de

SOFTWARE

http://www.acdsee.com
http://www.adobe.com
http://www.alienskin.com
http://www.andromeda.com
http://www.apple.com
http://www.arcadiasoftware.com
http://www.arcsoft.com
http://www.autofx.com
http://www.batchimageprocessor.com
http://www.corel.com
http://www.datacolor.com
http://www.digitalanarchy.com
http://www.digitalfilmtools.com

http://www.download.com
http://www.dxo.com
http://www.engelmann.com/eng/
photomizer.php
http://www.freephotoresources.com
http://www.getpaint.net
http://www.gimp.org
http://www.hdrsoft.com
http://www.humansoftware.com
http://www.imagenomic.com
http://www.irfanview.com
http://www.kekus.com
http://www.lumapix.com
http://www.magix.com
http://www.microsoft.com
http://www.niksoftware.com
http://www.ononesoftware.com
http://www.phaseone.com
http://www.photo-plugins.com
http://photoediting.dphotojournal.com
http://www.photolightning.com
http://www.photoscape.org
http://www.photoshopsupport.com
http://www.picnik.com
http://www.picturecode.com
http://www.pixelmator.com
http://www.serif.com/photoplus
http://thepluginsite.com
http://www.toolfarm.com
http://www.topazlabs.com
http://www.ulead.com
http://www.vertustech.com

Focus stacking software:
http://www.hadleyweb.pwp.blueyonder.co.
uk/CZP/Installation
http://www.heliconsoft.com
http://www.tawbaware.com/tufusepro
http://www.zerenesystems.com/stacker

Recovery software:
http://www.photonose.com
http://www.photosrecovery.com

MISCELLANEOUS

British Journal of Photography:
http://www.bjp-online.com
Camera manufacturer wiki:
http://www.camerapedia.org
Shared copyright licences:
http://creativecommons.org
Best practices and workflow:
http://www.dpbestflow.org
Famous photographs:
http://www.famouspictures.org
World news, features, pictures:
http://www.focalpointdaily.com
Photography gadget guide:
http://gizmodo.com
General street photography website:
http://www.in-public.com
Photography law:
http://www.photoattorney.com
Photography quotes:
http://www.photoquotes.com
Bill of Rights for photographers:
http://www.pro-imaging.org
Blog dedicated to flash and lighting:
http://strobist.blogspot.com
Technology news:
http://techcrunch.com
Tom Ang:
http://www.tomang.com
Technology/gadget reviews:
http://www.trustedreviews.com
Wired magazine:
http://www.wired.com
Women in Photography:
http://www.wipnyc.org
Photography festivals:
http://www.photographyforchange.net
http://www.rencontres-arles.com
http://www.scotiabankcontactphoto.com
http://www.visapourlimage.com

Further reading

HANDBOOKS

101 Great Things to Do with Your Digital Camera
Simon Joinson
David & Charles
An informative introduction to the basics of using a camera.

The Complete Photographer
Tom Ang
Dorling Kindersley
A guide to shooting ten of the most popular styles and subjects.

Digital Macro Photography
Ross Hoddinott
Photographers' Institute Press
Easy-going read by a knowledgeable, enthusiastic practitioner.

Digital Photographer's Handbook
Tom Ang
Dorling Kindersley
Classical photography techniques brought up to date for the digital era.

Digital Photography Masterclass
Tom Ang
Dorling Kindersley
How to learn new skills, improve your eye, and be a better photographer.

The Hot Shoe Diaries
Joe McNally
New Riders
An introduction to using electronic flash, with many inspiring examples.

Mastering Digital Panoramic Photography
Harald Woeste
O'Reilly
A detailed and sound guide to the subject, covering capture and post-processing.

Mastering Digital Photography
Michael Freeman
ILEX
Enormous, 640-page doorstop. Authoritative, good value for money.

Travel (National Geographic Field Guides)
Robert Caputo
National Geographic Society
Invaluable, field-tested advice in compact format. Highly recommended.

USING SOFTWARE

Adobe Photoshop CS5 for Photographers
Martin Evening
Focal Press
Large, very detailed, and used as standard.

Adobe Photoshop Lightroom 3 Classroom in a Book
Adobe Creative Team
Adobe
Well-produced, in-depth step-by-steps.

Apple Pro Training Series: Aperture 3
Dion Scoppettuolo
Peachpit Press
Exhaustive and thorough tutorials.

How to Cheat in Photoshop CS5
Steve Caplin
Focal Press
Essential reading for those who wish to make photo-realistic montages, written by a master of the art.

Photoshop Masking Compositing
Katrin Eismann
New Riders
Excellent introduction to selections and masks (though a little out-of-date).

Professional Photoshop
Dan Margulis
Peachpit Press
Comprehensive coverage of just one topic – colour correction in Adobe Photoshop.

Real World Color Management
Bruce Fraser, Chris Murphy, Fred Bunting
Peachpit Press
Top-class and authoritative introduction to the subject. Highly recommended.

PHOTOJOURNALISM

The Great LIFE Photographers
The Editors of LIFE
Thames & Hudson
A gloriously rich collection of images from the heyday of photojournalism.

Magnum Magnum
Brigitte Lardinois
Thames & Hudson
Photojournalism at its most iconic in this inspiring book of photographs.

Photojournalism: The Professionals' Approach
Kenneth Kobre
Focal Press
Classic textbook updated with many new images. Indispensable.

Truth Needs No Ally: Inside Photojournalism
Howard Chapnick
University of Missouri Press
Passionate, insightful account of photojournalism.

HISTORY

20th Century Photography
Museum Ludwig Cologne
Taschen GmbH
An impressive volume from one of the world's best collections. Great value.

PhotoBox: Bringing the Great Photographers into Focus
Roberto Koch
Thames & Hudson
A superb collection of photographs with commentaries and biographies by a world-class picture editor.

World History of Photography
Naomi Rosenblum
Abbeville Press
Standard work on the basic history of photography. Well-illustrated and highly readable.

ESSAYS

On Photography
Susan Sontag
Penguin Classics
A classic set of essays on the meaning of photography – a must-read for any photography lover.

DSLR FILM-MAKING

1001 Movies You Must See Before You Die
Steven Jay Schneider
Cassell Illustrated
Exploring every genre, this definitive list of must-see films features alongside many interesting facts and statistics.

Cinematic Storytelling
Jennifer Van Sijll
Michael Wiese
Van Sijll explores and explains 100 non-dialogue cinematic conventions.

Cinematography
Peter Ettedgui
Rotovision
An informative insight into the working methods of 15 cinematographers.

Directing the Documentary
Michael Rabiger
Focal Press
Complete guide to documentary film-making, revised and updated.

A Filmmaker's Handbook: A Comprehensive Guide for the Digital Age
Steven Ascher, Edward Pincus
Plume
Everything you need to know about digital film-making in this handy guide.

The Five C's of Cinematography: Motion Pictures Filming Techniques
Joseph V. Mascelli
Silman-James Press
Mascelli uses succinct illustrations to convey the ideas and techniques of motion-picture camerawork.

The Guerilla Film Makers Handbook
Chris Jones, Genevieve Jolliffe
Continuum International Publishing Group Ltd
An indispensable book for would-be film-makers. Informative and inspiring.

Radio Times Guide to Films 2011
Radio Times Film Unit
Radio Times
23,000 films get the critical treatment in this up-to-date, comprehensive guide.

Story: Substance, Structure, Style and The Principles of Screenwriting
Robert McKee
HarperCollins
Concise, practical advice on the art of storytelling for the big screen.

Glossary

Below is a list of terms relating to digital stills photography. For a list of film-making terms, see pp.352–53.

32x speed When a device records (writes) or reads data at 32 times the basic rate of 150 KB/sec, so 4.8 MB/sec; and similarly for other speeds, so 66x speed is 10 MB/sec, and 133x speed equals 20 MB/s.

24-bit Measure of the size or resolution of data that a computer, application, or component works with. Also 12-bit, 14-bit, 36-bit.

6,500 White light standard close to warm daylight; widely used as the white target.

9,300 White light standard close to daylight; suitable for viewing prints in daylight.

additive colour Combining or blending two or more coloured lights, in order to simulate or create the impression of another colour.

aliased Appearance of jagged, broken, or stepped tones that should be smooth or even, due to a lack of image data or poor processing.

ambient light Existing light arising from natural sources.

analogue Effect, representation, or record that is proportionate to some other physical property or change.

anti-aliasing Smoothing away the stair-stepping in an image or computer typesetting.

aperture Opening behind the lens through which light passes.

APS-C Sensor size: approximately 25.1mm x 16.7mm.

archive Full copy of files securely stored for safe-keeping on stable media.

artefact Feature or detail in an image caused by processing or manipulation.

AWB (auto-white balance) Automatic setting of white balance to correct colour cast.

background In layer mode, the bottom layer of an image; the base.

back up To make and store duplicate or additional copies of computer files.

banding Noise patterns appearing as bands, or solid stripes. Often seen in high-ISO images, particularly in areas of shadow.

bicubic interpolation Type of interpolation in which the value of a new pixel is calculated from the values of its eight nearest neighbours.

bilinear interpolation Type of interpolation in which the value of a new pixel is calculated from the values of four of its near neighbours: left, right, top, and bottom.

bit depth Measures of the amount of data available to code or name different colours; normally 8-bit per channel.

black An area that has no colour or hue due to its absorption of most or all light.

bleed (1) Photograph or line that runs off the page when printed. (2) Spread of ink into the fibres of a support material. This effect causes dot gain.

Bluetooth A standard for high-speed wireless connections between devices such as mobile phones or keyboards, and for networking.

bokeh Quality or characteristics of blur.

brightness Quality of visual perception that varies with the amount or intensity of light.

Brush Image editing tool used to apply effects such as colour, blurring, burning, dodging, and more.

burning-in Digital image manipulation technique that mimics darkroom burning-in.

byte A word or unit of digital information.

cyan A secondary colour made by combining the two primary colours red and blue.

calibration Process of matching characteristics or behaviour of a device to a standard setting.

camera exposure Quantity of light reaching the sensor: depends on the effective aperture of the lens and the duration of the exposure to light.

channel Set of data used by image manipulation software to define a colour or mask.

CMYK (cyan magenta yellow key) The colours of inks used to reproduce colour in images.

clone To copy selected parts of an image onto another part of it, or onto another image.

colourize To add colour to a greyscale image without changing the original lightness values.

colour Quality of visual perception characterized by hue, saturation, and lightness.

colour space Range of colours in which colours are recorded or manipulated.

colour cast Tint or hint of colour evenly covering an image.

colour gamut Range of colours producible by a device or reproduction system.

compositing Image manipulation technique that combines one or more additional images with a base image.

compression Process of reducing the size of digital files by changing the way their data is coded.

contrast Measure of a scene's subject brightness range.

crop To use part of an image for the purpose of, for example, improving composition, fitting an image to an available space or format, or squaring up an image to correct a tilted horizon.

Curves Control allowing changes to be made in the relationship between an image's input and output values; used to alter exposure and contrast.

D50 Target for white light, suitable for viewing prints by tungsten lamps.

dSLR Digital single-lens reflex camera.

definition Subjective assessment of clarity and quality of visible image detail.

depth of field Measure of zone or distance over which any object in front of lens appears acceptably sharp; lies in front of, and behind, plane of best focus.

diaphragm Group of curved blades in a lens that form a central hole: changing their setting alters the size of the hole, controlling lens aperture.

digital watermark Image or information embedded in an image identifying copyright owner; may be visible or readable only by software.

direct vision finder Type of viewfinder in which the subject is observed directly, through a hole or optical device.

display Device that provides temporary visual representation of data such as a monitor screen, an LCD projector, or the information panel on a camera.

DNG (Digital Negative) Format for the raw files generated by digital cameras.

dodging Technique for controlling local contrast by a localized increase in lightness.

DPI (dots per inch) Measure of resolution of an output device: number of points that can be addressed by a device.

driver Software used by a computer to control or drive a peripheral device such as a scanner, a printer, or a removable media drive.

drop shadow Graphic effect in which an object appears to float above a surface, leaving a shadow below it, and offset to one side.

duotone Colour mode that simulates the printing of an image with two differently coloured inks.

DVD (digital versatile disc) Data storage medium.

dye sublimation Printer technology based on the rapid heating of dry colourants, held in close contact with a receiving layer.

dynamic range Measure of the difference between the highest and lowest energy of significant areas in a scene.

enhancement Change in one or more qualities of an image in order to improve its visual or other properties, such as an increase in colour saturation, sharpness, and so on.

EV (exposure value) A measure relating exposure time and *f*/number to brightness: high EV indicates bright light. A change of one EV is equivalent to a change in one stop.

EVF (electronic viewfinder) LCD camera screen, viewed under an eyepiece, showing the view through the lens.

EXIF (Exchangeable Image File Format) Rules for including metadata with an image.

exposure Process of allowing light to reach light-sensitive material to create an image.

f/number Setting of the lens aperture that determines the amount of light passing into the lens.

face detection Technology that analyses an image to find human faces, in order to locate focus or other settings.

feathering Blurring a border or boundary line by reducing the sharpness or abruptness of the change.

file format Method of organizing computer data such as TIFF or JPEG.

fill-in (1) To illuminate shadows cast by the main light source, by using another light source or reflector to bounce light from the main source into the shadows. (2) To cover an area with colour – as achieved by using the Bucket tool, for example.

filter Software that applies effects to the image.

FireWire Standard for rapid communication between computers and devices.

firmware The software embedded in a digital camera by the manufacturer that controls its functionality.

flash (1) To provide illumination with a very brief burst of light. (2) Equipment used to provide a brief burst or flash of light. (3) Type of electronic memory used in digital cameras.

flatten To combine multiple layers and other elements together into a background layer.

focal length Distance between the lens and a sharp image of an object at infinity projected by it.

focus To make an image look sharp by bringing the focal plane of an optical system into coincidence with the sensor plane.

focus stacking Making a series of exposures with the camera shifted along the lens axis a very small distance with each exposure at a fixed focus setting, then "stacking" the images in software in order to obtain increased depth of field.

format To prepare a hard disk or memory card for holding data.

full-frame Sensor size: approximately 36mm x 24mm.

gamut Range of colours that can be displayed or output by a device such as a monitor or printer.

gamma In monitors, a measure of correction to the colour signal prior to its being seen; a high gamma gives a darker overall screen image.

Gaussian blur Method of computing blur effects based on a Gaussian or bell-shaped distribution.

geotag Geographical data added to images to identify their location.

GIF (Graphic Interchange Format) A compressed file format designed to use over the internet.

greyscale Measure of the number of distinct steps between black and white in an image.

hard-copy Visible form of a computer file printed more or less permanently onto a support material, such as paper or film.

HDR (high dynamic range) Scene, image, or display in which the range of brightness is larger than normal. May be applied to images of scenes of excessive dynamic range that have been tone-mapped.

histogram Graphical representation showing the relative numbers of something over a range of values.

hot-pluggable Connector or interface that can be connected or disconnected while computer and connected device are powered – for example, USB and FireWire.

hue the visual perception of colour.

IEEE 1394 Standard for rapid communication between computers and devices. The same as FireWire.

import To convert or register files so that they can be recognized by, or work with, certain software.

ingest To upload images from a camera or memory card onto a computer or other hard-disk storage.

ink-jet Printing based on squirting extremely tiny drops of ink onto a receiving substrate.

interpolation Inserting pixels into a digital image based on existing data.

ISO Name of the International Organization for Standardization: in digital photography, usually applied as the measure of sensor sensitivity, though many other ISO standards are also used.

jaggies Appearance of stair-stepping artefacts.

JPEG (Joint Photographic Expert Group) Data compression protocol for reducing file sizes.

K (1) Binary thousand: 1,024, or 1,024 bytes is abbreviated to 1 KB. (2) Degrees Kelvin, measuring colour temperature.

key tone The principal or most important tone in an image, usually the mid-tone between white and black.

keyboard shortcut Keystroke that executes a command.

landscape Image orientation in which the longest side is horizontal.

layer mode Picture processing or image manipulation technique that determines the way in which a layer in a multi-layer image combines or interacts with the layer below it.

LCD (liquid crystal display) Display using materials that can block light.

Levels Display of the distribution of pixel brightness in an image as a histogram – the height of the column is proportional to the number of pixels that are the indicated value.

light bundle Cone of light emitted by a subject that enters the lens and is focused at the sensor.

live view Observing an image in a dSLR on the review screen, instead of through the normal viewfinder.

load To copy enough of an application software into a computer to be able to run the application.

lossless compression Computing routine that reduces the size of a digital file without reducing the information in the file, for example LZW.

lossy compression Computing routine that reduces the size of a digital file, losing information or data, such as JPEG.

lpi (lines per inch) Measure of the resolution or fineness of photo-mechanical reproduction.

luminaire Synonym for an artifical light source – any light source other than the sun or the moon.

luminance range Range of brightness visible in a scene, from the darkest surface to the brightest. In practice, it is restricted to the parts of the scene that are photographically important.

LUT (lookup table) Database relating various conditions to appropriate camera settings, for example lighting conditions to camera exposure.

Mac OS Operating system used on Apple computers.

Marquee Selection tool used in image manipulation and graphics software.

mask Technique used to obscure parts of an image selectively, while allowing other parts to show.

megapixel One million pixels: measurement of the number of pixels recorded by a sensor.

metadata Information about the image – its location, time, creator, and more.

moiré Pattern of alternating light and dark bands, or colours, caused by the interference between two or more superimposed arrays or patterns that differ in phase, orientation, or frequency.

monochrome Photograph or image made up of black, white, and greys that may or may not be tinted.

nearest neighbour Interpolation in which the value of the new pixel is copied from the nearest pixel.

noise Irregularities in an image that reduce information content.

non-destructive Image manipulation that produces a set of instructions for altering the image that are applied only to a new version, preserving the original image.

opacity Measure of how much can be "seen" through a layer.

operating system Software program that coordinates a computer.

optical viewfinder Type of viewfinder that shows the subject through an optical system, rather than via a monitor screen.

out-of-gamut Colours from one colour system that cannot be seen or reproduced in another.

output Hard-copy of a digital file – an image as an ink-jet print, or a portfolio as a DVD, for example.

paint To apply colour, texture, or effects with a digital "brush".

palette (1) Set of tools, colours or shapes. (2) Range or selection of colours available to a printer, a monitor, or other device.

peripheral External device connected to a computer, for example a printer, a monitor, a scanner, or a modem.

photomontage Photographic image made from the combination of several other photographic images.

Pictbridge Protocol enabling prints to be made directly from a camera commanding a printer.

pixel Picture element: the smallest unit of digital imaging.

pixelated Appearance of a digital image in which the individual pixels are clearly discernible.

plug-in Application software that works in conjunction with a host program into which it is "plugged", so that it operates as if part of the program itself.

portrait Image orientation in which the longest side is vertical. Compare with "landscape".

posterized Banded appearance and flat areas of colour due to lack of data.

ppi (points per inch) Number of points which are seen or resolved by a scanning device per linear inch. Compare with "lpi".

proxy Low-resolution version of an image file, used for cataloguing and as a visual reference for processing effects.

racking (focus) Changing the focus setting while keeping zoom and position constant.

RAM (Random Access Memory) Component of the computer in which information can be stored or rapidly accessed.

RAW format Image file output from the camera with minimal in-camera processing, in a format specific to the camera model or range.

read To access or take off information from a storage device such as a hard disk or memory card.

resizing Changing the resolution or file size of an image.

resolution Measure of how much detail can be seen or has been recorded, and of how clearly it can be seen.

ring-flash Electronic flash arranged around the lens in a ring-doughnut shape that provides shadowless lighting.

RGB (Red Green Blue) Colour model that defines colours in terms of relative amounts of red, green, and blue.

scanning Process of turning an original into a digital facsimile – a digital file of a specified size.

screenshot Image of the display, or part of the display, on a monitor screen made by capturing the display data.

scrolling Process of moving to a different portion of a file that is too large for the whole to fit onto a monitor screen.

sharing Publishing of images on the internet, enabling others to comment on or download them.

slideshow Sequential display of images on a screen, optionally with transitional effects, text, or music.

SLR (single-lens reflex) Camera that views and takes photos through the same lens, using a mirror to control the light-path for viewing and shooting. See also dSLR.

Smile Shutter Technology that analyses an image to detect when a face smiles, to make the exposure at the peak of the smile.

snoot Light-shaper in the form of a cone with a small hole at the top that provides a narrow cone of light, producing sharp shadows.

softbox Light-shaper in the form of a tent, that fits in front of a luminaire to provide highly diffused lighting, producing soft shadows.

soft-proofing Use of monitor screen to proof or confirm quality of an image.

stop A change in brightness or exposure: reducing by one stop halves the amount of light and so reduces exposure, while adding a stop doubles the light and increases exposure.

system requirement Specification defining the minimum configuration of a computer (for example, processor type, speed, and minimum RAM) and the version of an operating system needed to run an application software or device.

telephoto Lens with a focal length greater than or twice that of the normal view.

thumbnail Representation of an image as a small, low-resolution version of the original image.

TIFF Widely used image file format, based on tags.

tilt-shift lens Lens mounted on a mechanism that allows it to be raised or lowered, or tilted up or down, in order to control the placement of the plane of best focus.

tint Overall pale colour affecting the whole image.

tone-mapping Using software techniques to translate, or compress, a scene or images with excessive dynamic range into an image with a normal range of tones.

transfer curve A line describing how input values, such as image brightness, are translated into output values, for example when printed. Used in Curves and in tone-mapping calculations.

TWAIN Standardized software used by computers to control scanners or cameras.

undo To reverse an editing or similar action within application software.

upload Transfer of data between computers, or from a network to a computer.

USB (Universal Serial Bus) Standard port design for connecting peripheral devices such as a digital camera, telecommunications equipment, or a printer, to a computer.

USM (UnSharp Mask) Image manipulation technique that has the effect of improving the apparent sharpness of an image.

veiling flare Glow of light spread across the image, caused by a bright light source reflected inside the camera's optics.

warm colours Hues such as reds, through oranges, to yellows.

Wi-Fi card Type of memory card that can communicate with wireless devices to upload files.

write To commit data onto a storage medium such as a memory card.

zip Proprietary name for a method of compressing files.

Film-making terms

180-degree rule See crossing the line.

AVCHD (Advanced Video Coding High Definition) Video recording format.

backlight Part of a three-point lighting set-up, the backlight helps define the subject against the background.

bandpass filter A method for cleaning up audio that ignores certain frequencies outside a specified range.

boom pole Pole used to direct a microphone closer to the sound source.

cardioid Type of microphone that accepts sound from a wide angle, including a little from behind.

clip A segment of footage.

close-up A shot that tightly frames a subject.

crash zoom A very fast zoom.

crossing the line A protocol whereby a camera must stay on the same side when filming narrative between two people.

cutaway A visual element cut into a film sequence.

DOP (director of photography) The principal cinematographer on a shoot.

establishing shot See general view.

extreme close-up A shot that shows specific detail. A tighter shot than a close-up.

FPS (frames per second) See frame rate.

fill light Part of a three-point lighting set-up, the fill helps balance the key light and remove shadows.

foley The process of recording sound effects for film, done off the film set.

footage Unedited video material.

frame rate The number of images per second at which a camera or television records or displays footage.

general view Often filmed outside, a shot used to convey where the action is taking place.

grading The process of colouring a film and making colour and exposure corrections.

HD (High Definition) A range of television standards with resolution greater than 720 lines.

in the can Phrase used to convey that a shoot is finished.

IRE A unit for measuring exposure where Black equals 0 and White equals 100.

jump cut When two very similar shots are edited sequentially.

key light Part of a three-point lighting set-up: the main light source.

medium shot A shot used when filming that ranges approximately from a subject's waist to his or her head.

NTSC Television standard adopted across North America.

PAL Television standard adopted across part of western Europe and parts of Africa.

pan To rotate camera about a vertical axis. Also distribution of sound between left and right channels.

pistol grip A device that connects a microphone to a boom pole.

point of view A shot used when filming to show the audience the world as seen by the protagonist.

proxy file A substitute file used in the editing process.

rolling shutter An issue when filming with dSLRS where an object appears to be pushed to one side.

SD (Standard Definition)
Generally refers to PAL, NTSC
or SECAM television standards.

SECAM Television standard adopted
across some of Europe, Africa, and
broadly across North Asia.

soundscape An audio environment
that is created from scratch.

storyboard A visual guide to
help develop shot ideas when
planning a film.

three-point lighting Basic
lighting set-up for video involving
key, fill, and backlights.

tilt Moving the camera across
a vertical axis.

time code The numbering system
used to determine time on footage,
broken down into hours, minutes,
seconds, and frames.

timeline The area within an editing
program that allows footage to be
modified.

transition The way in which one
clip is edited into another.

wide shot A framing that takes in a
person's full length – from feet to head.

wild track Ambient sound recorded
on location without dialogue.

windshield A cover placed around a
microphone when filming outside to
reduce the noise created by wind.

XLR cable The standard cabling used
for recording professional sound.

zebra stripes A visual reference
on a video camera for determining
exposure when filming.

Index

Acknowledgments

Tom Ang would like to thank:

My first and last thanks go to Wendy: my wife, partner, co-photographer, Chief Financial Officer, and Chief Operations Manager. Thank you for everything you bring to my work. Without your tireless support, little – if any – of this would have been possible. And thank you for your fine photography, which covered me on my off-days.

My warmest thanks, well due as they are, fail to do justice to the splendidly professional team at Dorling Kindersley, led by Nicky Munro and Sarah-Anne Arnold: Jo Clark, Hannah Bowen, and Hugo Wilkinson. The book has been a creative canter thanks to all your hard work, responsiveness, and sheer brilliance. And a big "thank you" to the managers, Stephanie Farrow and Lee Griffiths, for supporting the team.

Many thanks to Wendy Olver for her casting, design, and styling skills that made one shoot the worth of three. And special thanks for Maureen Ford who provided a refuge for the final stages of this book. To the heroes we met in Guyana: Alice Layton (Rupununi), Diane McTurk (Karanambu), Colin Edwards (Rock View Lodge), we thank you for your inspiring example.

Dorling Kindersley would like to thank:

Toby Richards for the film-making section of the book (www.typeb.net); Phil Gamble for the illustrations; Bob Bridle, David Summers, and Natasha Kahn for editorial assistance; Katie Eke, Sharon Spencer, and Yen Tsang for design assistance; Adam Brackenbury and Dave Jewell for retouching; Gerard Brown for additional photography; Margaret McCormack for the index; Ramesh Suren for assistance on location; Rebecca Tennant for being a patient and good-humoured model; and Annie Power at The Coal Hole for allowing us to shoot there.

About Tom Ang

Tom is a leading authority on digital photography, a photographer, author, educator, TV broadcaster, and traveller. He won the Thomas Cook award for Best Illustrated Travel Book for his photography of the Marco Polo Expedition, which pioneered the modern Silk Road crossing from Europe to China. He has worked as a magazine editor, picture editor, technical journalist, has exhibited internationally, and was a university senior lecturer in photography for twelve years. Among his 22 books on photography and video is the best-selling *Digital Photographer's Handbook*, which has sold more than half a million copies and has been translated into twenty languages, and the award-winning *Digital Photography Masterclass*. He was presenter for two 6-part BBC series on digital photography and for an award-winning 8-part photography series for Channel News Asia, Singapore.

www.tomang.com

Credits

The following images are © Adam Brackenbury: 241; © Dorling Kindersley: 92–95, 98–99; © Wendy Gray: 39 (c), 52, 60, 76–77, 91 (4th row, fr), 138 (tl), 152 (tc), 157 (l), 163 (top 4), 166–67 (except bc), 240, 276 (ll), 287, 292; © Matthew Roy Ing: 59 (r); © Andy Mitchell: 266–67; © Toby Richards and David Waldman: 298–319, except © Tom Ang 307 (3rd row) and © Getty Images 312 (br). All other images © Tom Ang.

Images on pages 24 (bc), 46 (4th row), 68, 79, 109 (fr), 113 (c), 118 (b), 120–21 are courtesy of Sony DIME, which commissioned them for the Learn & Enjoy site: www.sony.co.uk/hub/learnandenjoy.

Madoka Toguchi (p.26, pp.80–81) appears courtesy of the Singapore Dance Theatre.

Equipment used for this book includes: Sony A900 and A100 with Zeiss 16–35mm $f/2.8$, 24–70mm $f/2.8$, 135mm $f/1.8$; Sony 16mm $f/2.8$, 50mm $f/2.5$, 70–200mm; Canon 5D MkII, Canon 1Ds Mk II and MkIII with Sigma 12–24mm, Canon 100mm $f/2.8$ Macro, 24–70mm $f/2.8$, 28–135mm, 70–200mm $f/2.8$, 100–400mm $f/4$–5.6; Leica M6 with 35mm $f/2$; Panasonic LX3; Elinchrom Prolite. Software used includes: Apple Aperture, Adobe Photoshop CS4, Quantum Photomechanic, Photomatix Pro, Topaz Labs, Alien Skin, Image Trends. Computers used: 17-inch Apple MacBook Pro, Apple Power PC G5. Many thanks for help received from Topaz Labs, Alien Skin, Image Trends.